Love Affairs with Houses

Bunny Williams
Love Affairs with Houses

ABRAMS, NEW YORK

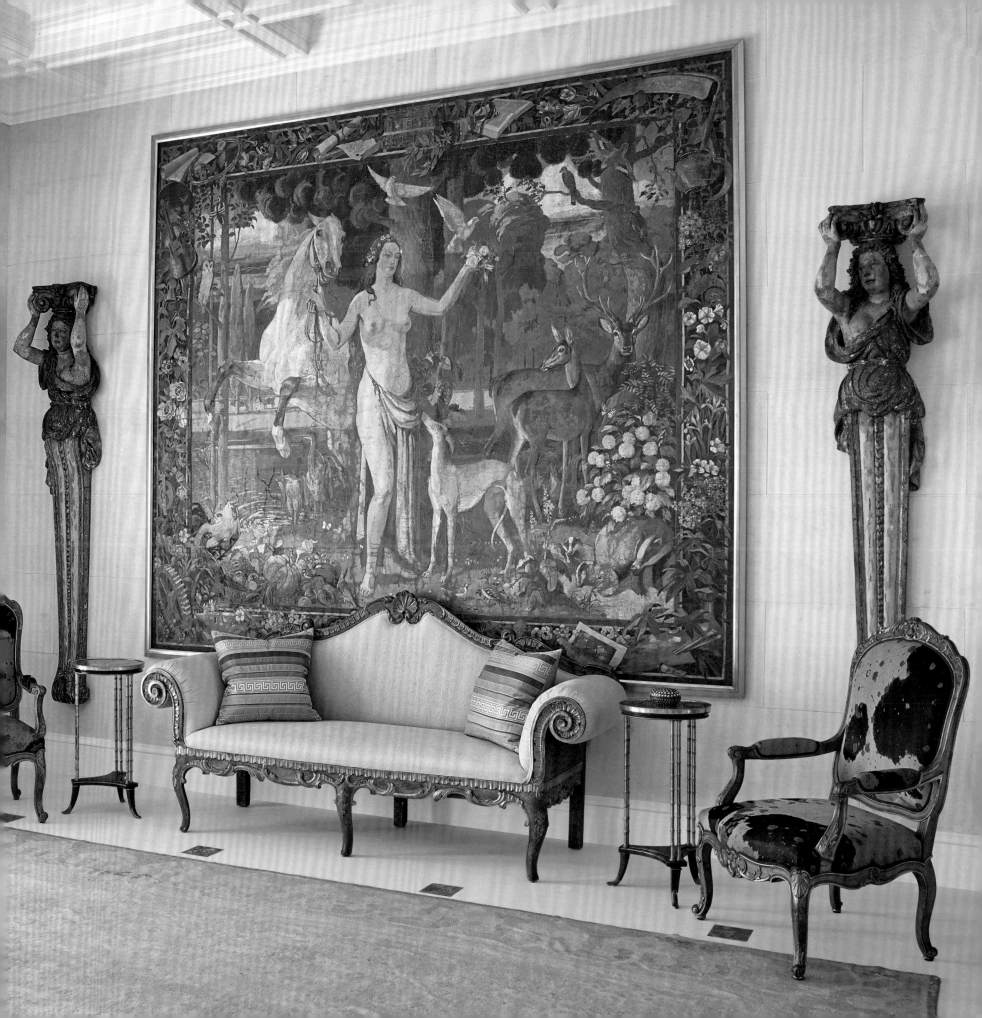

CONTENTS

BUNNY & ELIZABETH

It is hard for me to believe I have been designing for four decades.

I can still remember the excitement and nervousness of the first day in my first job at Stair and Company, the elegant antique shop on East 57th Street in New York City. Each day after that I would tour the five-story town house and stare in wonder at all the furniture, paintings, and exquisite objects that filled each floor. Mr. Stair was an encyclopedia of information, which he loved sharing. He opened my eyes to objects of the best quality. Those days in the shop unleashed a passion that has stayed with me ever since.

Two and a half years later, I was fortunate enough to land a job at the design firm Parish-Hadley. There my real education began. Starting at the bottom—preparing estimates and coordinating projects—taught me the basis for the business part of interior design. Then I was given the chance to become a shopper. Eventually I moved on to assistant designer and then to projects of my own.

I began my own firm after twenty years of working with two of the world's most creative people—Albert Hadley and Sister Parish—and facing the complexity of bringing homes into being every day. We began by studying the architecture, assessing the bones of each room, and making changes to enhance the spaces. Then we worked out the placement of furniture on the floor plans and rendered and studied the wall elevations. We did all this by hand because there were no computers in those early days.

I feel lucky that I began my career before the Internet because I learned so much by going, looking, and touching, and by talking to the dealers, the craftspeople, and the experts in the workrooms. Collaborating with a master painter was much easier than picking colors from a tiny paint deck. John Weidl, a wonderful painting contractor I often worked with, would arrive at the space with cans of white paint and a metal holder with all the tinting colors. Sammy, a master colorist, would start mixing, guided by a fabric or chip I had brought. When the blend looked right, we would apply it to the wall in the particular room with the actual light, drying it with a hair dryer. If the hue was off, Sammy adjusted it on the spot. It was such a luxury.

It still thrills me that every new project is like a new romance. There is the initial getting-to-know-you phase, the discovery of how people live, what their dreams are, what inspires them—such critical information as we begin the designing process. Each stage has its exciting moments as well as its anxious ones. First comes the collaboration with the architects, creating the bones of each room. The hunt begins for the unusual treasures that will give the rooms their magic. Throughout, there are the ups and downs of delays, budget overruns, and sometimes anxiety about the results. But when installation day comes, the trucks are emptied, the last picture hung, and the beds

made, the romance hits a sad point for me. Our role diminishes, and the project becomes a dear old friend. We hope the romance continues for the owners, that they discover absolute joy living in their new home.

All the projects in these pages would not exist without the fantastic teams that contributed to them. Some of the designers have gone on to have their own firms, as I did thirty years ago. But I am so fortunate that Elizabeth Lawrence, who started in my office as an intern, has now become my partner. I could not have done all this work without her and her amazing talent. Our firm has been established. Our future lies ahead.

— *Bunny Williams*

Summer was approaching, and my classes at New York School of Interior Design were ending. Time for an internship! I sent my résumé to fifty designers mentioned in *New York* magazine's latest edition of "The Top 100 Interior Designers." On the phone that evening, my mom suggested that I contact Bunny Williams. I was skeptical, but in less than two weeks I had an internship. Today, fourteen years later, after rising through the ranks at this venerable firm, I have now joined Bunny as her partner in Bunny Williams Inc. The lesson remains: Always listen to your mother!

In these years with Bunny, I have absorbed so much about the business and creativity of interior design. First, last, and always is the idea that every project we undertake is unique. We collaborate with our clients to design a home that celebrates the individual. From handmade furniture and beautifully constructed curtains to talented artists who can transform a space with custom wall finishes and murals, we seek out and work with the best in the industry. In shopping with a client, whether here or overseas, we have an opportunity to discover those perfectly wonderful items that can inspire or complete a room—an important piece of furniture, a fabulous object, interesting art, perhaps some sculpture for the garden.

Today I tell our interns that we need to know and understand our history, the genesis and tradition of interior design. Read the books about the "pioneers," including Sister Parish, Dorothy Draper, Nancy Lancaster, and John Fowler, to mention a few. Study how they worked and how they created lovely and livable homes for their clients. I've learned all this, and so much more, from working with Bunny. Her wealth of knowledge and impeccable taste are legendary. Bunny's legacy is rock solid. Ours is just beginning. — *Elizabeth Lawrence*

HOLLYHOCK

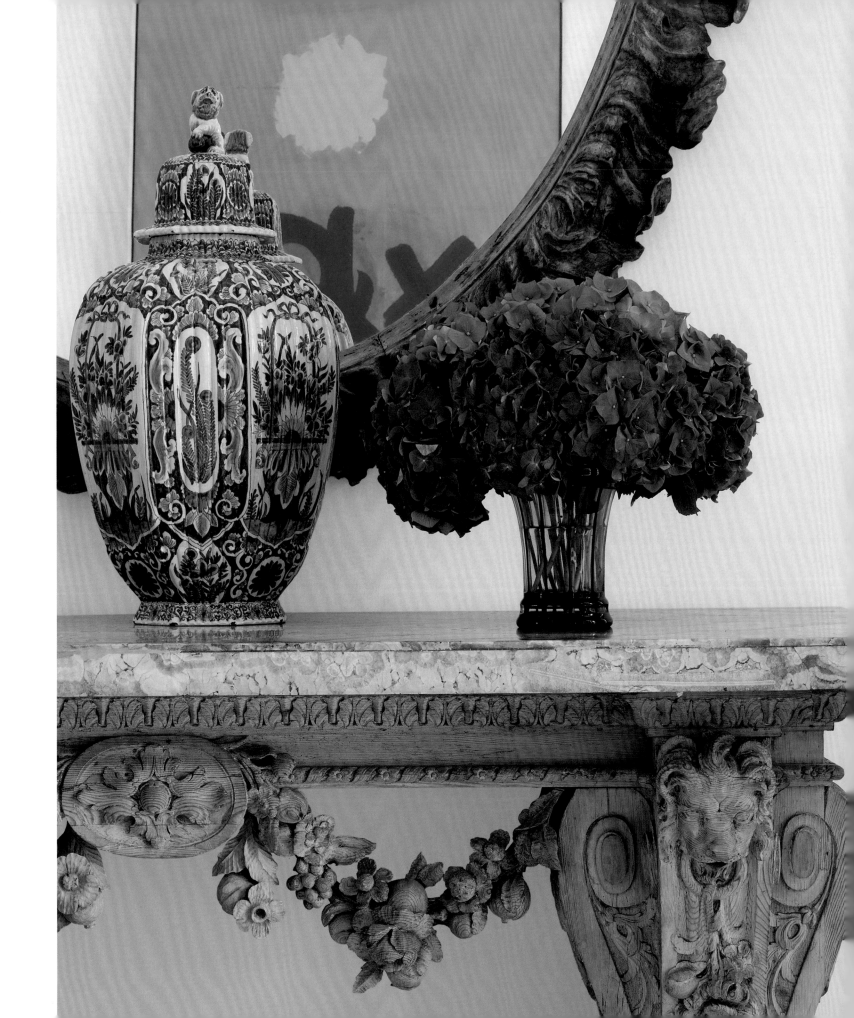

Couples rarely come to us with anything written, much less a poetic letter describing their dream for a new home, down to the required number of rooms. But these two clients took a long view. First they purchased a piece of property for its lush trees (a love I share). Then they commissioned architect Michael Dwyer to design a house inspired by the twentieth-century luminaries David Adler and Frances Elkins. (Michael's drawings were so exquisite we later had them printed in sepia to cover the powder room walls.)

A key aspect of the couple's vision was a large library, not only for their book collection but also as a place to work. They specified sizable surfaces for reading, comfortable seating for visiting with family and friends, and views to the garden created by Quincy Hammond.

Their wish list could have been mine: eighteenth- and nineteenth-century English, Irish, Swedish, and French pieces; porcelains; chintz; stripes; Chinese wallpaper; needlepoint carpets; and "a sprinkling of twentieth-century furniture." Their decorating muses were Nancy Lancaster, Billy Baldwin, and Parish-Hadley, close to home for me, too.

As Elizabeth and I worked with them and Michael on choosing materials and finishes, we developed floor plans and color schemes. When an amazing eighteenth-century Chinese wallpaper came up at auction, we had the dining room's first piece. Our client called to say she wanted the living room to be the very same blue as the drawing room in *Pride & Prejudice*, the 2005 movie. We watched it repeatedly because each frame contained so many different shades. With master painter John LaPolla, we ultimately achieved the right one.

Creating this house involved so many wonderful experiences, none more so than a shopping trip abroad. We began at the Masterpiece antiques fair. But it was the next few days in London where we found, one by one, fabulous pieces to place throughout. When the couple finally crossed the threshold, their eyes welled up. Their dream had become reality, to the letter.

Hold out for the perfect piece instead of compromising. It always comes when you need it. Just as we were about to install the house, the marble console tables came up at auction. I knew they were the ones, as did the client.

PAGES 10–11: The plan was to have a house that seemed as if it had always been there. PREVIOUS PAGE: An eighteenth-century English carved pine console table with its original marble top creates magic in the entrance hall. RIGHT: Architect Michael Dwyer based the entry gallery on that of a David Adler house in Lake Forest, Illinois. Picking up the floor's black-and-white motif, Anglo-Indian benches and marble consoles feel perfectly at home here.

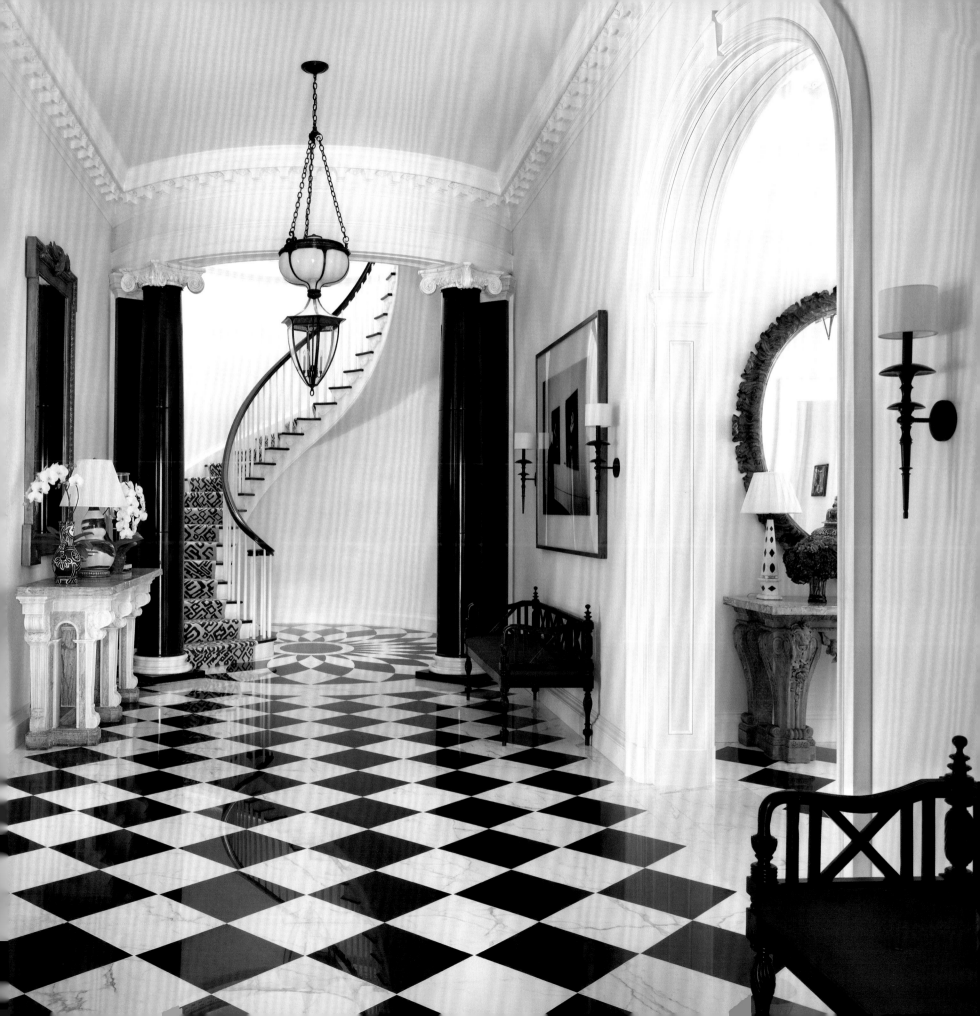

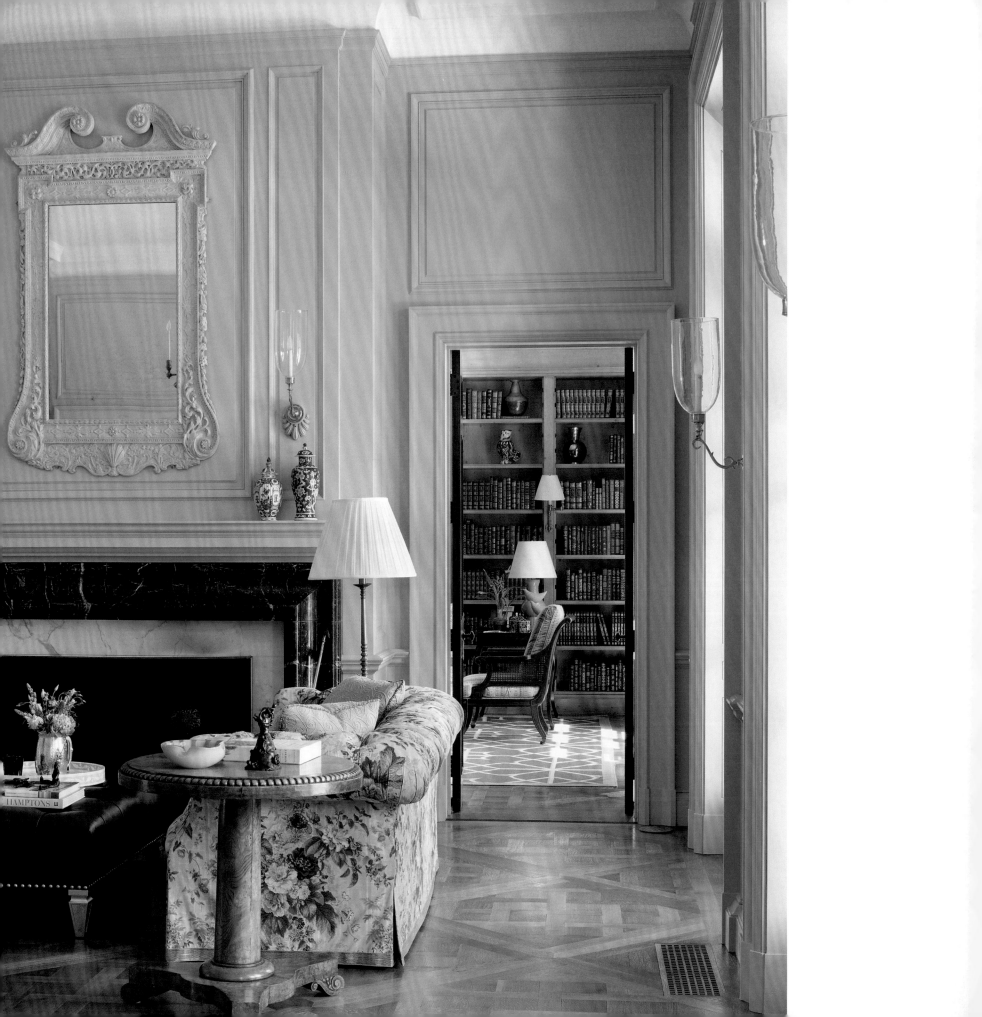

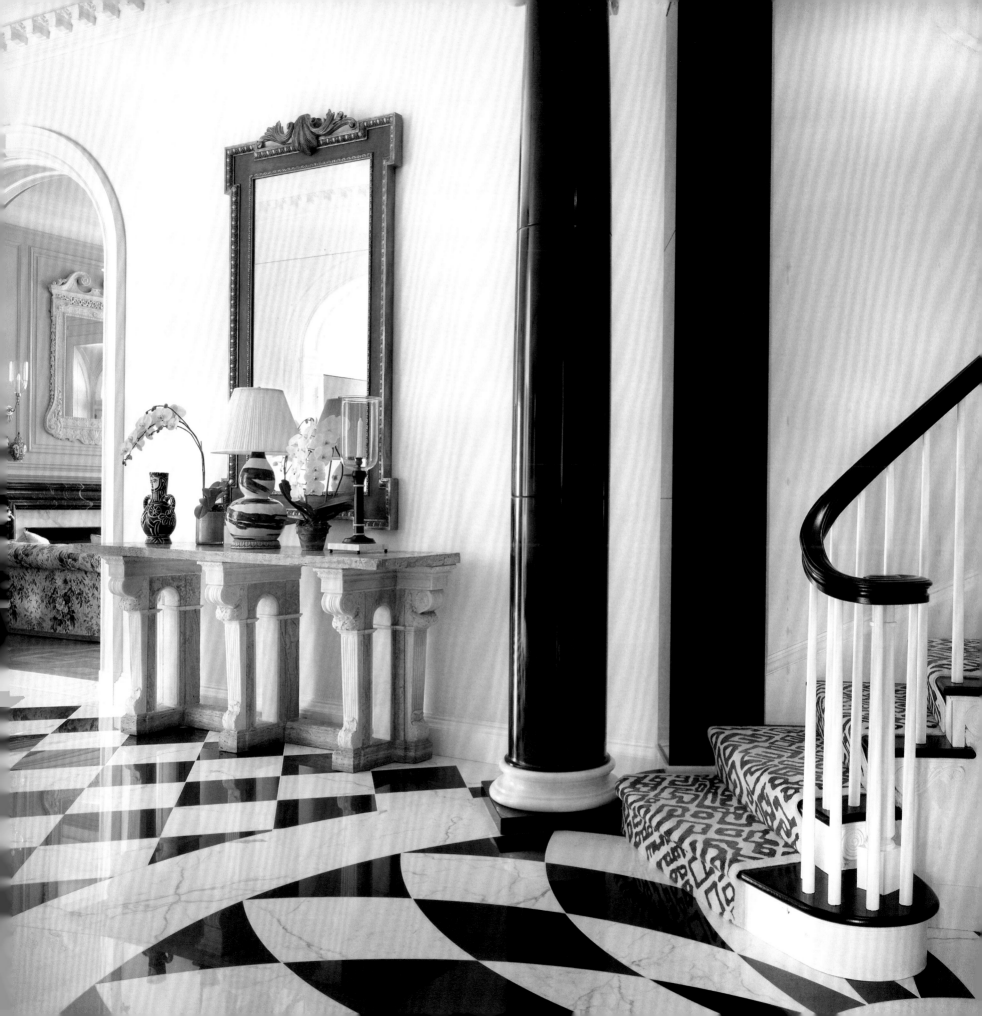

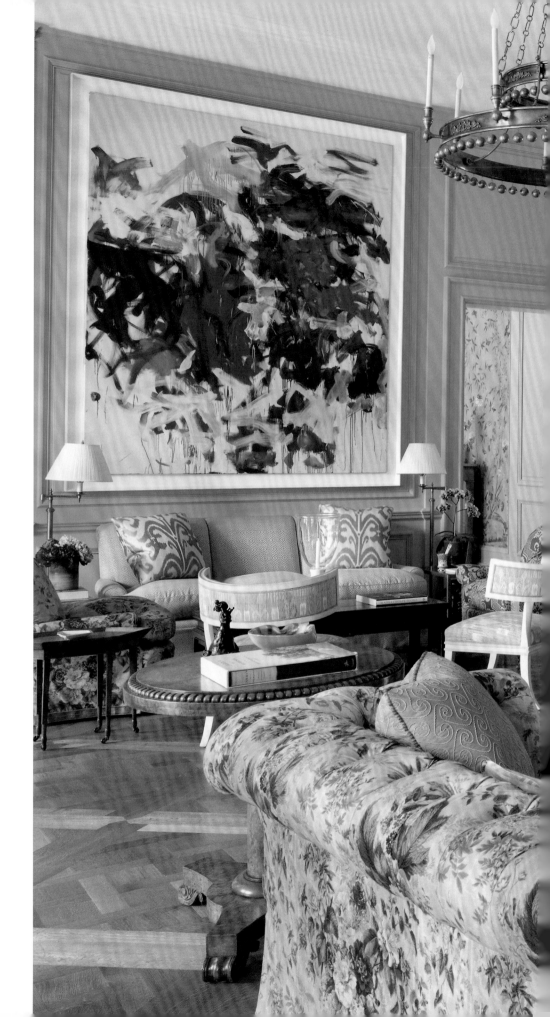

Mixing furniture of different periods with contemporary art creates a timeless quality, and the room will never feel dated.

PAGE 16: Matching precisely the same shade of blue as the drawing room in the 2005 movie *Pride & Prejudice* took us about four hundred viewings. An eighteenth-century Georgian mirror presides over the living room fireplace. PAGE 17: Boldly graphic, a contemporary carpet winds up the staircase. RIGHT AND FOLLOWING PAGES: The blue-paneled walls offer an incredible background for contemporary art. With bare floors, the room feels airy and open.

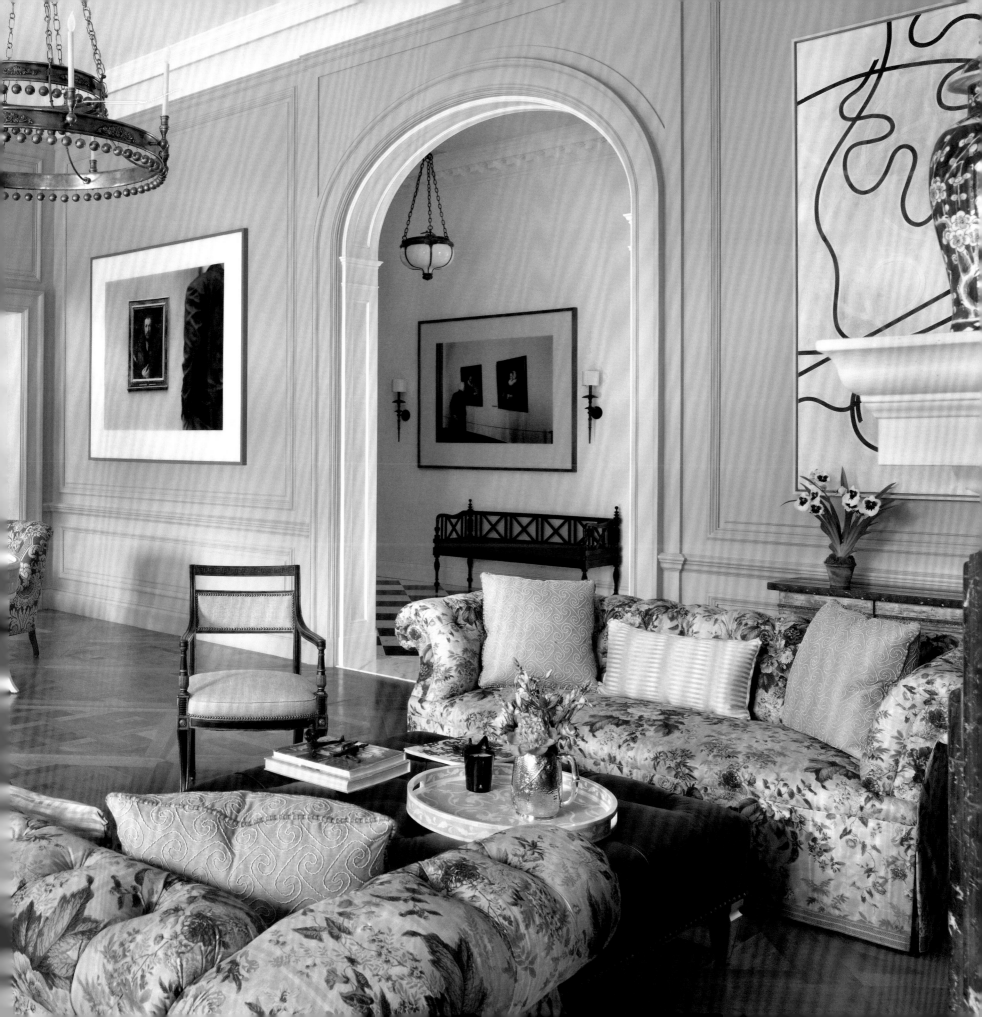

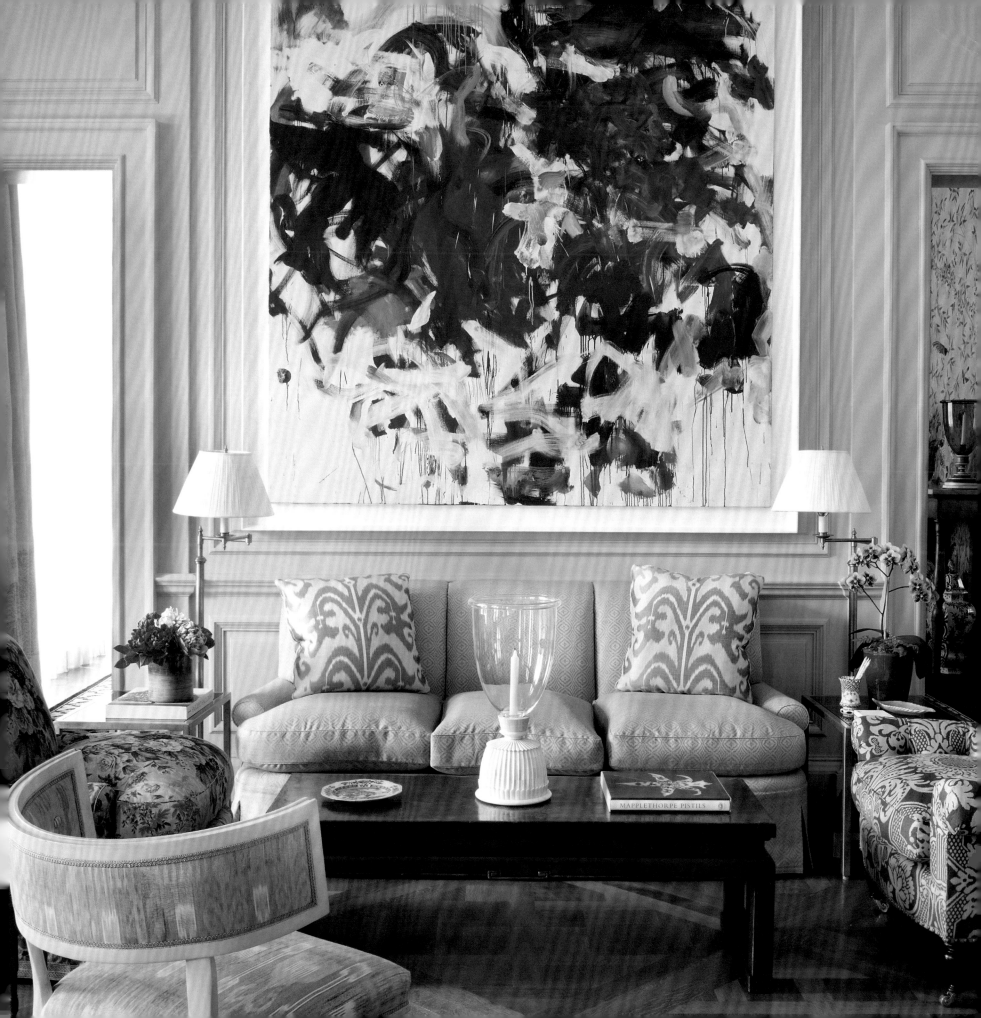

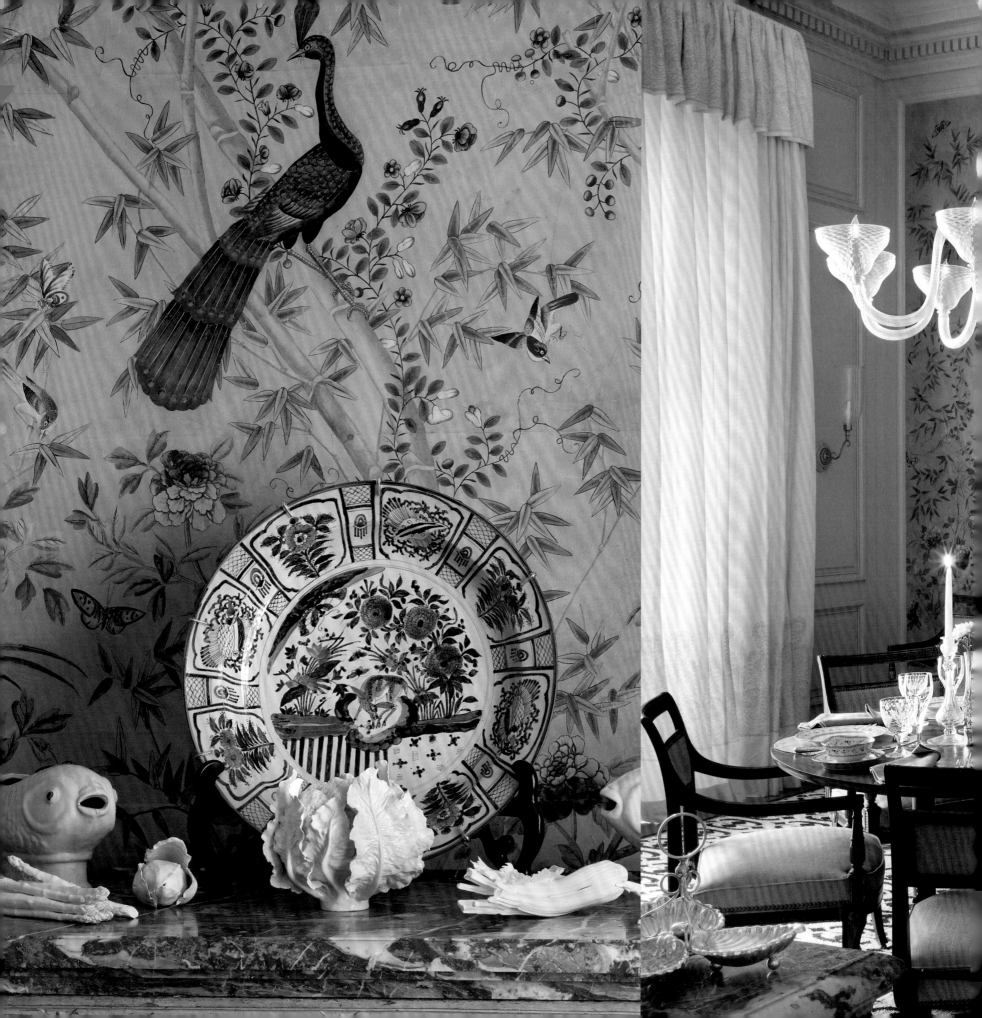

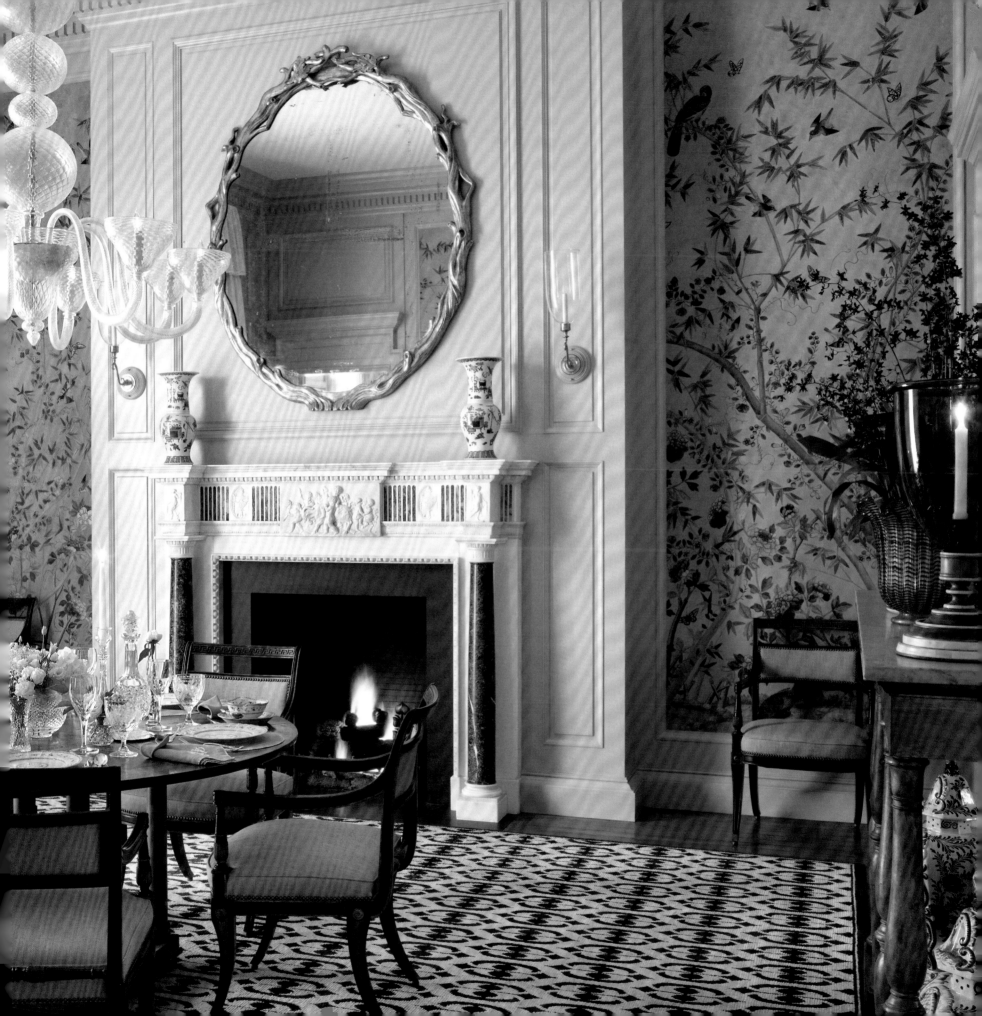

I'd rather have pieces that are oversized than too small because the scale of the furniture helps to enhance the room's scale.

PAGE 22: Eighteenth-century Chinese wallpaper, which we found at auction, was on the client's original wish list. PAGE 23: The wallpaper sets a wonderful stage for more modern elements, including 1950s Hollywood Regency chairs, a Murano chandelier, and a graphic, flat-weave carpet. RIGHT: This incredible, eighteenth-century Régence console with its original paint and marble top fit within inches of the dining room panel, just as if it was always meant to be there.

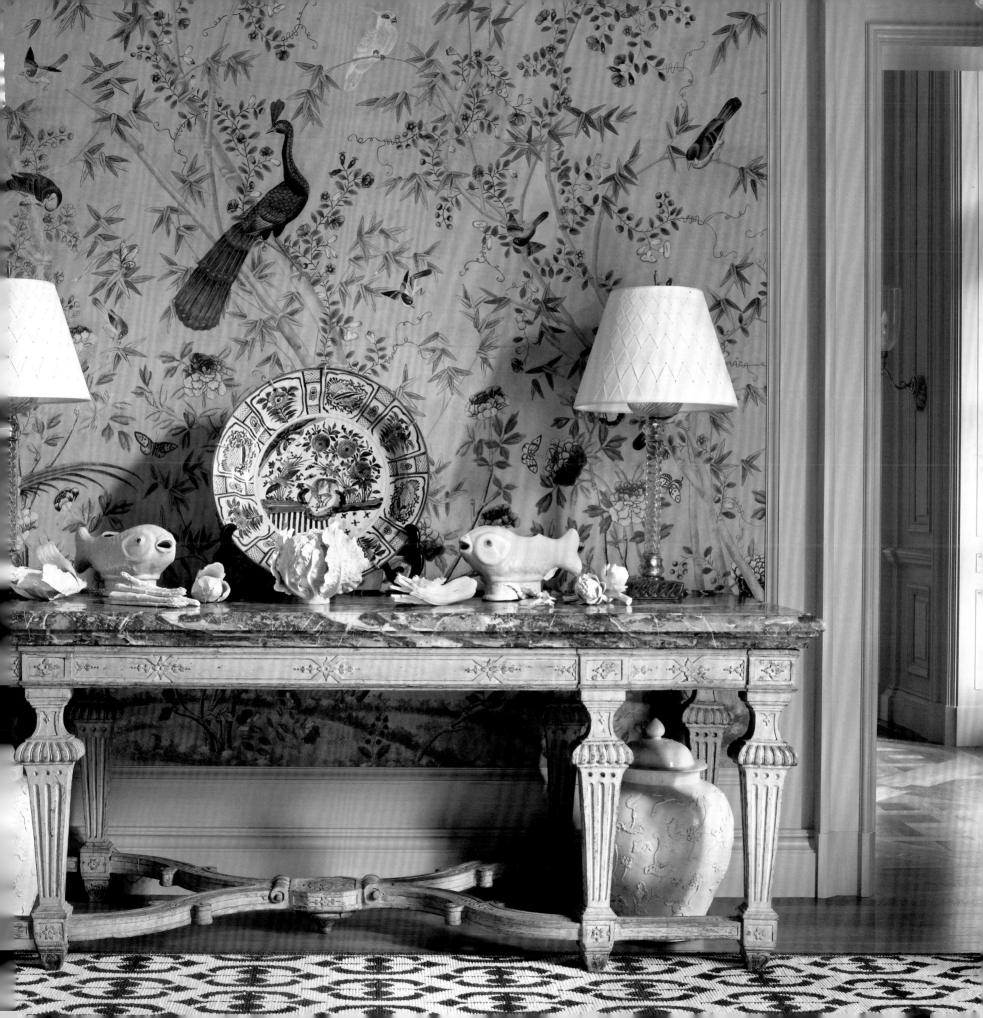

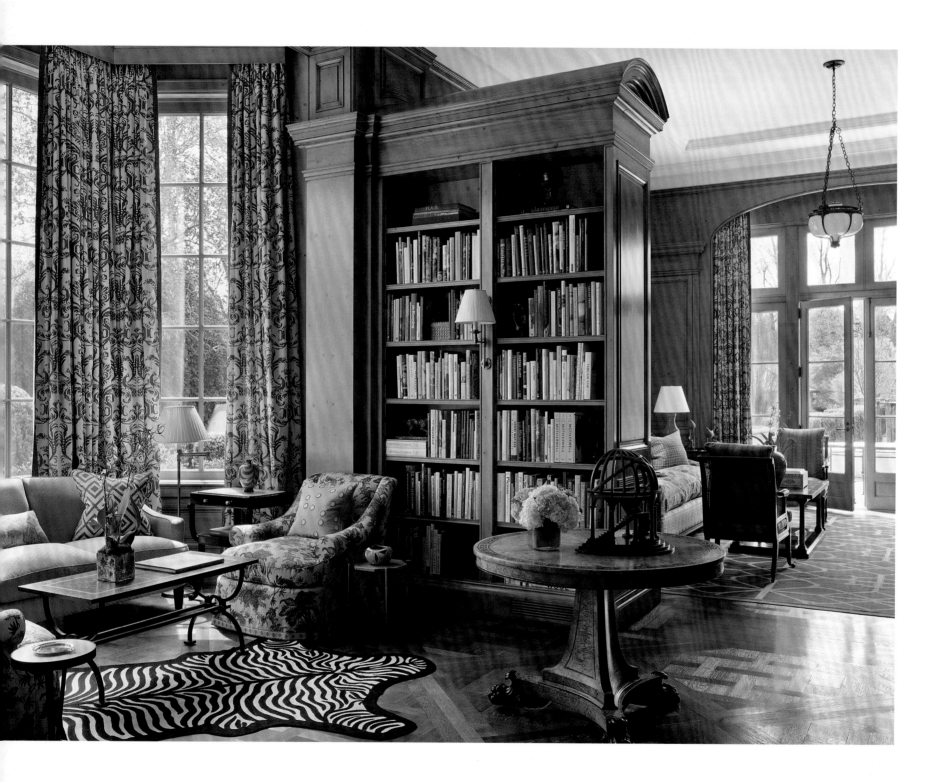

ABOVE AND OPPOSITE: Michael designed a beautiful three-bay library to be the focal point of the house—a place for the clients to read, work, and watch TV. Banks of bookcases project into the room's interior, creating more contained, intimate areas within the overall expanse.

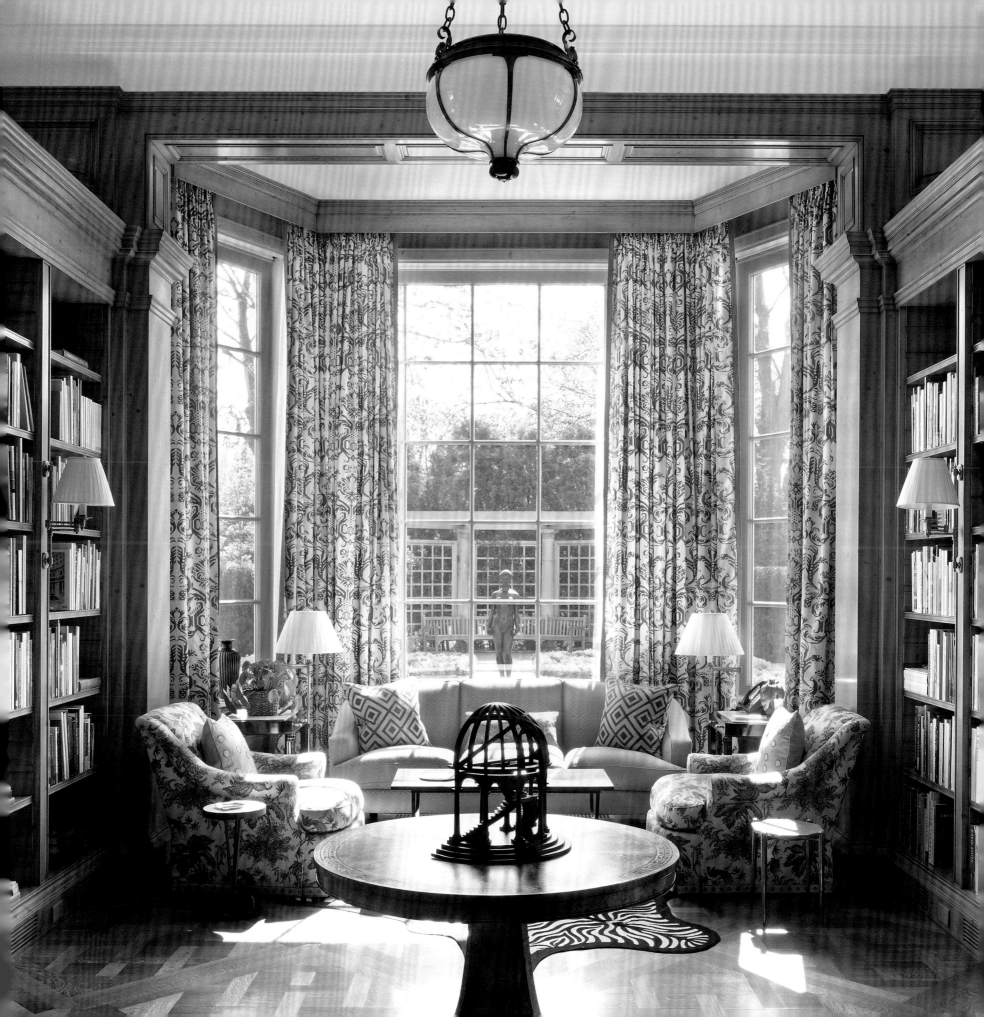

It is so important to spend time developing proper storage areas for every part of the house, whether for clothes, china, or linens. This detail often gets short shrift, but it makes living in a space much more enjoyable.

This family regularly holds proper family dinners, so we made sure to design the pantry to store all of their china, linens, and silverware—everything needed to set a beautiful table—close at hand. The faded vinyl floors work well with the soft gray-green of the cabinetry.

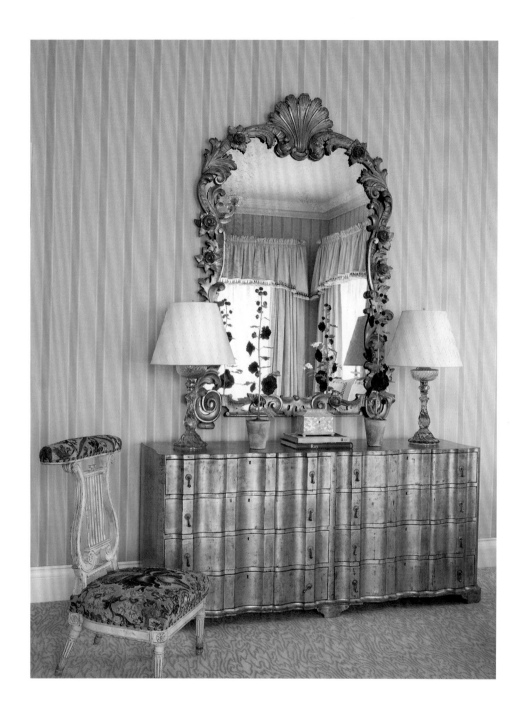

ABOVE AND OPPOSITE: In the master bedroom, an inviting chintz-covered Syrie Maugham bed nests against walls upholstered in a fresh, striped cotton. Infusing patina and history into the mix, an eighteenth-century Italian mirror hangs above a silver gilt mid-century commode with an eighteenth-century prie-dieu in its original needlepoint.

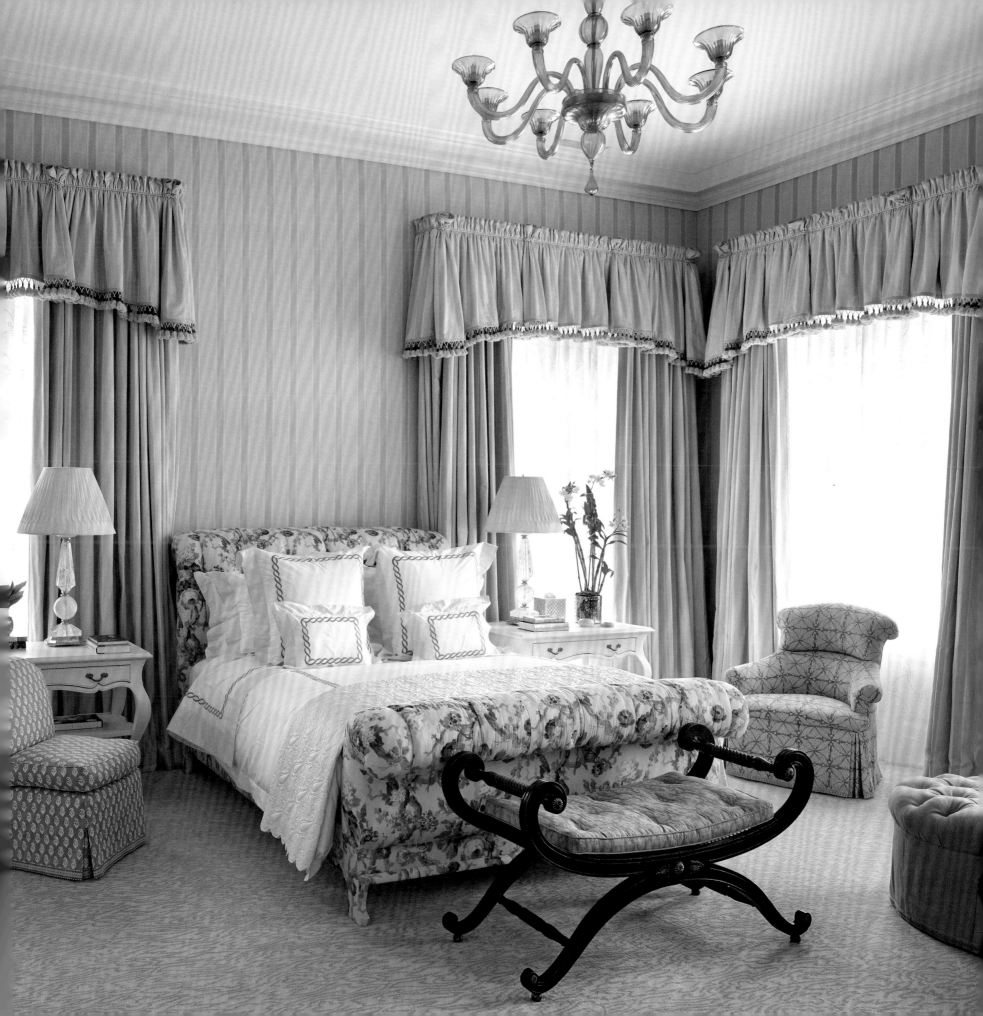

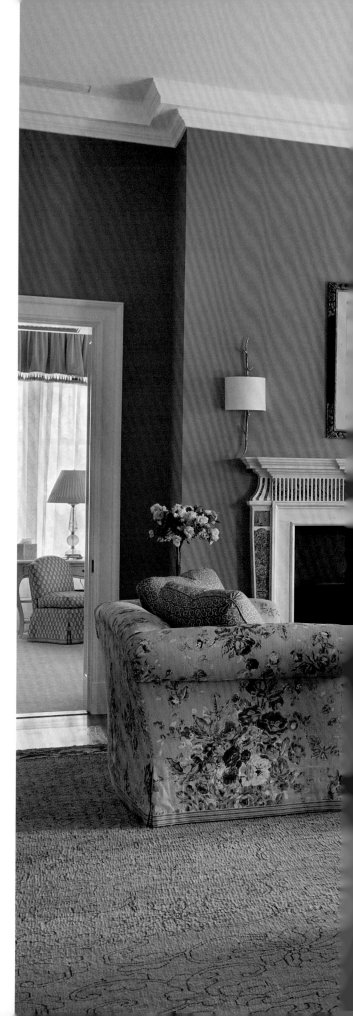

I feel that intense color needs to be softened by neutrals. Here, the chintz's beige background combined with the faded blue rug provides contrast to the very strong hue of the walls.

The second-floor sitting room serves multiple functions. Not only is it a comfortable reading space at all hours and a place to watch TV at night, but it also includes a table so the couple can have breakfast upstairs when they wish. Of course, it has the most wonderful view of the garden.

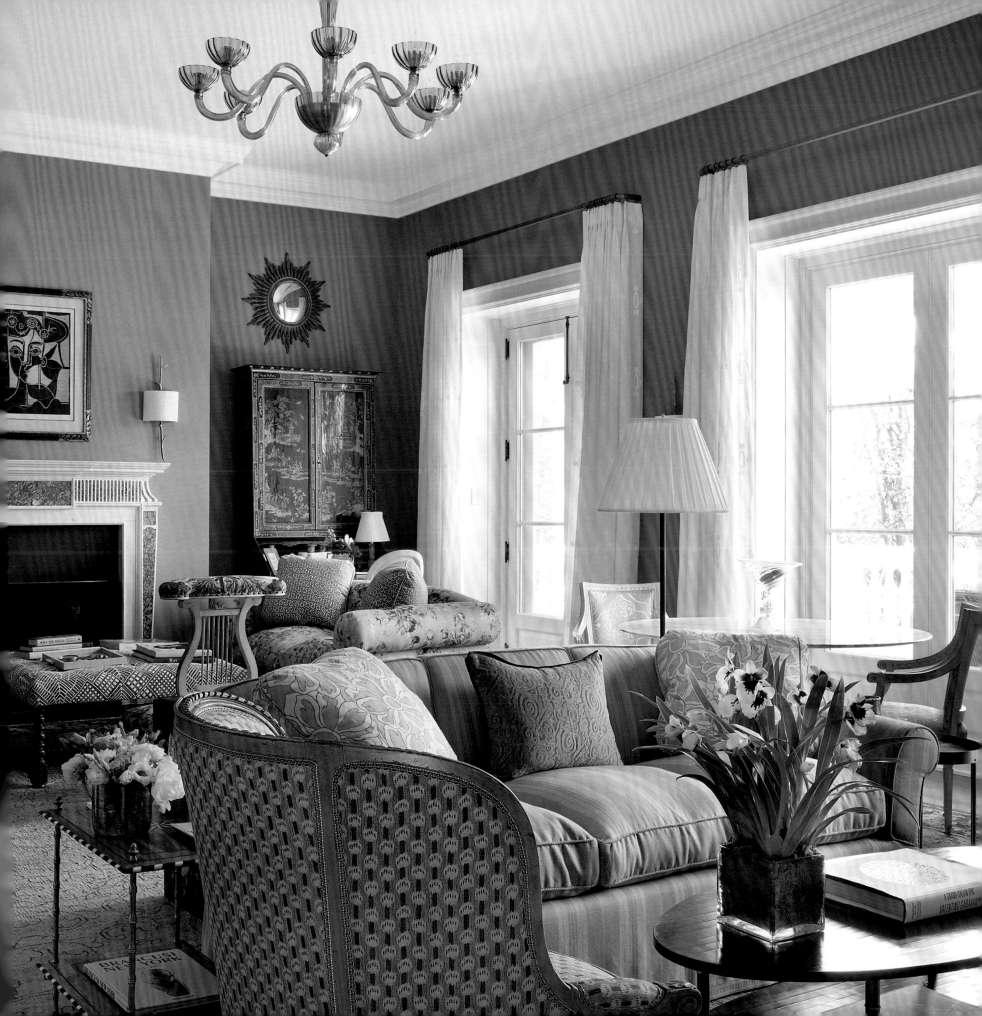

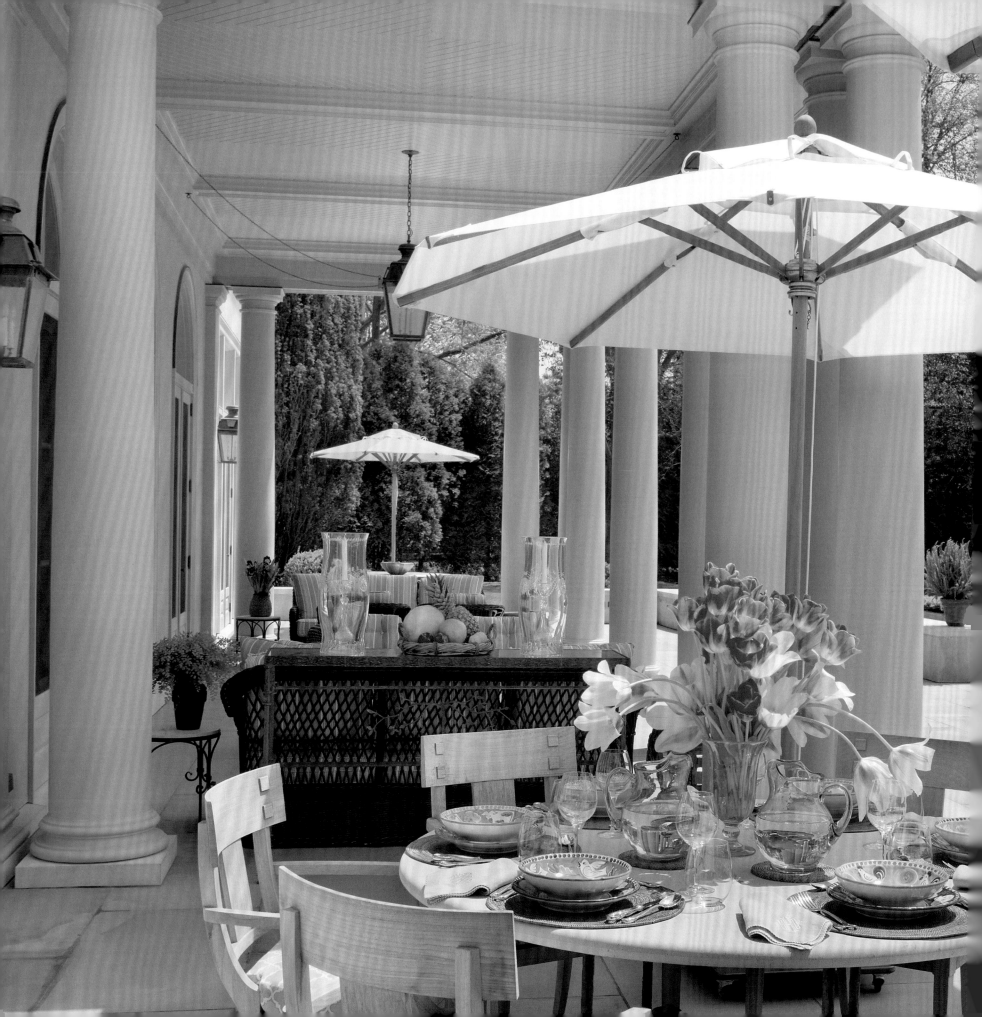

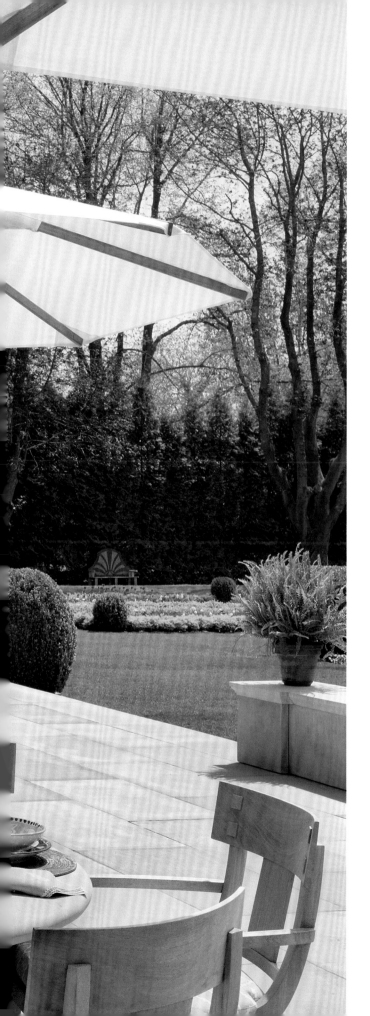

Outdoor living spaces should be equally as inviting as the interiors. It's important to plan them just as thoroughly for function and comfort because we use them the same way.

With comfortable seating and round tables, the outdoor terrace is just the spot for lunches and dinners overlooking the garden. Movable umbrellas provide shade as needed.

WEEKEND RETREAT

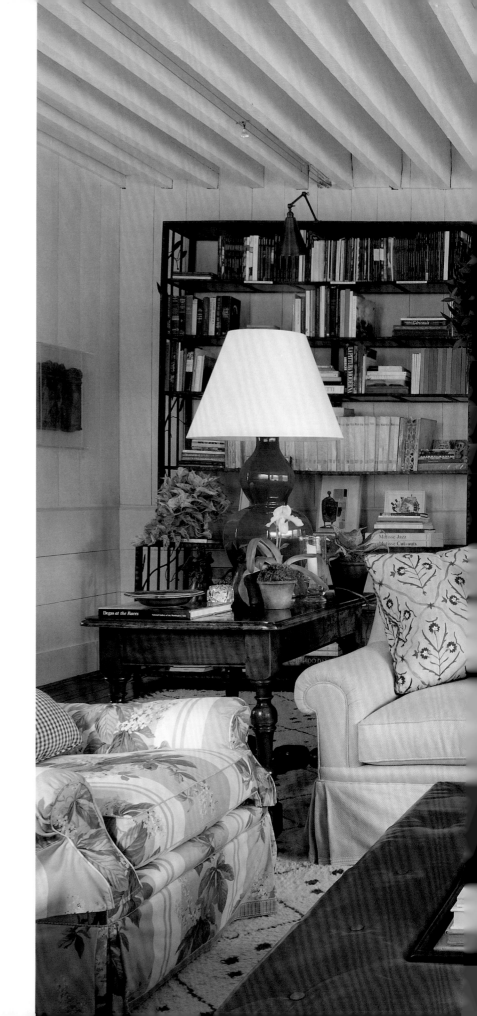

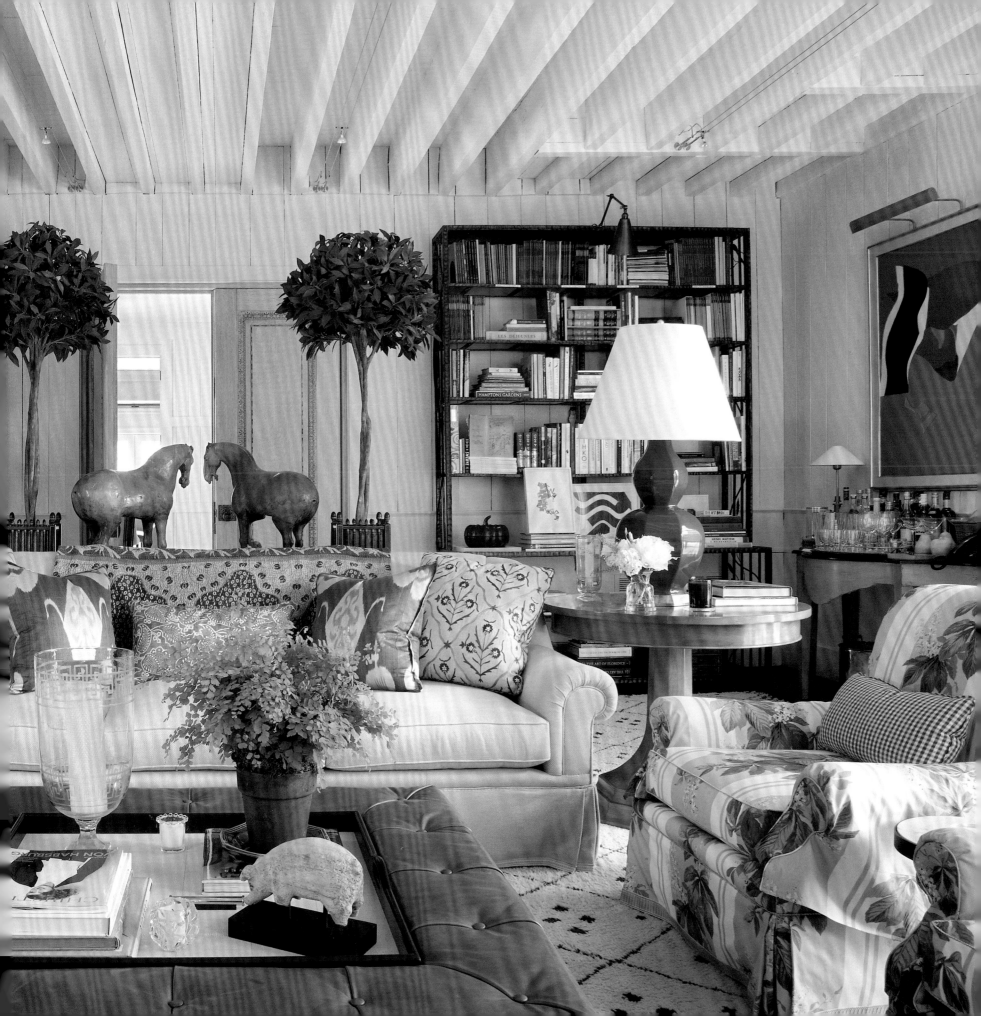

When a former client first invited me to visit this house, I thought, "What a perfect place."

Its sweeping lawn and gorgeous, mature trees give it real romance, ideal for a weekend retreat on Long Island. The ground floor contains several spacious rooms just perfect for a few people or large groups. The client, Elizabeth, and I set out to make the house truly comfortable and welcoming.

The living room has wonderful light from windows on three sides, but it lacked cohesion because of its mix of structural materials. Painting the rough board walls, beamed ceiling, and brick chimney the same shade of warm white helped unify the space. A large seating group around the fireplace, a card table in a bay window, and bookcases made to flank the entrance brought the room into focus. Hanging the client's wonderful art really made the room come alive.

The other sizable space became a combined dining/TV room with a long farm table at the window and a cozy seating group at the core. I have always liked that rooms can have more than one function, and these two are a natural pair. (So many of us do puzzles or write notes at the dining room table while watching a favorite TV show.) A colorful hooked rug on top of a sisal carpet and antique textiles for the sofa pillows contribute to the relaxed sensibility.

With a peaked ceiling and rustic beams, the master bedroom challenged our creativity. Our client wanted to repurpose some chintz curtains from her New York apartment. Because there wasn't enough fabric to cover all four windows—and the pattern had been discontinued—we decided to use it for the valances and cushions. For the curtains and walls, we had a small-scale pattern printed to match. An added molding under the ceiling beams helped establish a more intimate scale. This experience reminded me again that problem solving is the essence of design—and often the catalyst for a more interesting room.

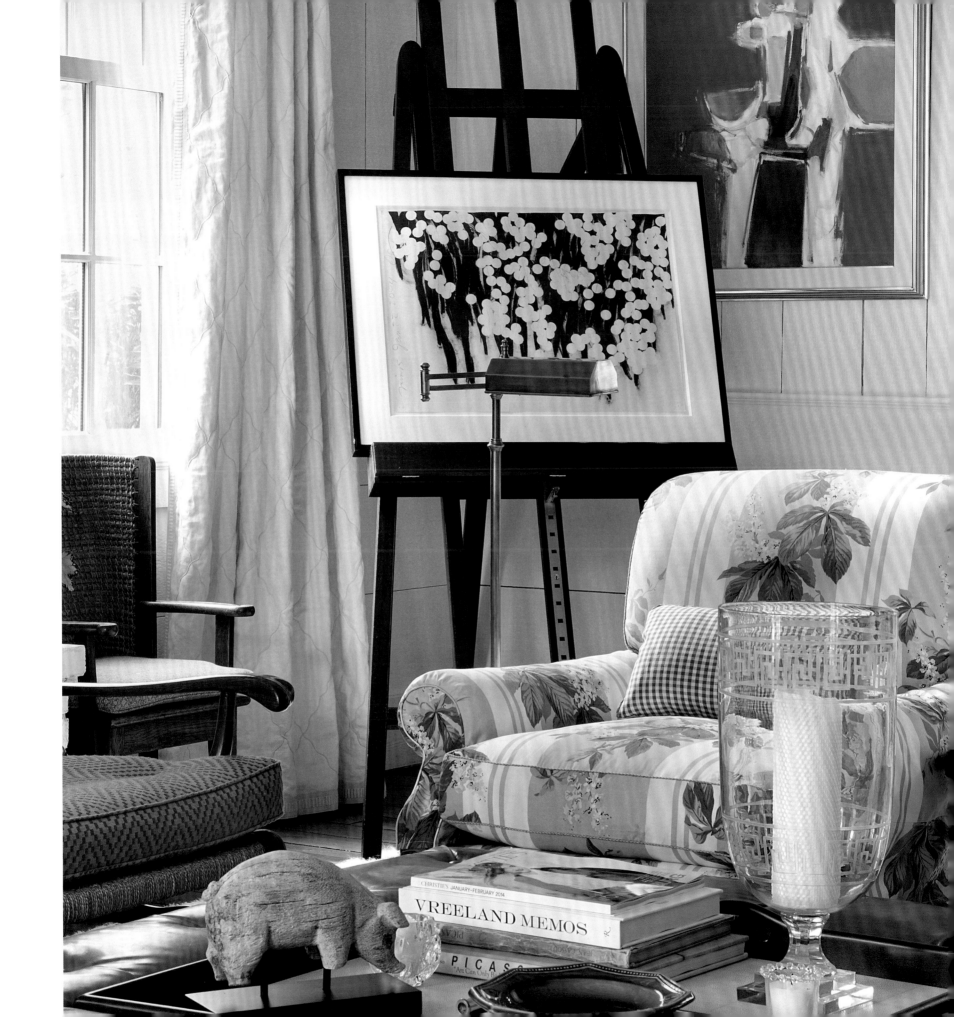

To help pull this room together, we painted all the different surfaces of the walls and ceiling in the same shade of creamy off-white.

PAGES 36–37: Flanking the room's entry with a pair of custom bookcases gives the collections a proper home. PREVIOUS PAGE: In one corner, an easel with an artwork draws the eye. RIGHT: With six chairs, a long sofa, and a large, square ottoman that doubles as a coffee table and footstool, this seating arrangement invites people immediately to the heart of the room.

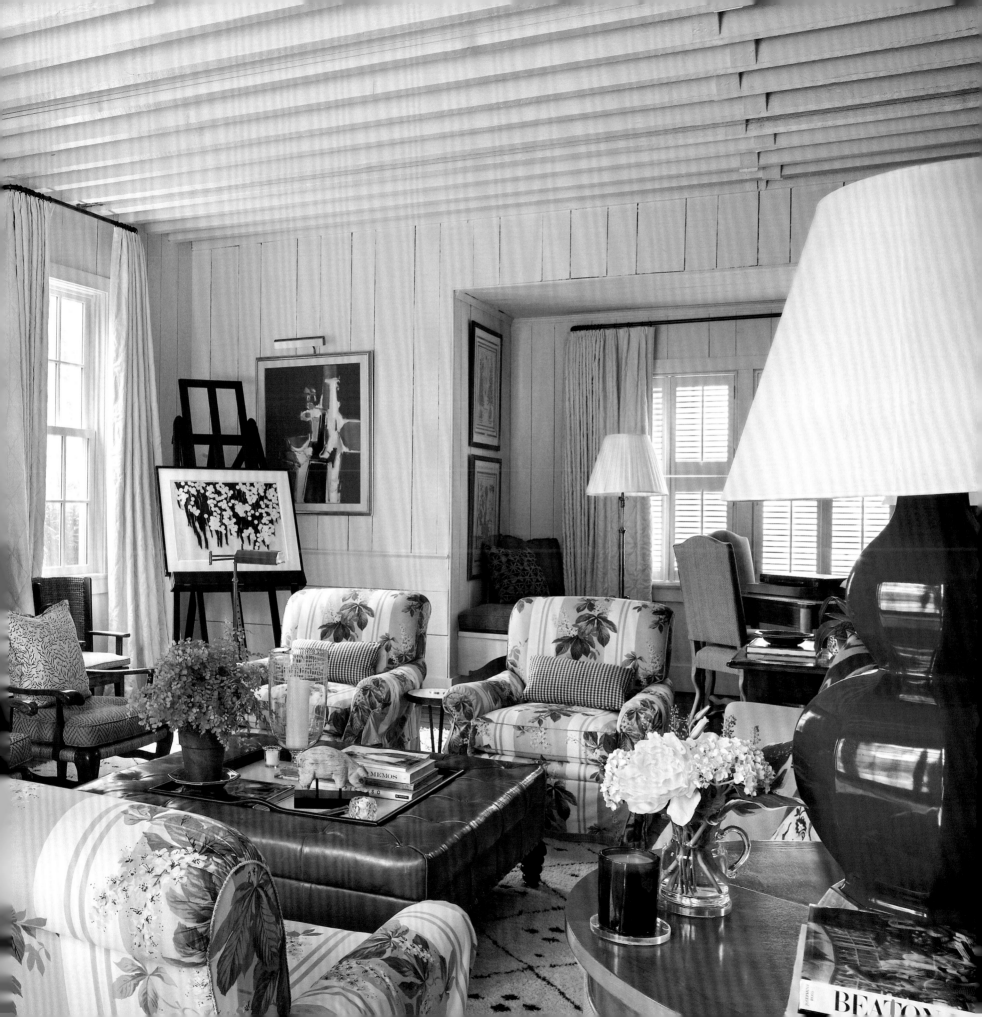

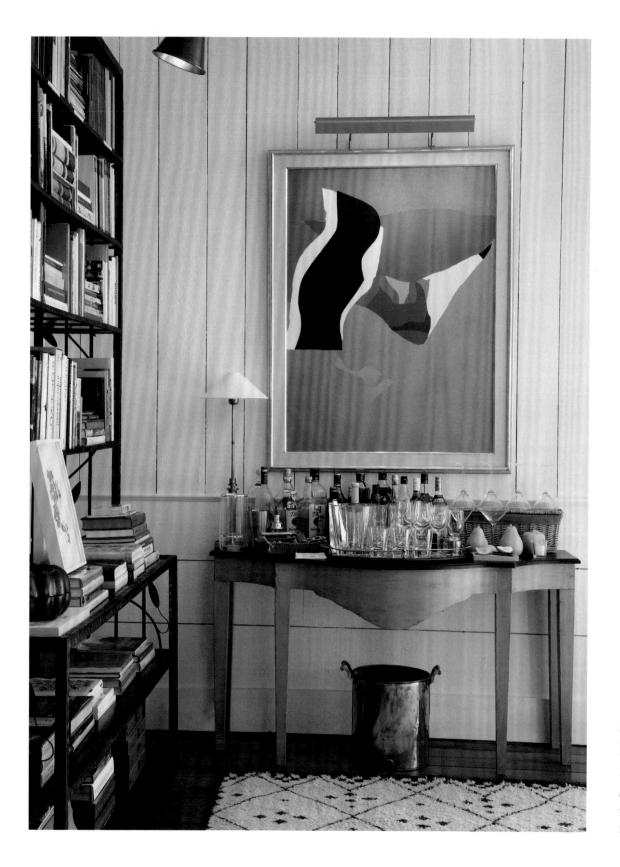

LEFT: A drinks table makes all guests feel welcome because it invites them to help themselves. This simple painted table serves the purpose. OPPOSITE: A set of overscale garden engravings framed and hung close together feels almost like wallpaper.

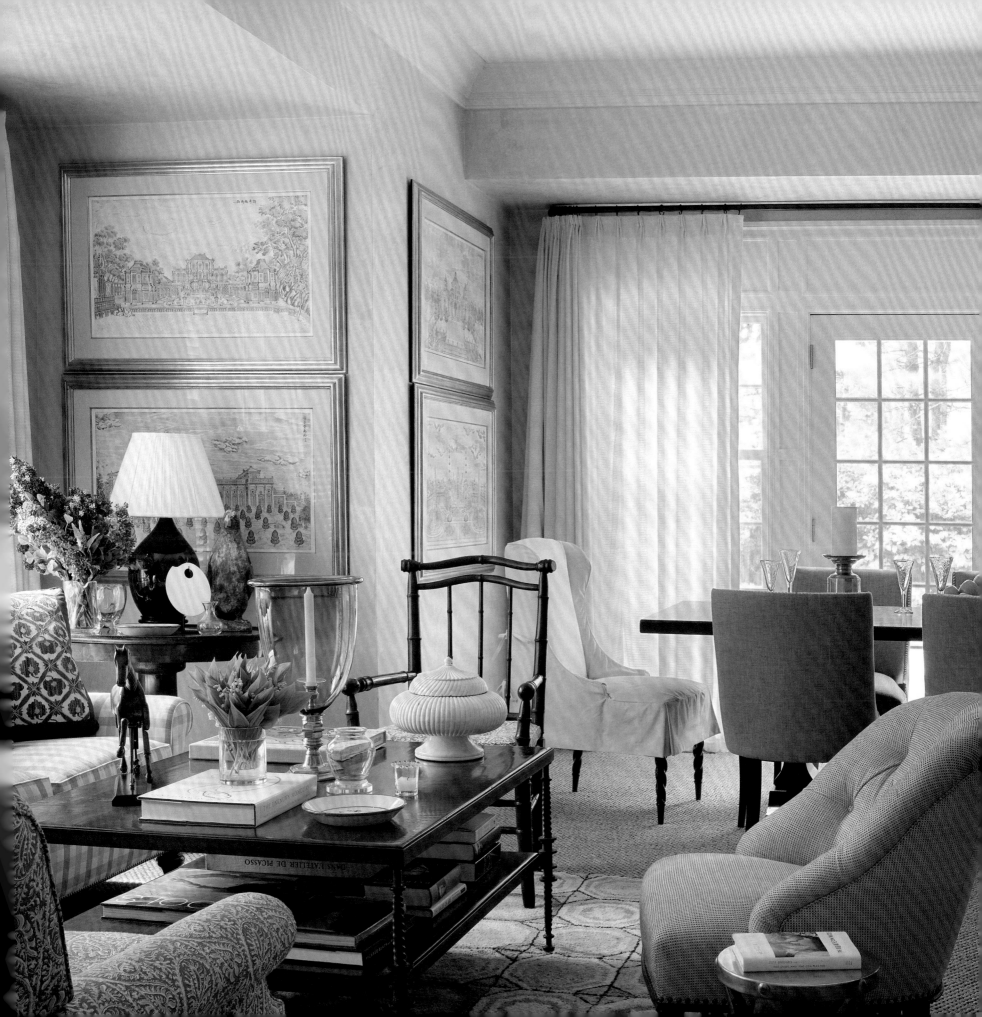

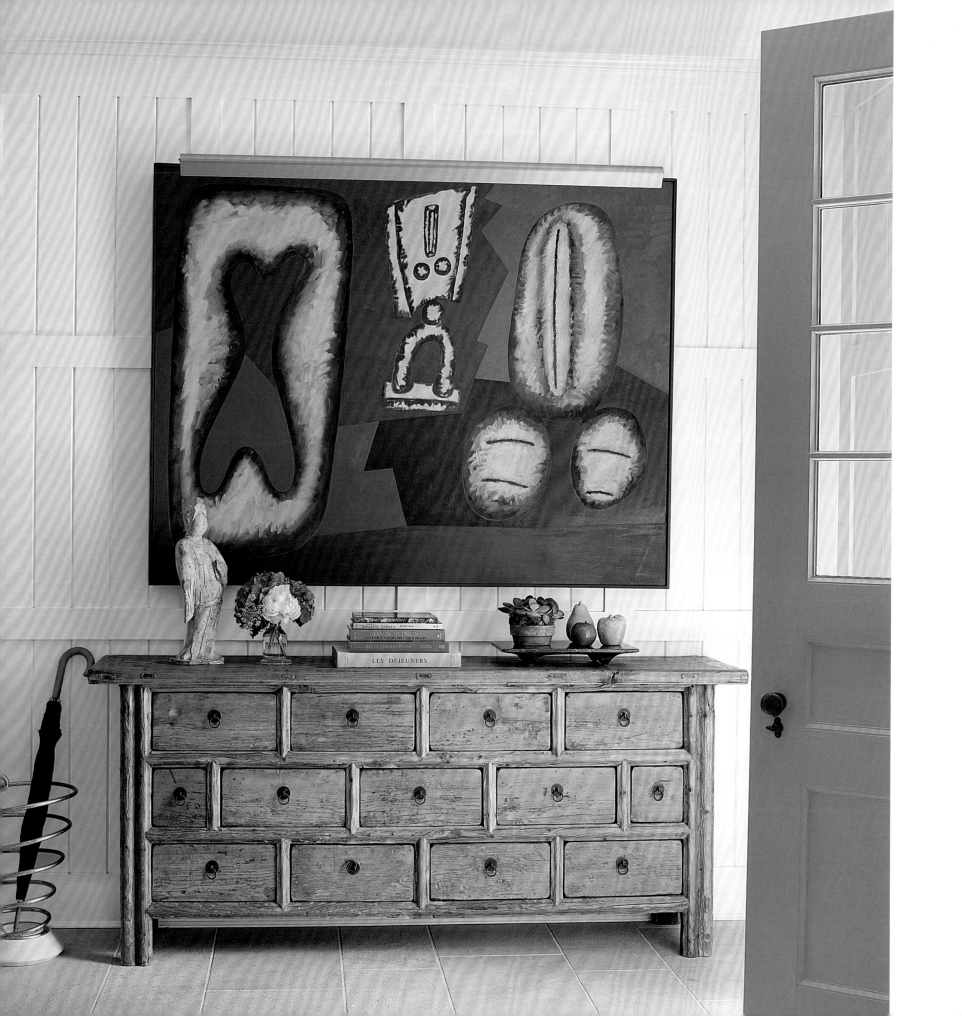

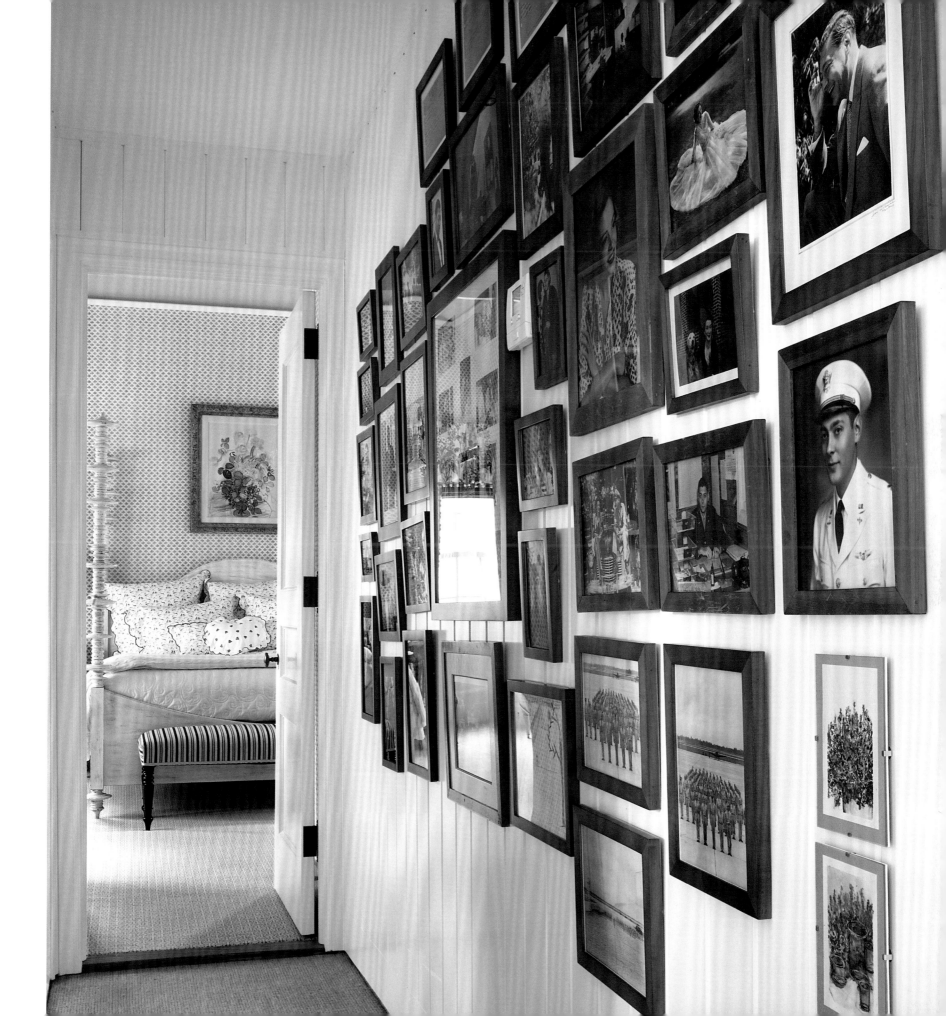

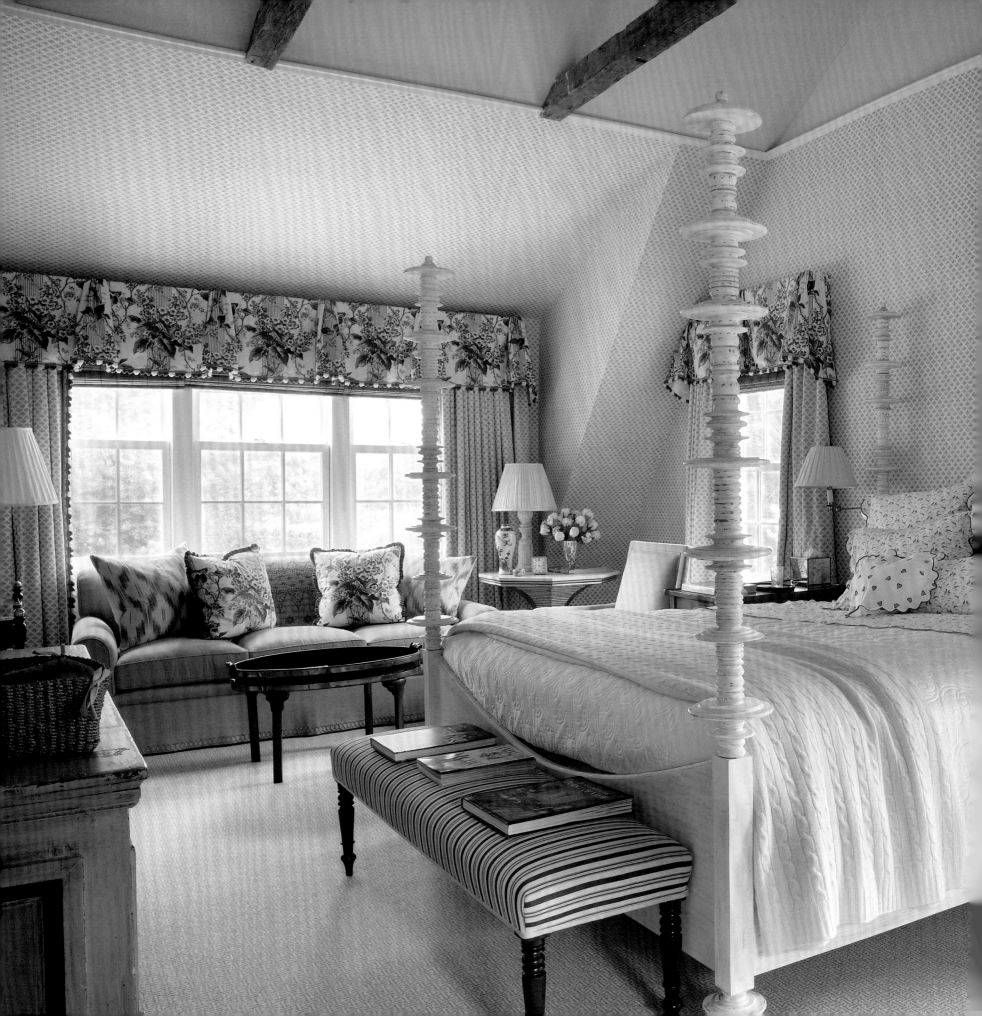

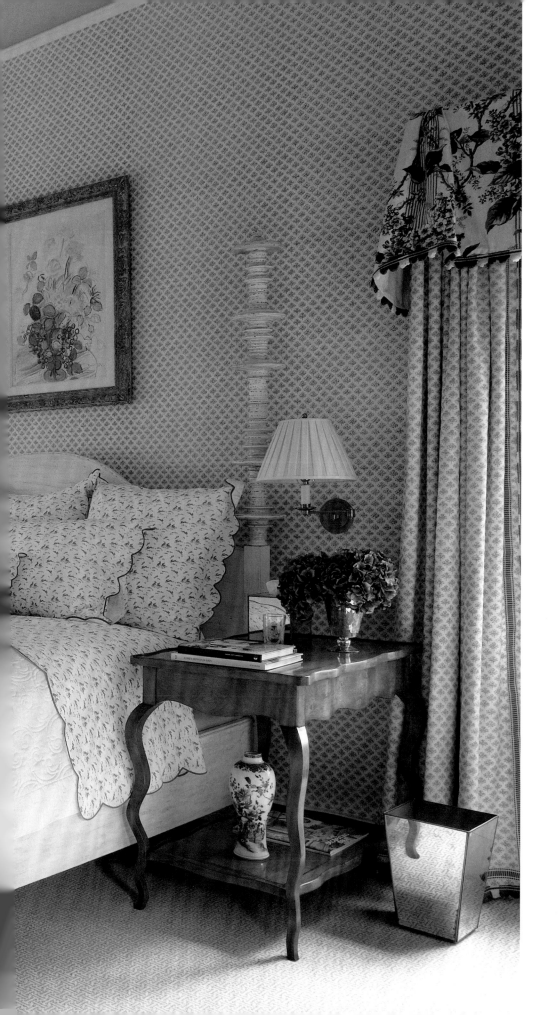

Favorite chintz curtains from the client's New York apartment sparked our creativity. Without enough fabric to cover the windows (and unable to get more), we created valances and cushions instead of drapes.

PREVIOUS PAGES, LEFT: Placing this bold painting over a provincial Chinese chest in the entrance hall brought the house immediately to life. PREVIOUS PAGES, RIGHT: Long bedroom halls are fantastic places to display family photos. I like to frame them all alike for coherence. LEFT: To help unite some of the room's awkward architectural features, we covered the walls in a small-scale print custom dyed to match the blue of the chintz. The four-poster bed complements the ceiling height and draws the eye upward, while a baseline molding under the beams helps establish a more intimate scale.

A VIEW OF
THE SEA

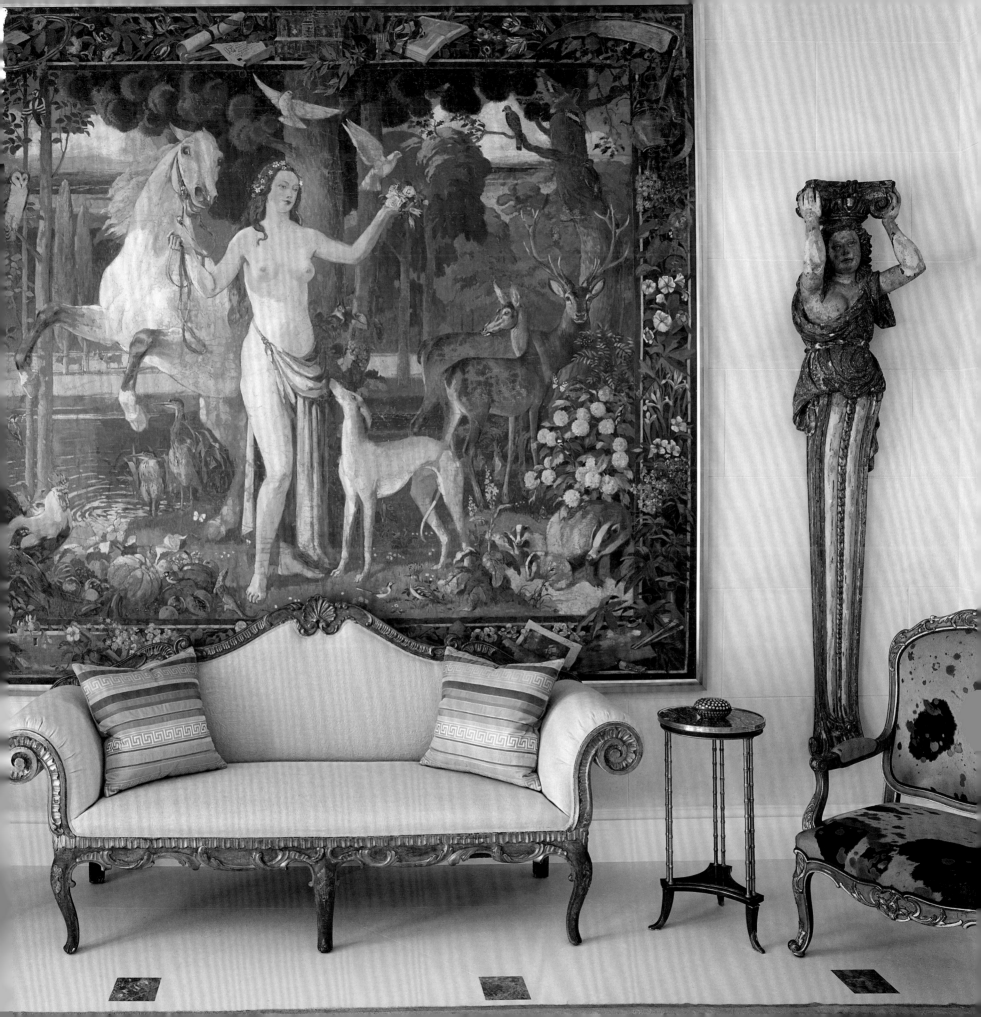

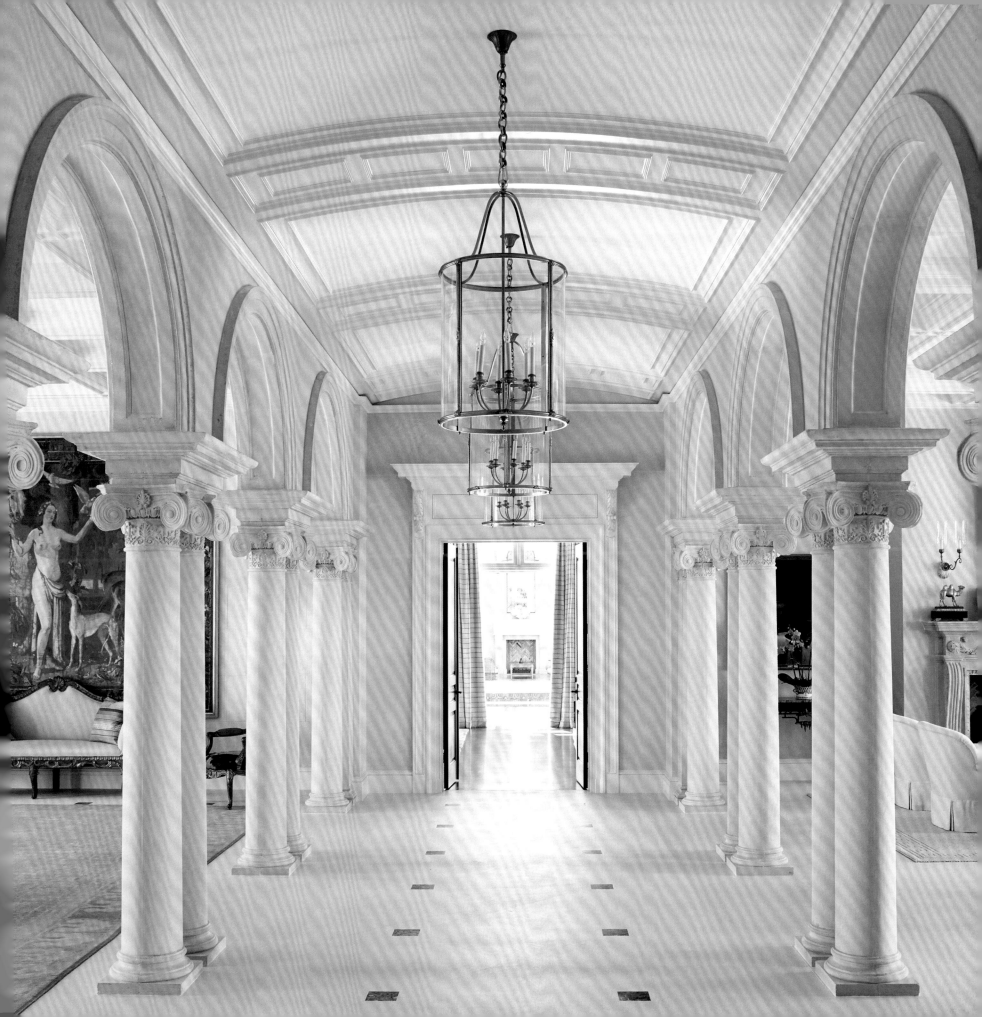

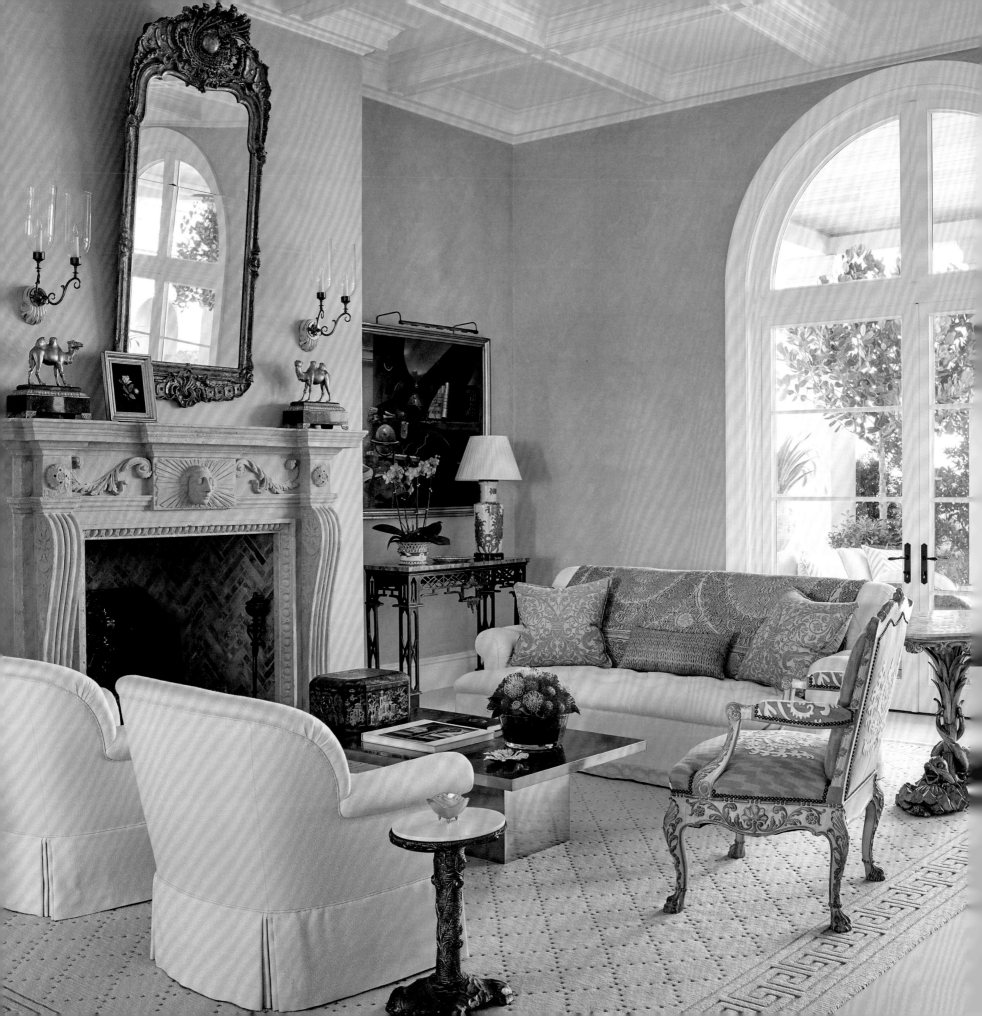

I first met this lovely European couple when they rented our house in the Dominican Republic. They were thinking of building or buying a property on the island at the time, although they later chose Florida. When they asked me to be the designer, we had already gotten to know each other. And it was special to have our Dominican Republic home as a point of reference.

Creating the bones of a house is always exciting, because they are the canvas on which design begins. Our first stage here was working with the builder to refine the room layout. After we studied each space, we produced an interior architecture package that included sourcing antique mantels and designing coffered ceiling patterns throughout. One of our architectural gestures was developing a vaulted gallery, framed by arches and double Ionic columns, to separate the entrance hall and living room.

Our every thought focused on making the house comfortable and luxurious for the owners and their guests. Getting scale and proportion correct is essential for this purpose. In expansive rooms like these, I find that combining overscale pieces with more petite ones really embraces the surroundings. Somehow, small furnishings alone make such spaces feel intimidating.

We wanted to furnish the house with a mixture of styles. Finding pieces substantial enough was fun, but a challenge. The search took time. We scoured auctions and shops all over the country and Europe. The clients traveled, too, and often sent images of amazing items for consideration, like the sizable wallpaper panel that completely transforms the entrance hall.

In the formal dining room, I added a mirrored niche to hold a French Directoire side table and create the illusion of additional width. This room opens onto an informal dining and sitting room, just the place for breakfast or a casual lunch on a cool day. We covered its walls in simulated lattice and lush tropical vegetation, all painted on canvas in the studio of Artgroove. The inspiration came from images I had saved of an Italian villa, which I've long loved. Here at last was the ideal place for it.

At the end of the house near the water is a vast room designed and furnished for entertaining. Doors open on both sides to the terrace, creating enough space so large groups can dine, or even dance the night away.

When the clients requested an open structure to cover the swimming pool, I was somewhat apprehensive. But it protects the swimmer from the sun—and it is truly one of the property's most beautiful spots.

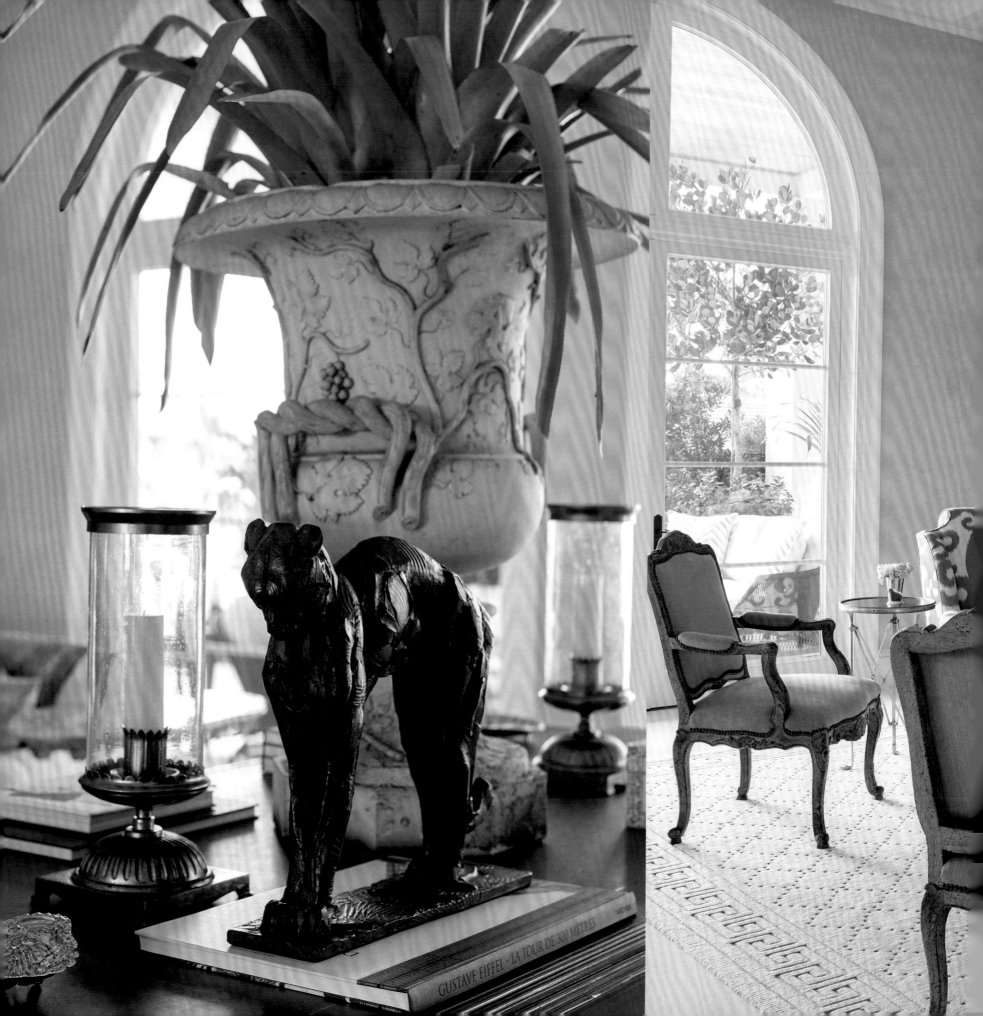

GUSTAVE EIFFEL · LA TOUR DE 300 METRES

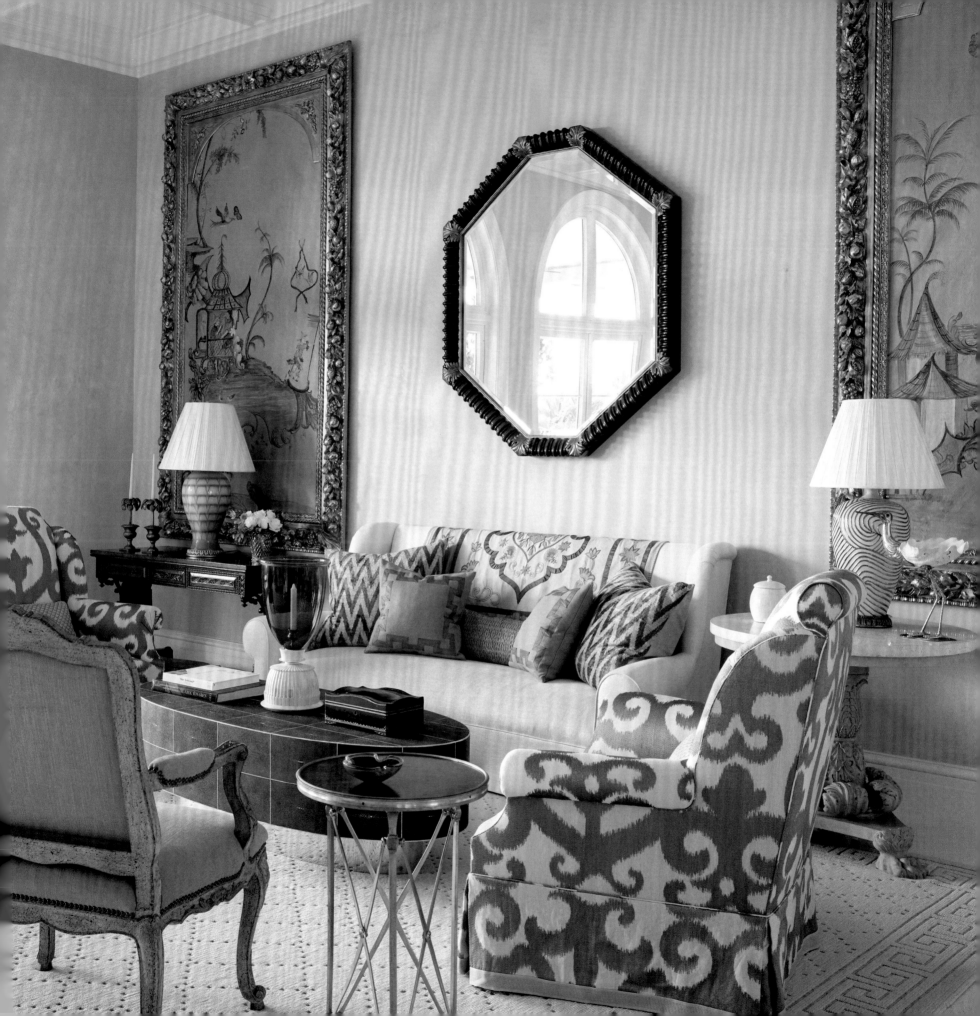

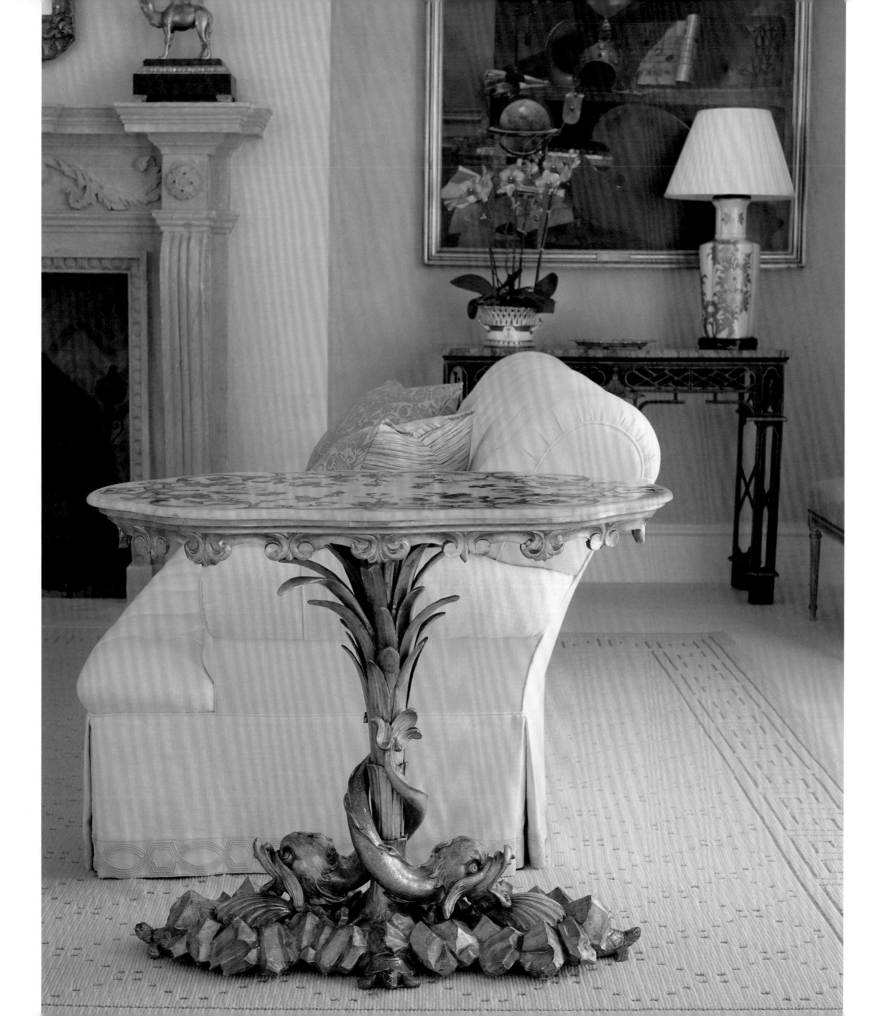

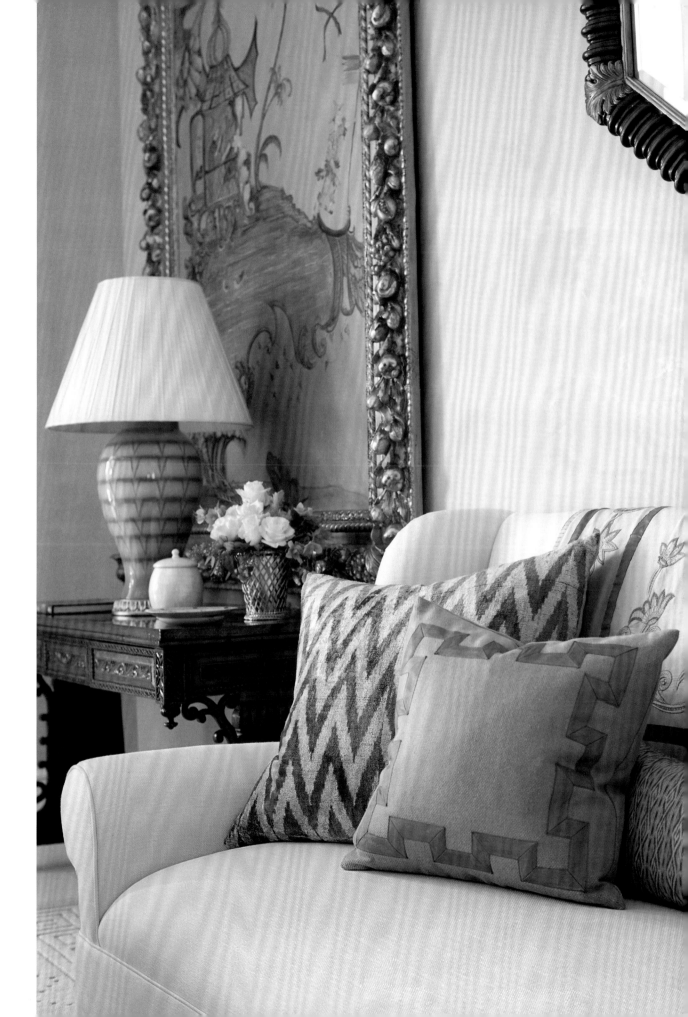

PAGES 48–49: An extraordinary, early twentieth-century wallpaper panel found by the clients is the perfect scale for the entrance hall. PAGE 50: With its fluid curves, harmonious lines, and balanced proportions, this eighteenth-century Venetian sofa sits elegantly in front of the panel. PAGE 51: We designed the vaulted, double-column gallery to separate the entrance hall and the living room. PAGE 52: When I found the eighteenth-century limestone mantel, I knew immediately it would give character to one end of the living room and provide a focal point for a seating group combining comfortable upholstered furniture with Italian chairs and a contemporary coffee table. PAGE 54: The center table dividing the living room's two seating areas welcomes an eighteenth-century carved marble urn filled with huge bouquets. PAGE 55: To create intimacy in an expansive room, I use overscale pieces. A handmade Spanish rug defines the seating area at the living room's other end and gives warmth to the French limestone floors. On either side of the sofa, chinoiserie panels flank a mirror. OPPOSITE: A fantastic, eighteenth-century Italian gilded table with a pietra dura top and a base of carved dolphins wrapped around a palm tree seems right at home in this Florida house. RIGHT: In the layering of textiles, fabrics, warm woods, and gilded frames, each piece speaks.

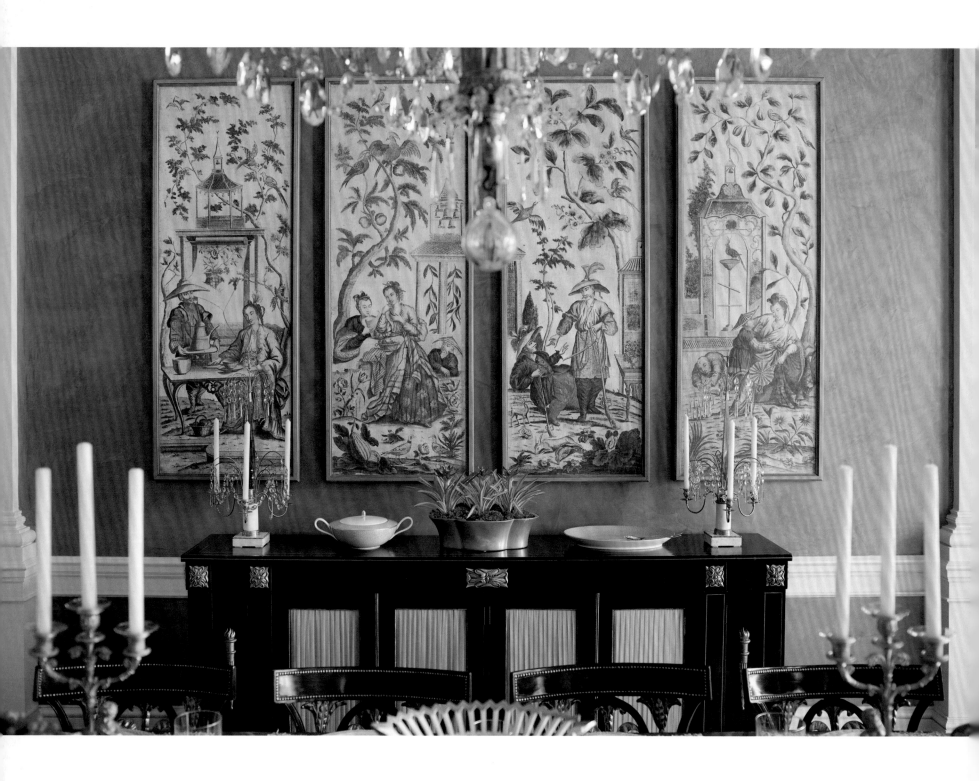

ABOVE: In the dining room, a quartet of grisaille chinoiserie panels commands the wall above a Regency cabinet. OPPOSITE: In a kind of optical illusion, the mirrored niche on the opposite wall seems to expand the room's width. A contemporary painting over a French serving table provides an interesting contrast to the antique and vintage pieces.

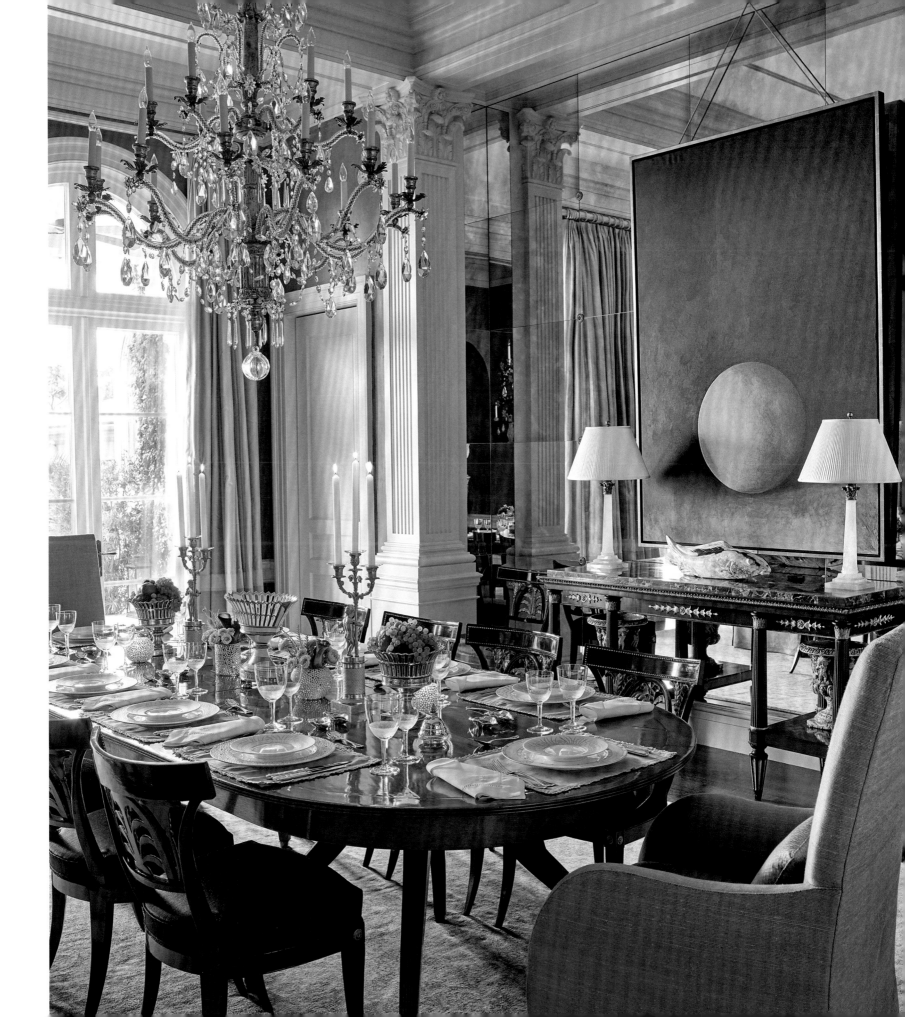

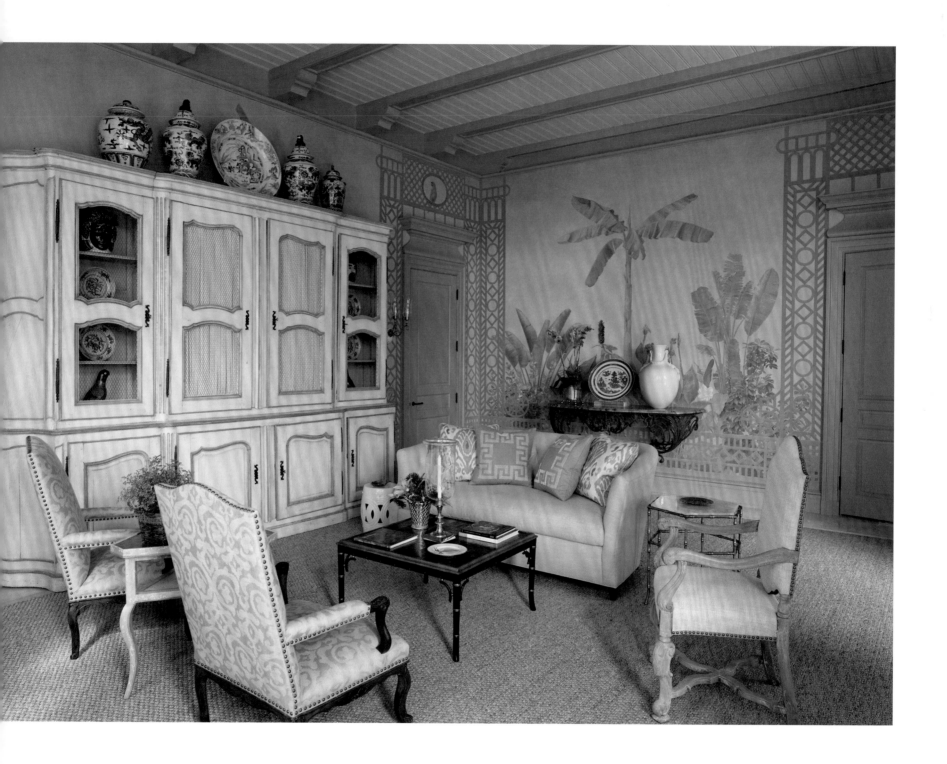

ABOVE: A spacious, painted French cabinet in the breakfast room houses the TV for tuning in to the morning news with coffee.
OPPOSITE, LEFT: Snug in the corner under the windows, a round table surrounded by comfortable chairs is a welcome place for breakfast or lunch. OPPOSITE, RIGHT: Painted with exotic vegetation and lattice motifs, the walls tie the interior and exterior together.

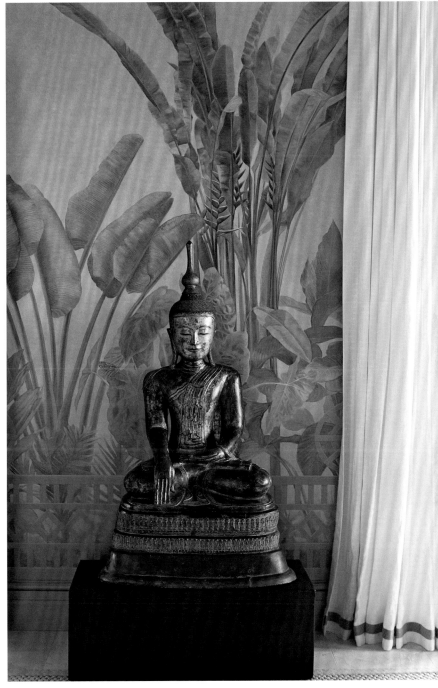

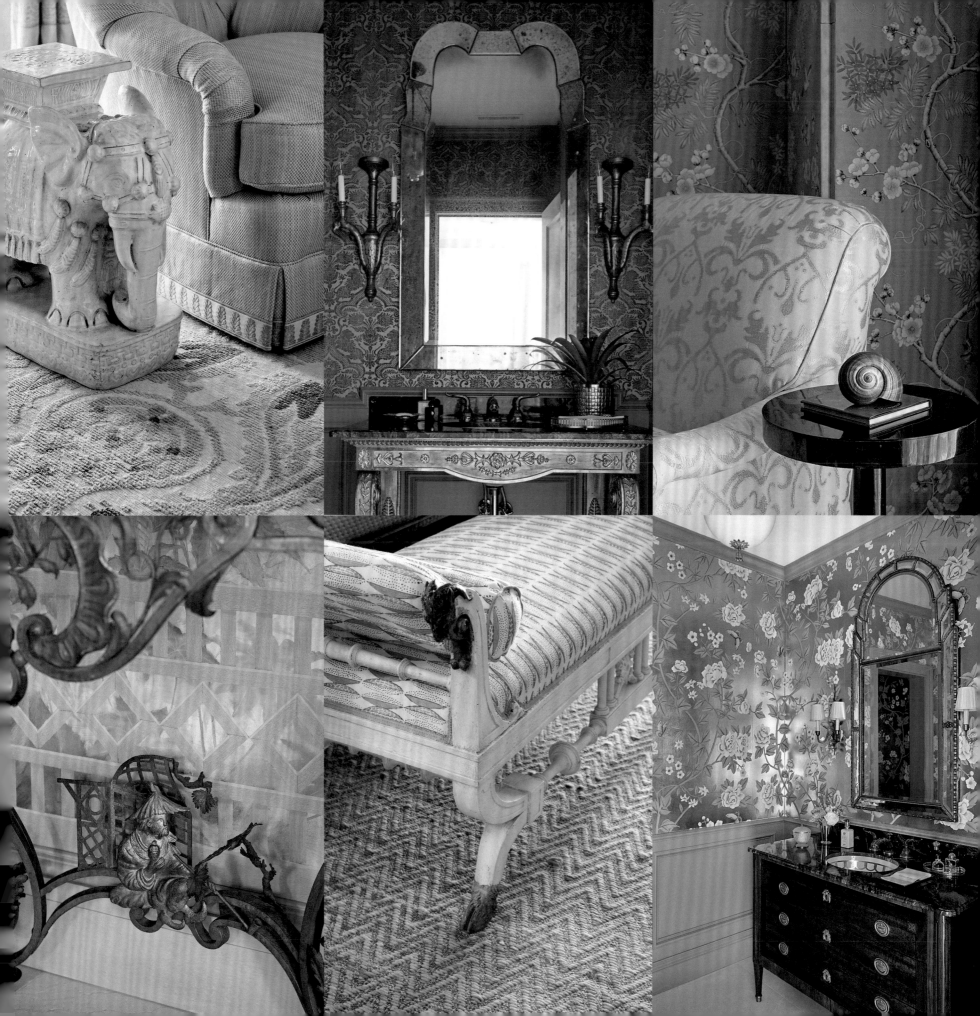

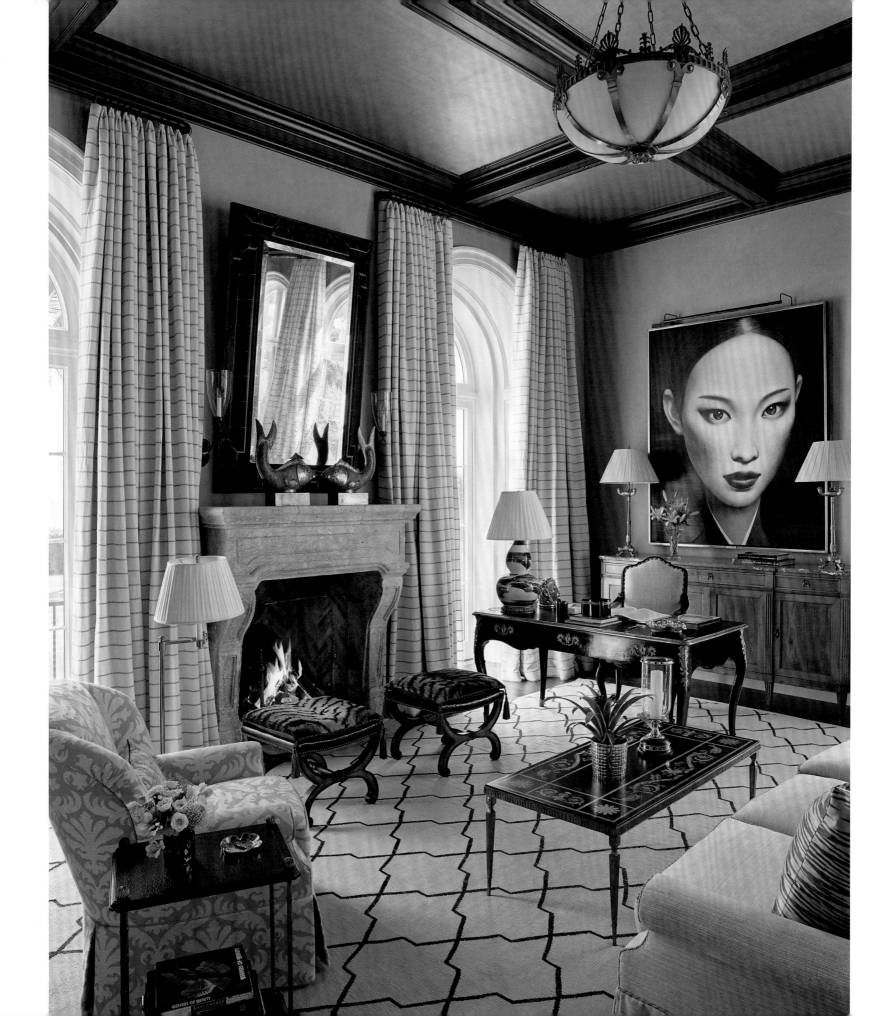

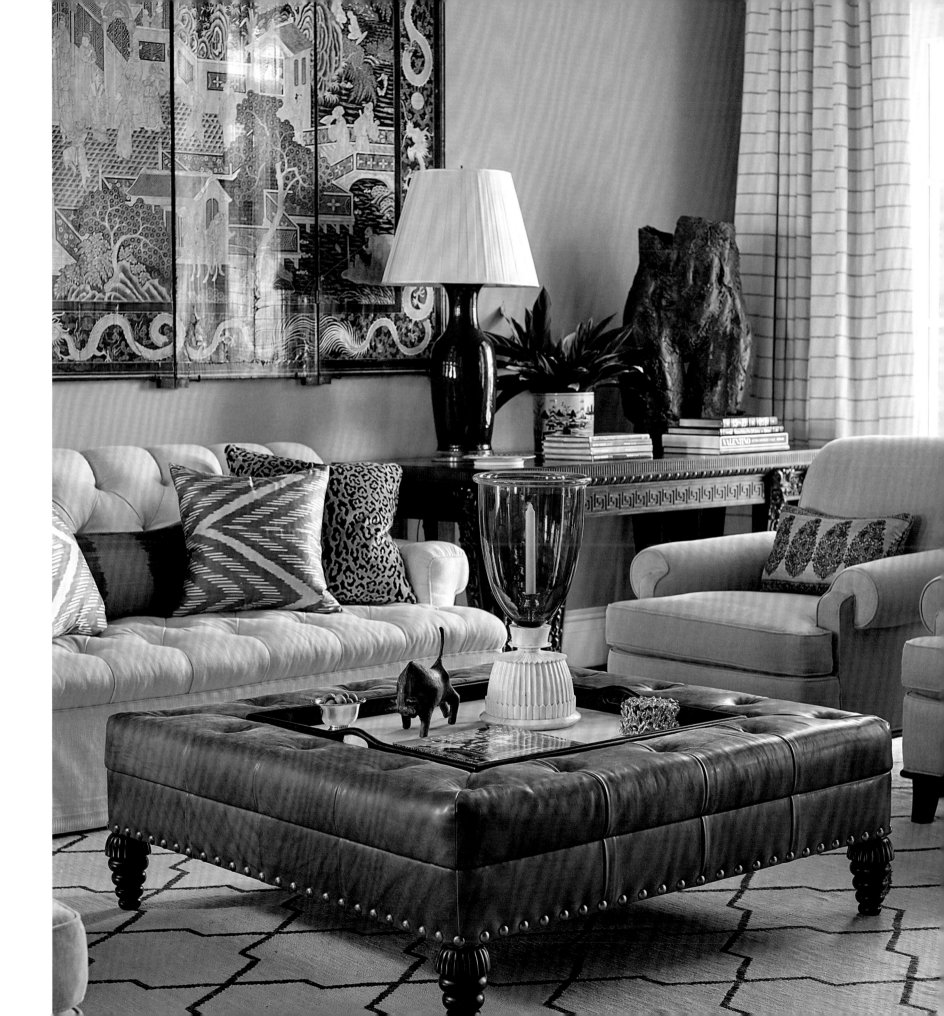

PAGES 62–63: In a collage of details, it becomes clear how interesting shapes and furniture forms offer the viewer both variety and points of focus. PAGE 64: We divided the expansive library into two spaces. At one end, a working area by the fireplace holds a desk and a long cabinet for storing papers and stationery. PAGE 65: At the opposite end, comfortable seating creates a place to gather around the TV for a movie. LEFT: A pair of very large Indonesian carved wooden birds perch in the corner of the great room. OPPOSITE: At the far end of the house, this room with exposures on three sides overlooks the water and opens to the exterior spaces—the perfect spot for large parties. Rattan furniture and straw rugs keep the feeling very casual and are easy to move around as the occasion demands.

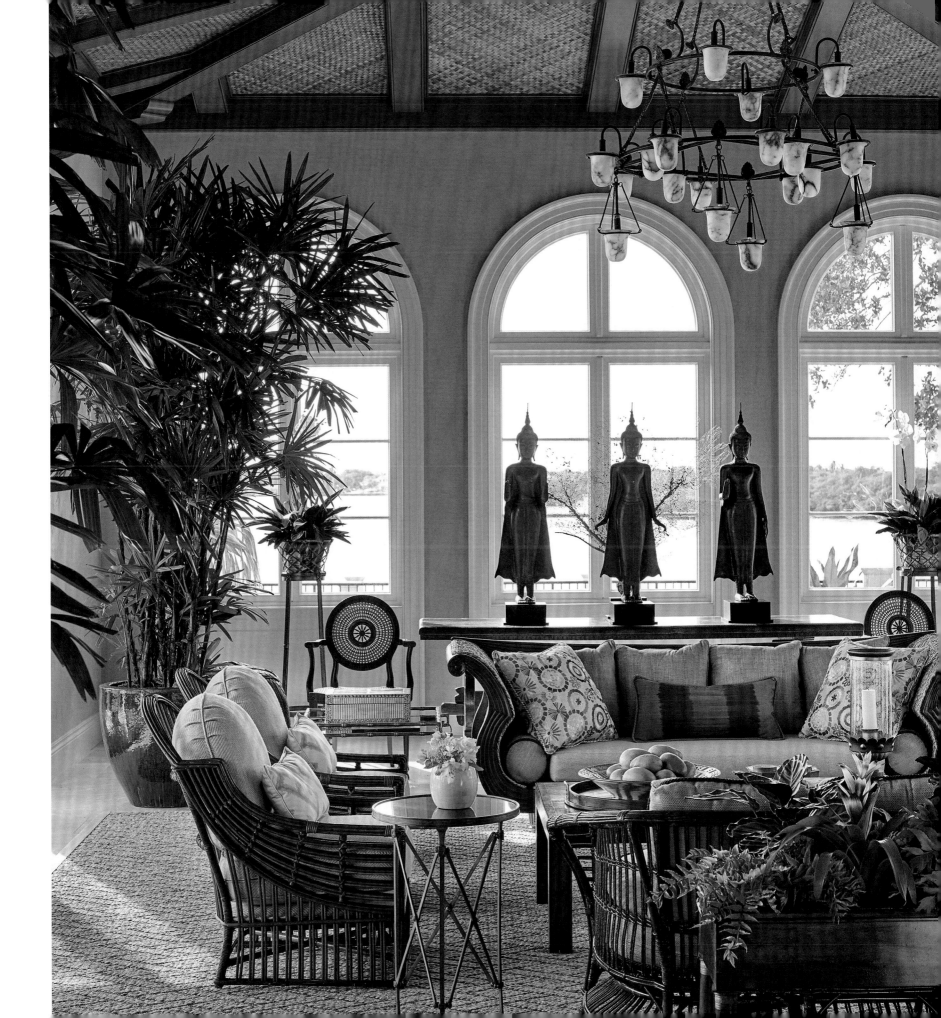

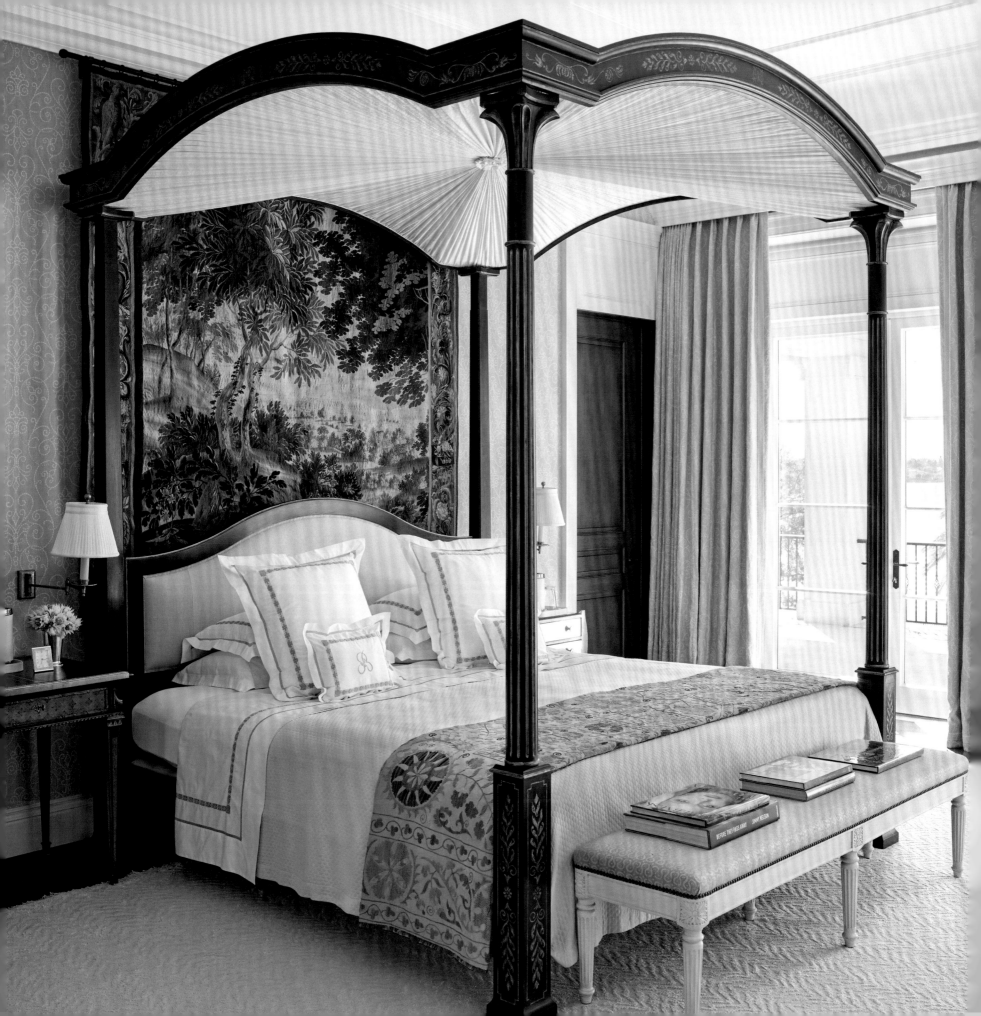

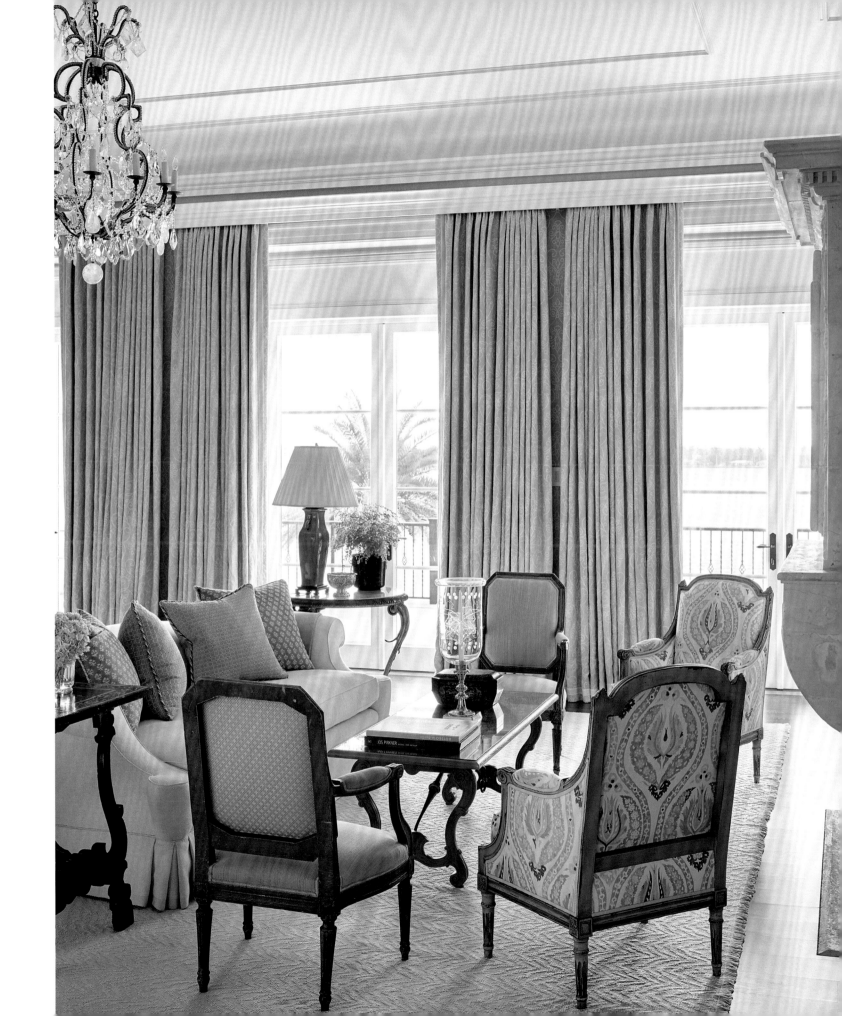

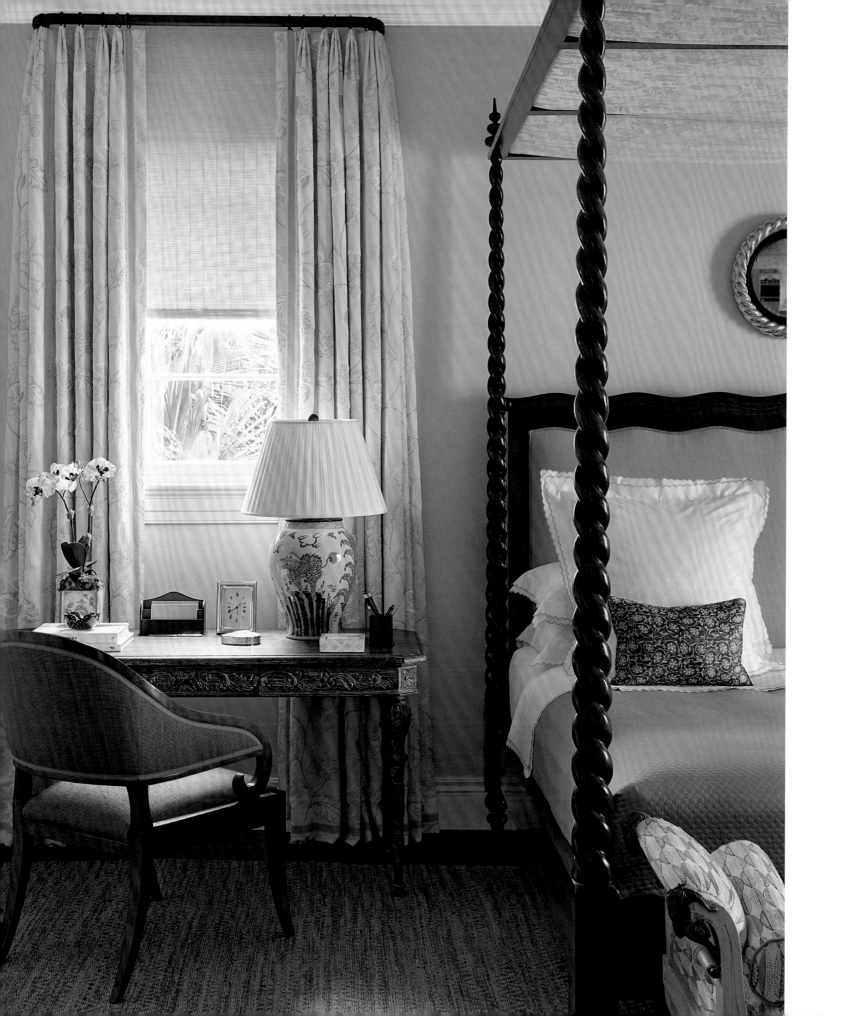

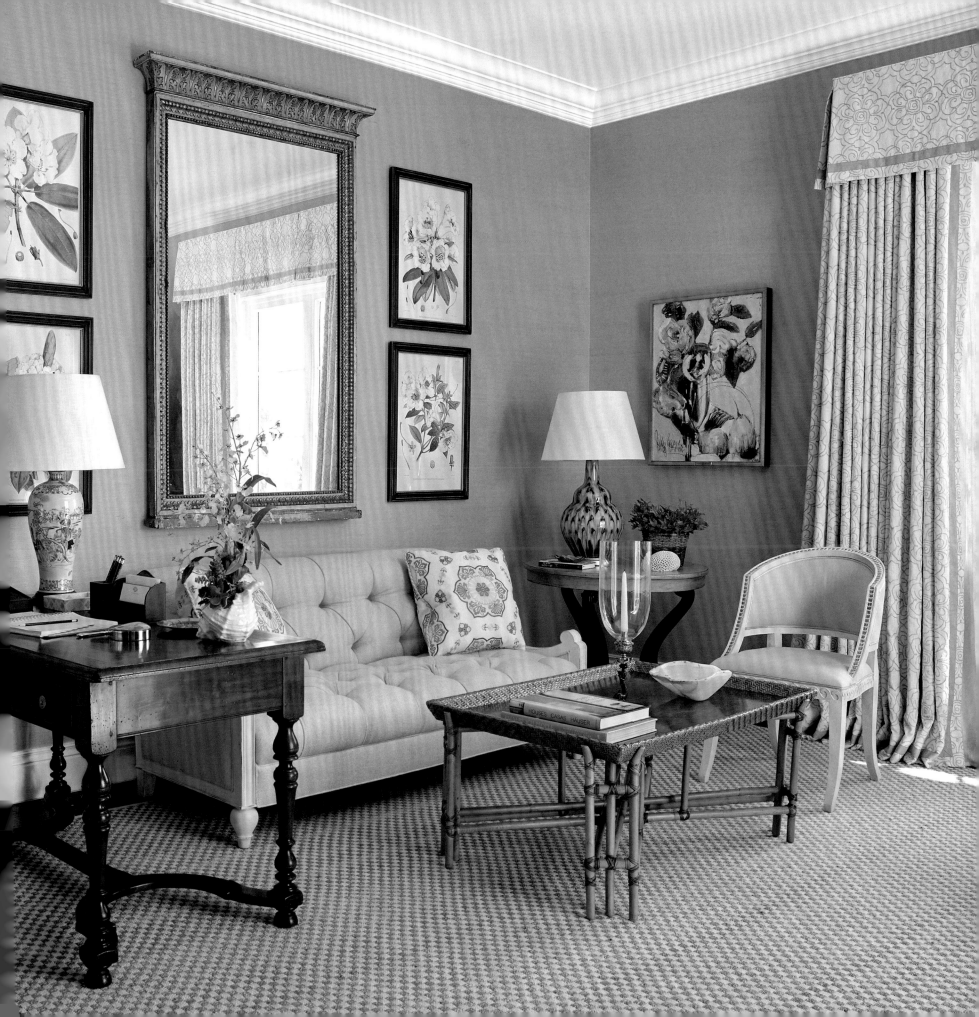

To bring a house to life, put together the most interesting items you can find and concentrate on how they play together rather than worrying about whether they match.

PAGE 68: In the master bedroom, the posts of the canopy bed frame a nineteenth-century Flemish tapestry. PAGE 69: At the opposite end, a French stone mantel anchors a welcoming seating area. Using the same fabric for walls and windows unites a room, especially when it has very large windows. PAGE 70: Large canopy beds, desks, and comfortable seating make guest bedrooms feel like home. PAGE 71: In each guest bedroom, a sitting area gives visitors a cozy place to read or get away for an afternoon nap. RIGHT: A fully roofed swimming pool is one of this property's most magical spots.

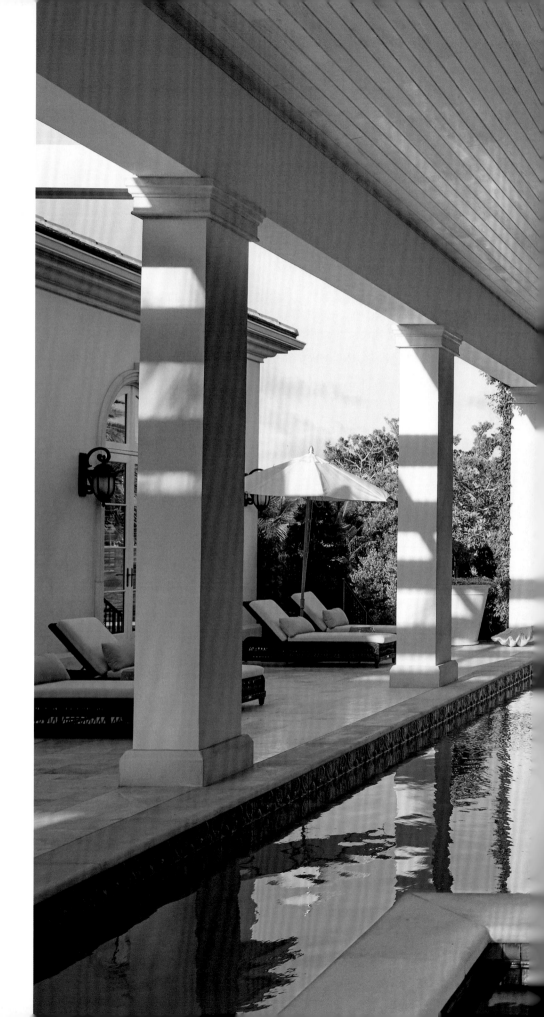

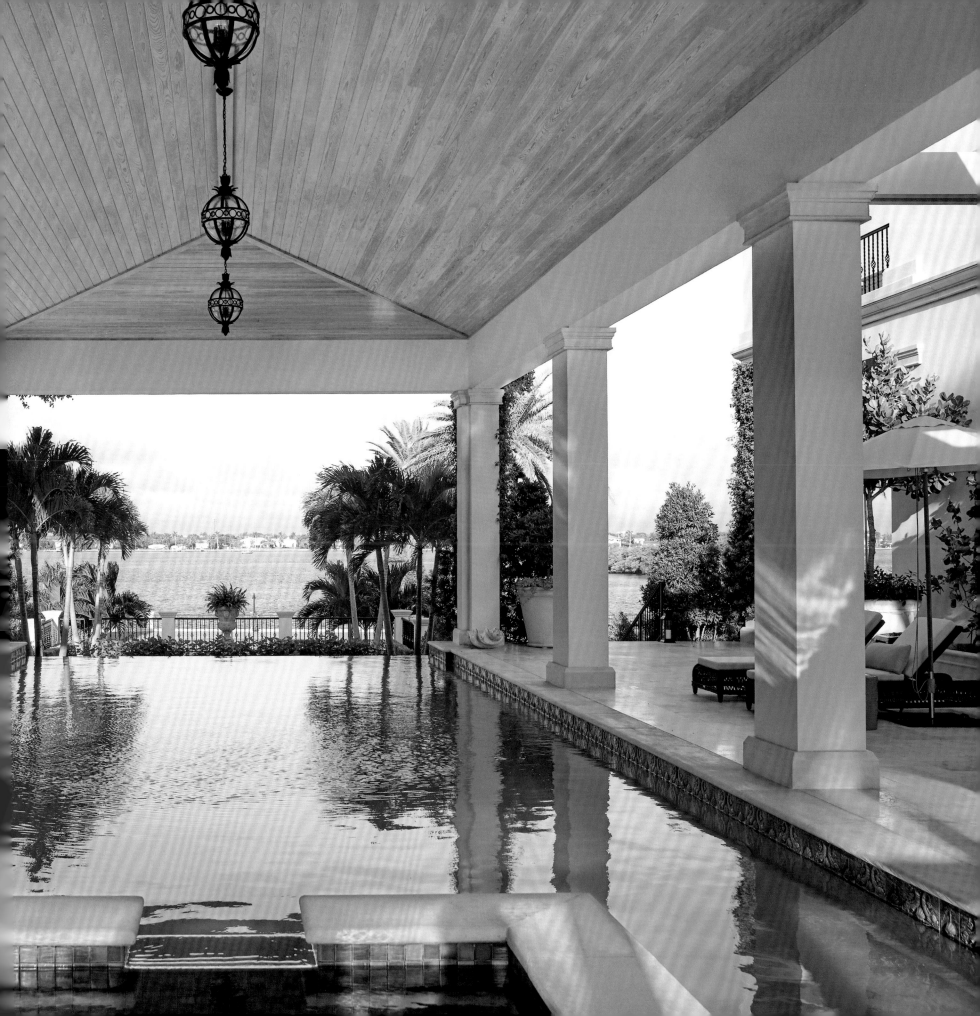

THE
PENTHOUSE

From the time I designed this family's apartment years ago, they had wanted to restore it to its original duplex format. When they were finally able to purchase the penthouse above, they called me to put the two spaces back together without greatly altering their existing apartment. To join the floors, we envisioned a circular, steel-and-glass staircase in the living room corner. Working with architect David Hottenroth of Hottenroth+Joseph, we found a manufacturer for the unit, which functions almost as a piece of modern sculpture.

The upstairs, a maze of small rooms surrounded by a narrow terrace, needed complete redoing. Every family member had a request for function: a spot for TV watching, a reading space, a place for informal dinners, an office, a guest bedroom, and more. We opened up the floor in the manner of an airy modern loft and created multipurpose areas to fulfill the family's wish list. At either end we installed floor-to-ceiling metal doors and windows to connect the indoors to the exterior.

I have always loved the contrast of patina within modern surroundings, for the combination is so compelling. To tie the contemporary penthouse to the traditional apartment below called for a richness of detail with a fresh perspective on history. Covering the chimneybreast with seamed, hand-rolled zinc panels introduced a layer of patina, but in a very modern way. Wanting the ceiling to read almost as sky, we encased the beams with the same zinc and inserted glass panels, back-painted sky blue, in between.

A small solarium (added years before) became a quiet reading area and an office reached through an entry framed by antique painted columns. An incredible set of 1940s table and chairs by André Sornay, an extremely innovative twentieth-century French designer, was our very first purchase, perfect for casual dinners and meals on football game nights.

The request for a guest room posed a major challenge because there was no place for a bed and I did not want to add a (usually uncomfortable) foldout sofa. Touring a closet shop in a design center in Florida, I discovered the solution: an ingenious mechanism that stows a bed vertically behind a cabinet. I designed a black-lacquer bookcase with a red interior for the purpose. At the push of a button, the lower panel extends out to reveal a very comfortable bed.

The completed penthouse has given the duplex such a breath of fresh air. Climbing the few steps up or down the spiral staircase is like traveling between SoHo and the Upper East Side: the best of both worlds, without leaving home.

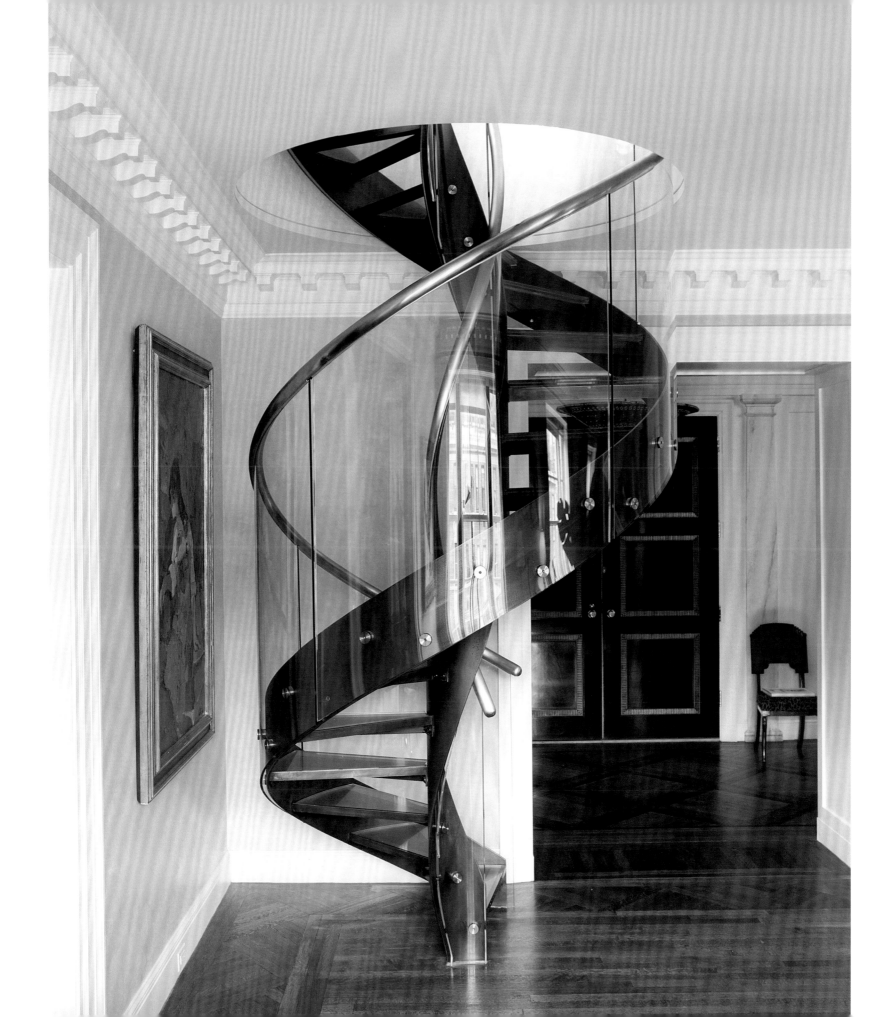

I wanted this space to feel contemporary but not cold. Subtle but rich architectural details combined with furniture of different periods give it warmth and character.

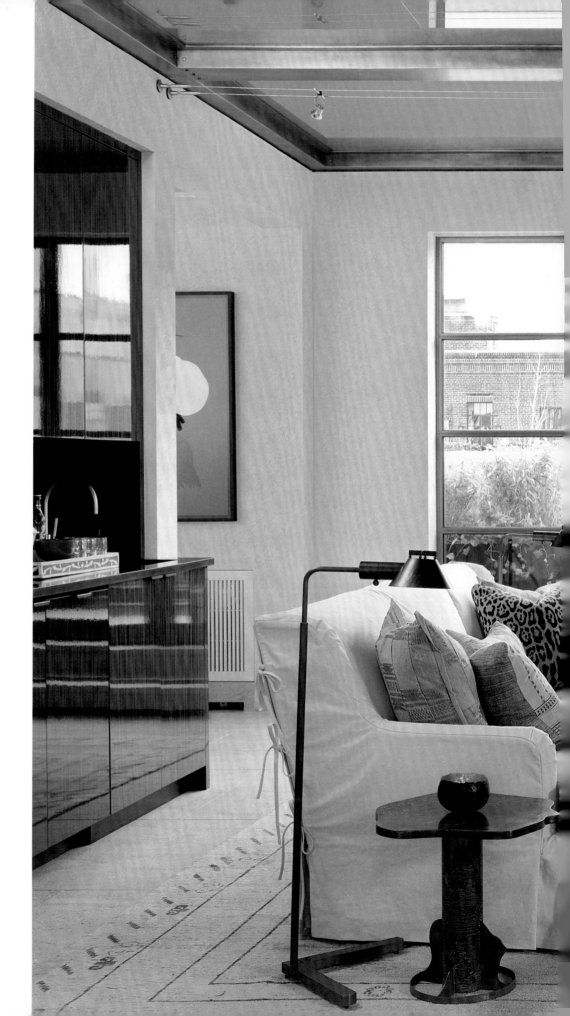

PAGES 74–75: Columns in their original condition punctuate the entrance to the original conservatory, where we added low bookcases and file drawers for extra storage. A Lalanne sheep from Paul Kasmin Gallery stands guard. PAGE 77: The spiral stair reminds me of a Brancusi sculpture. OPPOSITE: A faded Chinese rug blends beautifully with the stone floor. An eighteenth-century chair mixes happily with mid-century and contemporary designs.

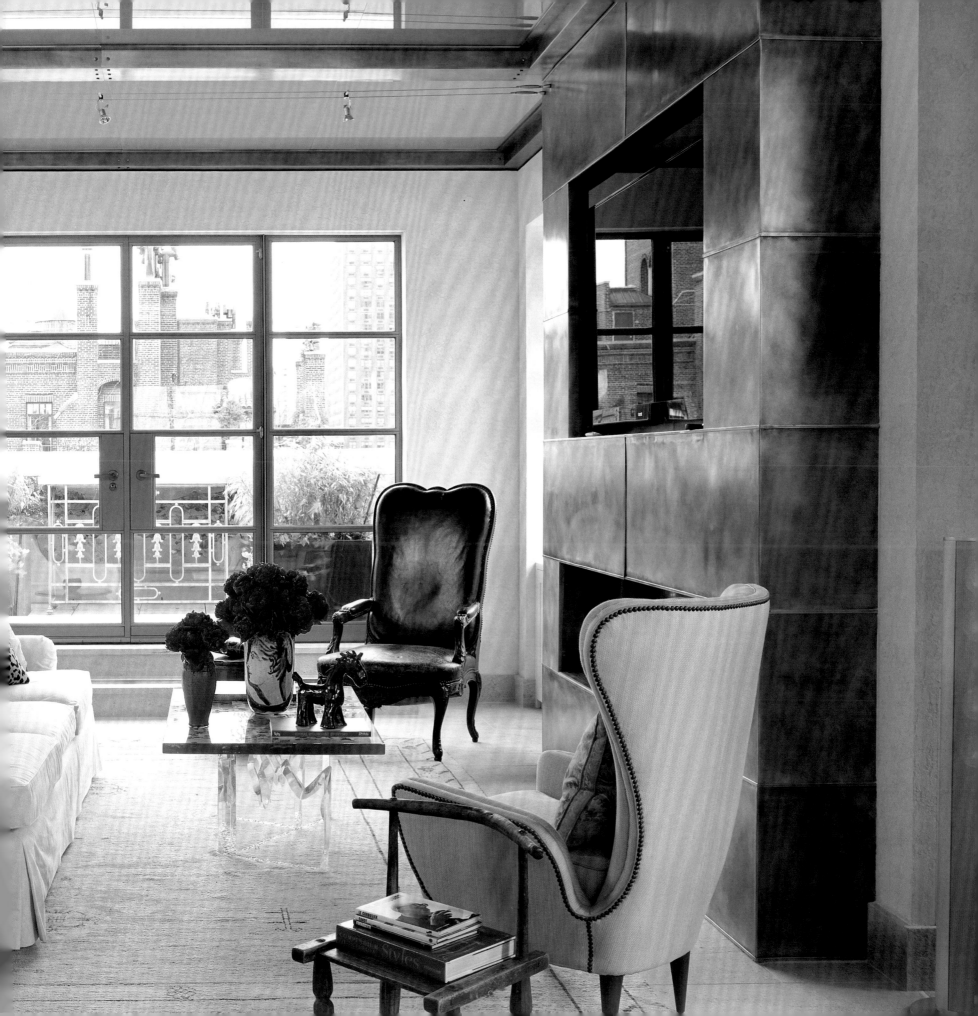

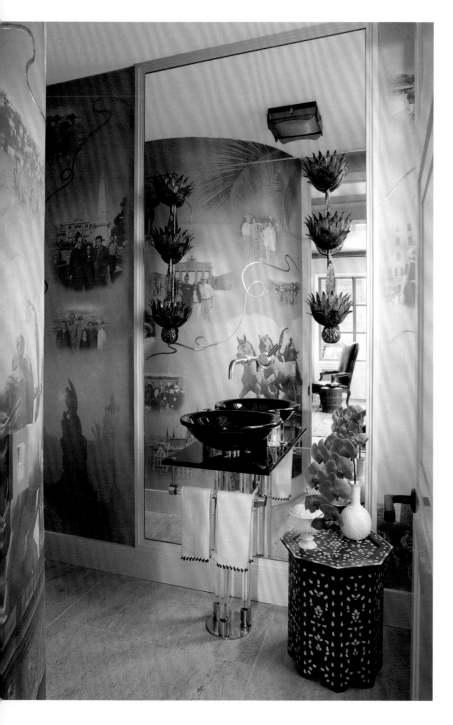

ABOVE, LEFT: For the collage of family photos that covers the powder room walls, images of the family's yearly trips were assembled on the computer and then printed on canvas wallcovering. ABOVE, RIGHT: Comfy chairs, an African ottoman, and Frank Gehry's Wiggle stools create a quiet reading area for the husband at one end of the conservatory. OPPOSITE, LEFT: The guest bed, unfolded and made up for visitors. OPPOSITE, RIGHT: When the cabinet's bottom panel closes, the mattress slides up into the back of the cabinet.

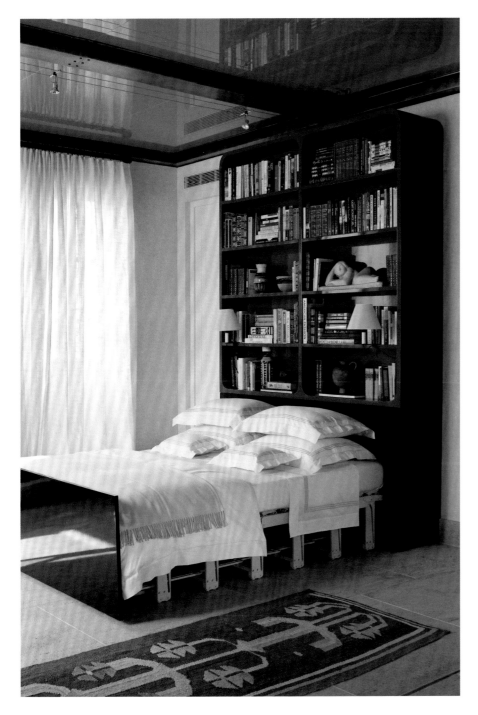
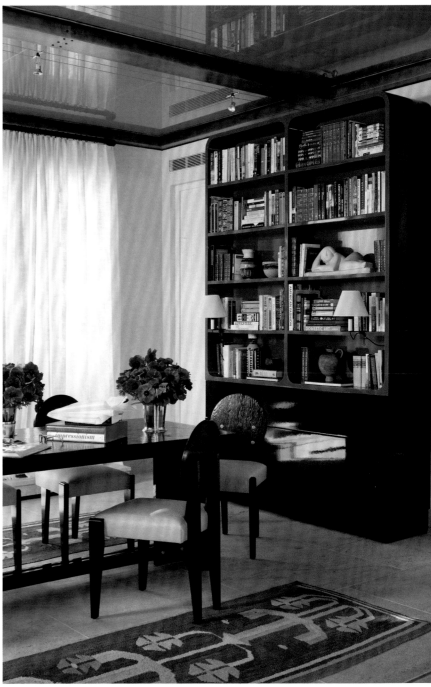

SOUTHERN CHARM

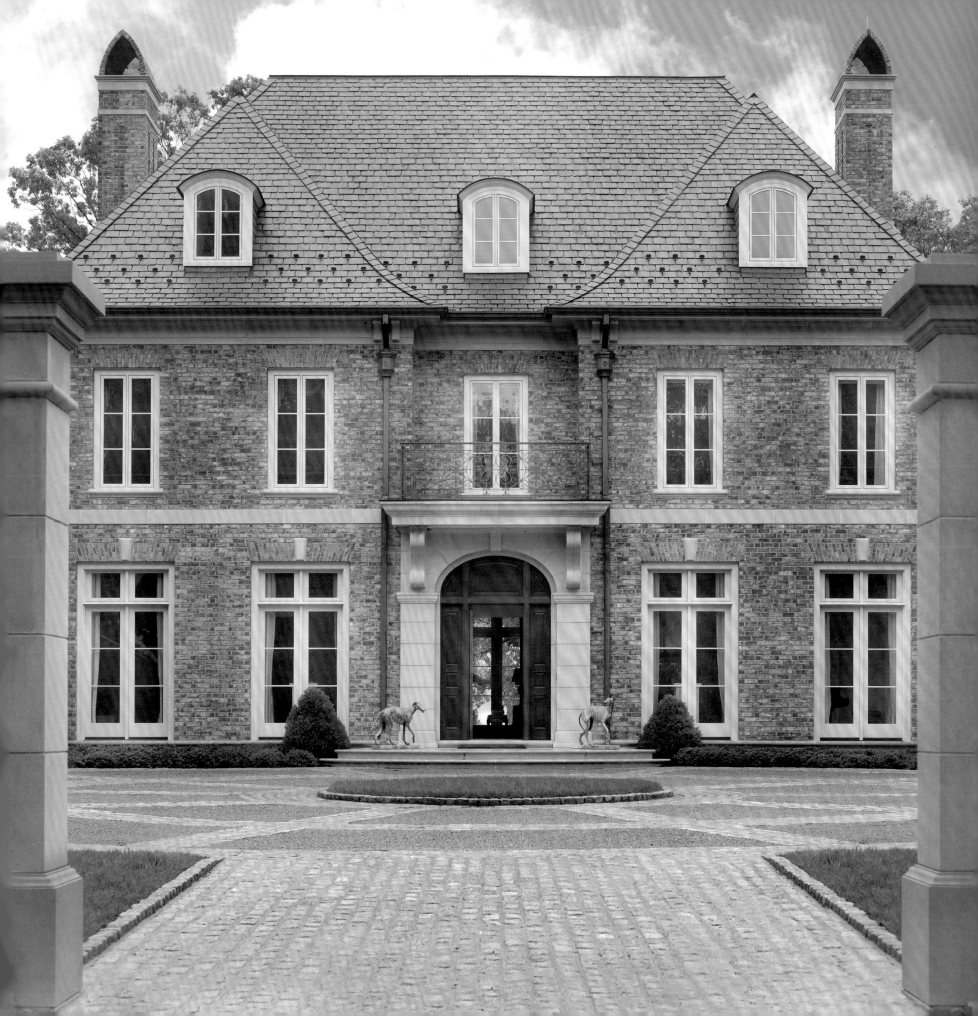

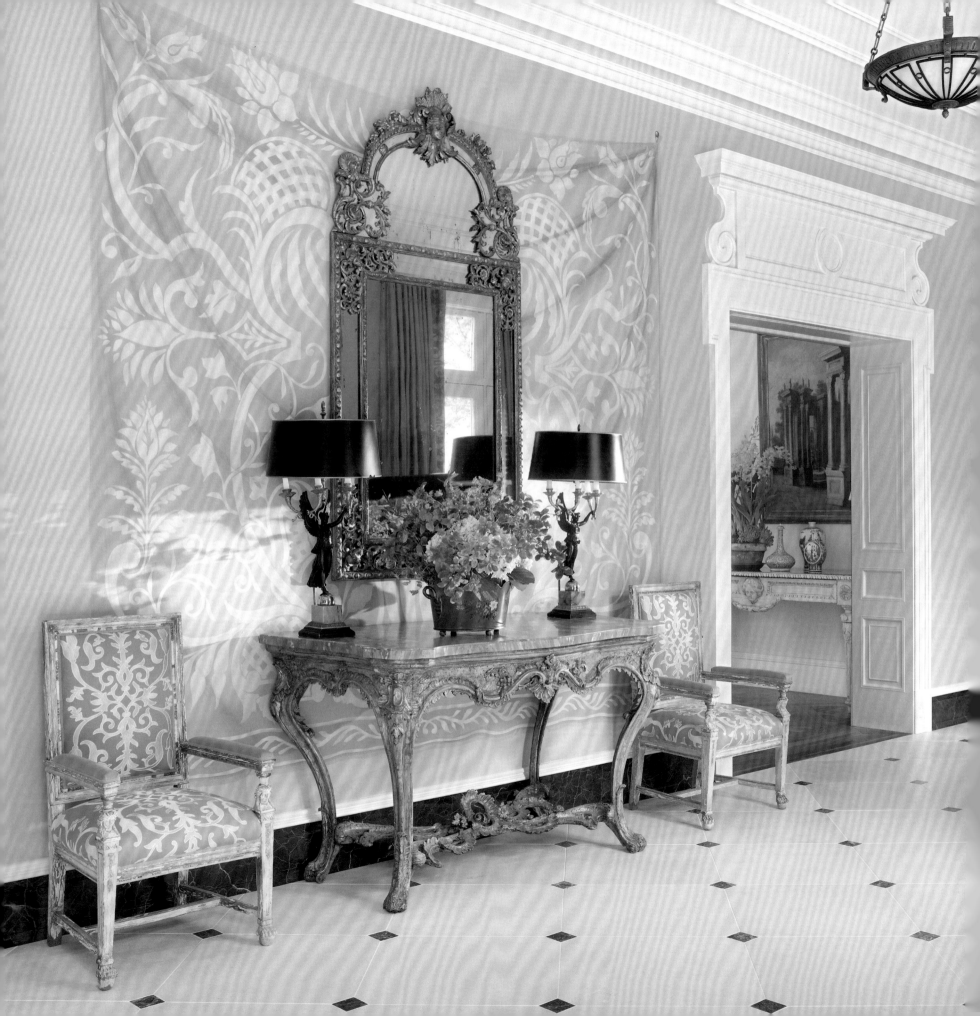

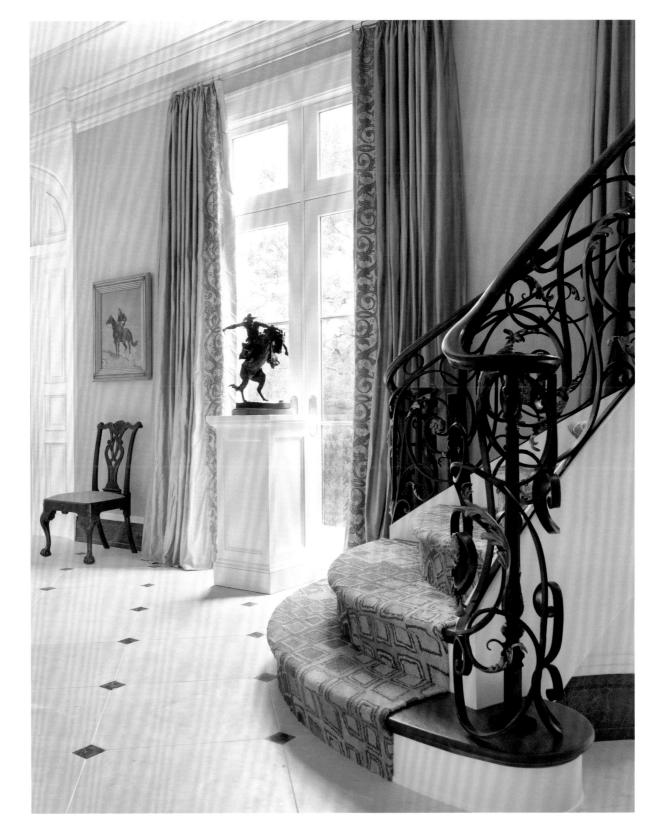

PAGE 83: The designs of architect William Lawrence Bottomley inspired the exterior of the house. OPPOSITE: In the gallery, a trompe l'oeil drapery painted by Bob Christian provides a background for a collection of French and Italian pieces. RIGHT: To show the client's collection of Remington bronzes in the best light, we placed them on pedestals in front of windows in the long gallery; the bronze is echoed in the stair's curved railing.

A trip to Virginia to meet these prospective clients presented me with a dilemma. Newly married, the couple was living in a house the husband had built in the 1950s on an extraordinary piece of property at the edge of Richmond. In long conversations about their needs and wants, they focused on gracious spaces for entertaining family and friends and a large working office for the husband. The bride, who is European, talked about her love of Continental antiques, though none were evident among their American treasures. I tried to imagine how I would remodel the interior. With small rooms, sliding glass doors, and low ceilings, it was not the best of the period. After several nights of tossing and turning, I picked up the phone on a Saturday morning to deliver a message I knew they probably did not want to hear: that they tear down the house and begin again. After a pause, the husband became excited about the idea.

I always study houses of the area for inspiration, so here we turned to the work of William Lawrence Bottomley (1883–1951), a superb regional architect. With the Richmond-based architecture firm 3north, we developed exterior elevations and established a plan featuring a long, light-filled entry gallery with openings to the living room and dining room for easy circulation during large parties. For more casual living, we included an expansive, double-height room off the kitchen wing.

The couple's amazing American furniture gave us a wonderful starting point. Over the three years it took to design and build the house, we assembled a marvelous collection of English, French, and Italian antiques along with some twentieth-century pieces on shopping trips and at auction.

Every designer really wants her clients to truly love their home. When this couple invited me to a spectacular birthday party for the husband—they covered the entire garden with a clear tent—I saw how proud they were of the house. It brought me to tears.

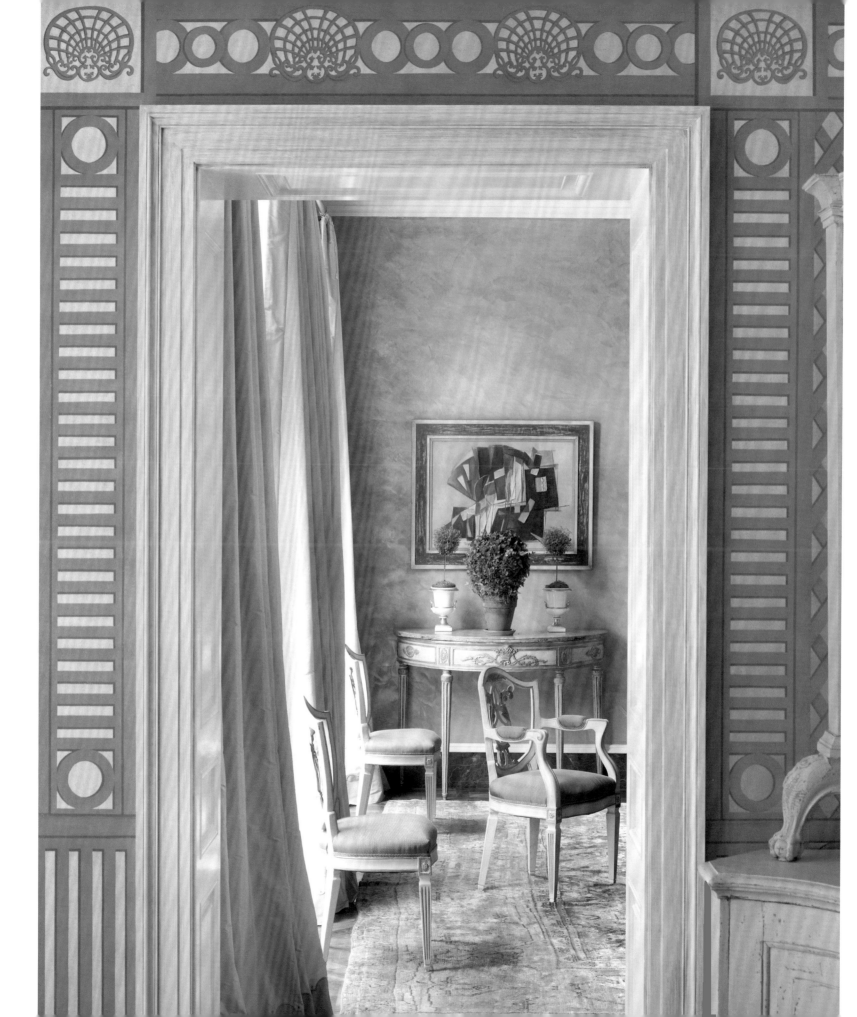

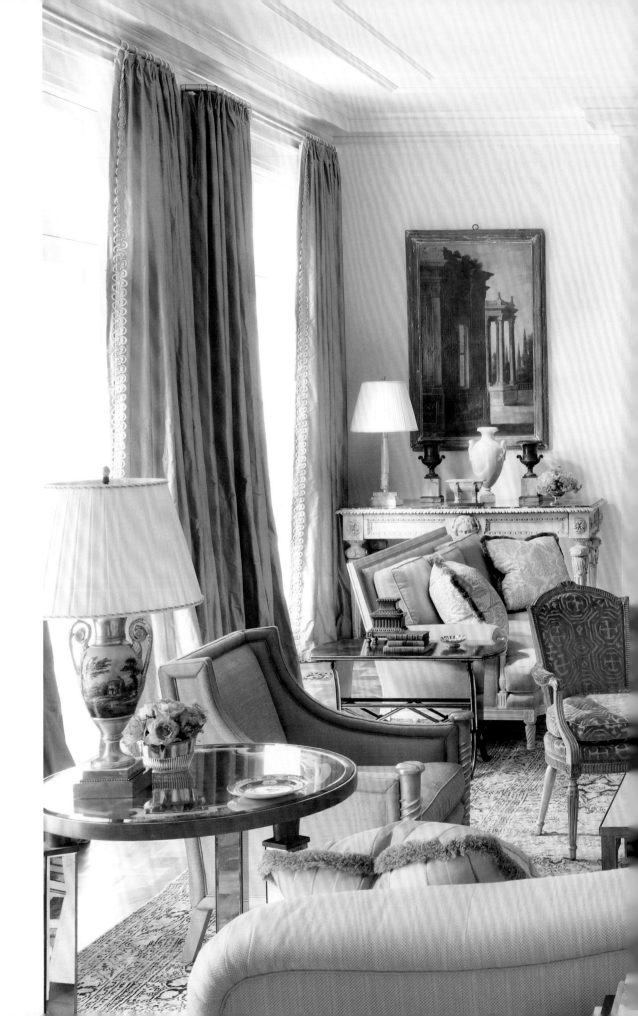

PREVIOUS PAGE: We conceived the floor plan to emphasize light, ease, and flow; the breakfast room opens organically into the dining room. RIGHT: The living room began with the purchase of an eighteenth-century French limestone mantel and a large, softly colored Persian rug. Silk curtains hang from simple gilded poles, and a pair of nineteenth-century landscape paintings adds the patina of age over a pair of painted French side tables. The furnishings mix English, Italian, and French antiques with mid-century pieces.

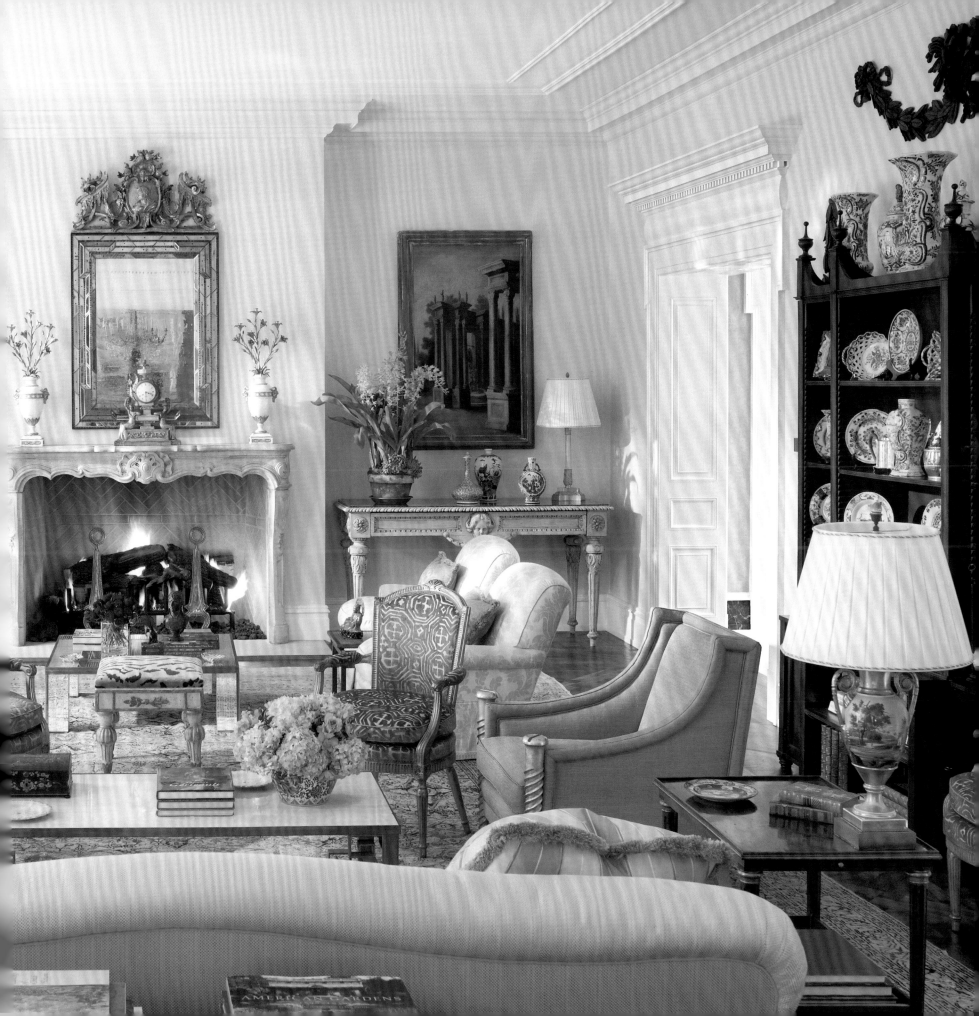

To give the dining room a warm, rich glow, we covered the walls in a faded copper-colored Venetian plaster and the ceiling in silver tea paper.

RIGHT: To create the illusion of greater width, we added a niche. Mirrored panels on its back wall reflect candlelight in a magical way. A set of Italian painted chairs surrounds an English mahogany table. FOLLOWING PAGES, LEFT: An iron console table with marble top adds to the breakfast room's garden feeling. FOLLOWING PAGES, RIGHT: Custom Gracie wallpaper panels painted with green trellising over silver paper create the feeling of a mirrored, latticed room. Painted chairs pull up to an English table. Nearby, porcelains fill a painted Swedish corner cupboard.

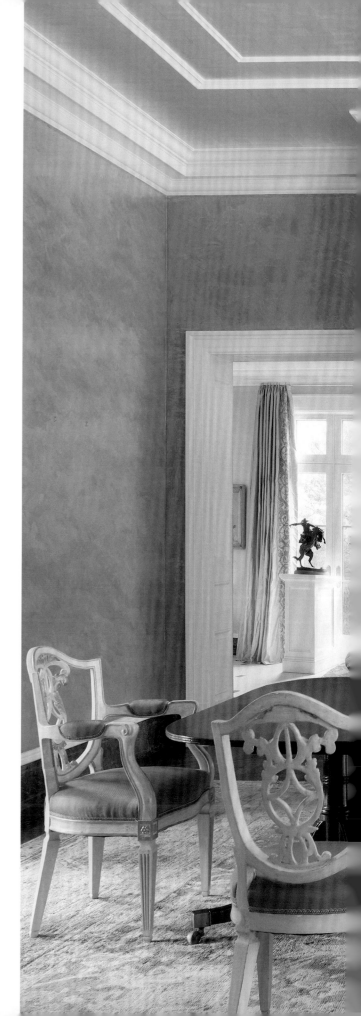

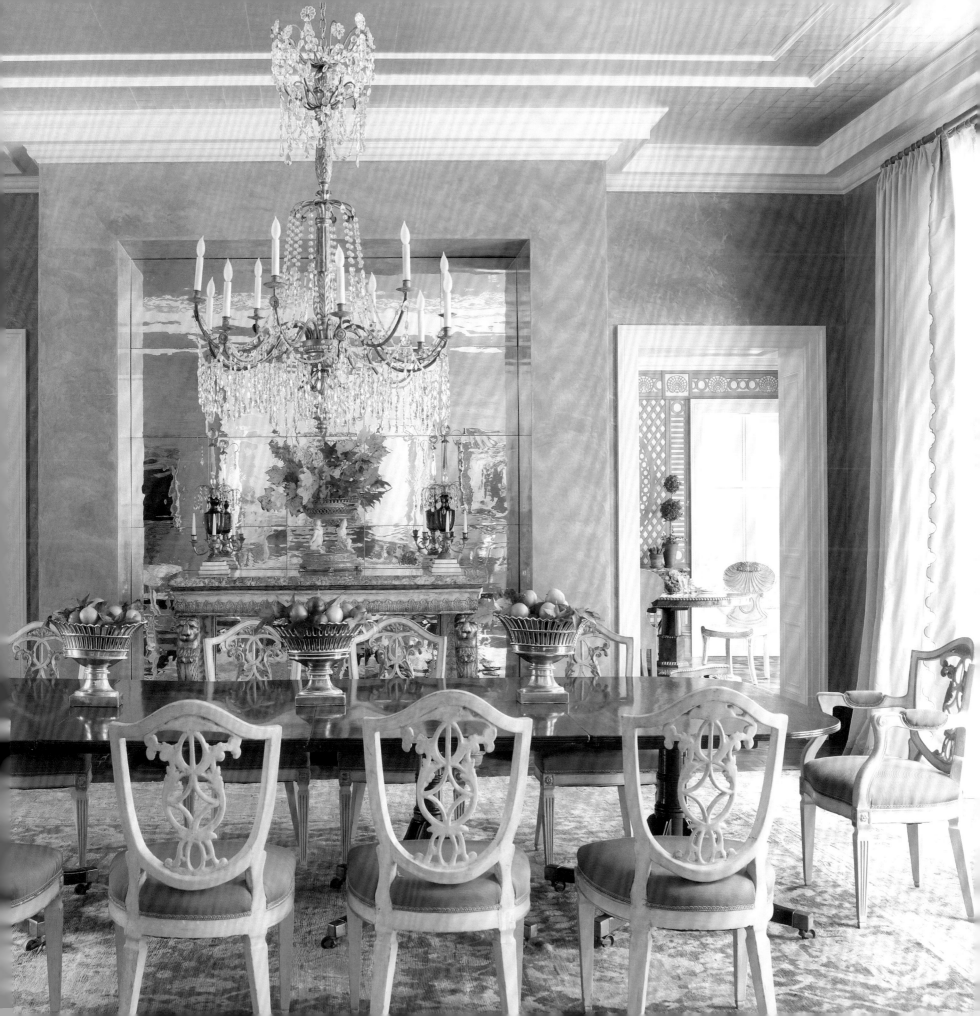

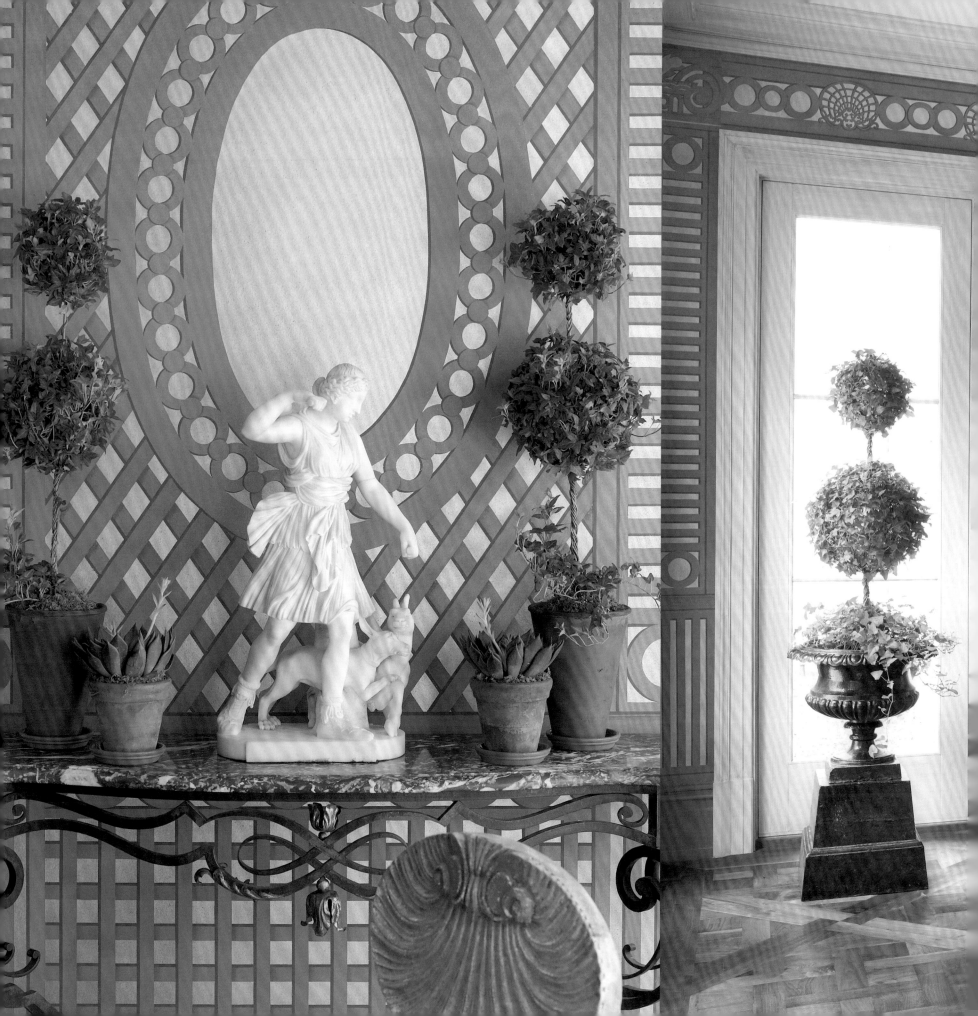

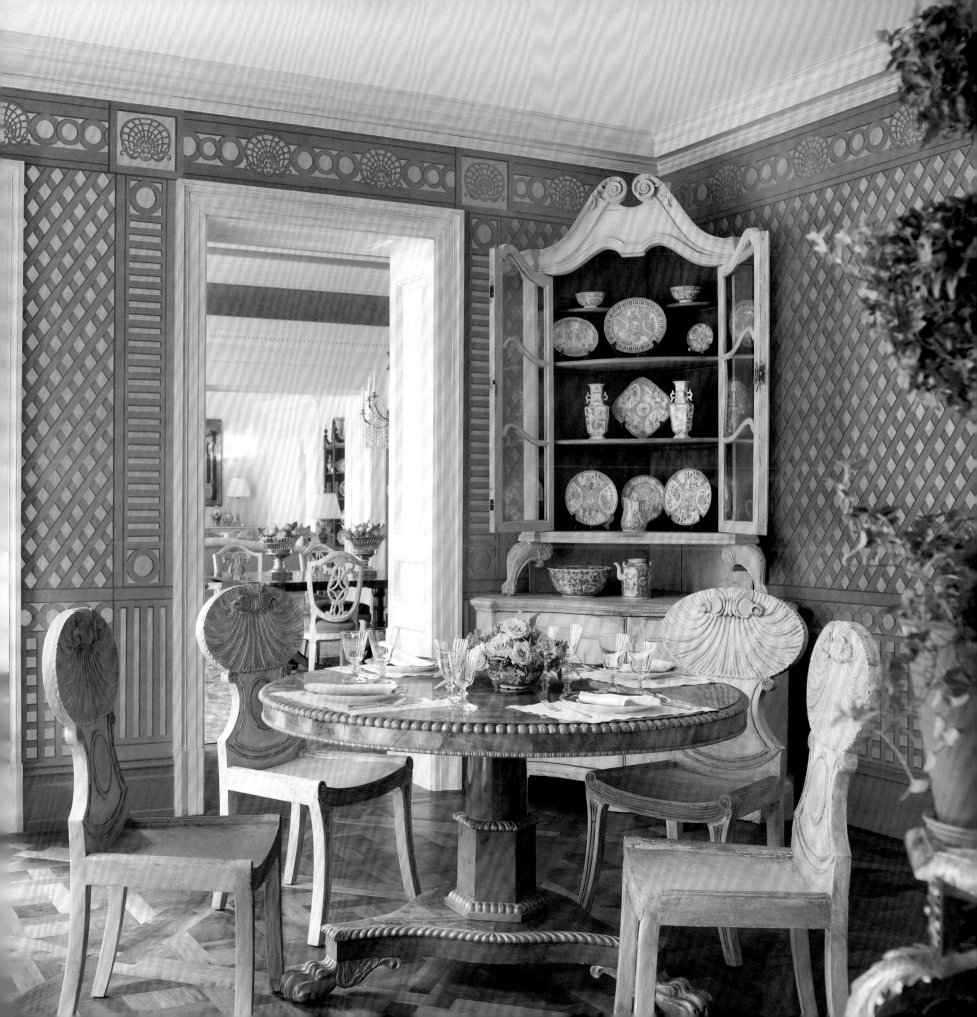

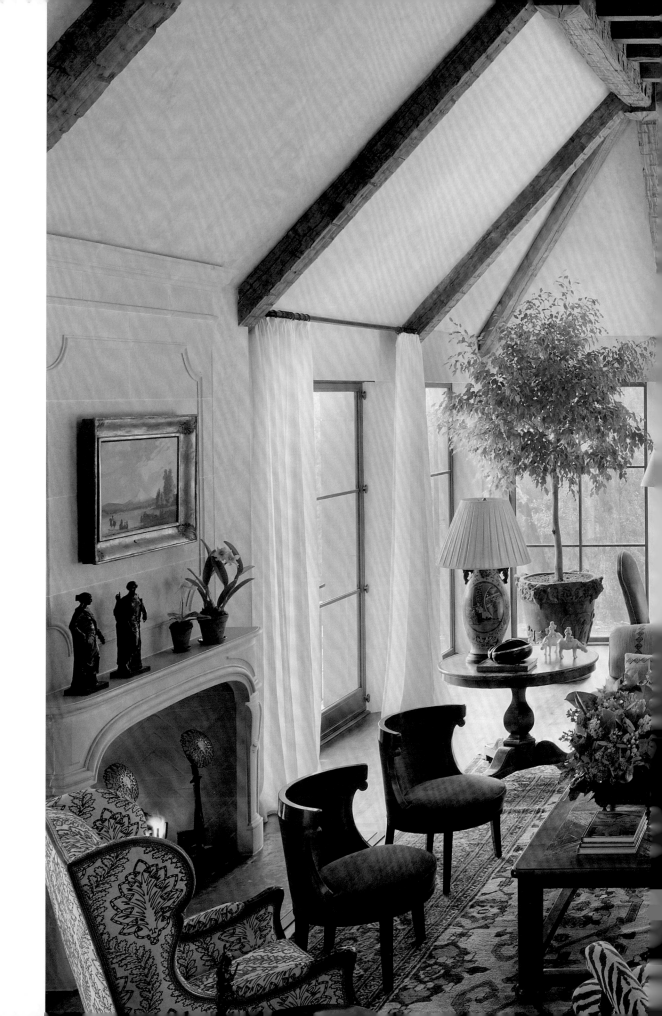

Off the kitchen, a large family room is a perfect venue for casual dining and entertaining. The carefully placed windows make this the perfect spot for watching the deer and wild turkeys that roam the Virginia countryside.

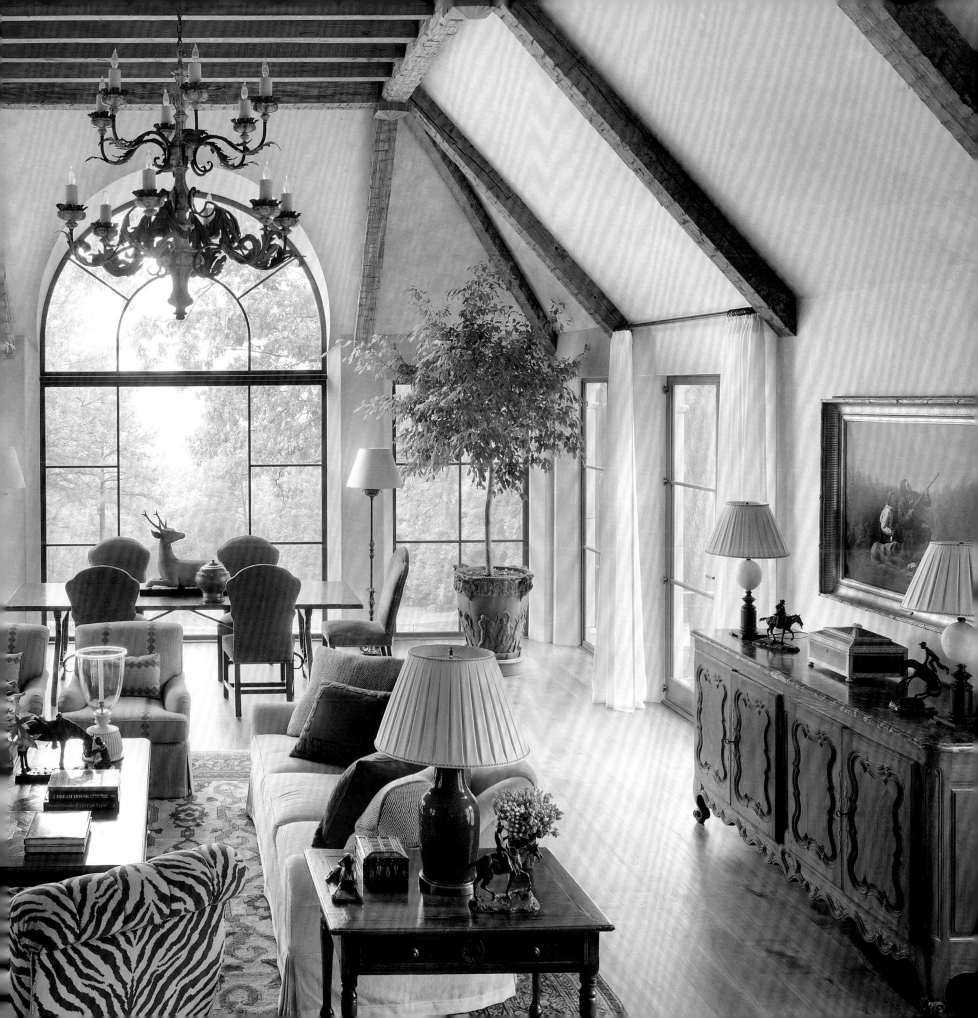

A custom Gracie wallpaper forests the walls with faint, lacy white trees. Carved in England, the silk-lined bed is a copy of an eighteenth-century model; the headboard features embroidery by Penn & Fletcher. Beauvais Carpet's reproduction of an antique Aubusson covers wall-to-wall sisal.

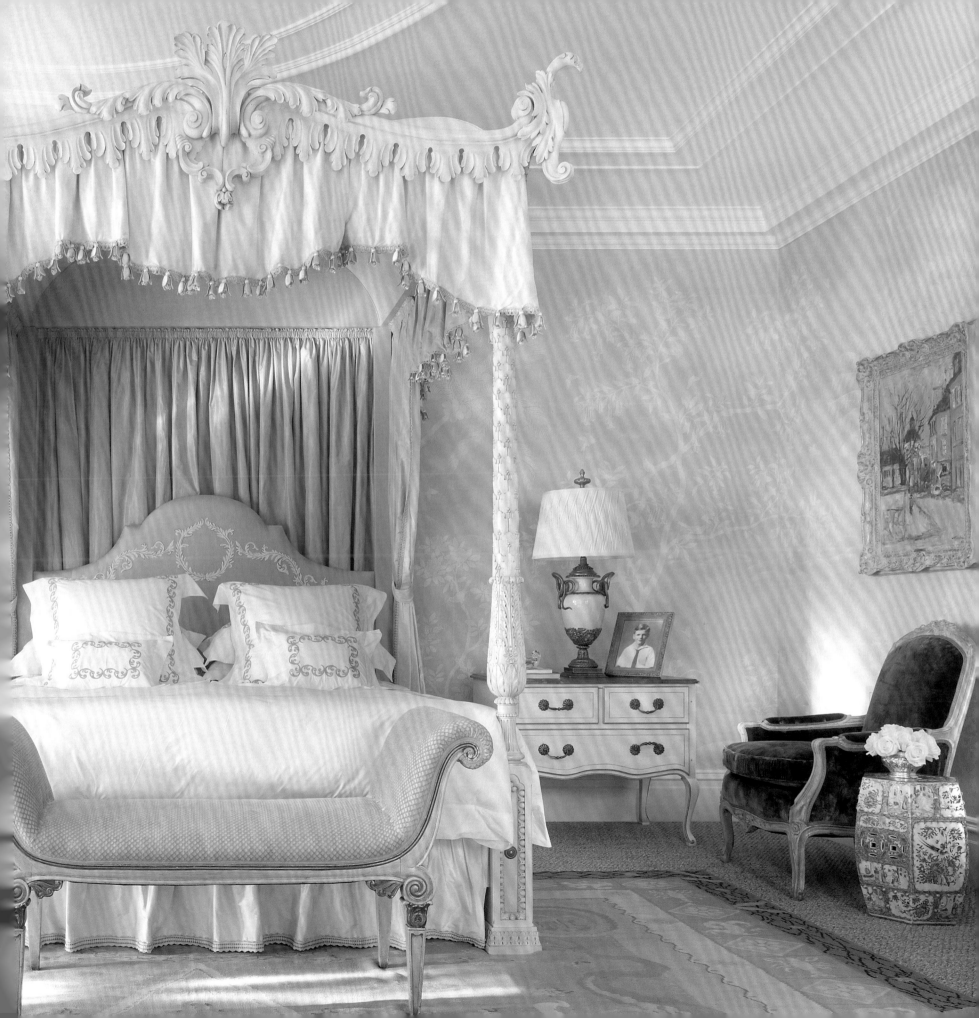

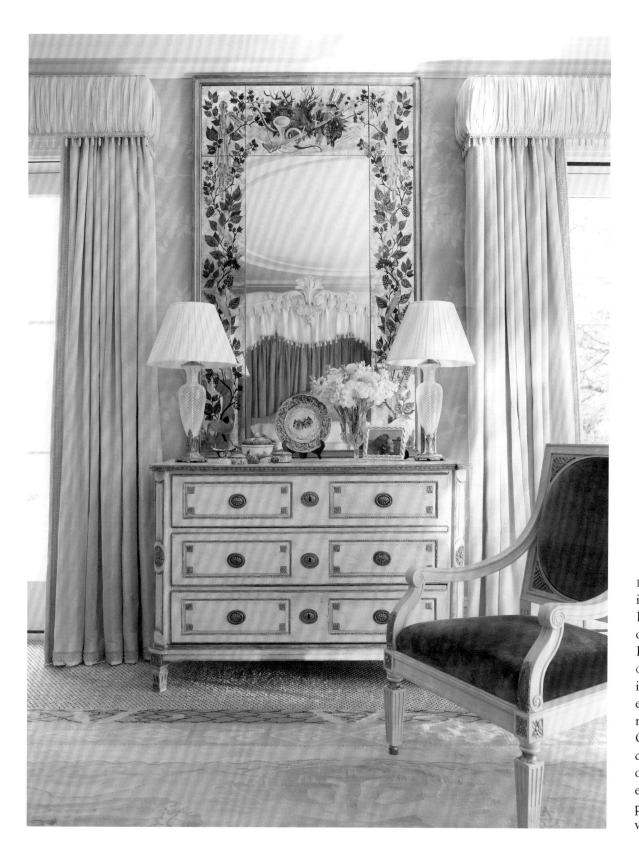

LEFT: Adding delicate flowers into the mix, a mid-century French eglomise mirror hangs over an eighteenth-century French commode.

OPPOSITE: A mosaic set into the marble floor of the expansive master bath feels rather like a carpet. Bob Christian's painted panels cover the vault and fan the overdoor with delicate, eighteenth-century-inspired patterns. A pair of matching vanities flanks the entry.

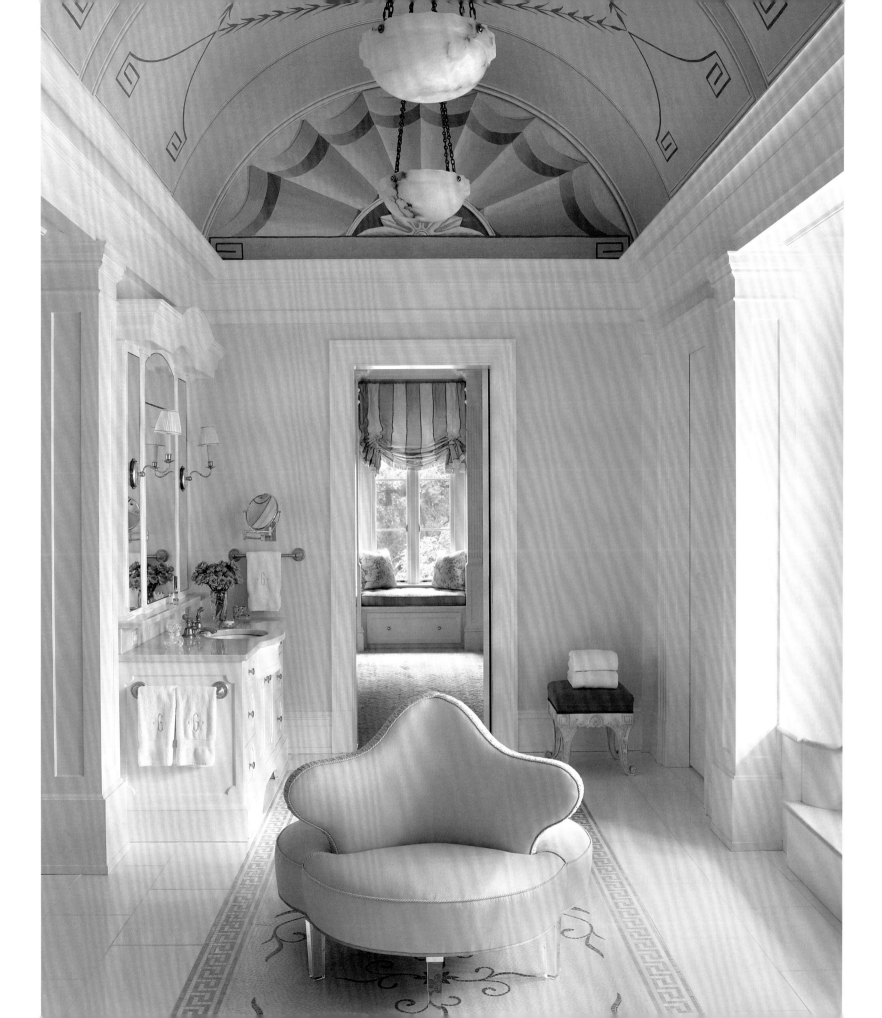

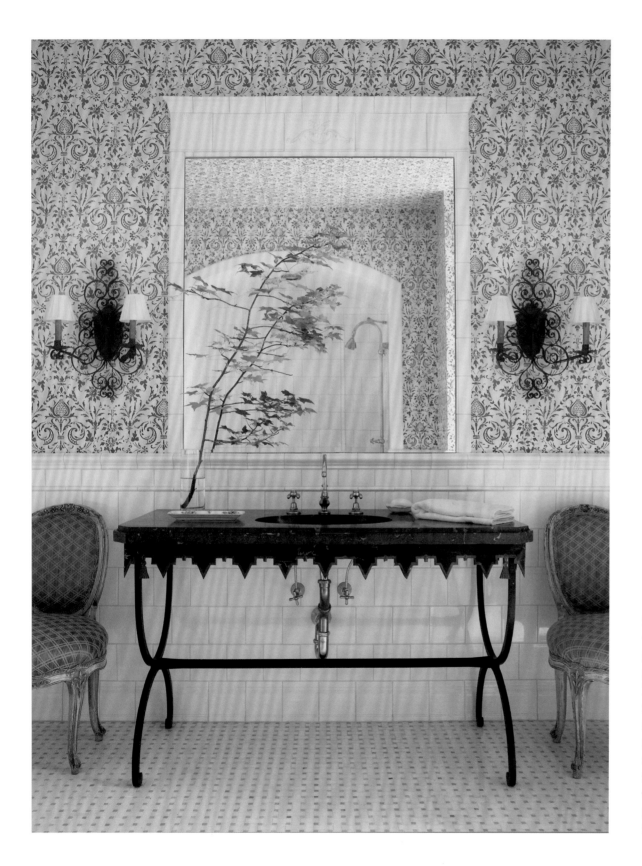

LEFT: In a guest bathroom, we repurposed a reproduction metal garden table with an inset sink to serve as a vanity. RIGHT: Mismatched, antique Sicilian tiles behind the La Cornue stove, an antique parquet floor, and repurposed ceiling beams add layers of age and patina in the kitchen. A custom hood with inset stone brackets resembles a European hearth from an earlier era.

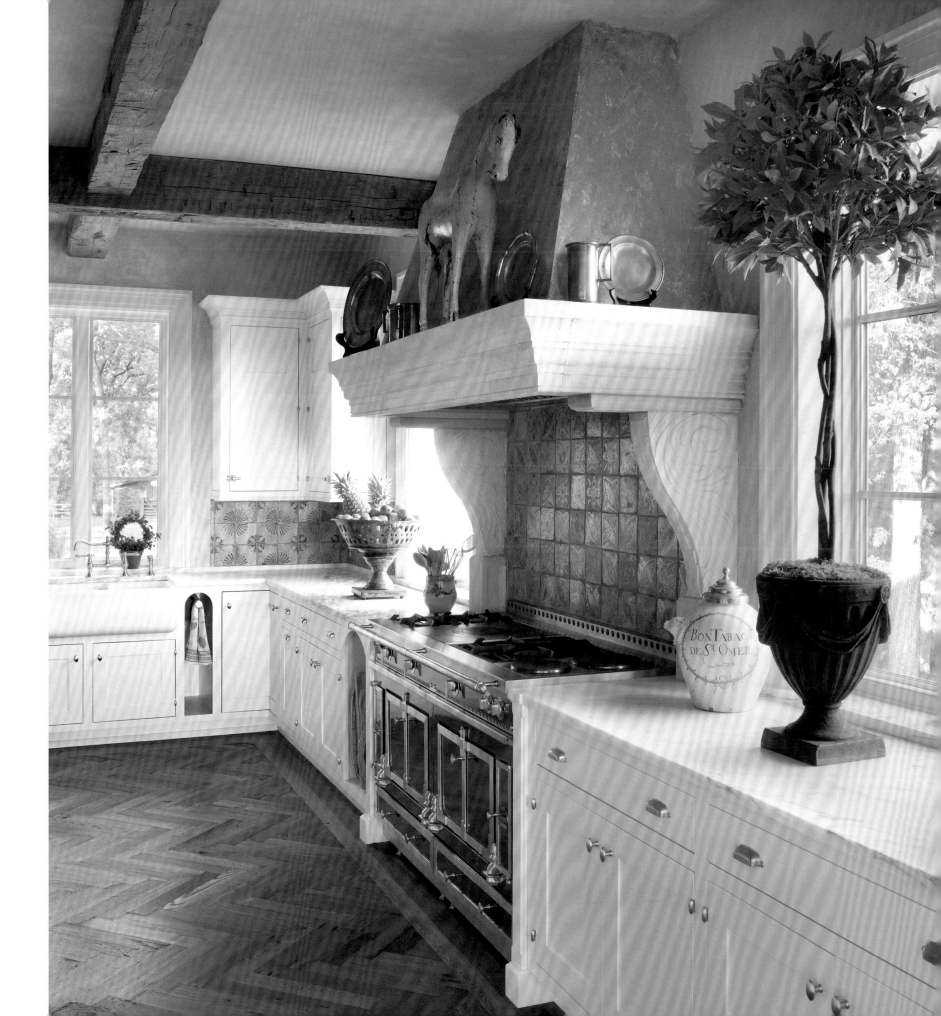

PIED-À-TERRE

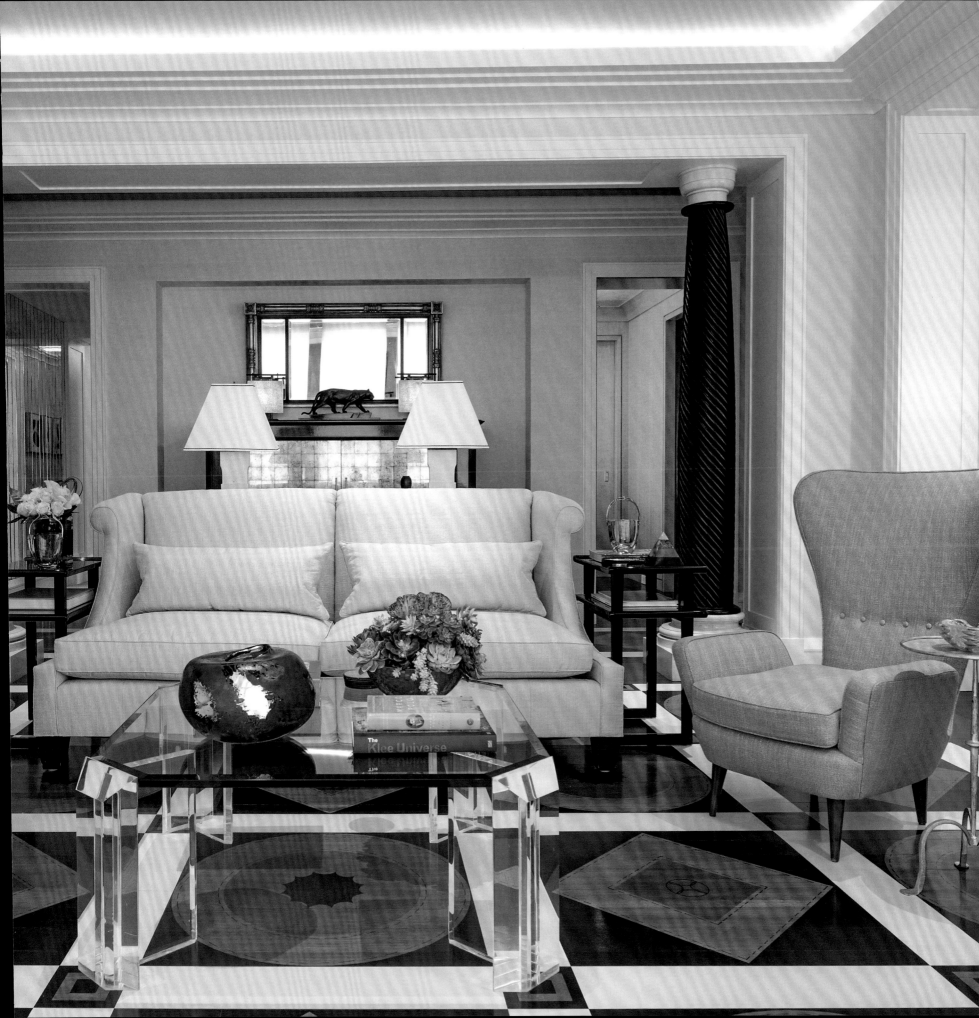

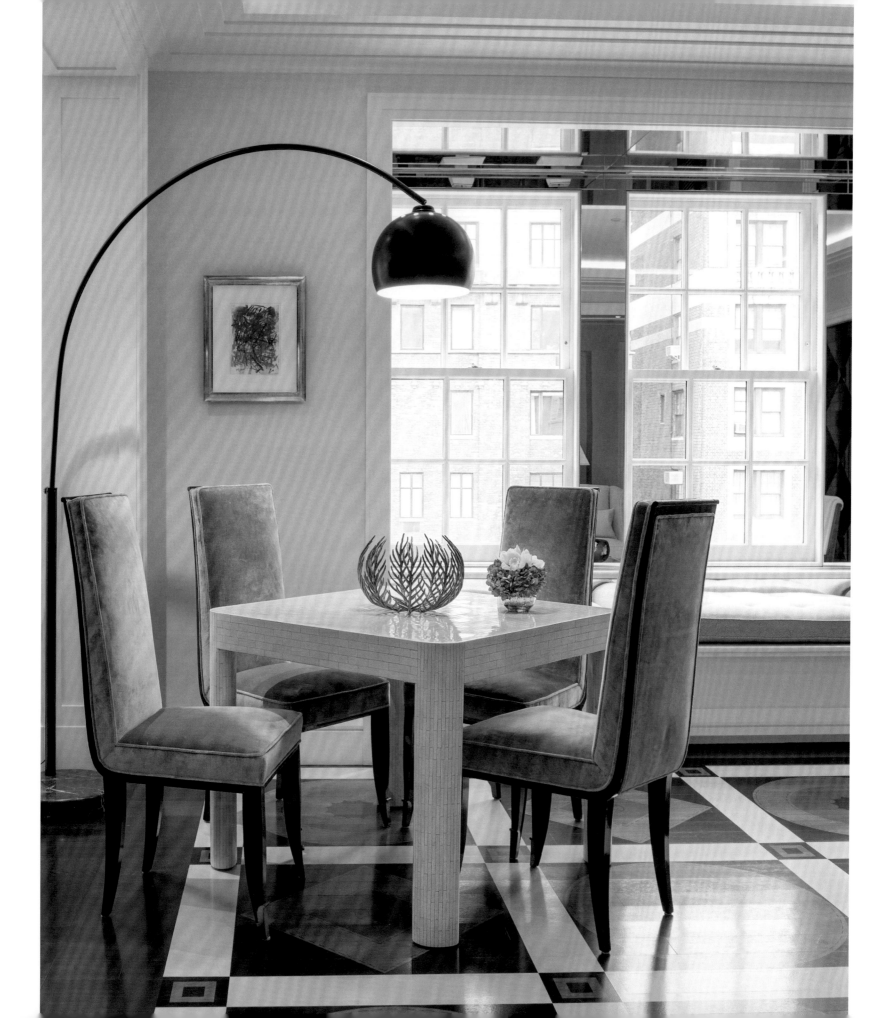

Working with clients you adore is always joyful, so we were ecstatic when a favorite couple called architect Andrew Giambertone and me to say they had decided to undertake a New York City pied-à-terre. The place they had in mind was raw space in a new building just going up on the Upper East Side. Their ideal apartment was sophisticated, glamorous, and light-filled, but also comfortable and functional for the family.

Andy started by designing a floor plan with an expansive living room, dining room, library, kitchen, three bedrooms, and dressing rooms. We kept the architectural details simple but opted for luxurious materials, such as French-polished wenge wood in the library and black marble columns to form an entrance to the living room.

We gave the living room two different personalities, both with a clear purpose. At one end, an elegant sitting area with a boldly stenciled floor by artist Carolina von Humboldt and chic, mid-century furnishings radiates the longed-for drama that inspired the family to create this Manhattan retreat. At the opposite end, we carved out an area for the family to gather together around the TV set on the wall behind a mirror. With a curved sofa on a modern hand-tufted rug, this cozy spot is perfect for watching sporting events and movies.

These clients love the unexpected, which set us free to imagine unusually exciting spaces, including the kitchen. Here, red-lacquer cabinets combine with a stainless-steel cornice, hood, and base. The white glass panels of the backsplash complement white Caesarstone counters. For comfort and contrast, we opted for cork floor tiles.

With curved corners, the master bedroom has a wonderful sense of enveloping embrace. Covering the walls in silver tea paper from Gracie infused the interior with an almost art deco allure and allowed for artist Chuck Fisher to paint in stands of different exotic trees along the panoramic sweep. Mirrored shutters installed at the lower part of the windows allow for privacy. What could be more glamorous?

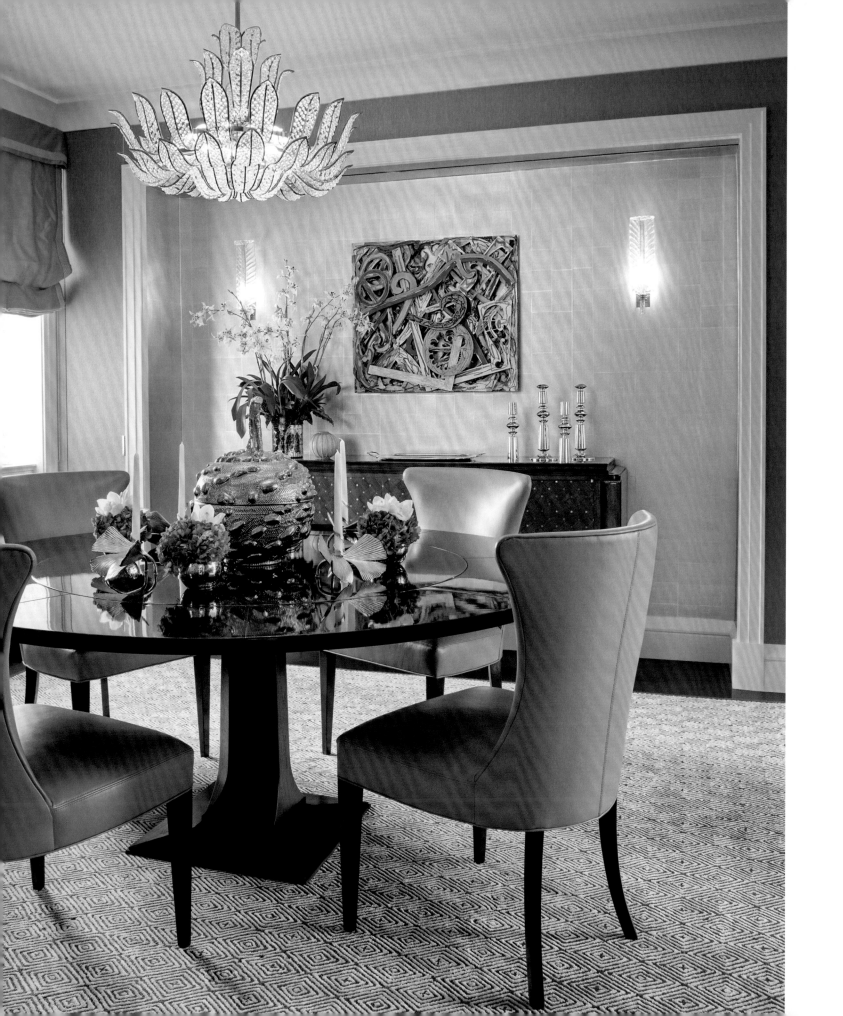

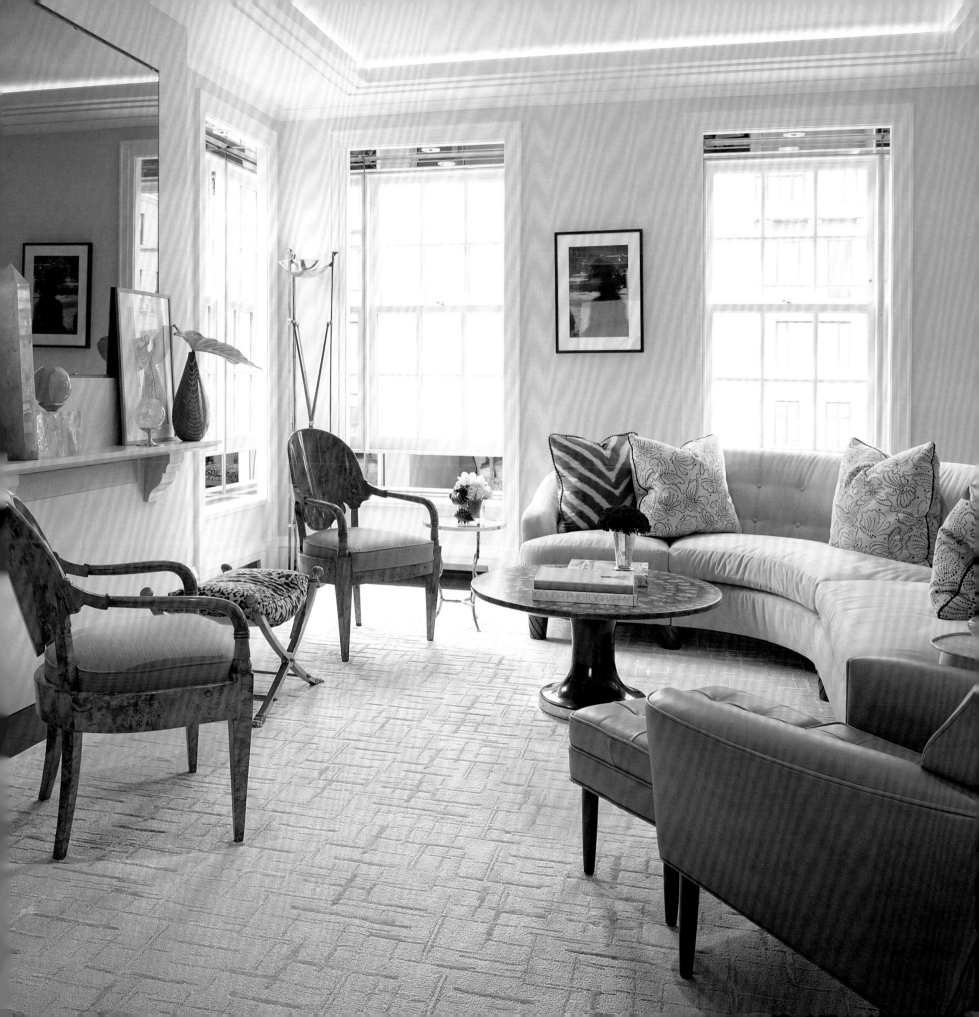

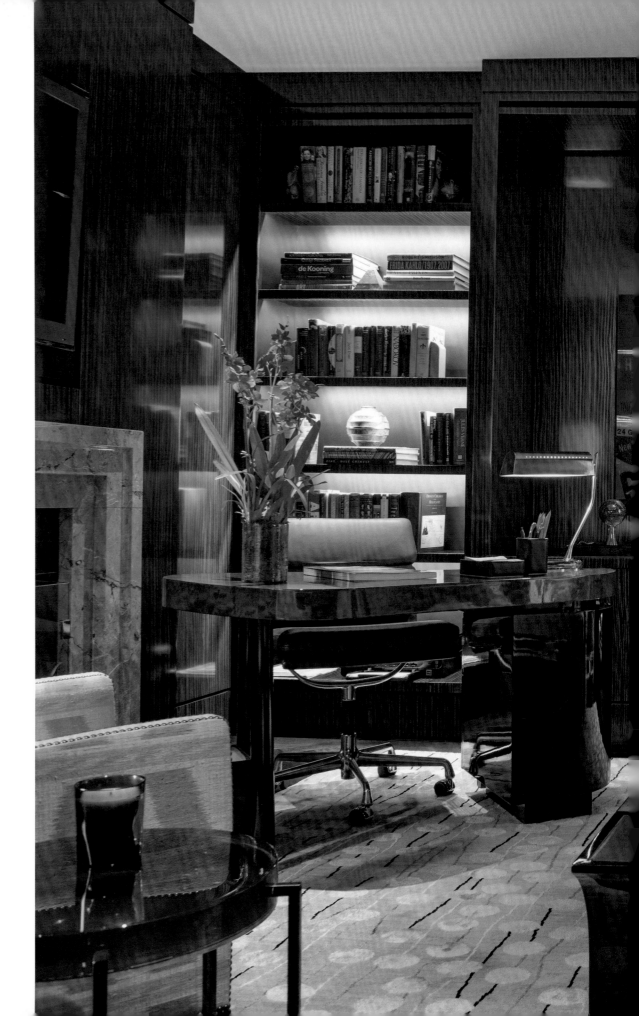

PAGES 102–103: Polished marble columns clearly separate the entrance from the living room, where mid-century chairs float on the dramatic stenciled floor. A Lucite coffee table ensures that the floor is visible from all angles. PAGE 104: Mid-century chairs around a parchment table form just the spot for family games and conversation. Mirrored window reveals reflect light and the city views. PAGE 106: In the dining room, a niche covered in gold paper provides a sparkling background for a Jules Leleu server. PAGE 107: At the other end of the living room, a curved sofa defines a casual, welcoming place for family and friends to gather in front of the TV. RIGHT: With French-polished wenge panels and bookcases, the library is the epitome of quiet luxury.

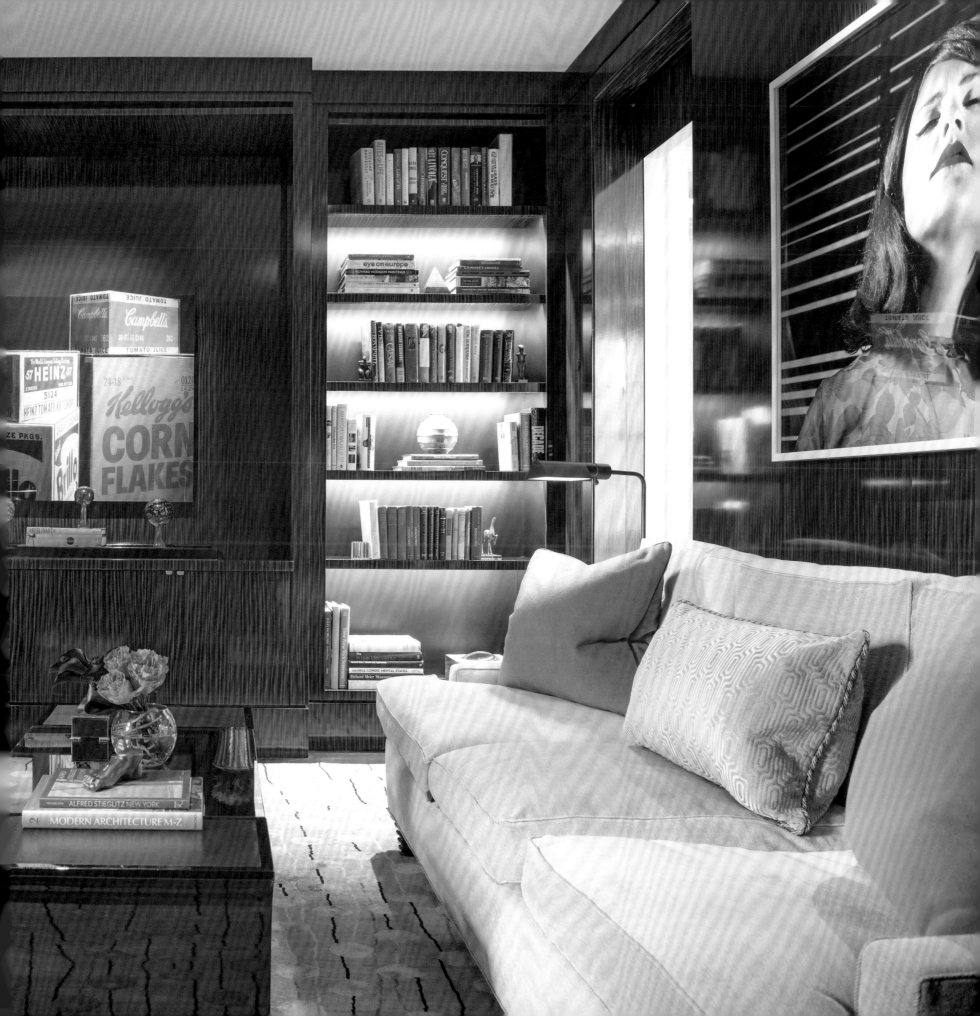

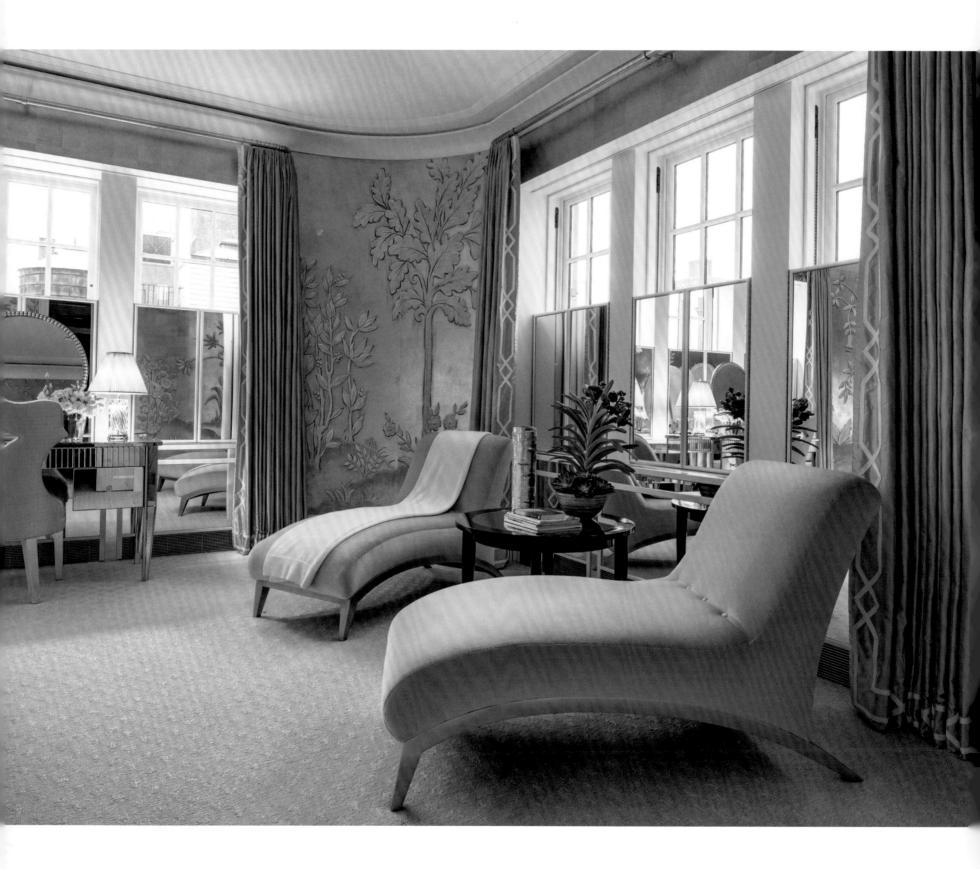

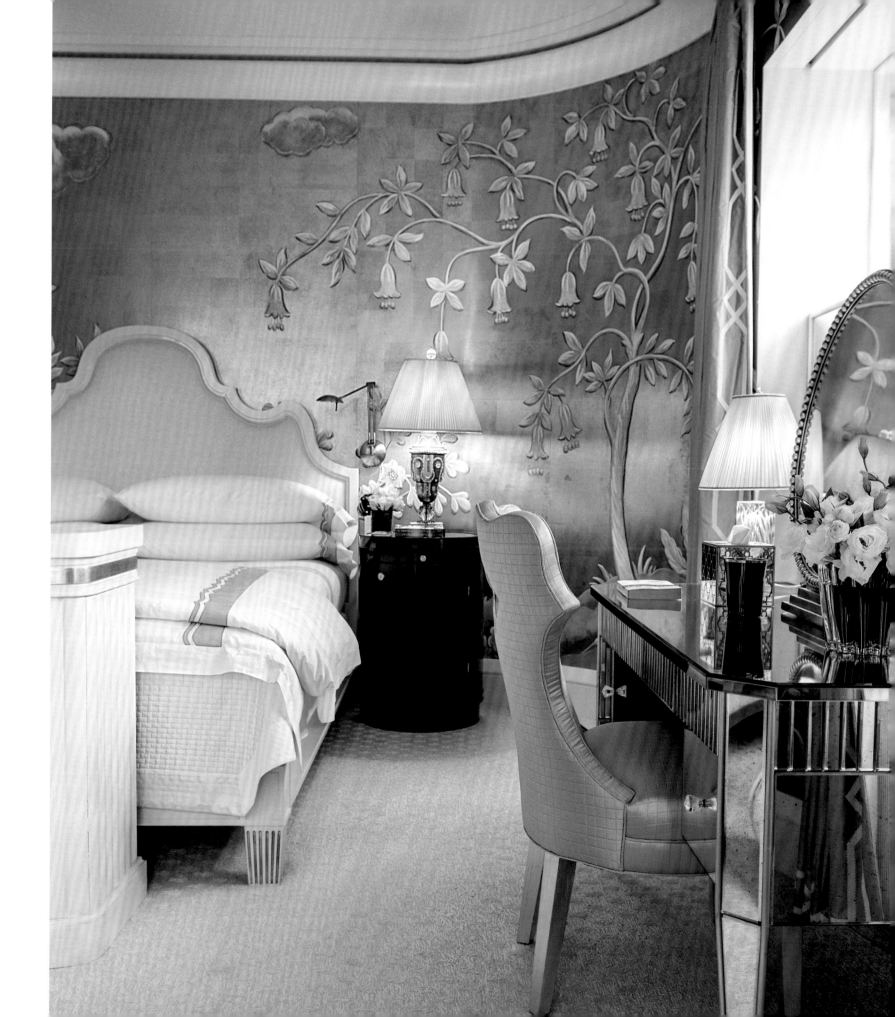

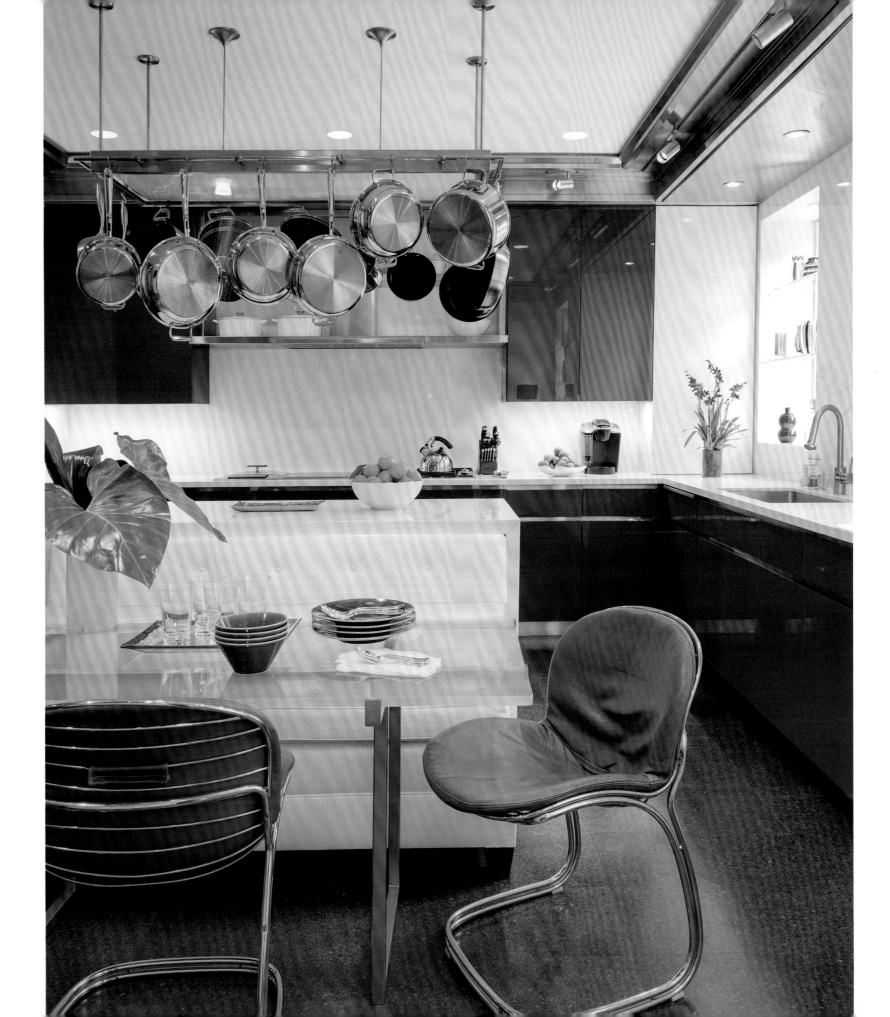

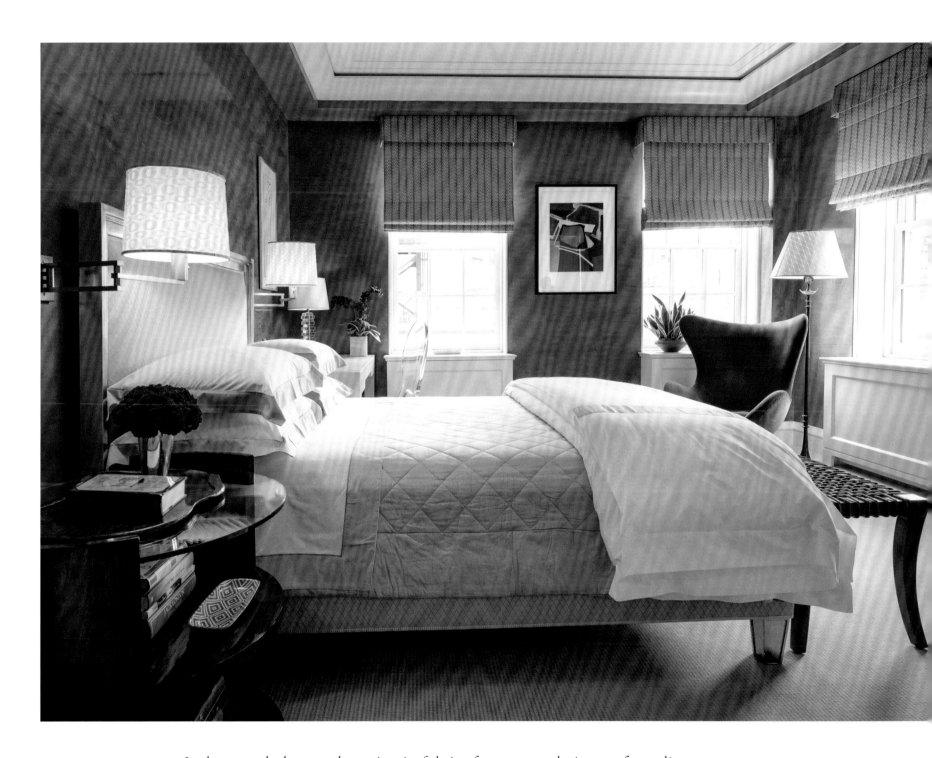

PREVIOUS PAGES, LEFT: In the master bedroom, a dramatic pair of chaises forms a very relaxing spot for reading or conversation. PREVIOUS PAGES, RIGHT: Curved corners gave the artist Chuck Fisher interesting opportunities to paint the exotic trees that forest the silver tea-papered walls. A mirrored vanity in front of a large window also catches and reflects light. OPPOSITE: With red-lacquer cabinets, white counters, stainless-steel accents, and a cork floor, this kitchen has an air of jazzy drama. ABOVE: A bright pink Venetian plaster bathes the daughter's bedroom in a warm, rich glow.

HICKORY HILL

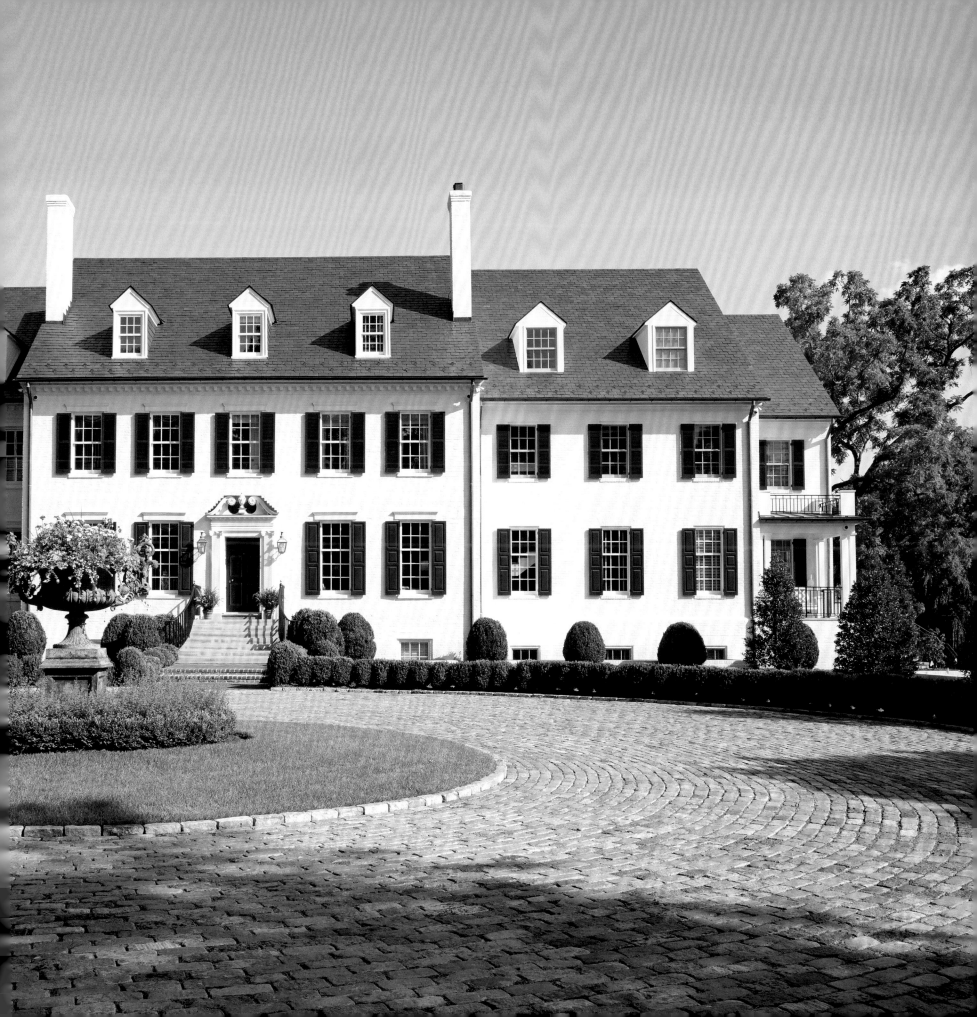

Certain properties need no introduction. Hickory Hill, built just after the Civil War, is one of them. Jack and Jackie Kennedy purchased it in the mid-1950s and sold it to his parents, Joseph and Rose, a year or so later. Not long after, Bobby and Ethel moved in with their eleven children. The home stayed in Kennedy hands until this fantastic young couple acquired it.

The opportunity to work on a famous house is both thrilling and daunting for the designers charged with the task. The owners brought in architect John Milner and me to give Hickory Hill the major renovation it needed. Our decision to add a new wing caused some concern, yet it provided the couple with much-needed living spaces for their young family: a spacious modern kitchen, a family room, more bedrooms, and up-to-date bathrooms, as well as a back stair for the kids to run up and down to the kitchen and family room. We restored the original living and dining rooms and smartened up the original library with lovely wood paneling. To create the gracious entry hall the house lacked, John Milner's firm combined several small rooms and narrow halls to make the space for the graceful, curved staircase leading up to the third floor.

Working with the owners to furnish the house over the two years of construction was a delight. As we developed the floor plans for each room, we chose color schemes and fabrics. We wanted the house to feel like a home, not a museum, so we focused on mixing styles and periods. Shopping all over the country and poring over auction catalogs, we gradually acquired the special pieces that give the rooms their collected sensibility.

With the renovation complete, many people could not figure out where the new wing began, including those who had been sure it would ruin the original. Landscape architect Charles Stick then reworked the property beautifully. Hickory Hill was so lucky to have this visionary couple take ownership. Not all great houses land in such caring, respectful hands.

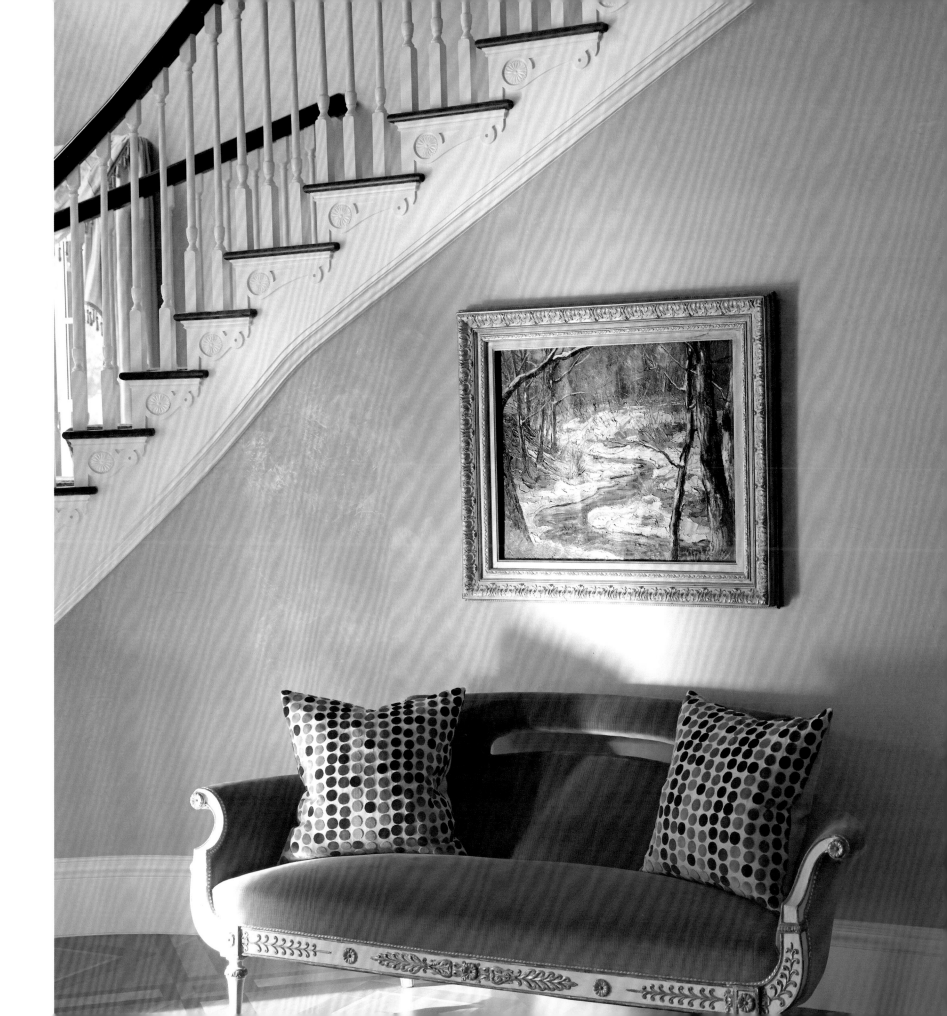

PAGES 114–115: Our planned addition to Hickory Hill made many people uneasy, but with the renovation complete, it's impossible to tell where the new wing begins—and the house is now balanced.

PREVIOUS PAGE: Finished in a clear blue Venetian plaster, the entry hall is so inviting.

THIS PAGE: Stenciling the floor helped bring the sweep of the stair into high relief.

FOLLOWING PAGES, LEFT: Three painted lanterns (one for each floor) hang from chains in the stairwell.

FOLLOWING PAGES, CENTER AND RIGHT: Made to display intaglios, an incredible nineteenth-century Irish table is the entry hall's centerpiece.

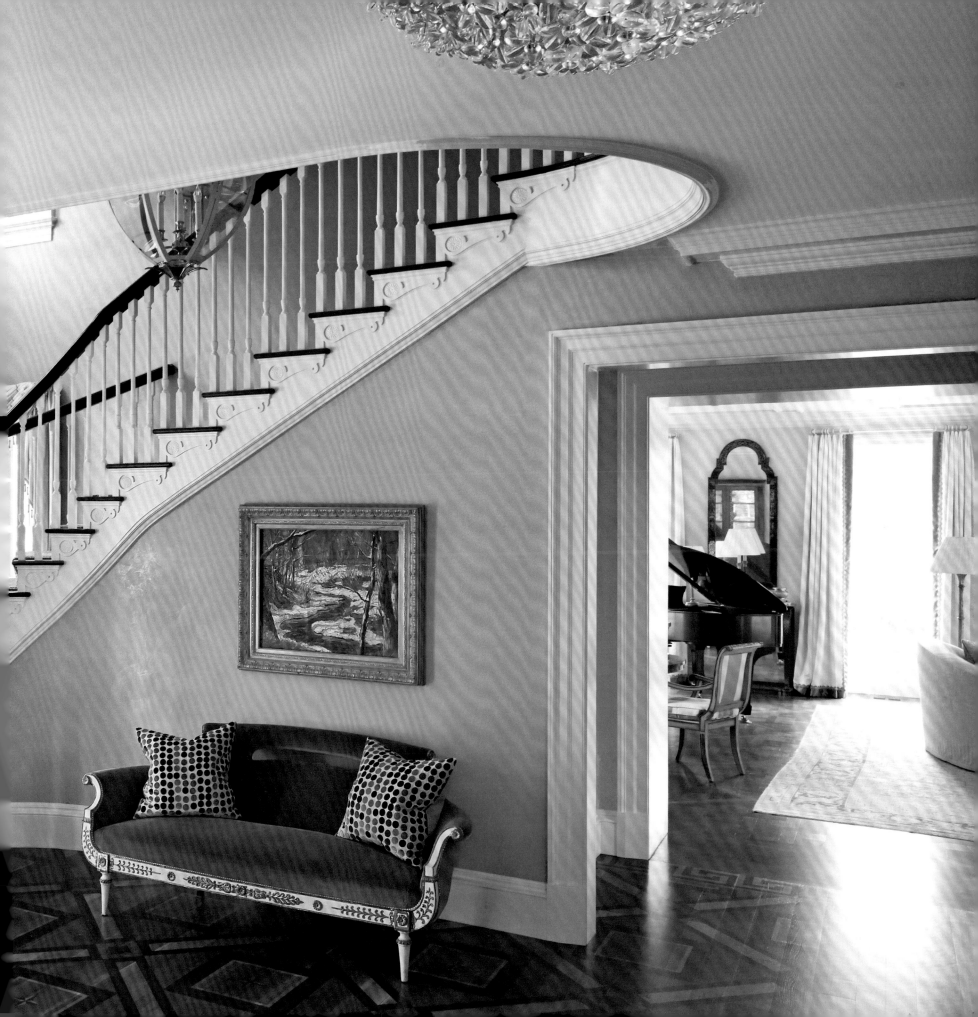

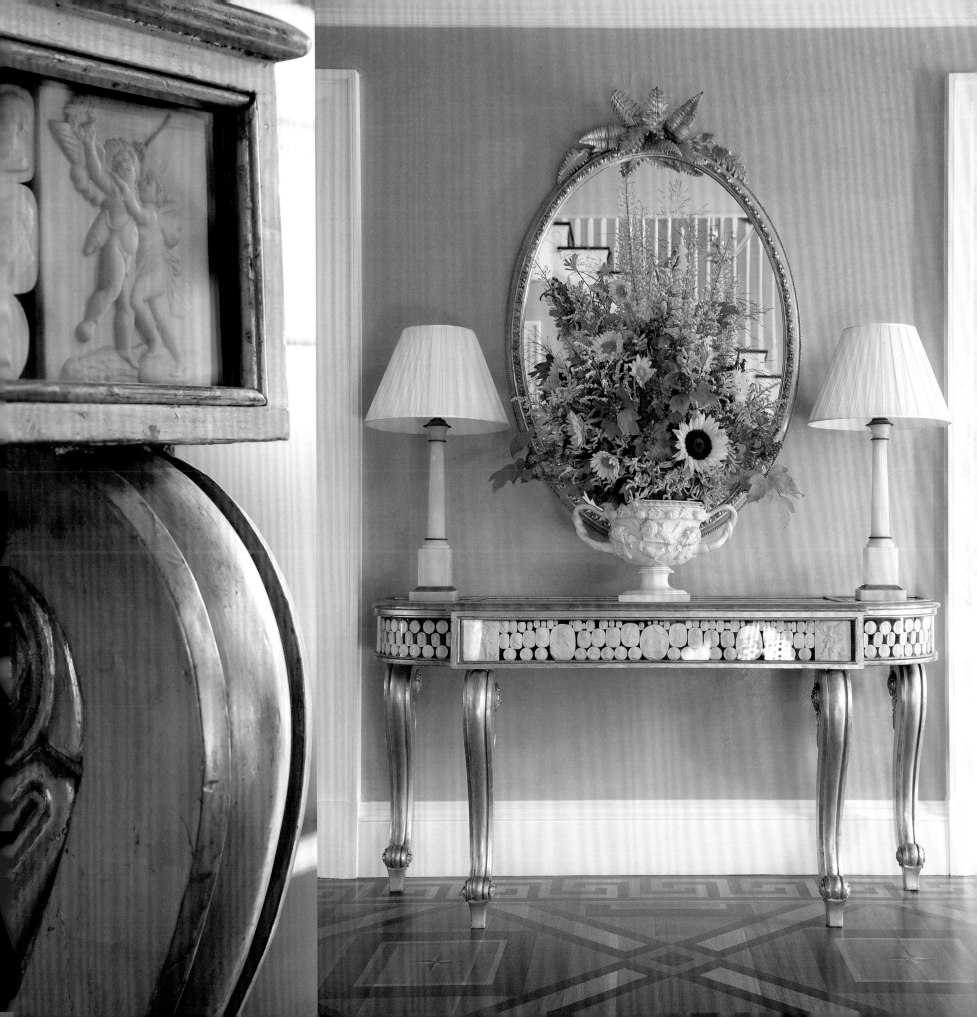

I love mixing furniture of different periods, styles, and finishes. The contrasts make each individual piece stand out and the entire room much more interesting.

To give the large living room a center of gravity and create another conversation area, we floated a pair of generous curved sofas around the fireplace.

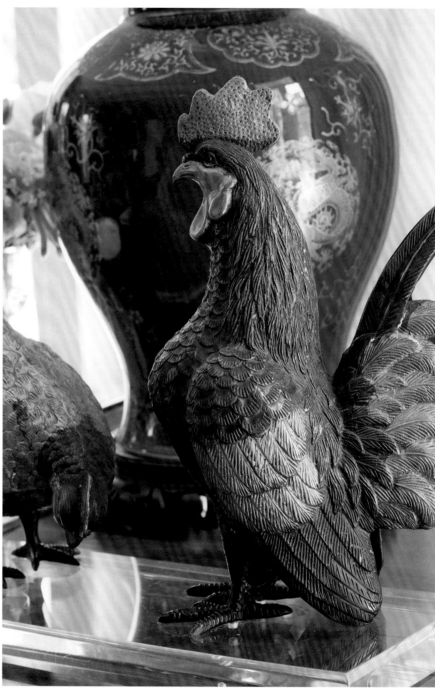

ABOVE, LEFT: In a seating group at one end of the living room, an eighteenth-century sofa faces a scagliola-topped coffee table. ABOVE, RIGHT: One of a pair, this Japanese bronze chicken has such personality. OPPOSITE, LEFT: A grand piano at the room's opposite end is so wonderful for cocktail parties. Italian painted armchairs around an English table form another small seating group. OPPOSITE, RIGHT: The scagliola introduces another layer of color, pattern, and texture. FOLLOWING PAGES: No matter how small, each gesture contributes to the overall character.

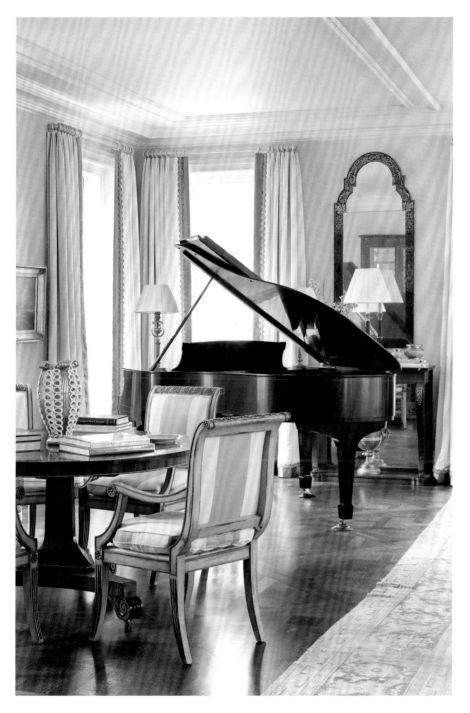

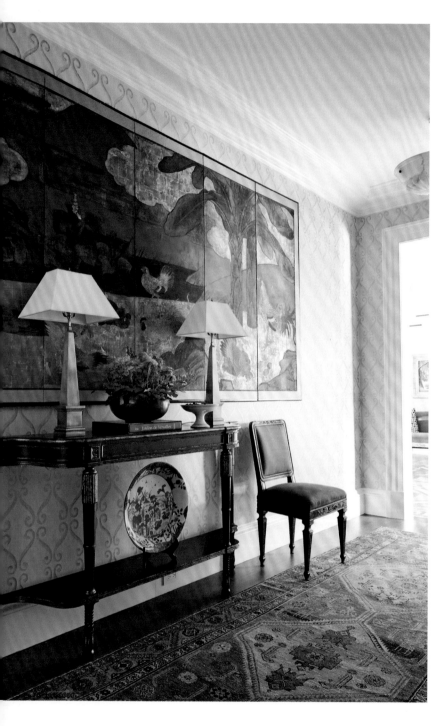

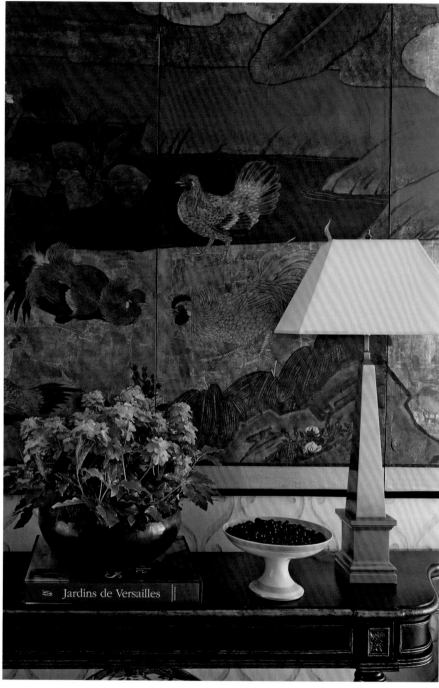

ABOVE, LEFT AND RIGHt: The wall of a long hallway is a perfect place to hang a multipaneled Japanese screen.
OPPOSITE, LEFT: The dining room's blue Gracie wallpaper was a client request. Under a gorgeous chandelier, a set of 1950s
Hollywood Regency chairs pull up to an eighteenth-century table. OPPOSITE, RIGHT: For table settings, we began a collection
of peach-and-white old Paris porcelain. FOLLOWING PAGES, LEFT: Indonesian wood tigers roar under a French painted console
table. A primitive painting hangs above. FOLLOWING PAGES, RIGHT: The family room is part of the new wing.

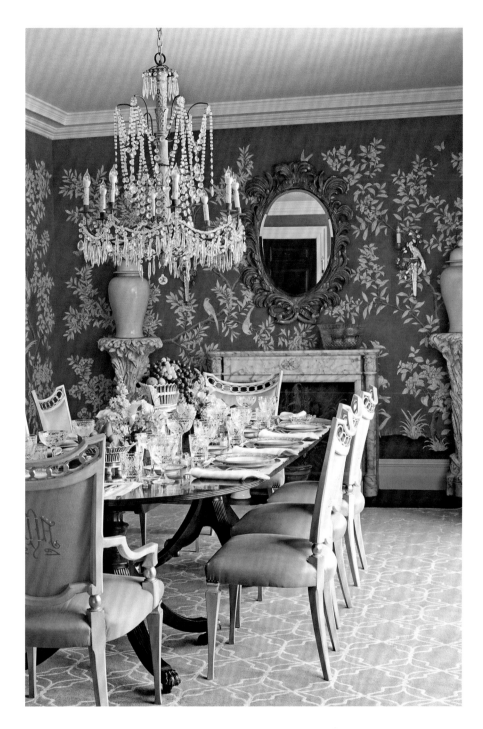

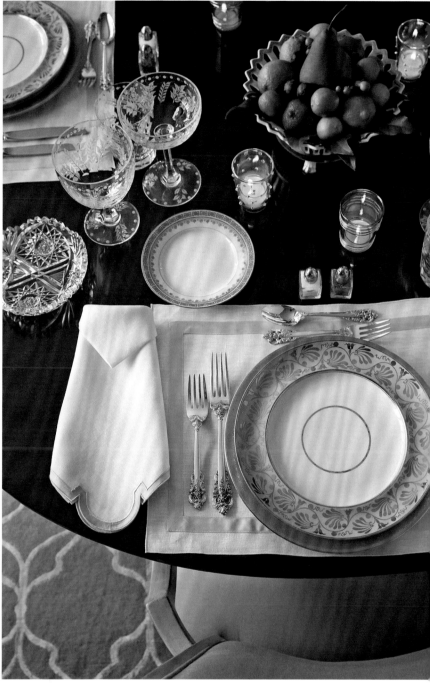

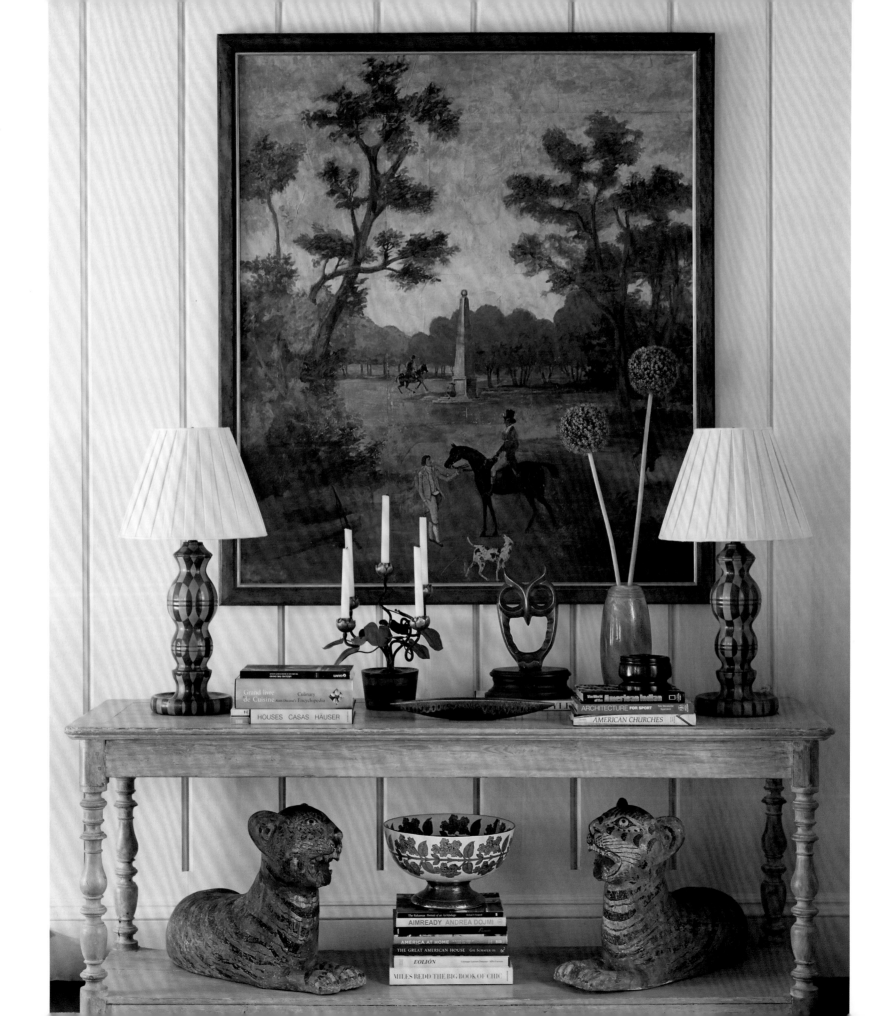

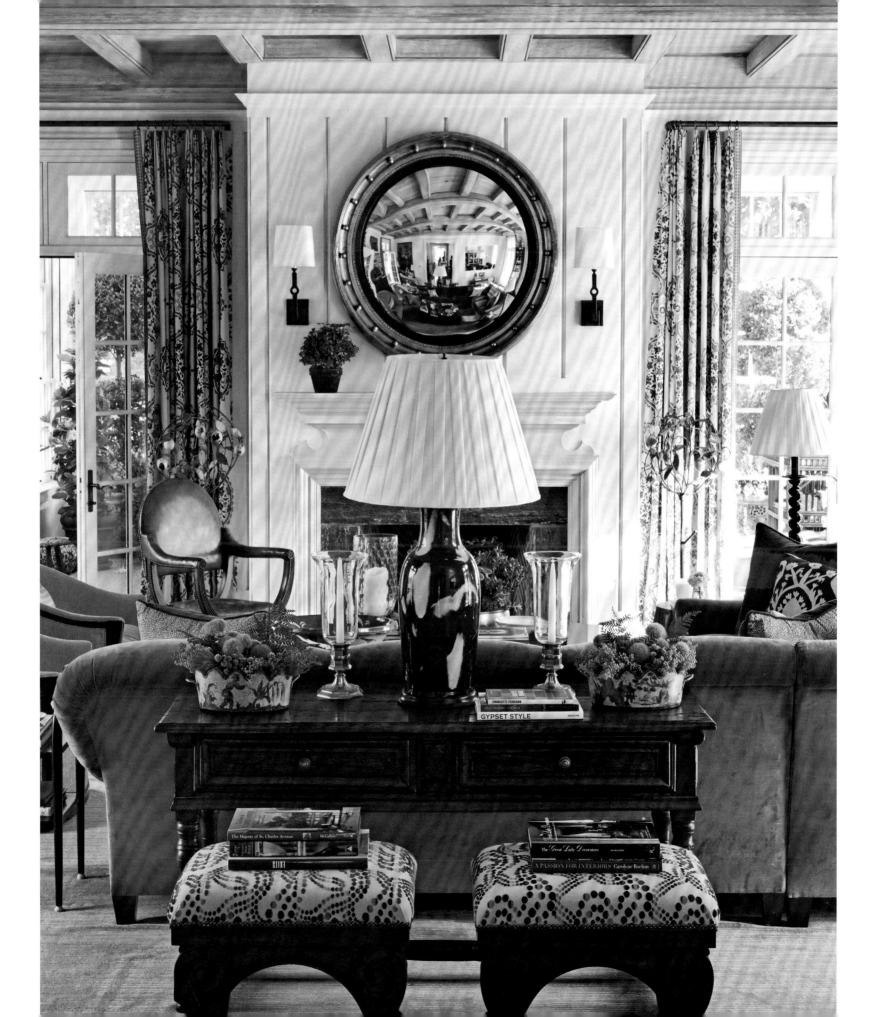

The client gave explicit instructions that we make the L-shaped sofa extra sturdy because it might be used by their children as a trampoline.

RIGHT: With the large, L-shaped sectional sofa and extra pull-up chairs, the family room is a cozy place for the owners to watch TV with their kids or with groups of friends. FOLLOWING PAGES, LEFT: We updated the walls of the original library with new wood paneling. FOLLOWING PAGES, RIGHT: It's the character of things that draws my eye. PAGES 136–137: Triple-hung windows that retreat into panels below change the sunroom into a screened porch furnished with wicker pieces and fabulous plants.

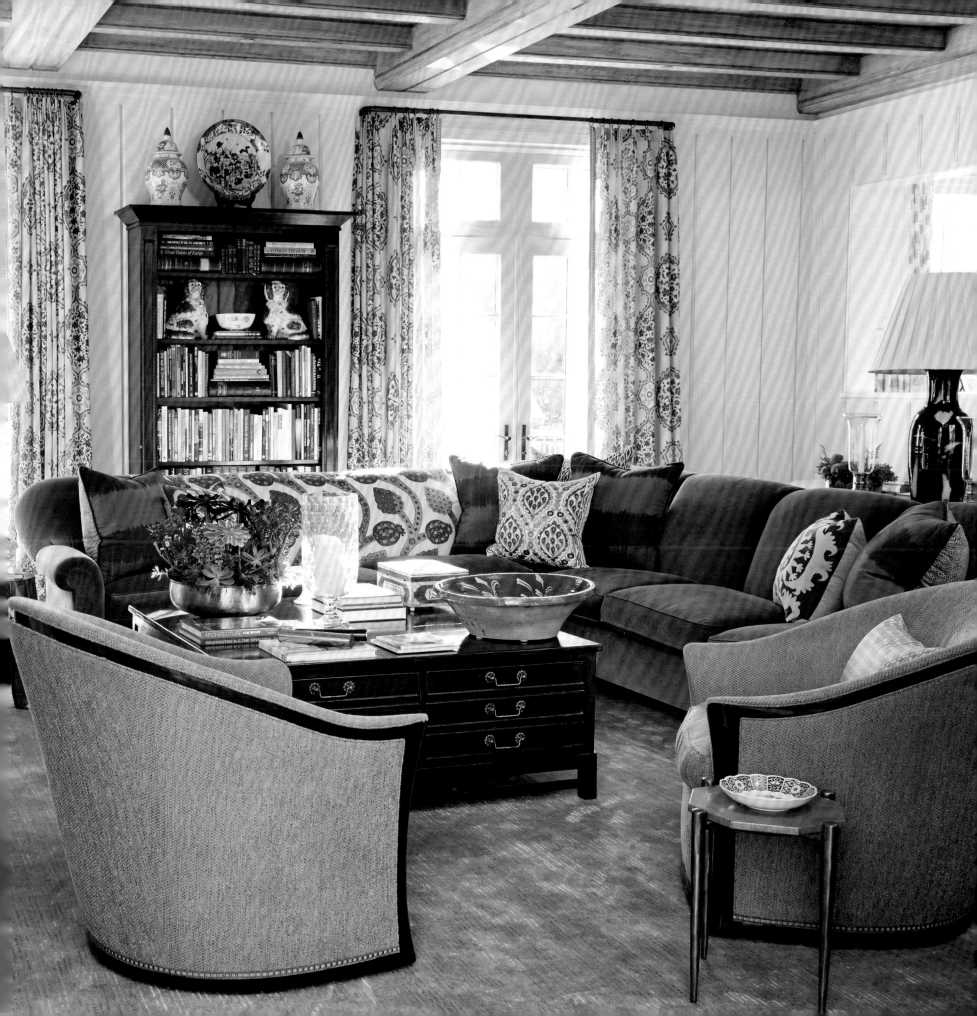

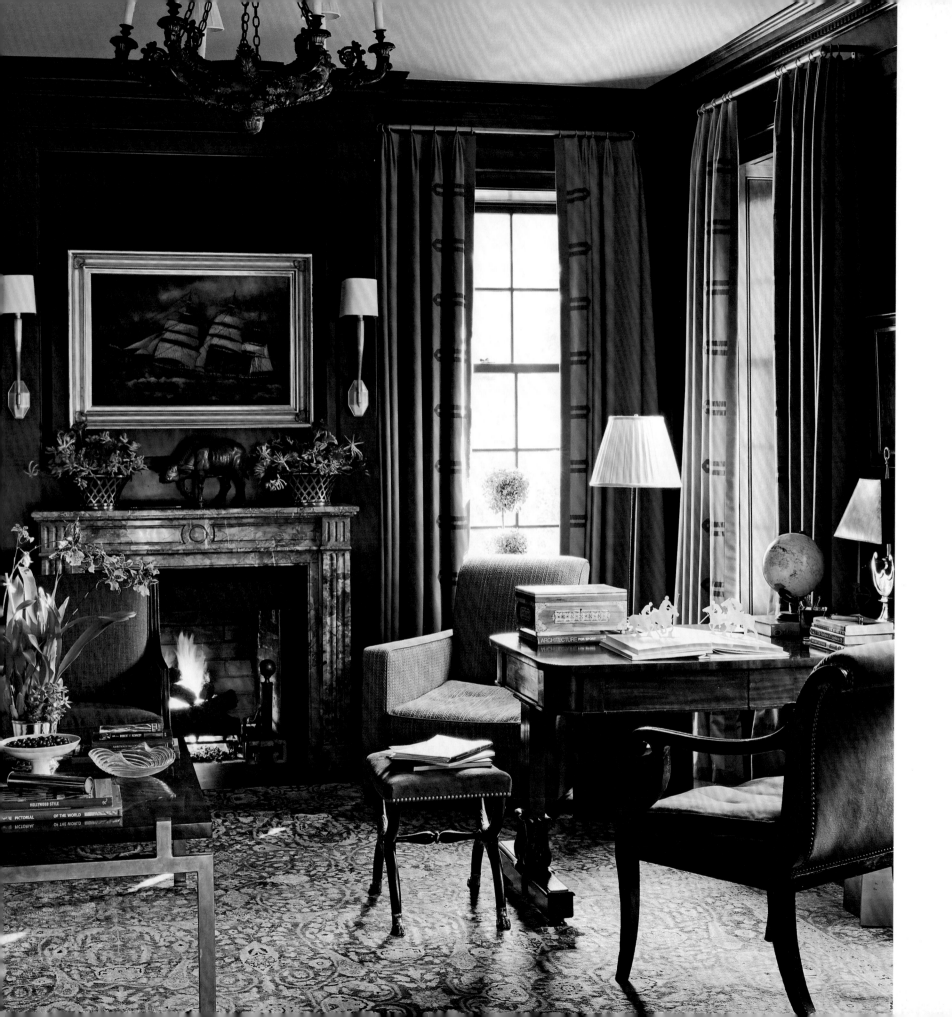

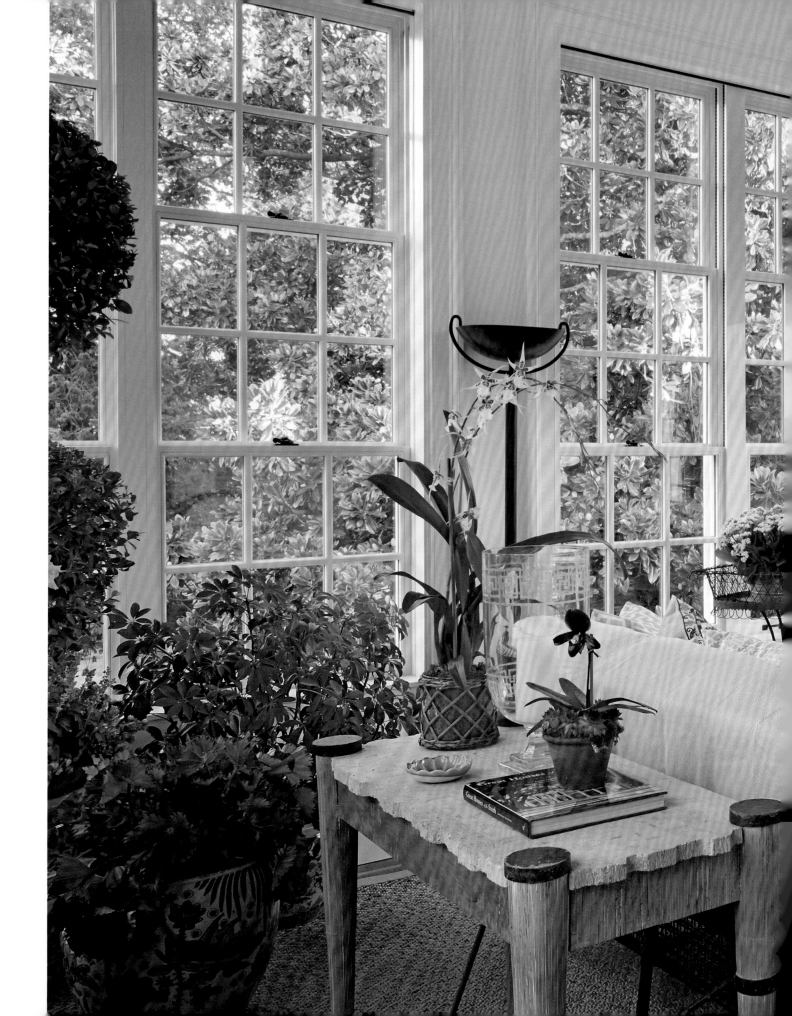

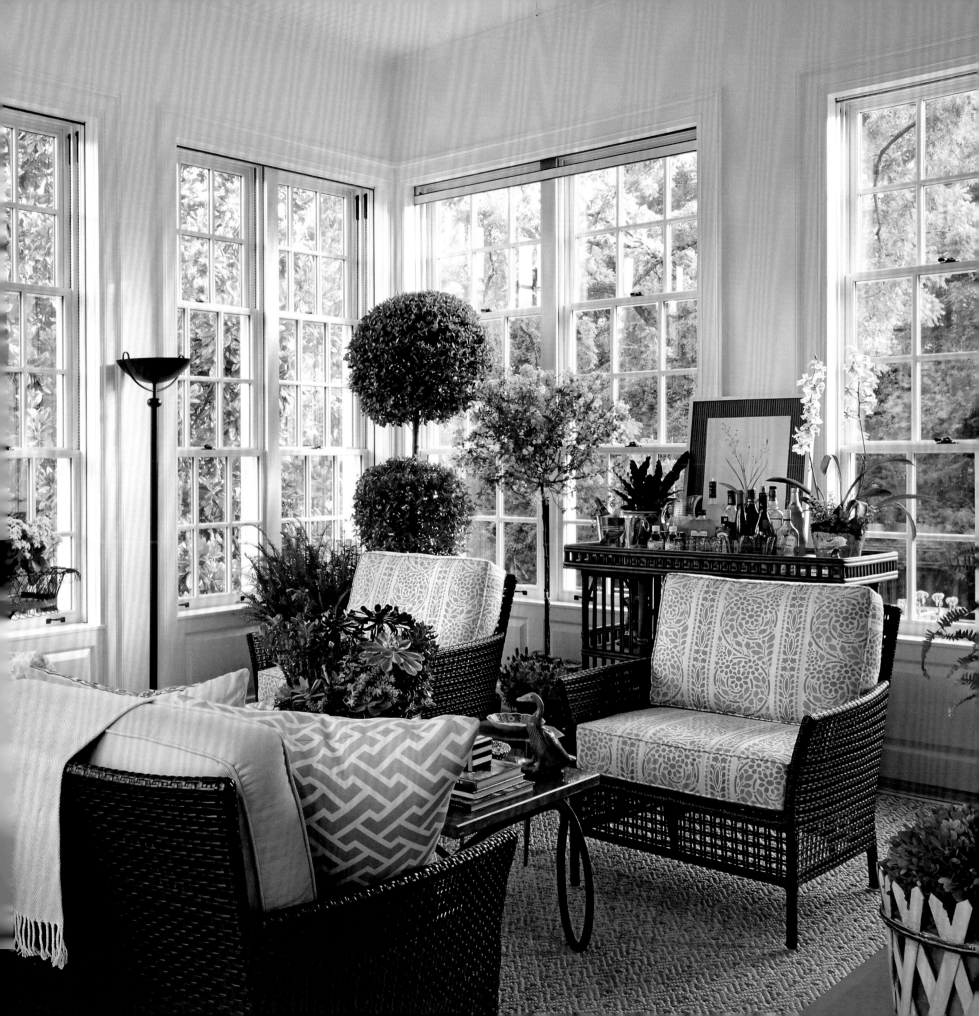

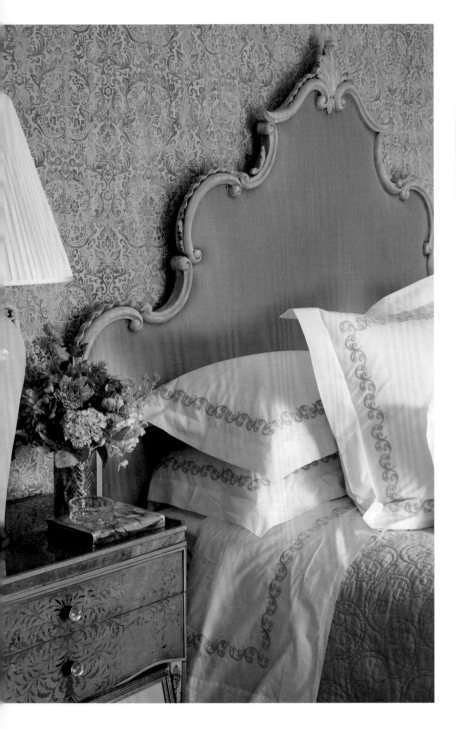

ABOVE, LEFT AND RIGHT: We covered the walls of the master bedroom in a Groves Bros. fabric and upholstered the rococo-shaped headboard in a contrasting solid. OPPOSITE, LEFT AND RIGHT: Slabs of Carrara marble and an exquisite mosaic floor infuse true glamour into the master bathroom.

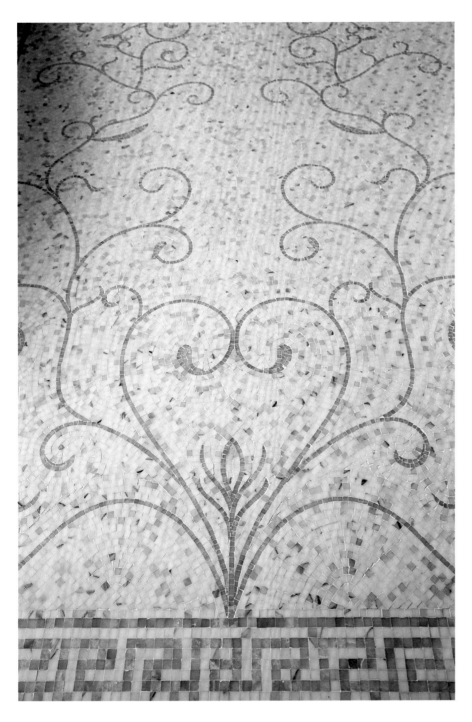

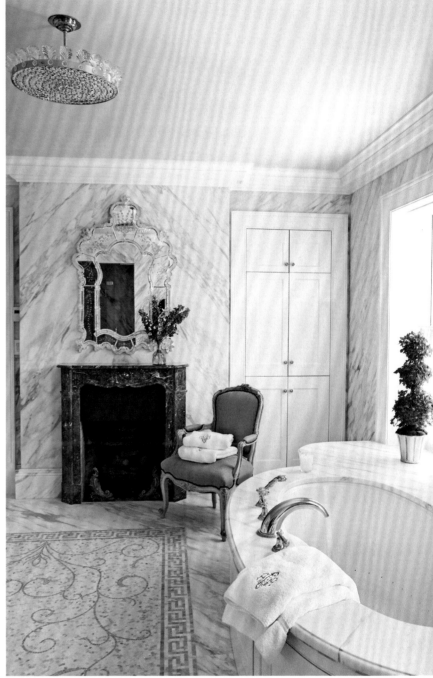

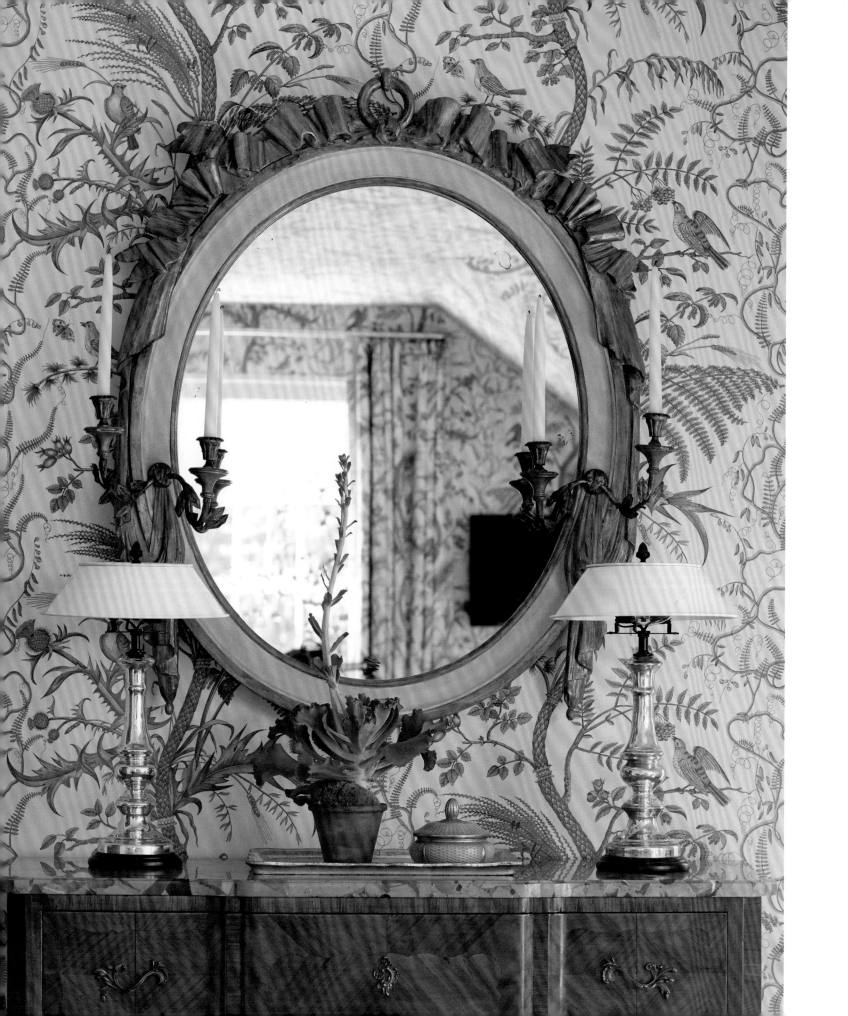

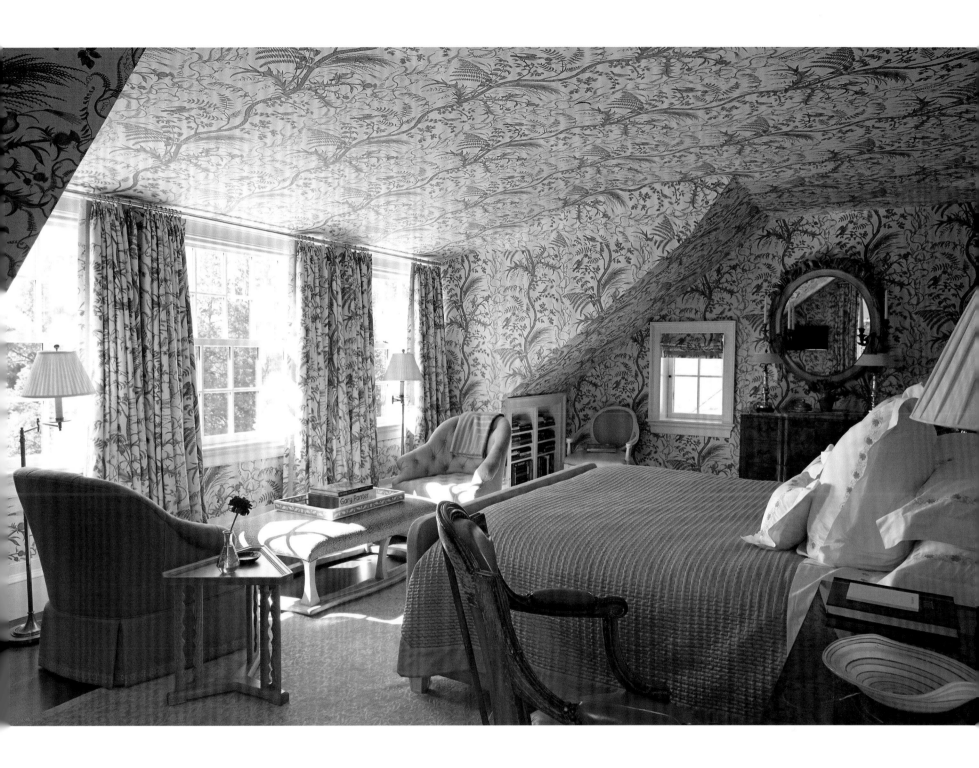

OPPOSITE AND ABOVE: In a third-floor guest bedroom in the eaves, we covered the walls, ceiling, and windows in a classic toile. It almost feels like a garret room in a French chateau.

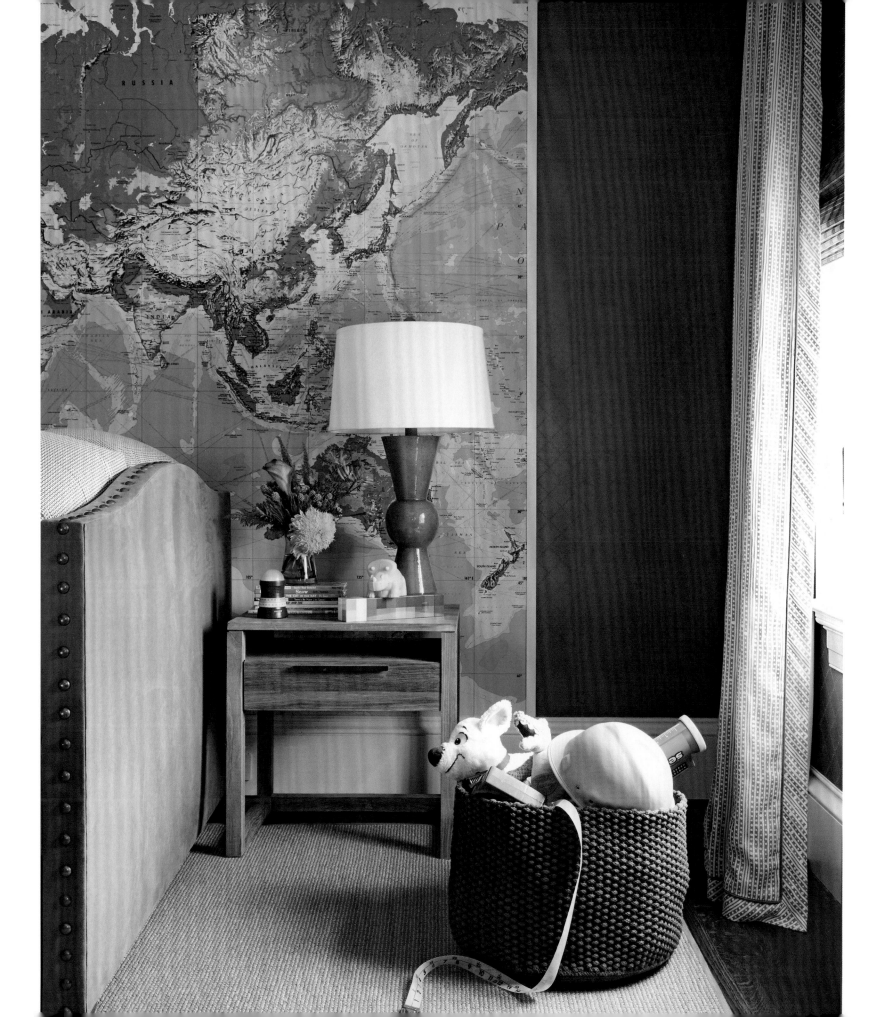

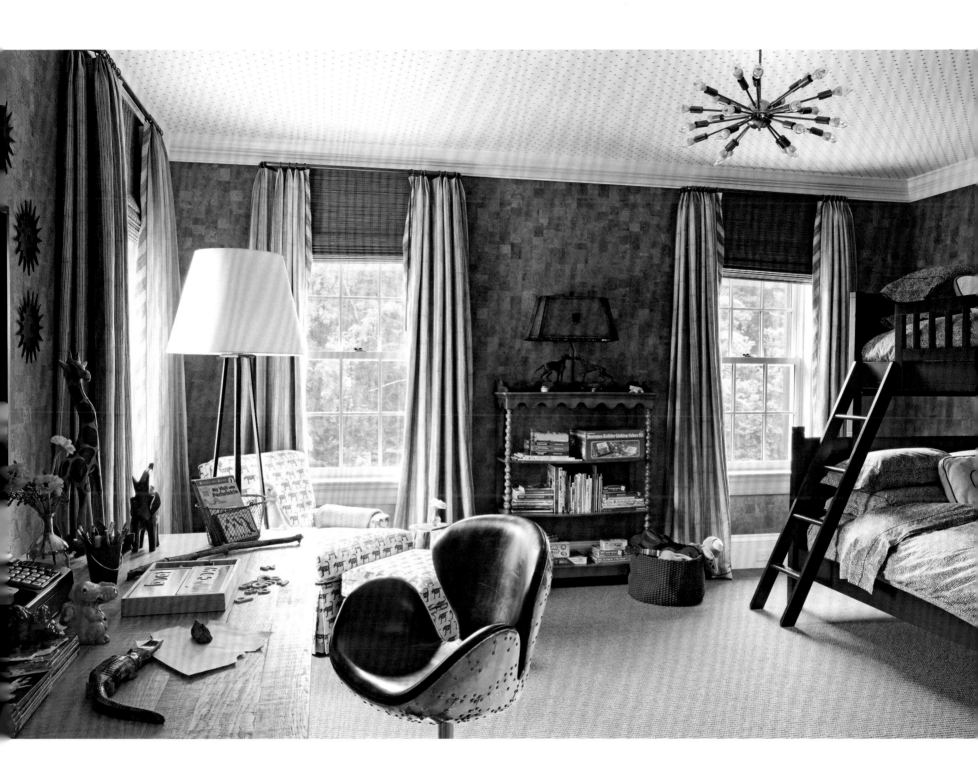

OPPOSITE: In one son's bedroom, a giant map behind the bed encourages a sense of discovery and adventure.
ABOVE: Bunk beds and handsome cork wallcovering in the other son's bedroom are just right for an active, growing boy.

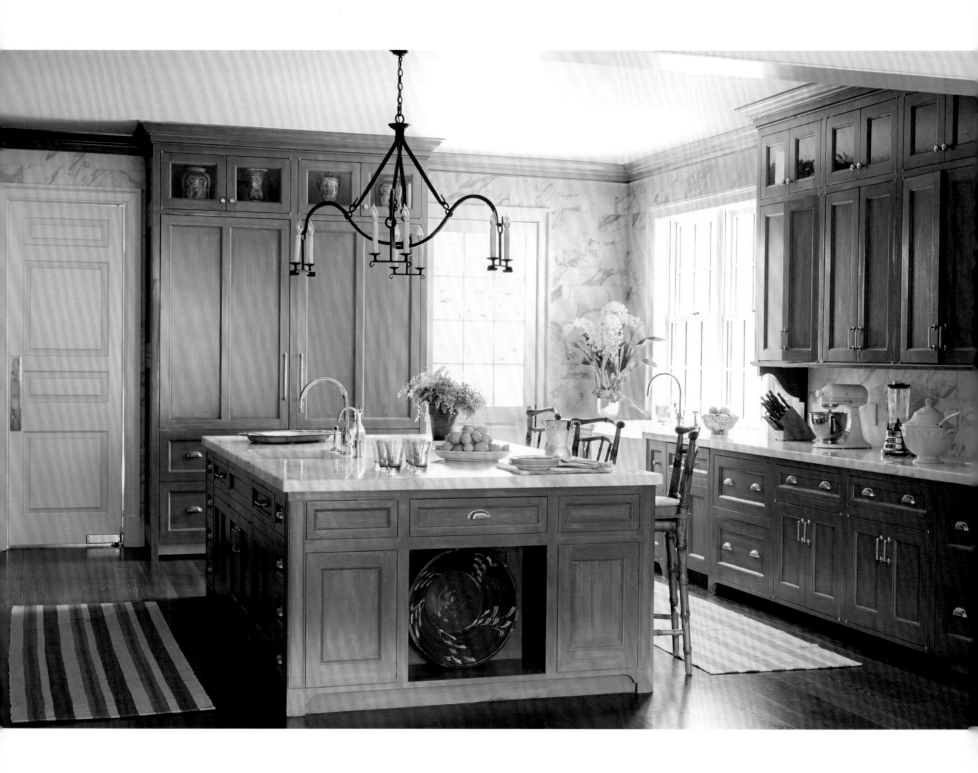

ABOVE: Reclaimed wood floors infuse an atmosphere of age and tradition into the kitchen. We finished the cabinetry in a washed blue inspired by the antique painted French larder. OPPOSITE, LEFT: A small room on the third floor was perfect for a home salon. OPPOSITE, RIGHT: We created a craft studio around red metal cabinets sold in the hardware department at Home Depot. I've always loved them, and I finally found a place to use them.

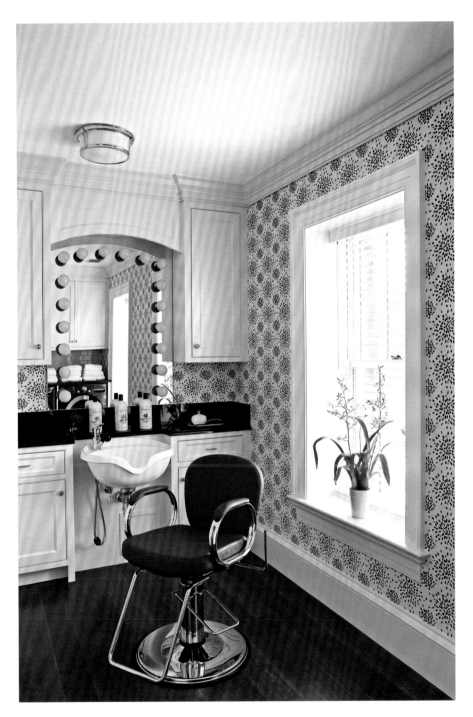

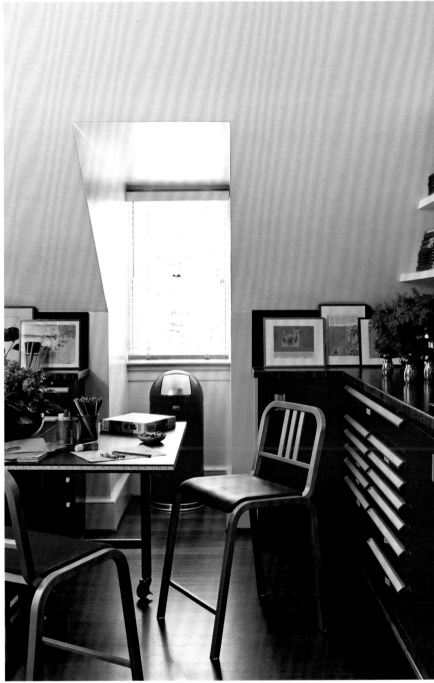

BEHIND
THE HEDGES

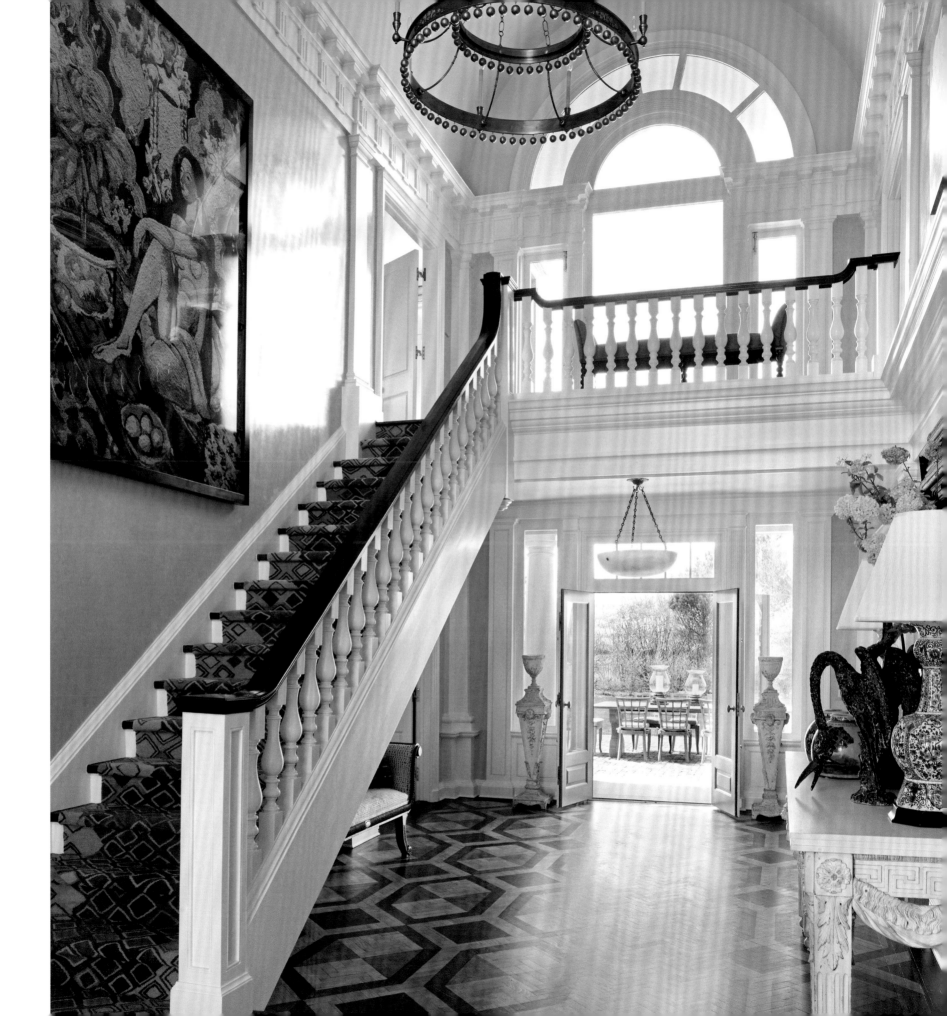

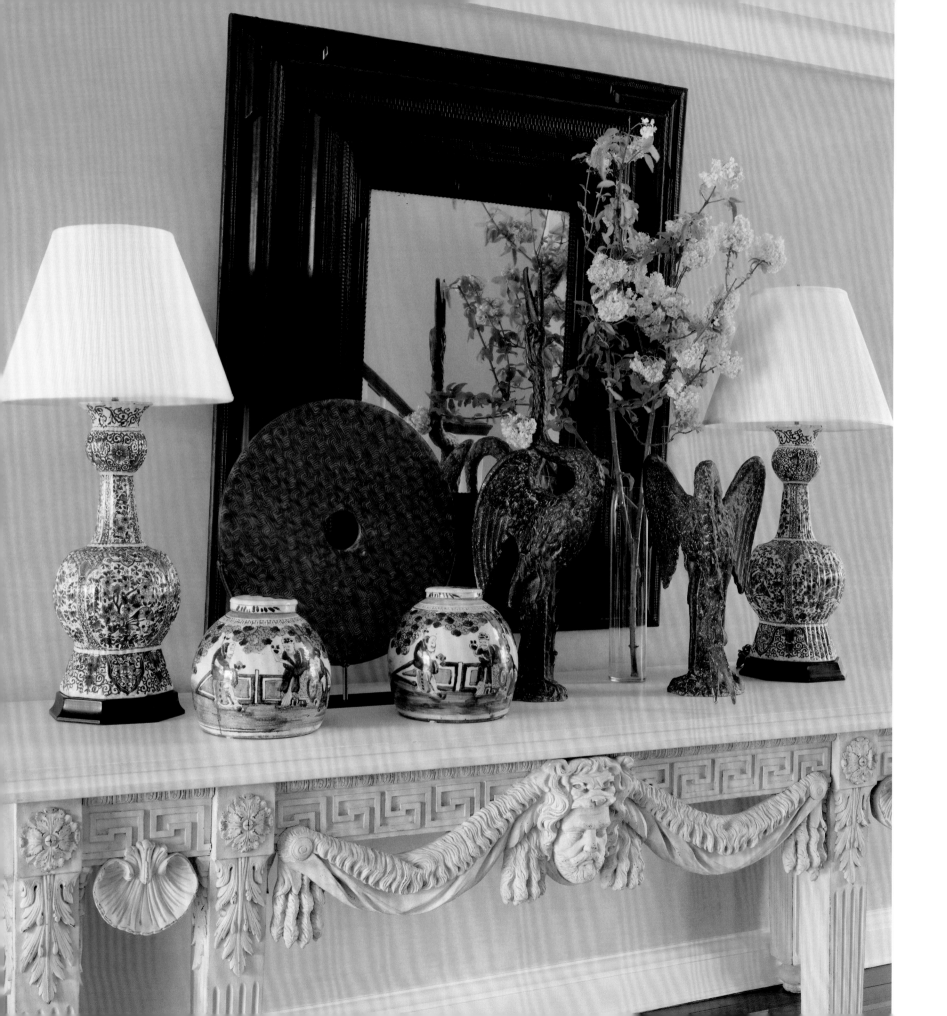

Some clients truly have a sense of daring. When their house is full of interesting opportunities, the project is always a thrill.

The drama here begins at entry with a vaulted, double-height gallery that extends from the front door to the back terrace. To the left is a spacious living room with a fireplace and exposures on three sides. To the right are a cozy, wood-paneled library and a dining room with garden views. From here, the interior opens into a sizable area with the kitchen and breakfast room, as well as access to an adjacent conservatory. Architect Doug Wright worked with me to create an expansive media/TV room off the breakfast room and reenvision all the bathrooms and dressing rooms.

Knowing we needed to collect quantities of furniture, I suggested that we take a shopping trip to Belgium, where over the years I have discovered so many wonderful shops. We journeyed to Brussels for our five-day hunt. These trips are so exciting and, at the same time, so very hard. You drive miles from town to town in search of treasures, stopping in country barns along the way. Each day, with every new discovery, the excitement builds. The quest calls for patience and stamina. Personal bonds develop. The memories of the expedition enrich the experience of living in the house.

As much as I love antiques, I love new technology, also. Clients that are game for a unique decorative adventure spark my creative juices. The dining room's photomurals, which explore the potential of Photoshop, are an example of what I mean. We purchased images of landscapes by the nineteenth-century Romantic artist Hubert Robert from Getty Images. The creative team at Artgroove reworked them on the computer to fit the walls exactly, manipulating the hedges into the room's corners. When we had the final panorama photoprinted and installed, the effect was magical.

I find that mixing exciting contemporary art with antiques and modern furniture creates a room that will stand the test of time.

PAGE 147: Windows on high fill the gallery with light. Bright, melon-colored walls enhance the radiance. The floor's bold stenciling mimics the play of light and shade. PREVIOUS PAGE: The top of the chalk-white English console offers a perfect stage for massing blue-and-white china to greatest effect. RIGHT: The side tables flanking the sofa are treasures from our European shopping trip. A strong, hand-blocked fabric mixed with modern ikats contributes to an inviting seating group.

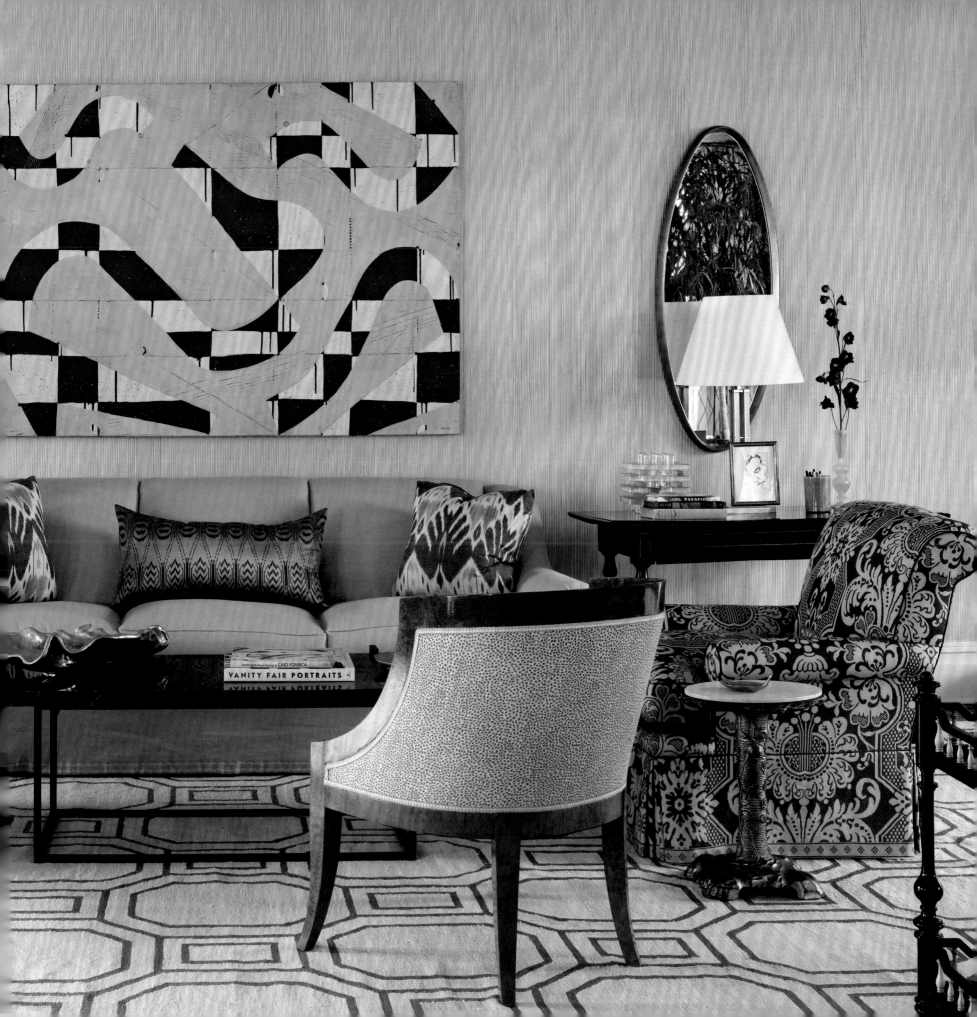

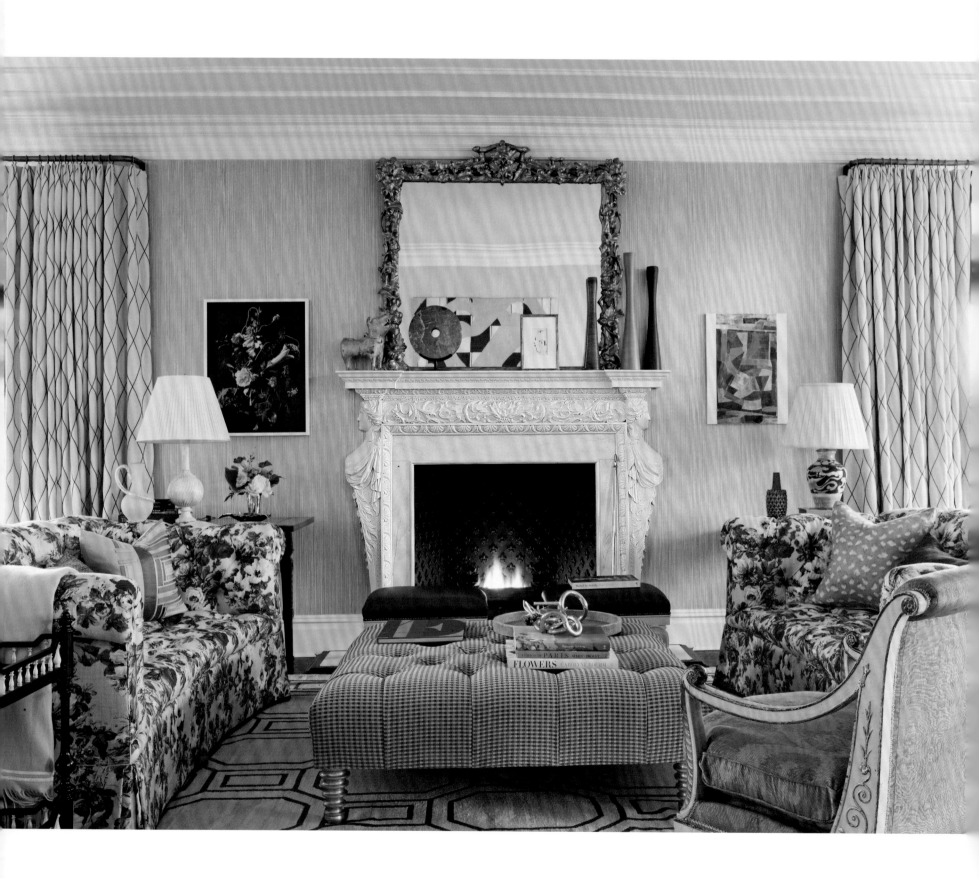

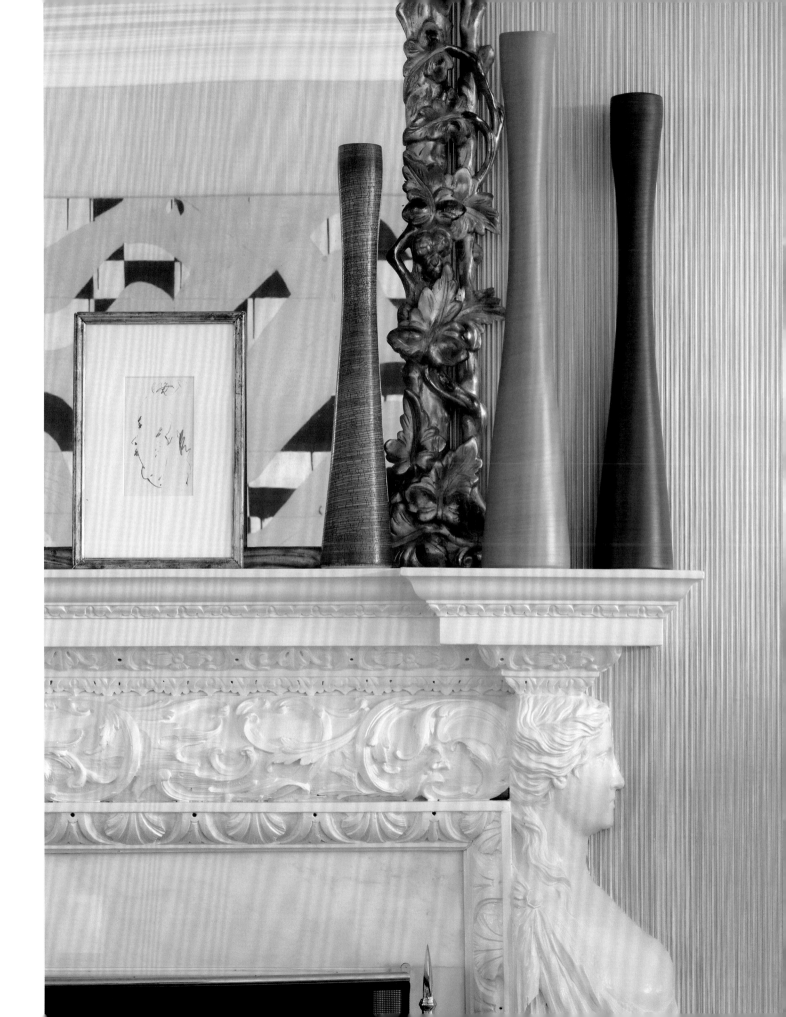

PREVIOUS PAGES, LEFT: Textured, hand-glazed walls and stitched linen curtains form a subtly textured, neutral background for a pair of bright, chintz-covered sofas. PREVIOUS PAGES, RIGHT: Atop an eighteenth-century English mantel, a carved, gilded mirror draws the eye. ABOVE, LEFT: A whimsical mirror over a contemporary work of art inserts a note of quiet humor. ABOVE, RIGHT: A handwoven silk ikat gives a contemporary twist to period Italian chairs. OPPOSITE: In a neutral room, I love using porcelains and fabrics to insert small, balanced doses of a brilliant hue. With a well-stocked drinks tray, the long console table does double duty as a bar.

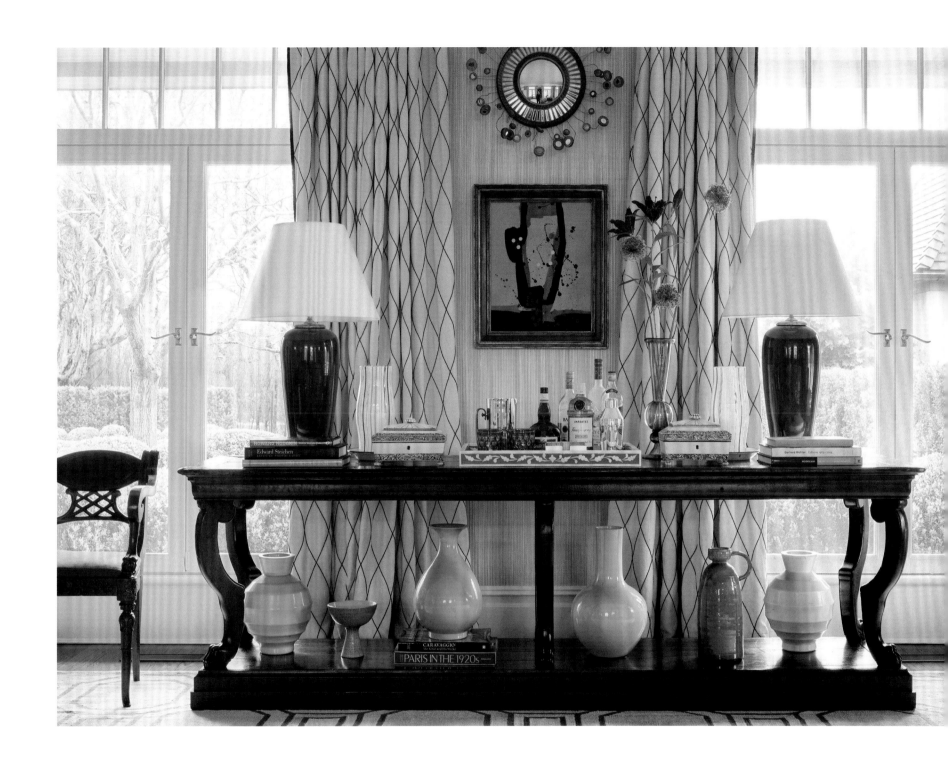

The dining room overlooks the garden. Using today's technology, we brought the outside inside, manipulating images by the eighteenth-century French landscape painter Hubert Robert with Photoshop to create murals that fit the walls perfectly and place the hedges in the room's corners. The dining table, which seats twelve, separates into two square tables.

When friends and family gather to watch TV, it's important to make sure the screen is visible from many different vantage points. Comfortable chairs on swivels are perfect for the purpose.

A Moroccan rug helps to create a cozy feeling in this brilliantly lacquered room. It also provides a fabulously neutral background for various antique textiles as well as the printed fabric from Robert Kime that we used for the curtains.

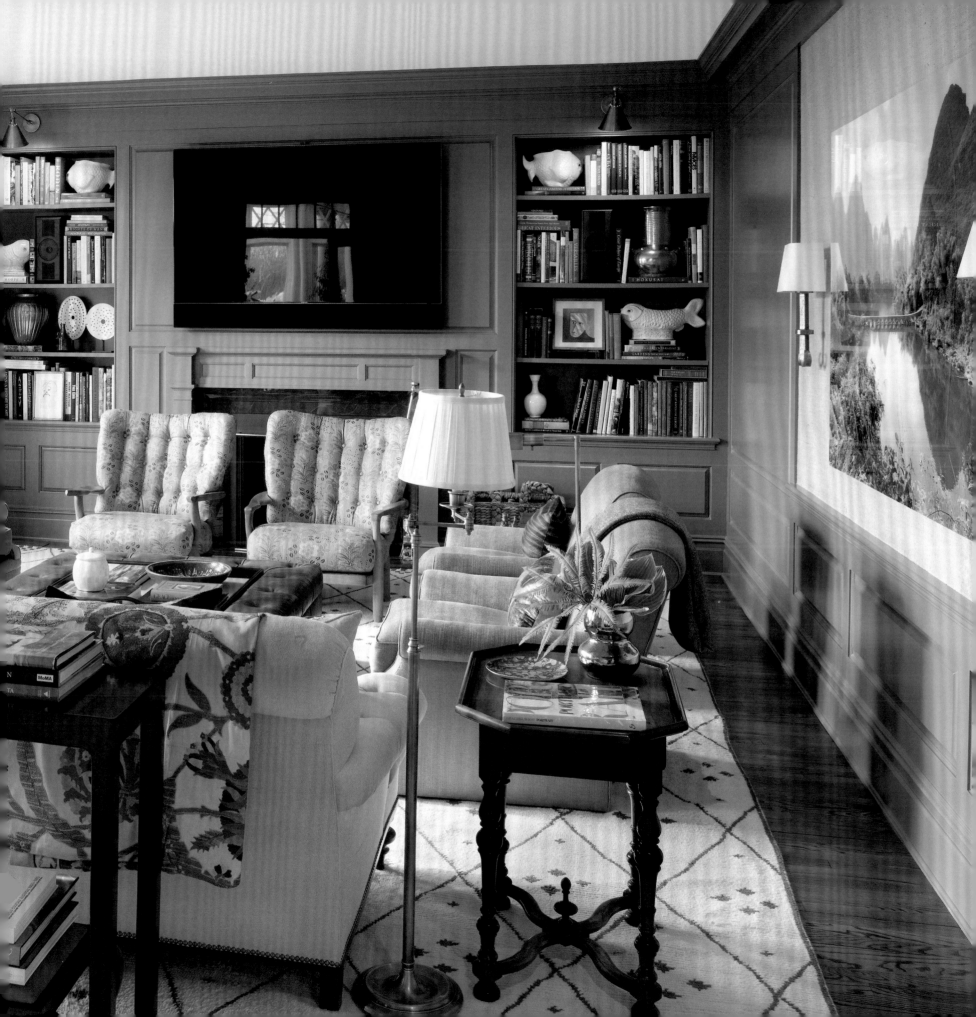

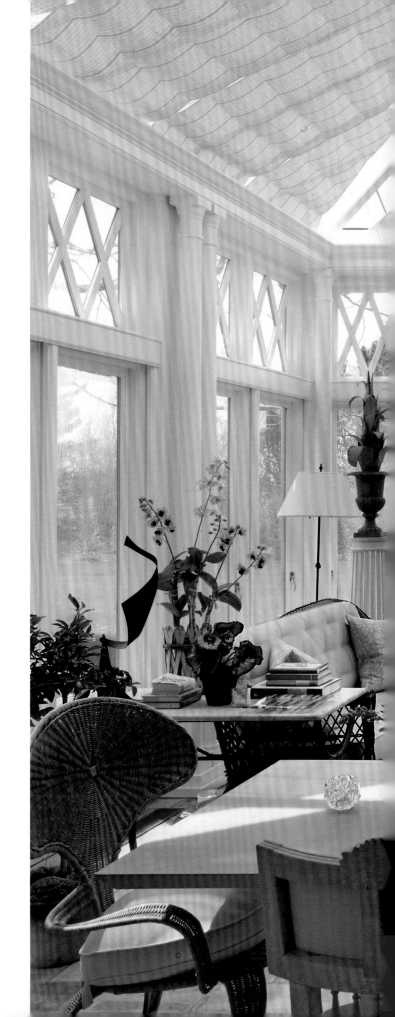

Solariums are always one of a home's more popular rooms, especially in winter. Flooded with sun and filled with plants, they feel like a garden no matter the season.

The family loves to use this room all year around, so we've designed it for multiple functions with a large stone table and painted Italian chairs for casual meals and antique wicker recycled for lounging and conversation.

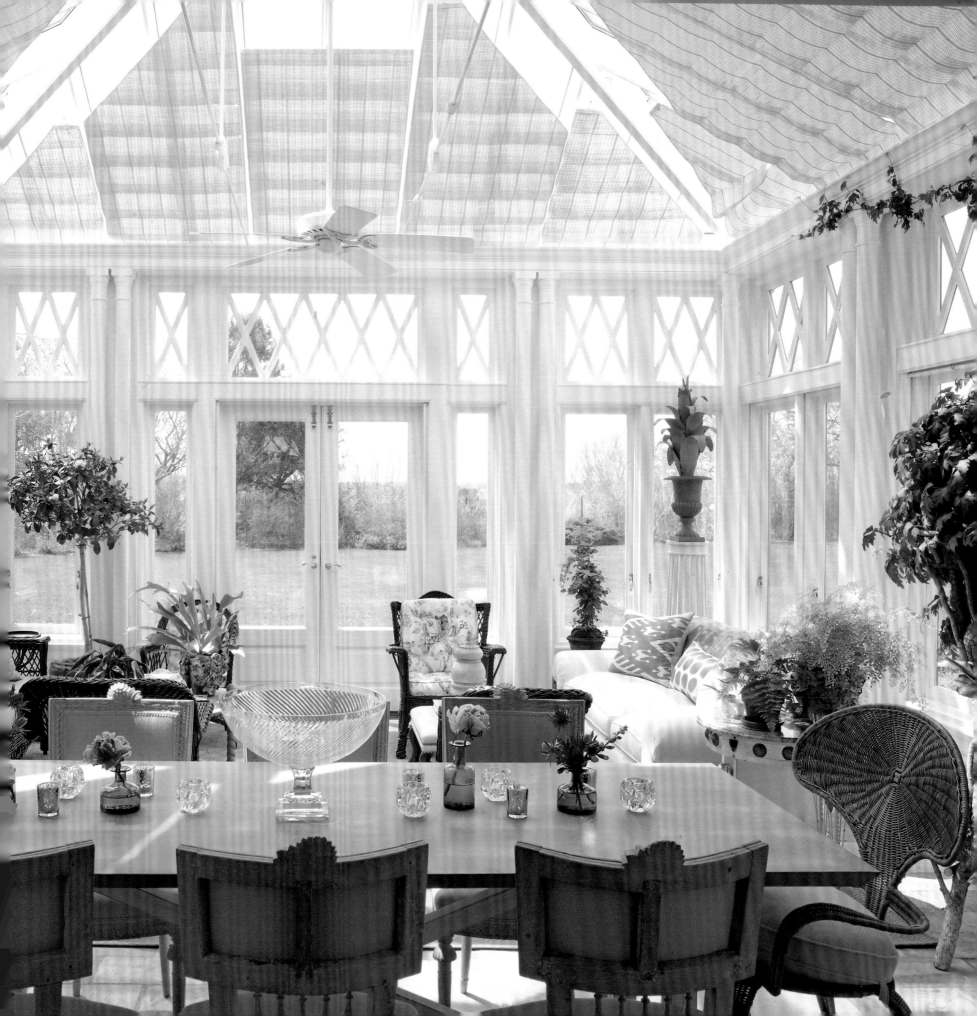

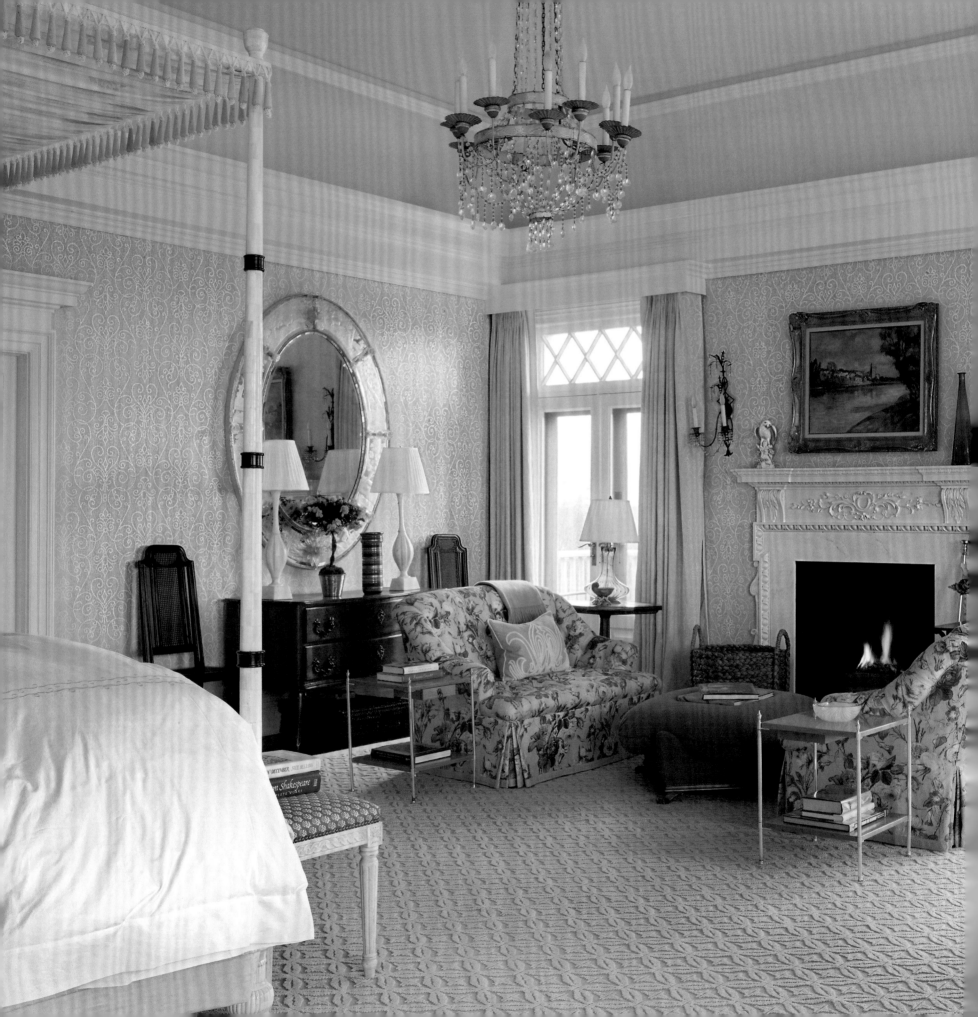

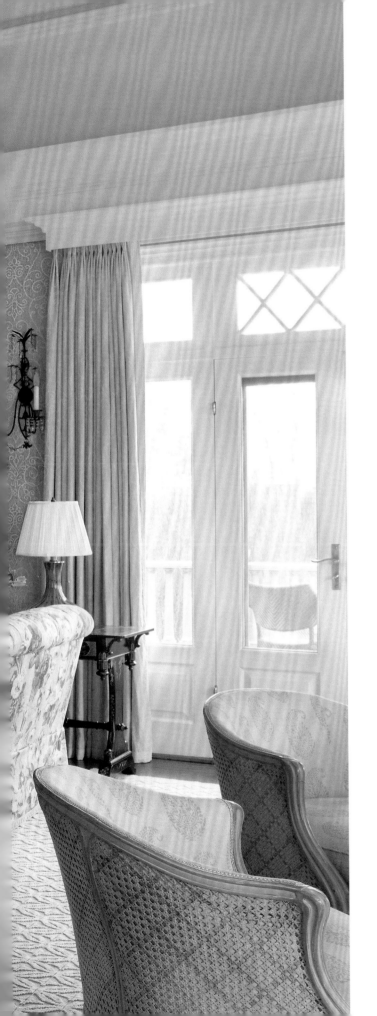

To unite the doors and windows of this very large master bedroom, we used the same printed fabric for wall upholstery and curtains.

LEFT: The English chintz on the sofas framing the fireplace brings in a floral note. A four-poster bone bed from John Rosselli adds verticality but keeps the feeling light. To anchor one side of the room, black-lacquer English chairs frame an eighteenth-century bureau. FOLLOWING PAGES, LEFT: At the room's other end, a seating group and desk create an intimate spot for quiet conversations and note writing. FOLLOWING PAGES, RIGHT: As soon as we hung the client's art, the room sprang to life with its energy.

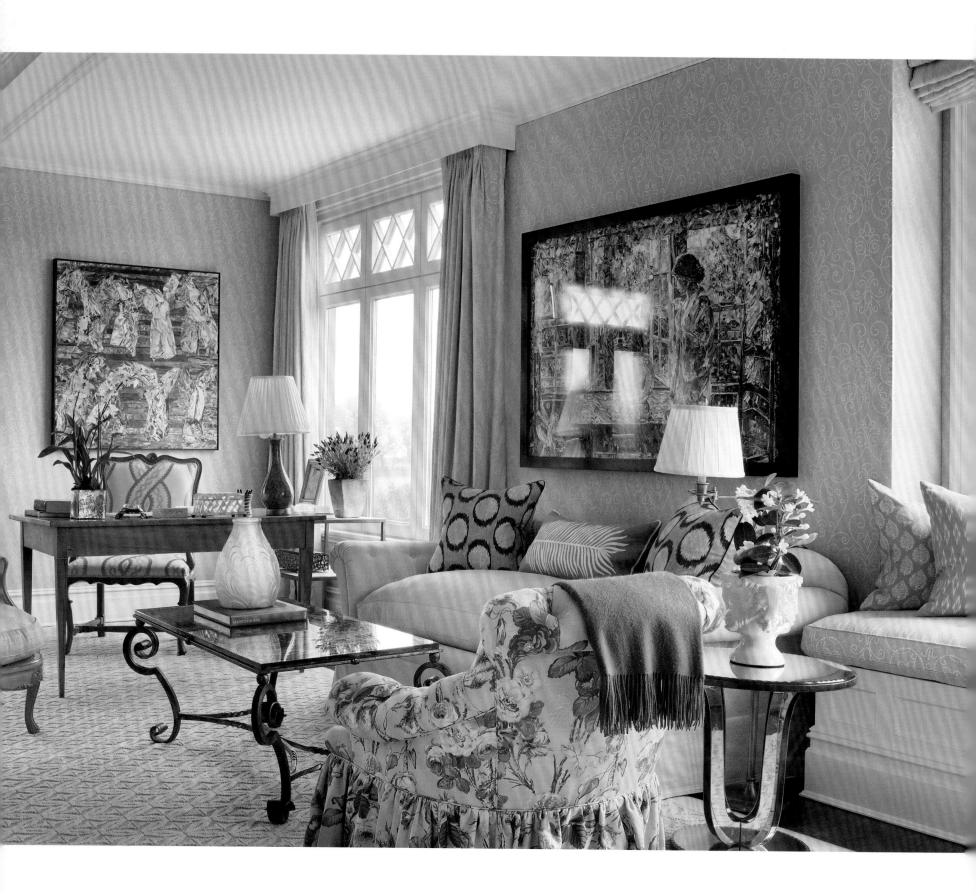

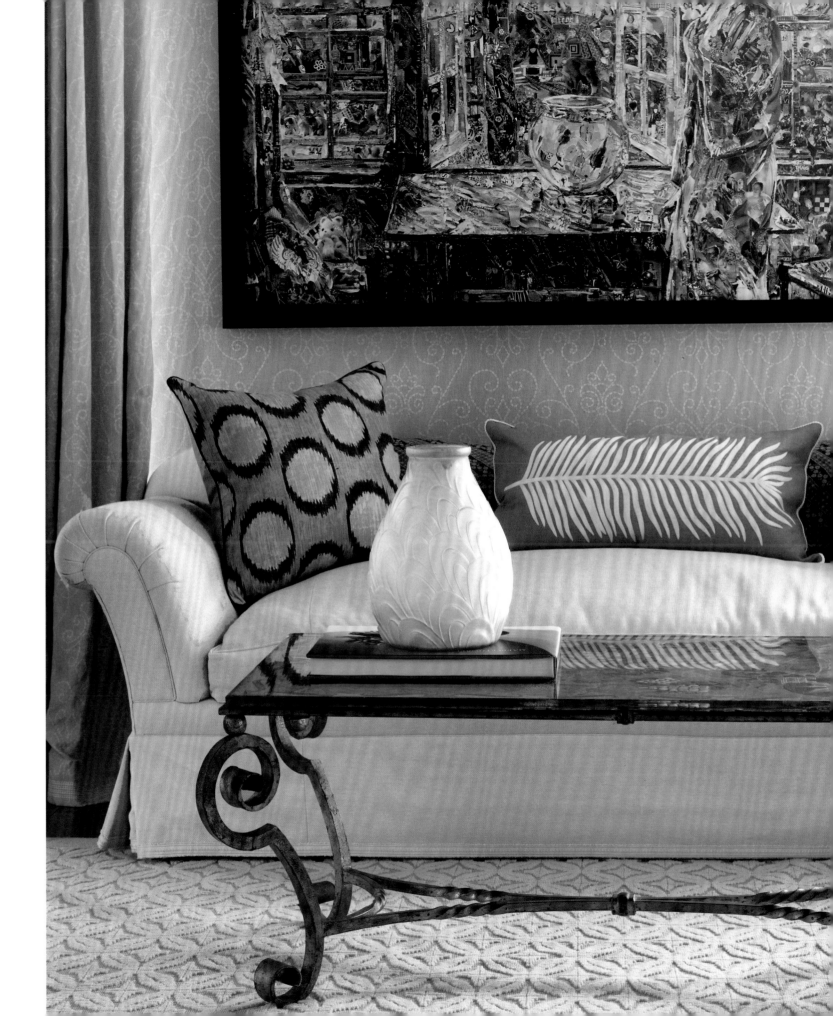

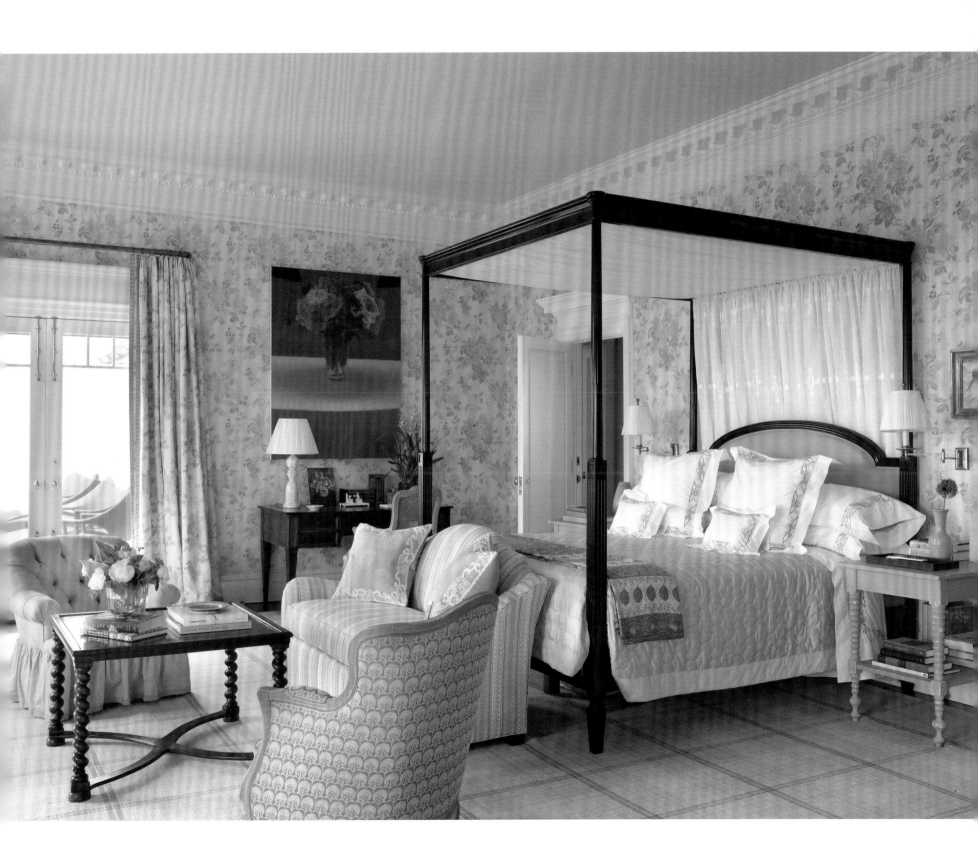

PREVIOUS PAGES: To really make guests feel welcome, a guest bedroom should have all the comforts of home. A soft, hand-blocked floral print on walls and curtains establishes an air of intimacy in this large guest room. A reproduction, black-lacquer four-poster bed creates a cozy nest. At its foot is a comfortable seating group.

RIGHT: We redesigned the library walls to accommodate a bookcase with space for a large TV. To add even more warmth, we filled the room with a variety of red-and-beige patterns.

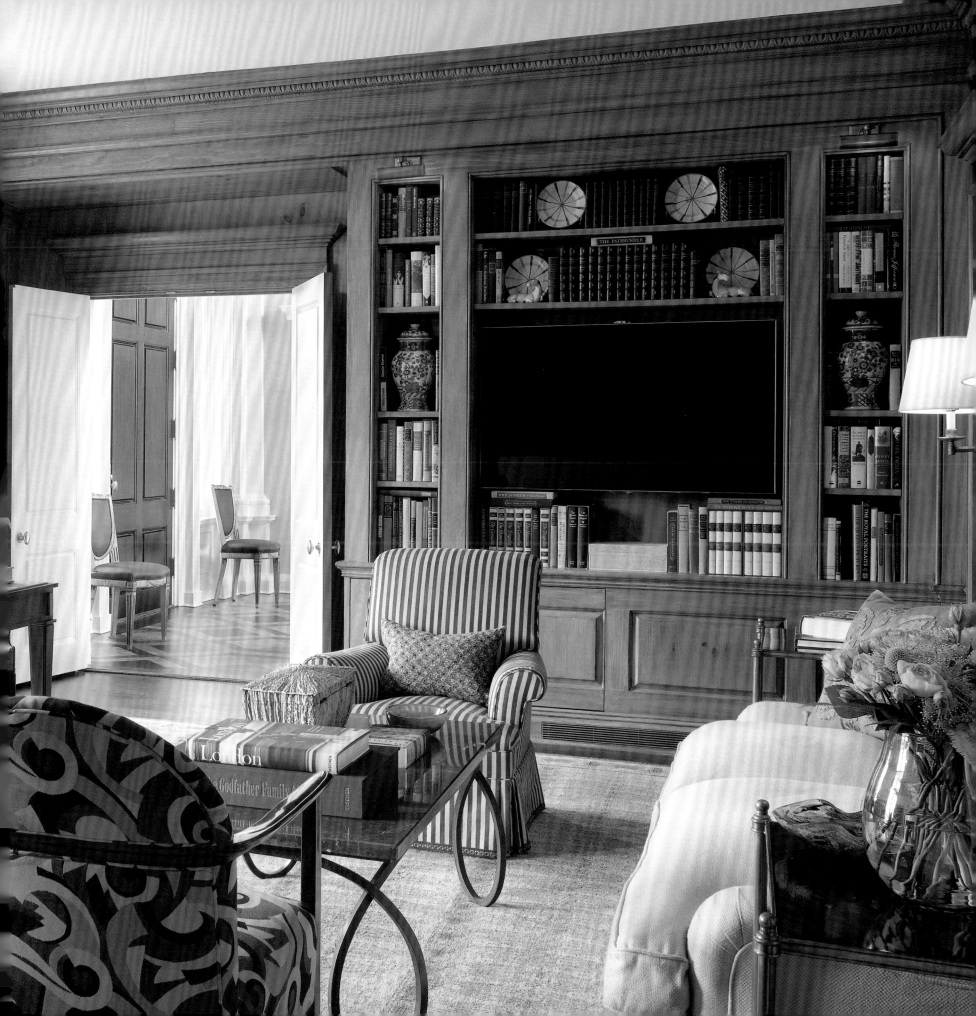

EAST SIDE
TOWN HOUSE

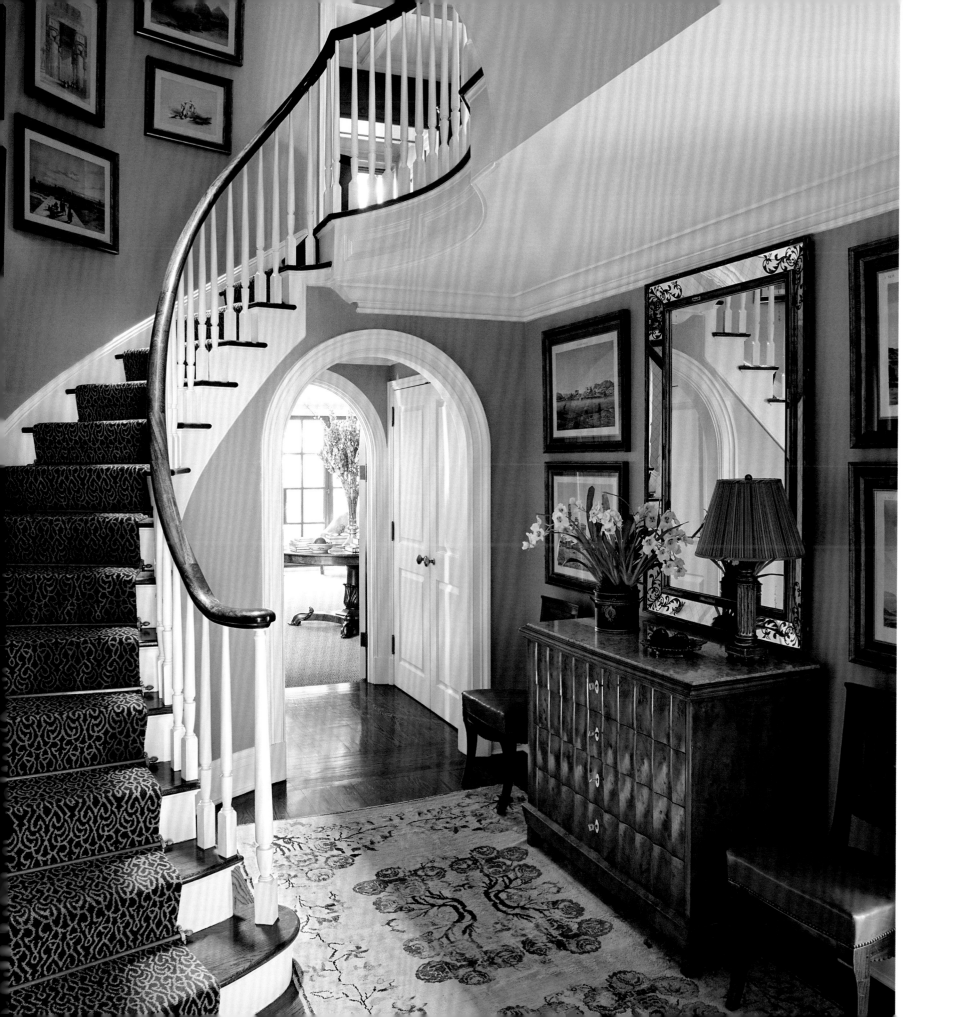

When your close friend marries an absolutely wonderful man and gives you the task of combining their tastes and viewpoints, the challenge becomes very interesting. It also presents an abundance of risks. Both parties in this case already had superb collections of paintings and objects. Luckily and happily for me, these two have similar tastes in furniture—and in colors and fabrics as well.

Their home on Manhattan's Upper East Side is a beautiful, nineteenth-century town house, which I had renovated for my friend years ago with the architect John Murray. Now it was important to make it feel that it was theirs, not just hers.

The ground floor entry opens into a low-ceilinged hall that leads to the dining room and garden beyond. We decided to reinvent the dining area as a combination dining room/library. To solve the problem of the low ceiling, we painted it a shiny gray lacquer that is so reflective you almost feel it doubles the height of the space.

A graceful curved staircase ascends to the main floor, where an elegant living room occupies the front of the house and a cozy library at the back overlooks a garden. As the focus of the living room, we installed two, rare eighteenth-century Chinese wallpaper panels, perfect for each end of the space. The panels, originally part of an entirely papered room, are family heirlooms.

The third floor houses the master bedroom, a dressing room, and a small office. We completely renovated the fourth floor to carve out an office and a comfortable TV room. Guest rooms fill the top floor.

The couple's individual belongings mix together beautifully here—the ultimate combination of two special people and a special house. Soft, muted colors throughout provide a great background for their furniture and art. Whether they are at home alone or entertaining a large group at their elegant, always memorable Christmas party, their rooms work perfectly.

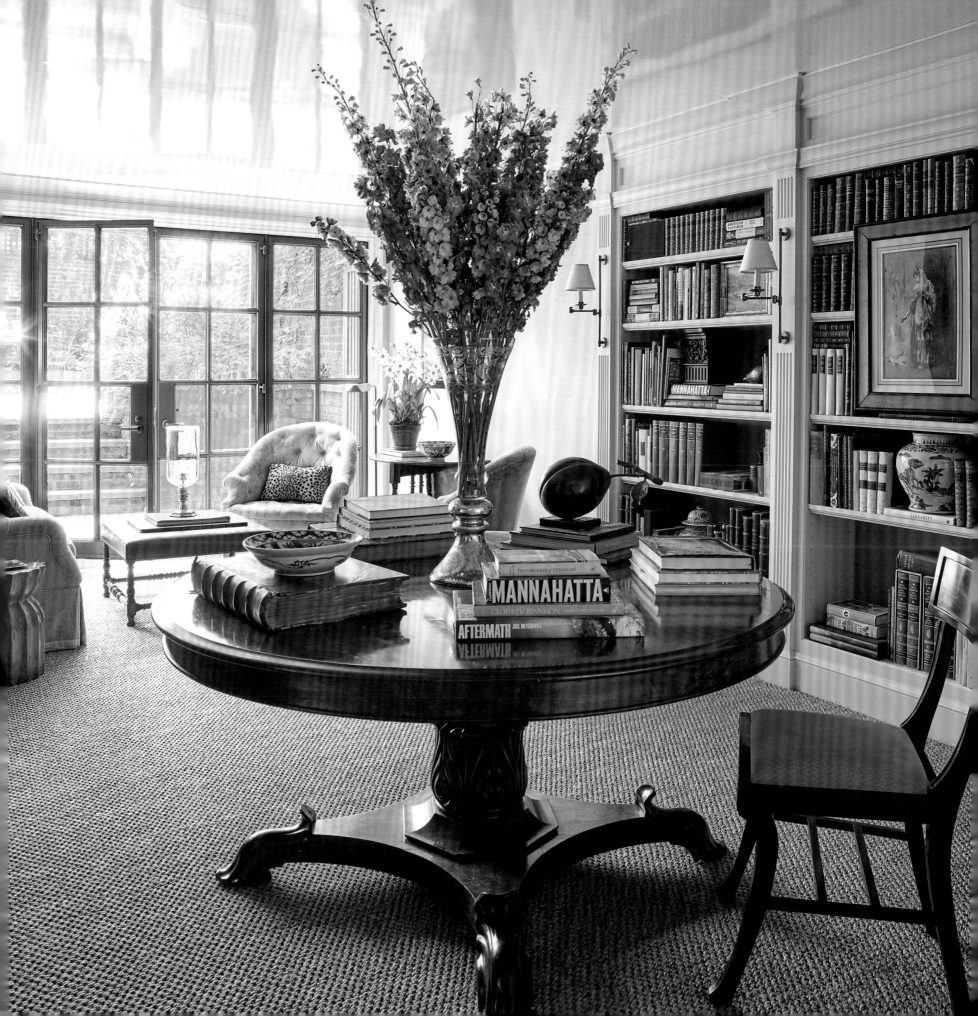

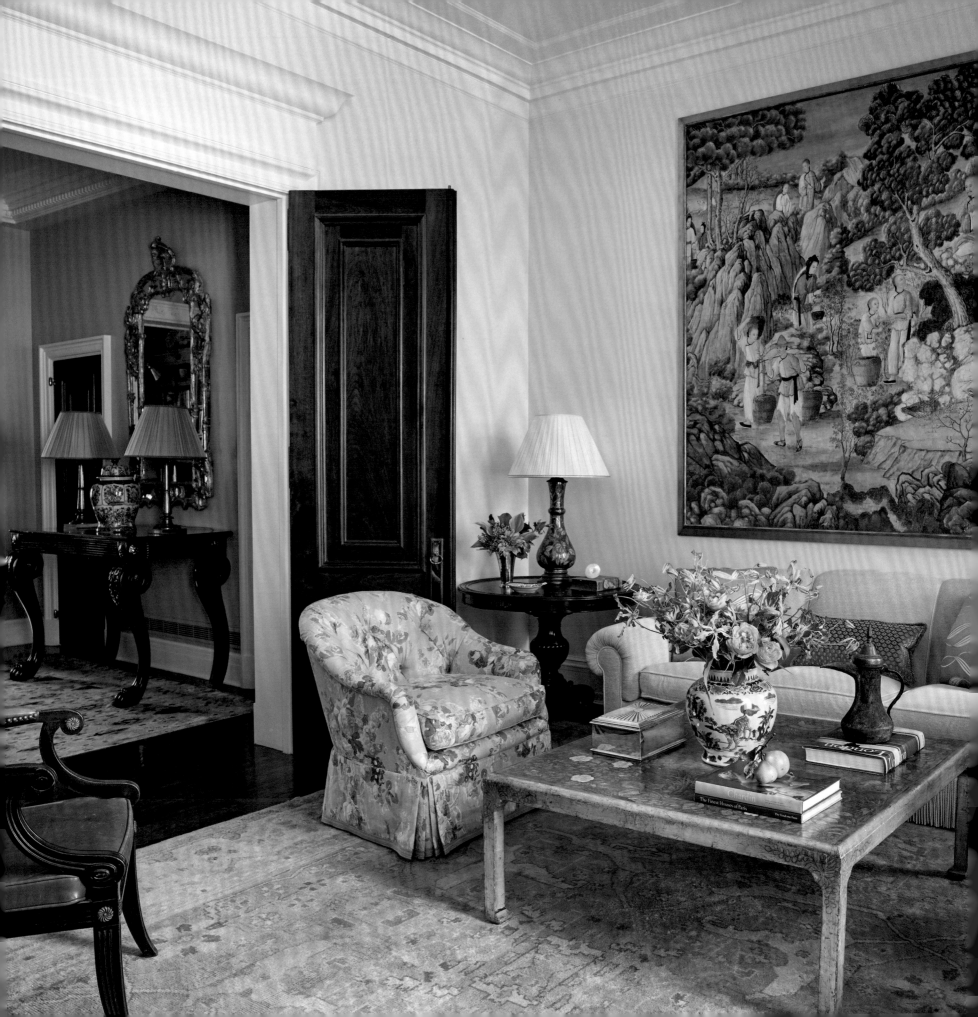

It's so special to be able to incorporate pieces that have been in the client's family. Because these items have such personal meaning, they constantly prompt warm memories.

PAGE 170: An unusual Bessarabian carpet covers the entry floor. A peach-tinted paint mixed by Donald Kaufman gives the stairwell a warm glow from top to bottom. It's difficult to find one shade that works throughout because the light changes profoundly from level to level. PREVIOUS PAGE: The room holds two sixty-inch round tables. By moving a few chairs and setting up another table, the couple can seat sixteen. LEFT: With a soft Oushak carpet underfoot, we were able to pull colors from the panels into the room's scheme.

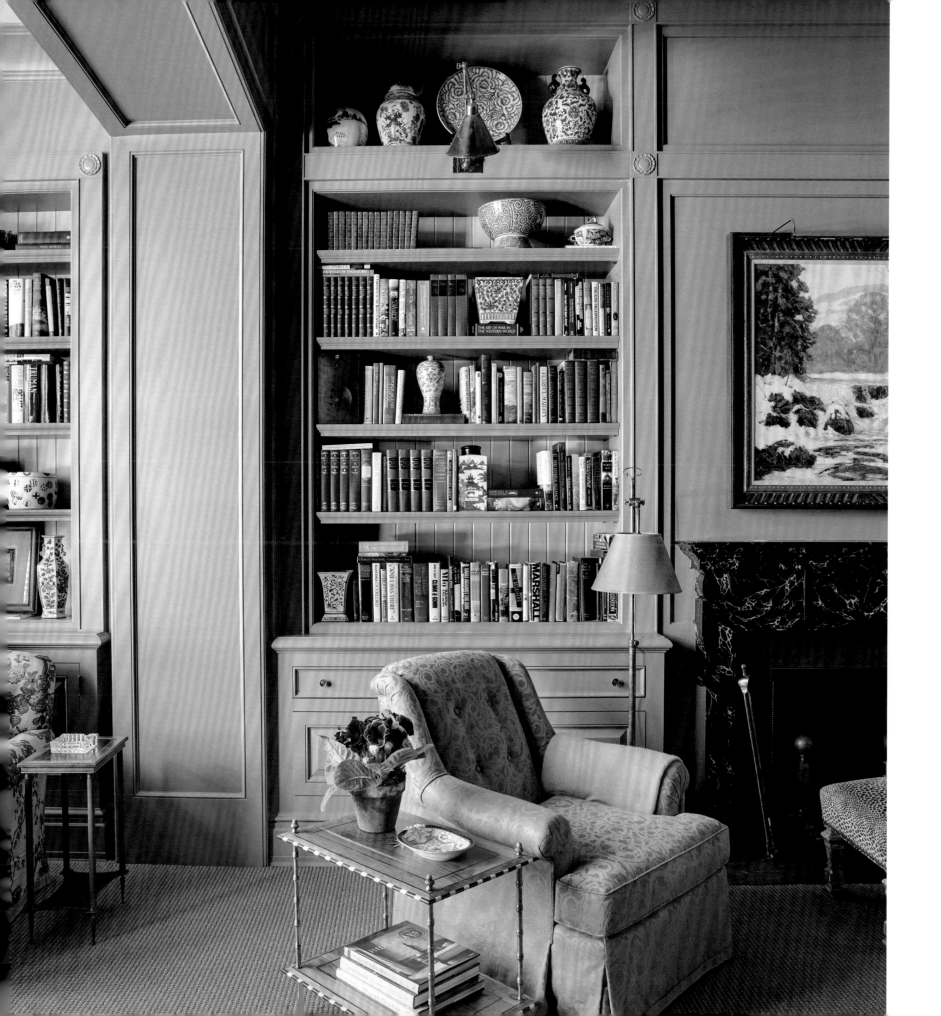

Bookcases can become a home not only to a collection of books but also to a collection of wonderful objects. And I never think twice about hanging a picture over the books when I need more wall space.

PAGE 176: In the library, a voluptuous bouquet picks up on the eglomise table's decorative motifs. PAGE 177 AND RIGHT: Against a soft gray-green background, blue-and-white china, art, and polished wood furniture look their best.

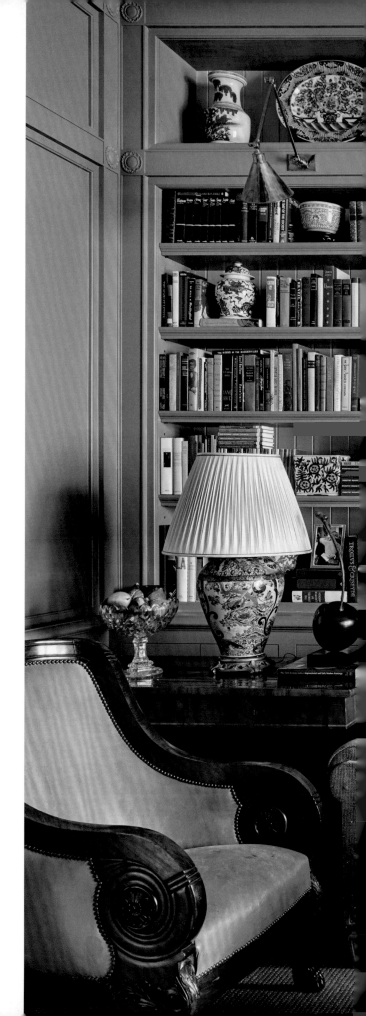

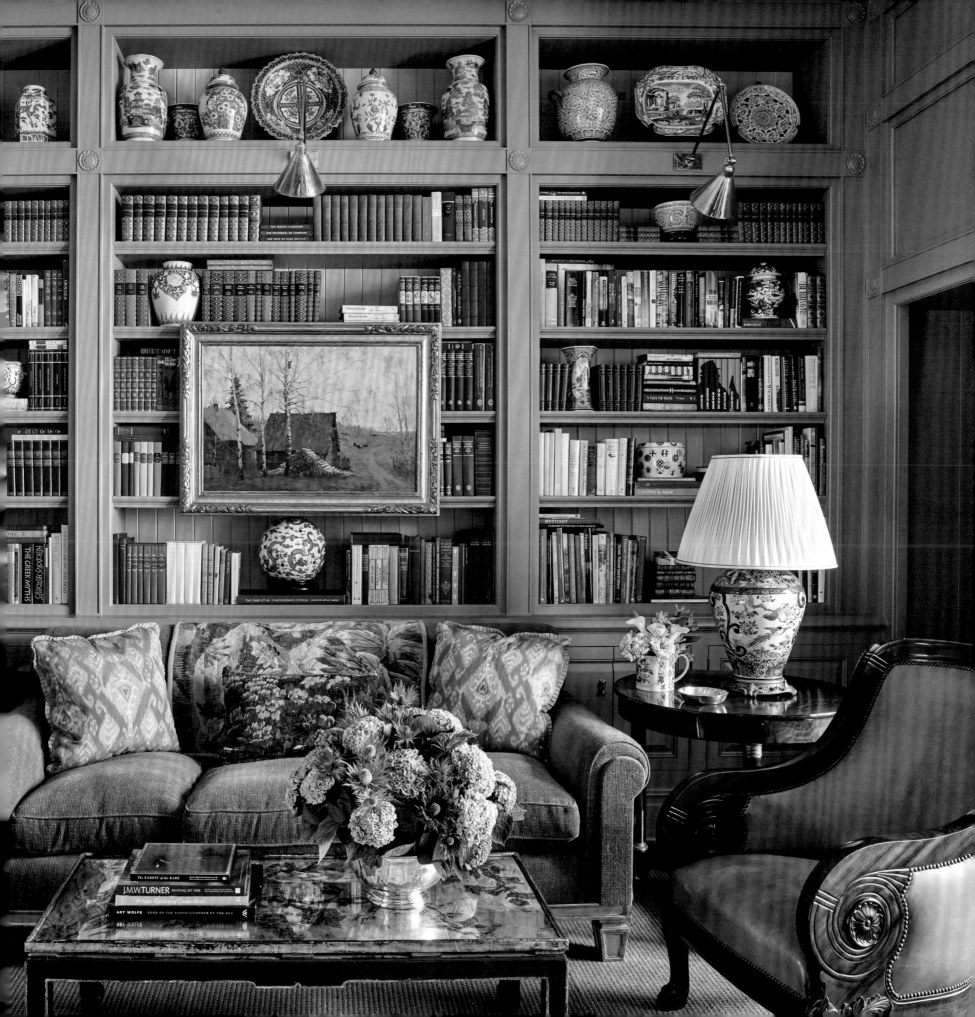

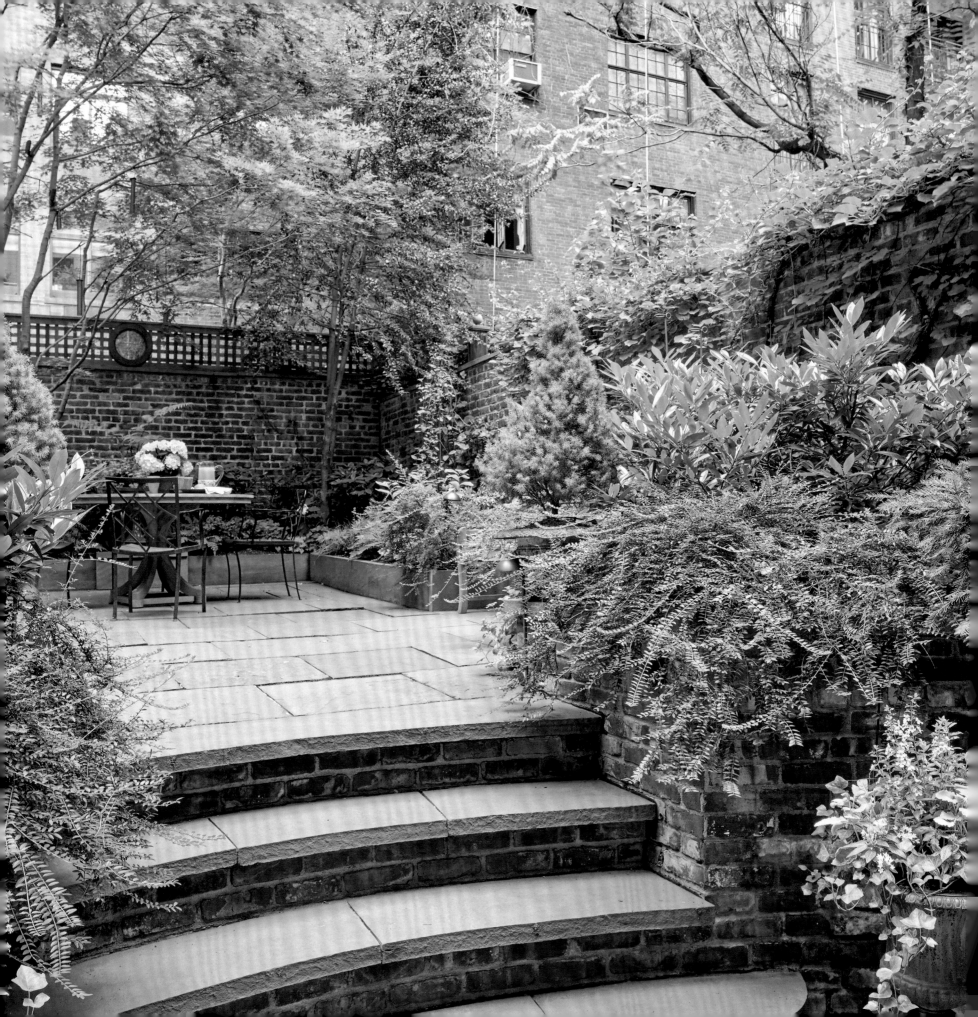

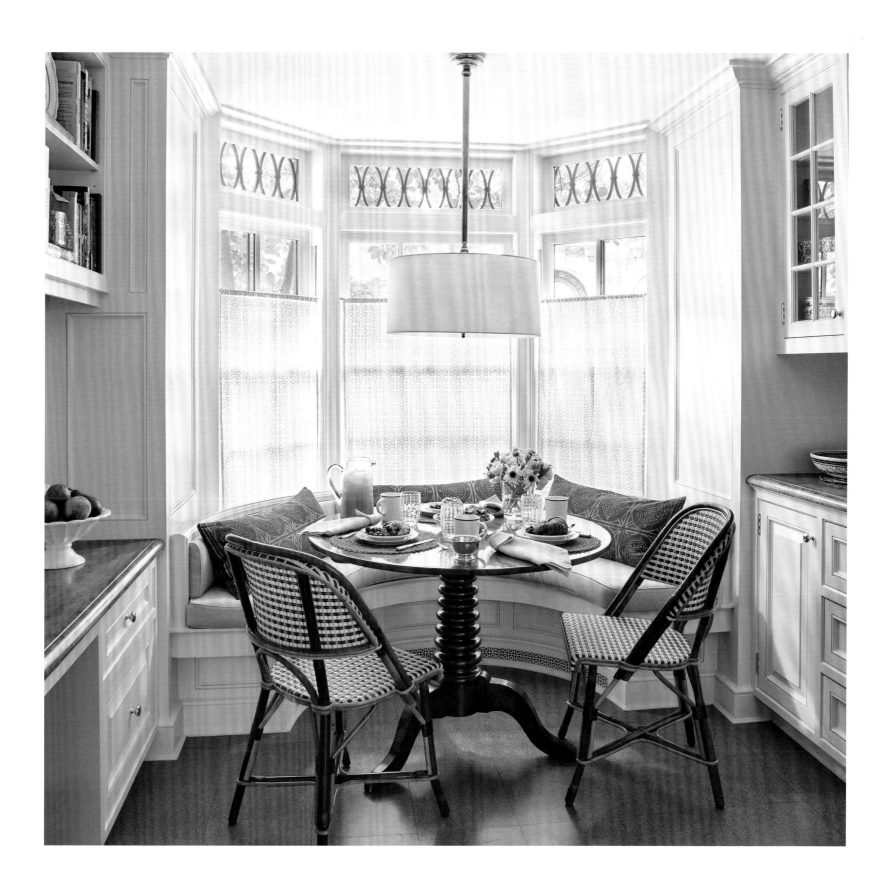

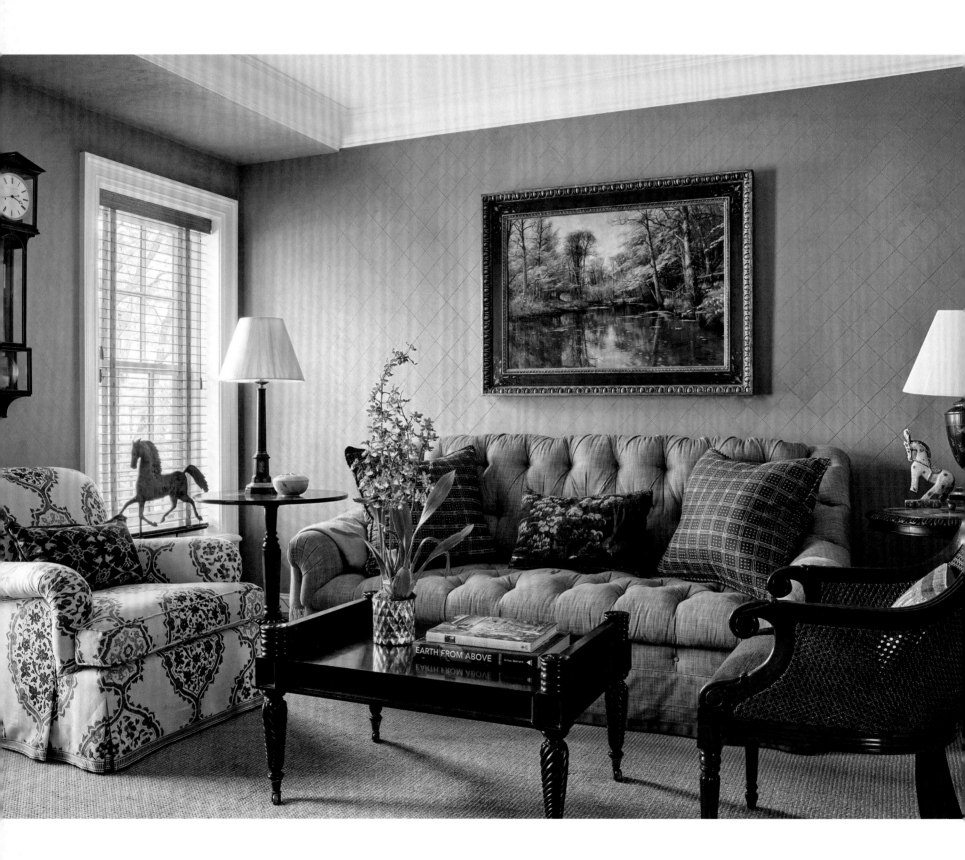

PREVIOUS PAGE, LEFT:
Stone steps lead up to
a secret garden space.
Cascading vines and
plants spill over the walls.
PREVIOUS PAGE, RIGHT:
Building in a banquette
in the kitchen window
bay created a nook for
breakfast and casual
meals. OPPOSITE: The
fourth floor became "his"
space and incorporates
an indulgently large
television. RIGHT: An
eighteenth-century
English secretary provides
a home for antique books
and porcelains.

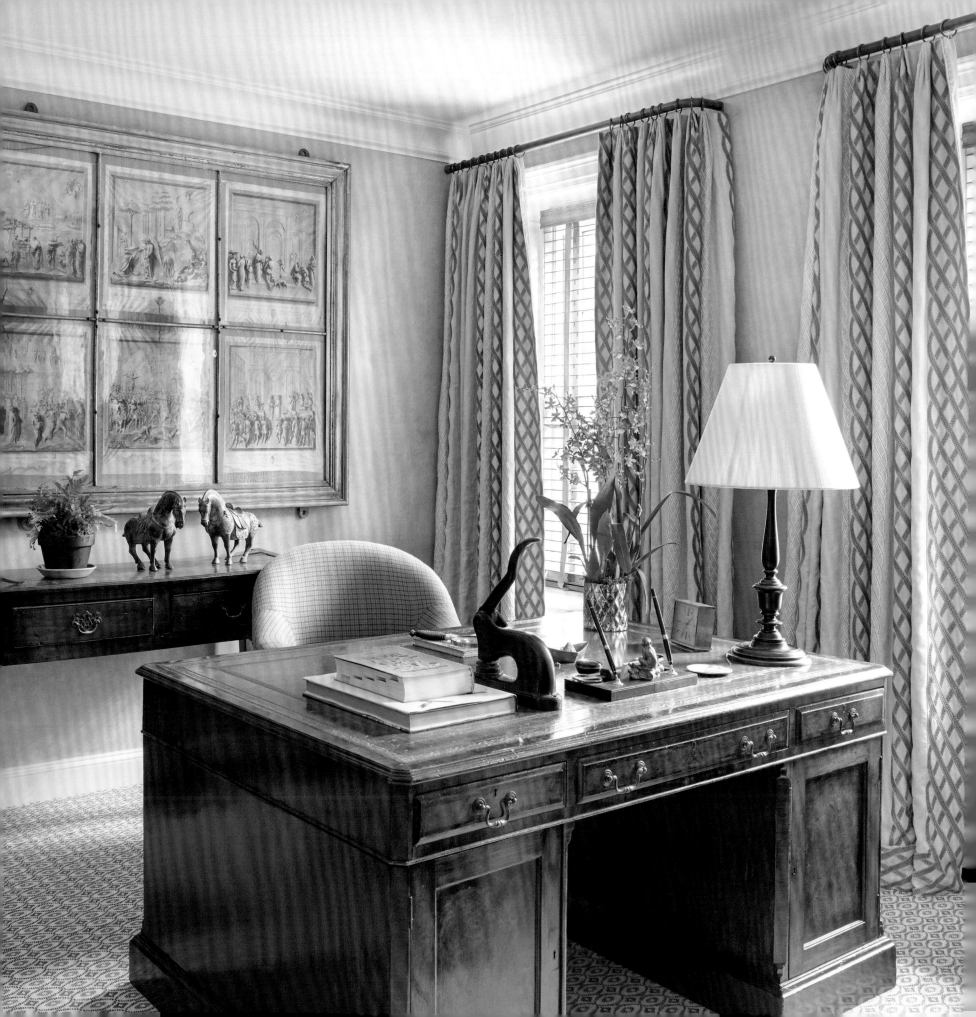

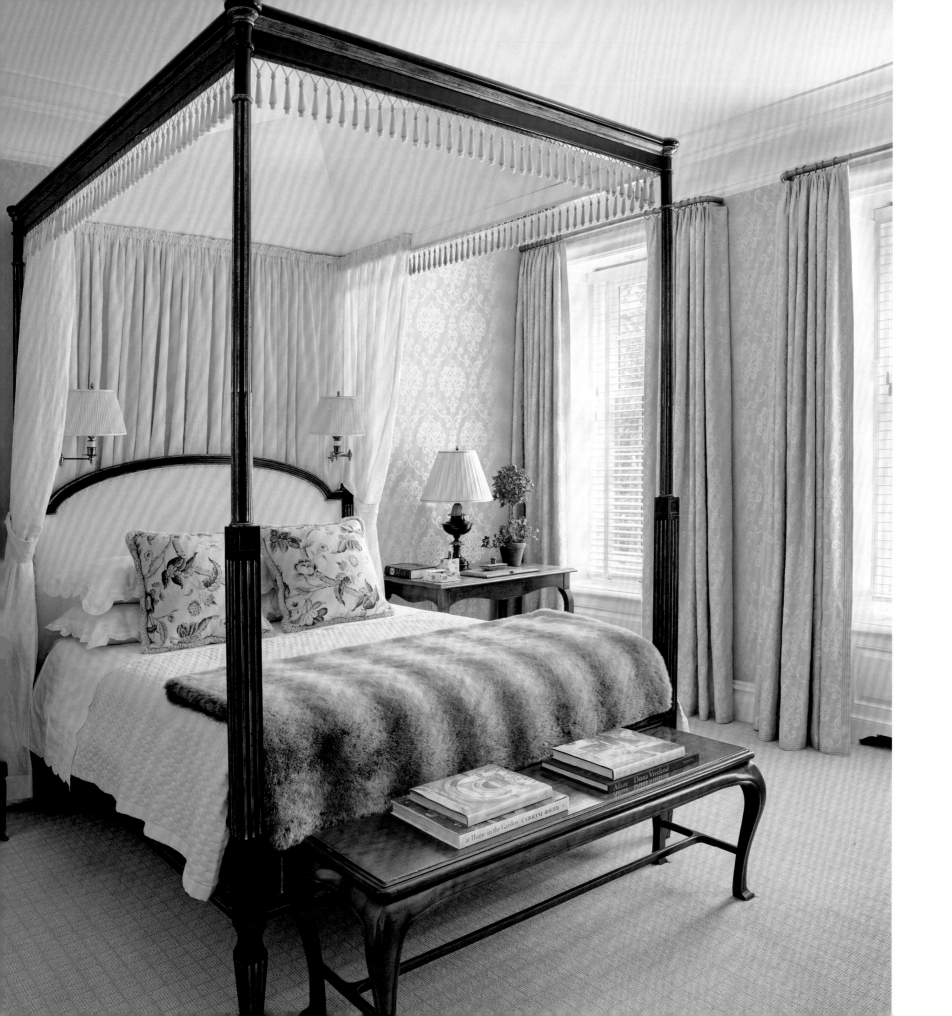

PREVIOUS PAGE, LEFT:
In his newly created office,
an English partners desk feels
right at home. Embroidered,
striped curtains hang
handsomely from metal
poles. PREVIOUS PAGE,
RIGHT: A large panel made
with antique etchings hangs
above a country English
sideboard. OPPOSITE: At the
foot of the bed, an English
bench offers a convenient
place for books.
A four-poster bed always
makes a room look taller.
RIGHT: The master bath is
light-filled and serene.

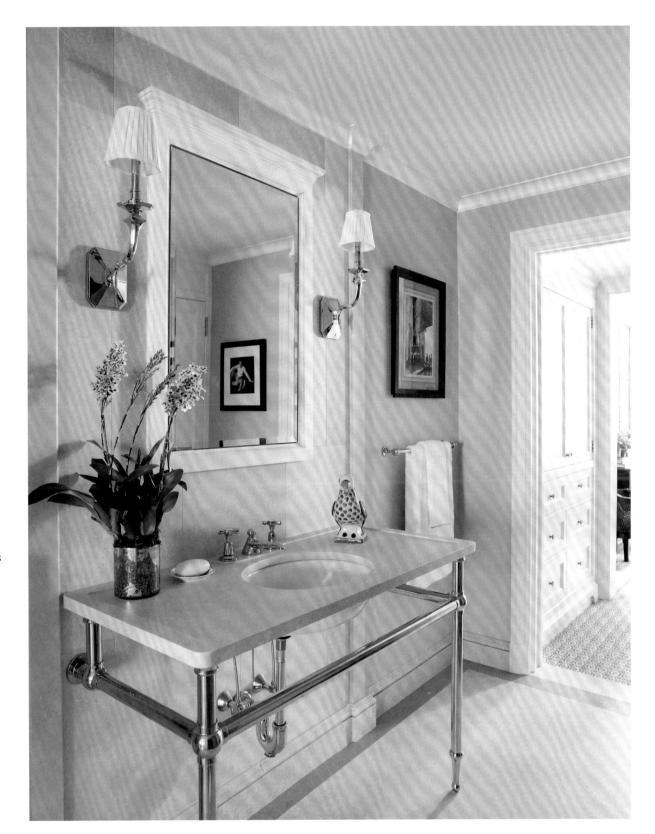

GEORGIAN
STONE HOUSE

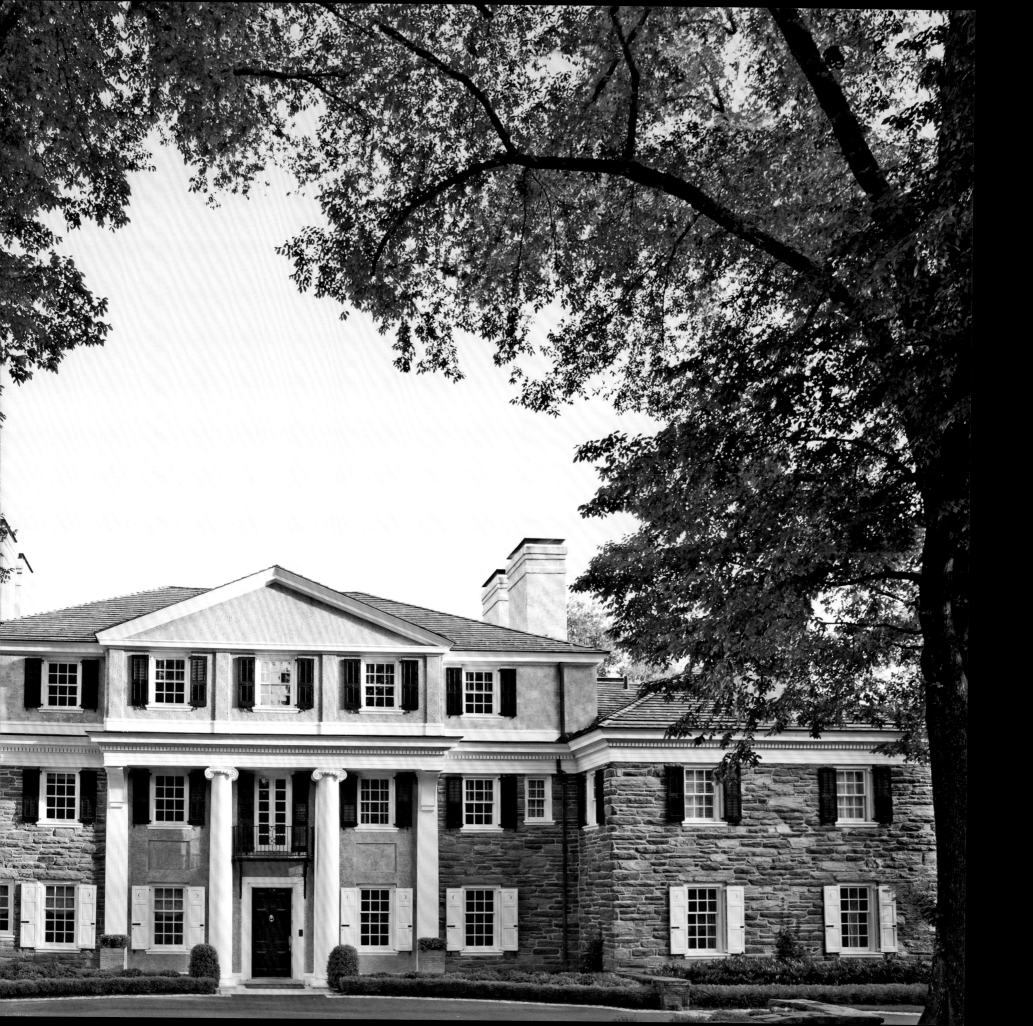

Imagine this homeowner's surprise when he asked his wife what she wanted for Christmas and she answered: to have me decorate their newly purchased stone house on the East Coast. Luckily for me, he agreed, and the most delightful family came into our lives.

The Georgian-style house dates to the 1920s, a period that I think inspired some of America's most beautiful residential architecture. Though its kitchen and baths needed updating, its large, gracious halls led to perfectly proportioned rooms, each with many large doors and windows that encourage daylight to flood in and offer captivating vistas to gardens beyond.

When the couple arrived for our first design meeting, they had a clear vision of what they wanted and a folder of photos showing pieces they had acquired on trips to Paris and visits to the flea markets. We spoke at length about lifestyle and their desires for the house to be a real family home with a welcoming living room; a place for children to read, play games, and even horse around; and a kitchen the family could also use for breakfasts and casual suppers.

The long living room had a fireplace at one end, so we decided to place back-to-back sofas in the center and create two large sitting groups. A writing table between windows offers a perfect place to write a letter or work on a laptop. A game table beckons in one corner. A giant chaise sits by the fireplace, inviting children to climb up for a favorite story.

The library, which was to become the husband's study, was paneled in a very unappealing wood. Ebonizing it and adding a coat of shiny lacquer made it come alive.

Fully refreshed with the help of Archer & Buchanan Architecture, the house now sings with the happy sounds of children running through the halls, followed by beloved four-legged friends, all managed by the greatest parents ever—just the family home they envisioned.

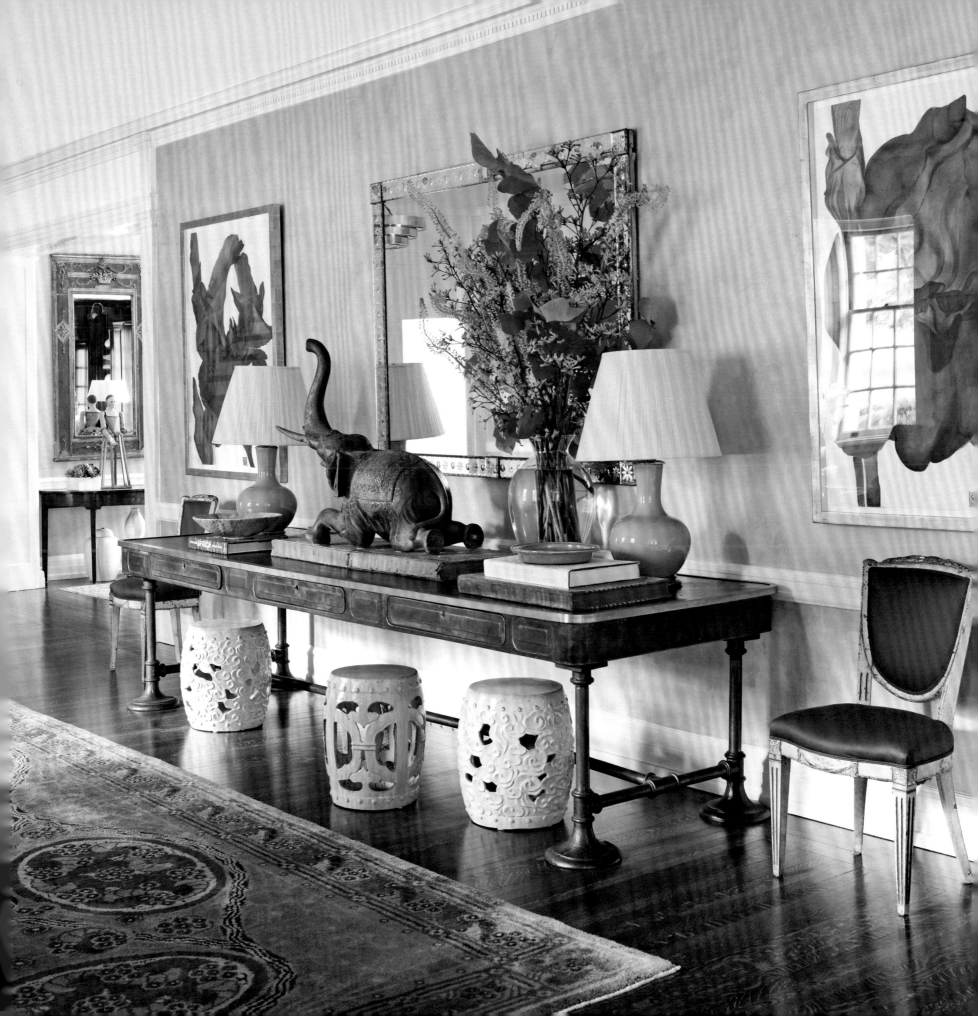

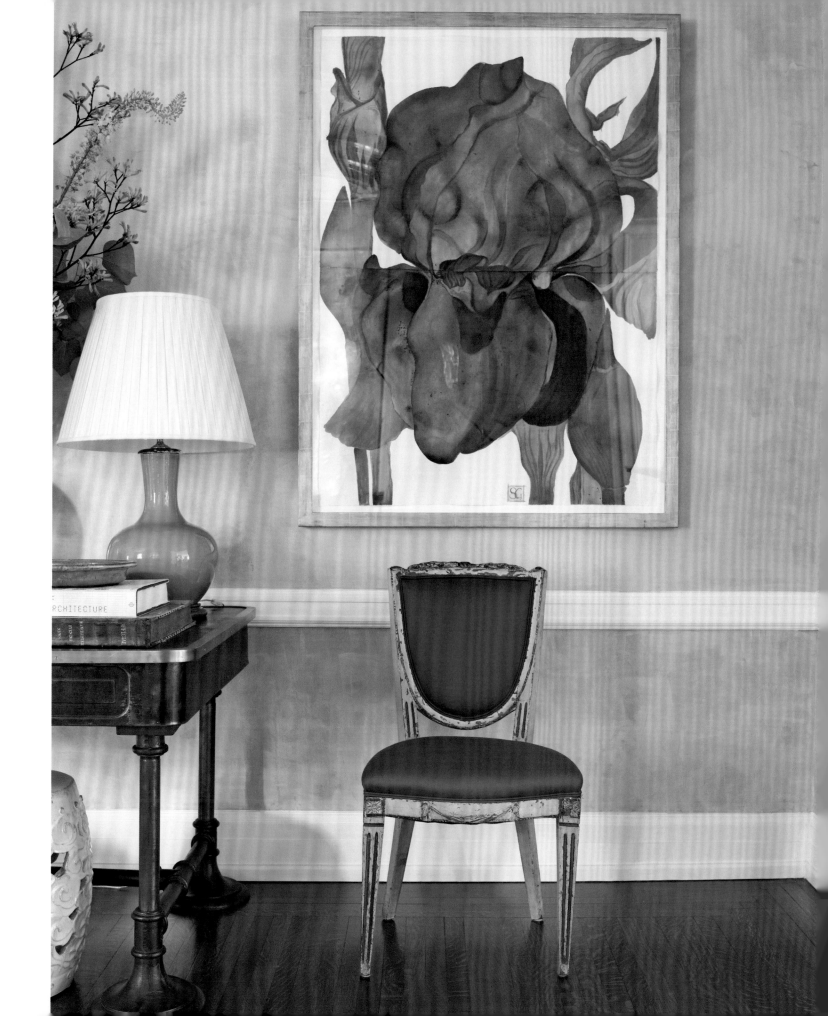

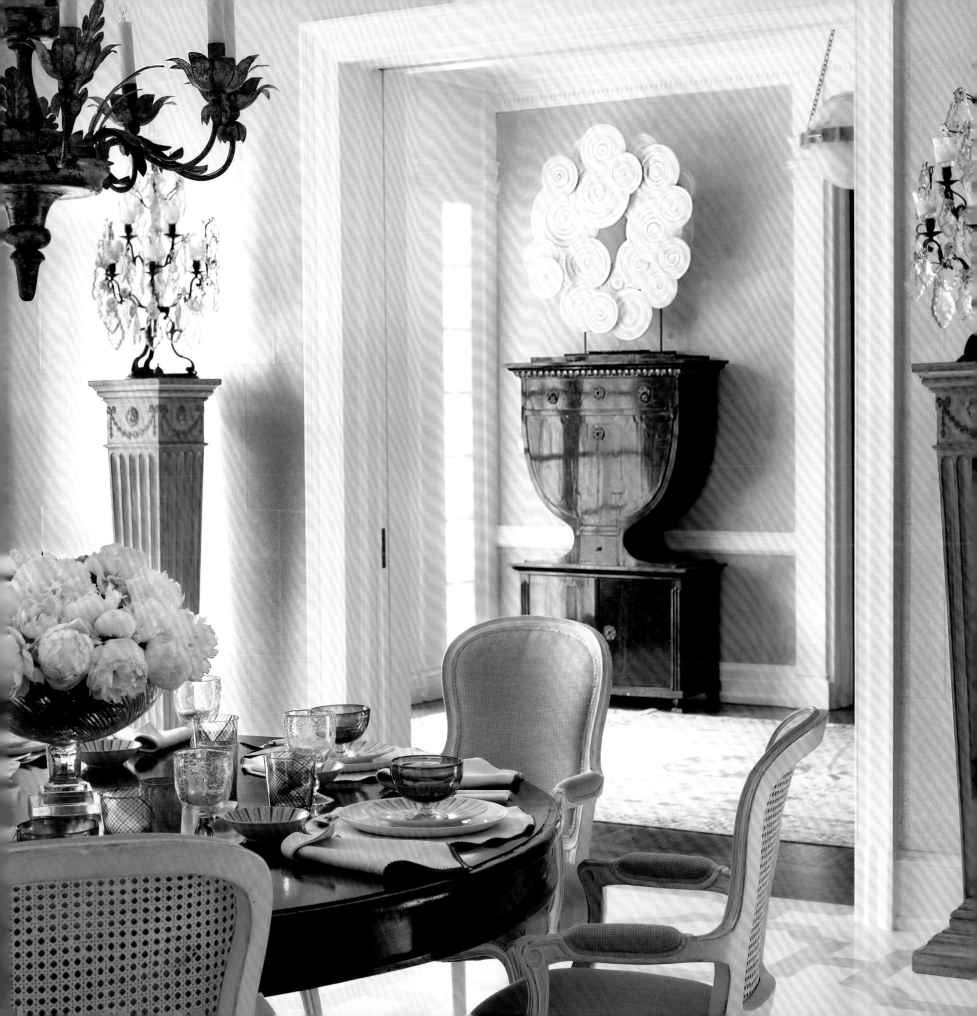

PAGES 188-189: The perfectly balanced façade is built with local Delaware stone.

PAGE 191: The owners found the industrial table at the Paris flea markets. With its ample proportions, it became the centerpiece for the large entrance hall. Paintings by artist Sarah Graham flank a Venetian mirror. A very unusual Scottish carpet covers the floor.

PREVIOUS PAGE, LEFT: The mix of styles and eras begins in the entry hall, where an eighteenth-century chair seems made to pair with Sarah Graham's painting.

PREVIOUS PAGE, RIGHT: Wherever the eye travels, I want it to land on something arresting and beautiful. An unusual, sculptural, nineteenth-century Biedermeier cabinet commands the view through the dining room. LEFT: Painted finishes contribute much to the dining room's overall blue-and-white palette. OPPOSITE: With painted chairs around an ebonized dining table (another flea market find), the painted floor gives the formal dining room an airy feeling.

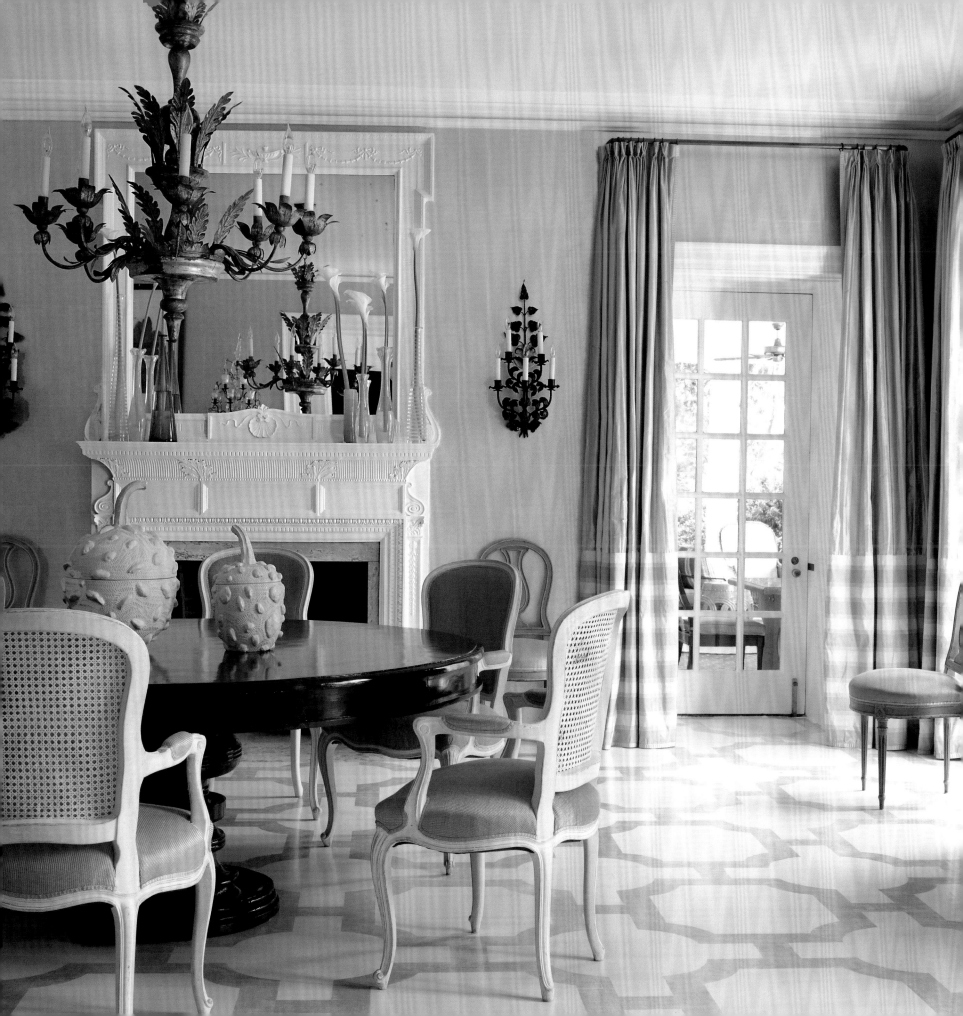

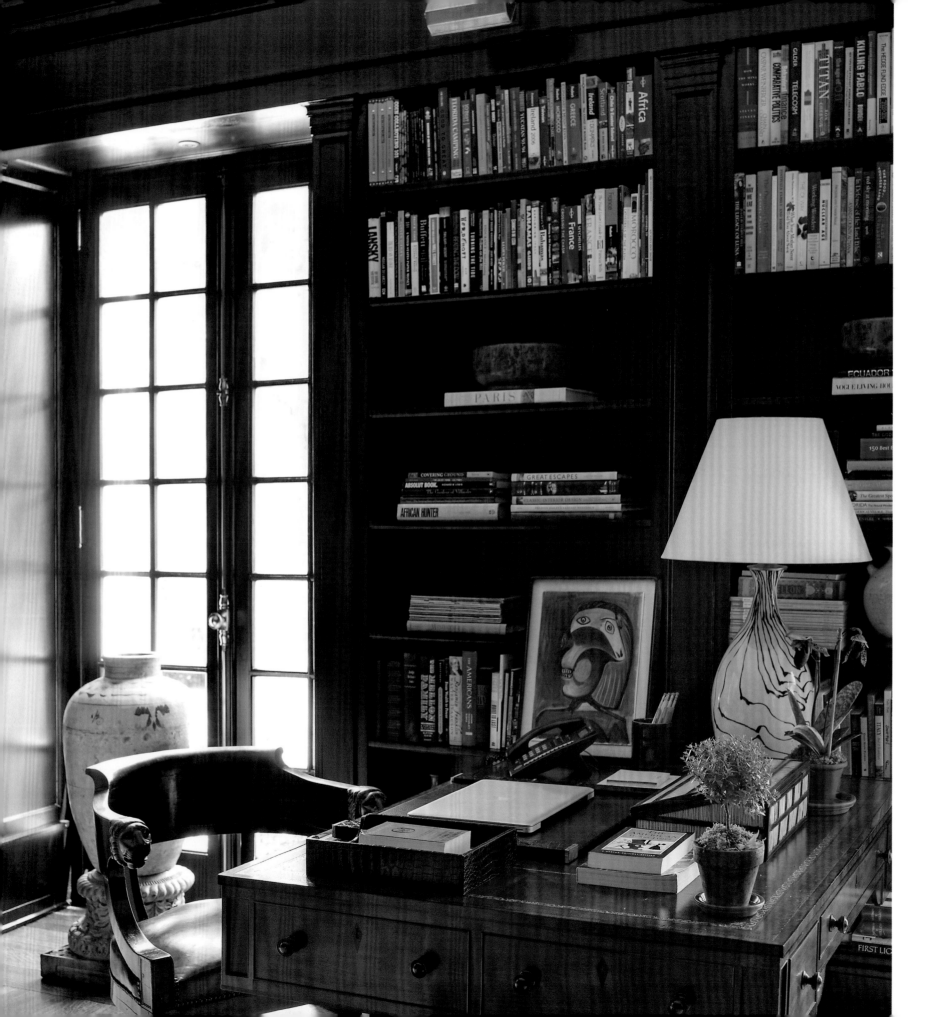

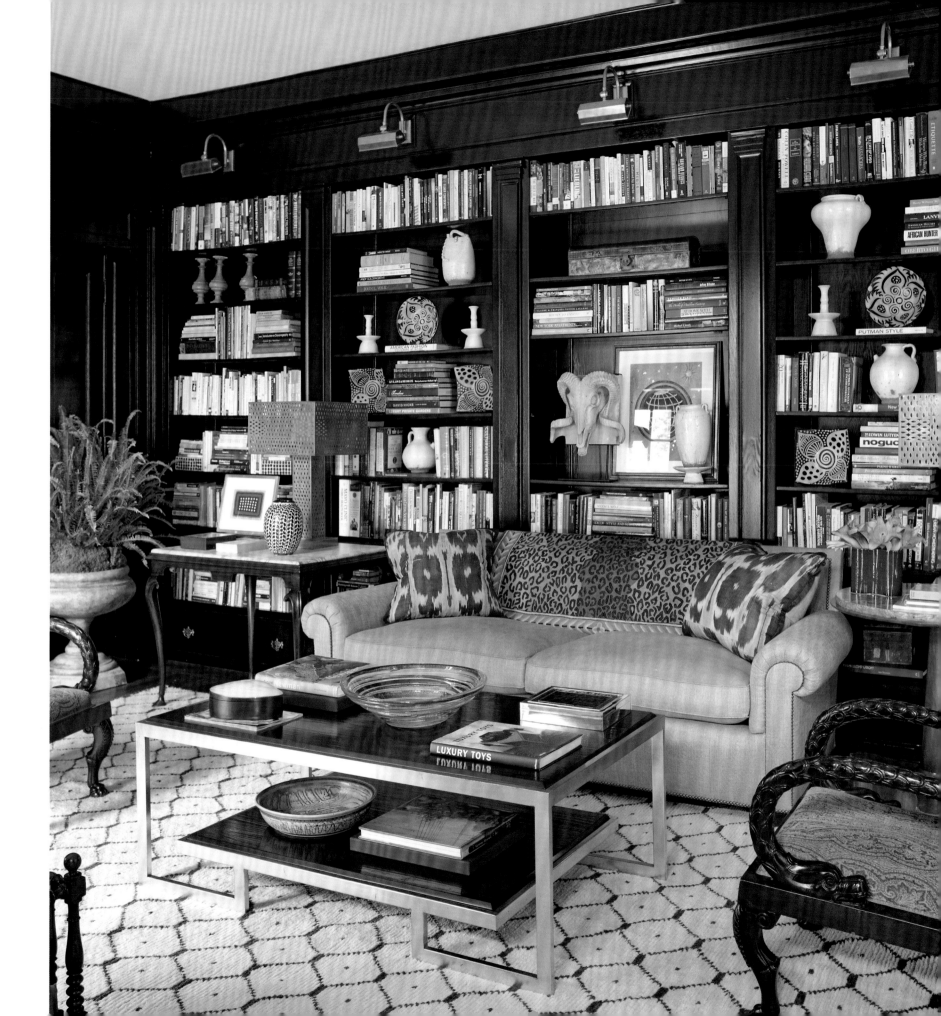

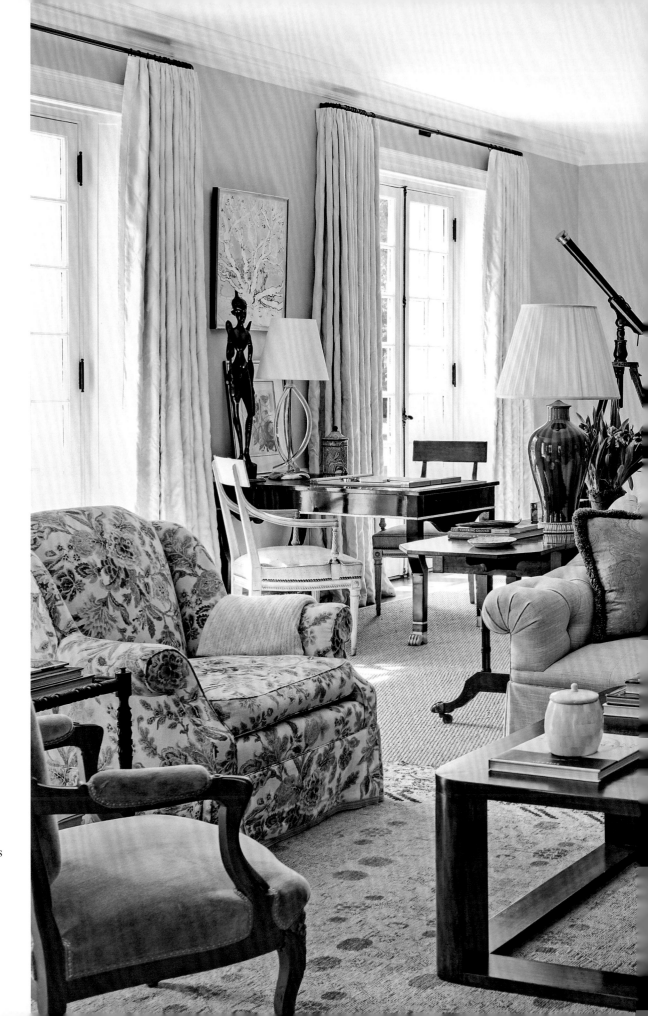

PREVIOUS PAGES: To refresh the library, we ebonized and polished the wood of the bookcases. Paradoxically, a dark, polished finish often lightens a room because of the way it reflects light.
RIGHT: Because the living room is so expansive, we placed back-to-back sofas in the center to anchor two seating groups as well as a desk that can also double conveniently for backgammon or chess.

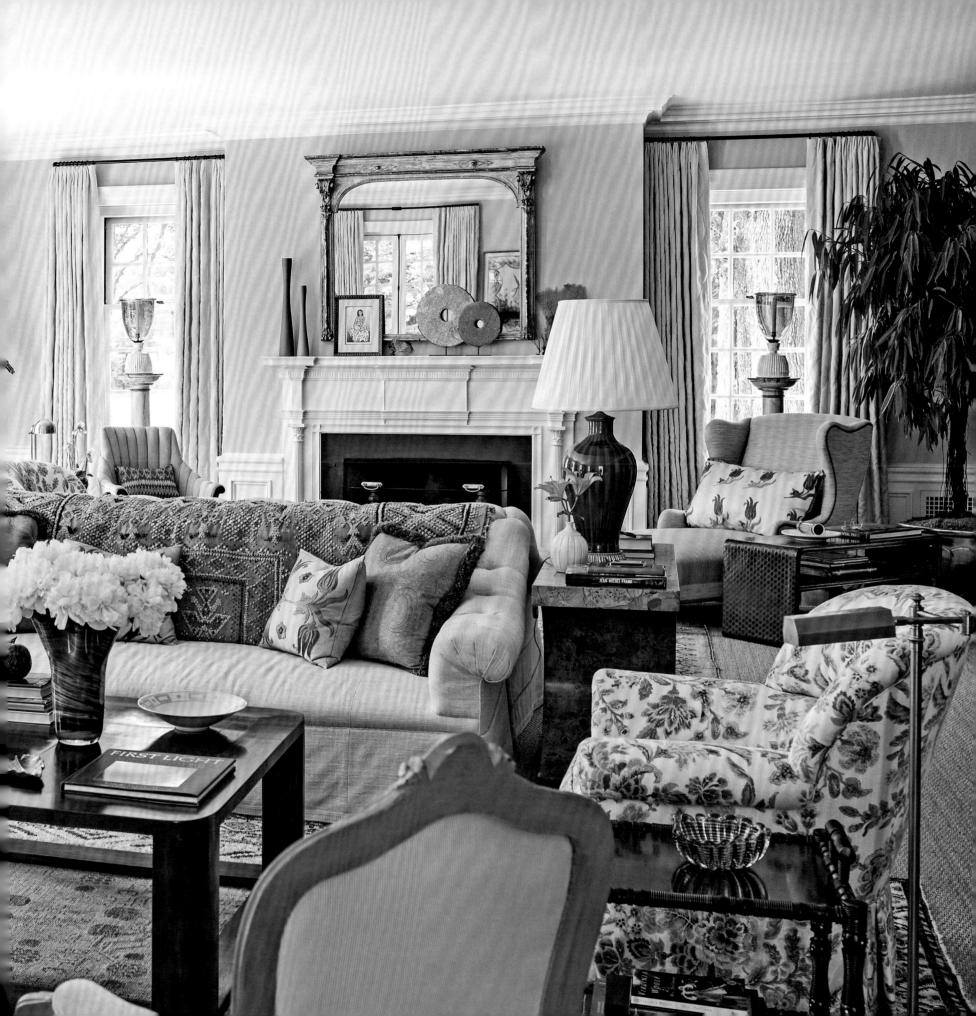

LEFT: One corner of the living room holds a double-wide chaise that's just perfect for reading stories to children. OPPOSITE: In another corner, an English piecrust table serves as a game table. A mirrored screen reflects the rest of the room.

To create a house that is comfortable and functional, I have to imagine what people are going to do in every space and design accordingly.

PREVIOUS PAGES, LEFT: Furnished with a nineteenth-century Victorian sofa and colored glass lamps, the upstairs stair hallway becomes its own room. We built the incredible Venetian mirror into the stair landing. PREVIOUS PAGES, RIGHT: In the master bedroom, a nineteenth-century Zuber grisaille wallpaper sets the scene. A complementary palette of whites and yellows enhances the effect. RIGHT: Wicker seating and French iron furniture entice the family and their friends out to the open porch. Plants on plant stands bring the garden into proximity.

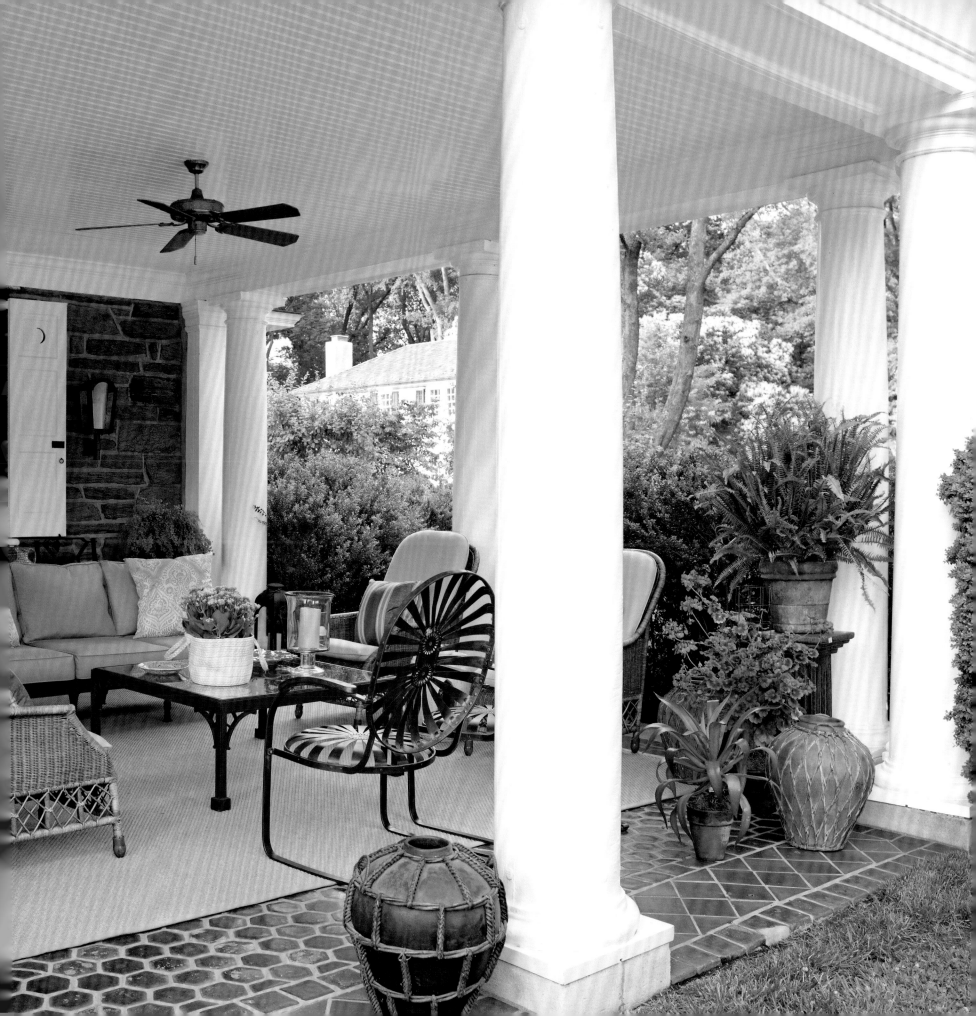

NEW YORK DUPLEX

There are very few couples who think nothing of having forty guests in for a sit-down dinner or who would open their home to hundreds to celebrate an event or support a charity. But the owners of this apartment are just such people. When an adjacent duplex came on the market, the couple decided to join the two spaces to create more room for entertaining and more living space for the family and dogs (my favorite, of course). They assigned the task of the combination to Mark Ferguson of Ferguson & Shamamian, whom I have collaborated with for years.

We wanted the new residence to feel timeless. Our design direction focused on architecture that respected the quality of the lovely prewar building. Within this frame, we opted for more transitional decor that mixed some of the clients' antiques with more contemporary furniture and their collection of modern art.

After studying the adjacent spaces, Mark and his team designed one large entry gallery with a large oval oculus opening to the second floor, a perfect, unifying space of welcome. Feeling that the gallery needed a bold flourish on the floor, we developed a modern parquet pattern with three varieties of woods: oak, mahogany, and ebony. At the top of the oculus, a safety railing features glass spindles so as not to block the light from the windows above.

The original living room, which I had done years before, was rearranged to accommodate its new entrance off the gallery. The second, more casually furnished living room (at the gallery's opposite end) includes a TV behind a mirror over the fireplace and a round table for small, intimate dinners, meetings, or games.

Because the merged apartment now had two kitchens, we wanted them to be very different in style. The main kitchen just off the dining room combines warm, cerused-oak cabinets and marble countertops; underfoot is a classic tumbling block pattern made with three shades of Amtico vinyl tiles. The second kitchen—often used for baking cookies and supplying popcorn for the adjacent TV room—has a more modern look. Inspired by a red-lacquer kitchen I had admired in an Italian magazine, I located the manufacturer so we could re-create it here.

No matter how hard an architect and designer work to make a space come alive, it is really the client who fills it with energy. This apartment bustles with warmth and excitement because of the clients' own love of life. I feel it every time I visit.

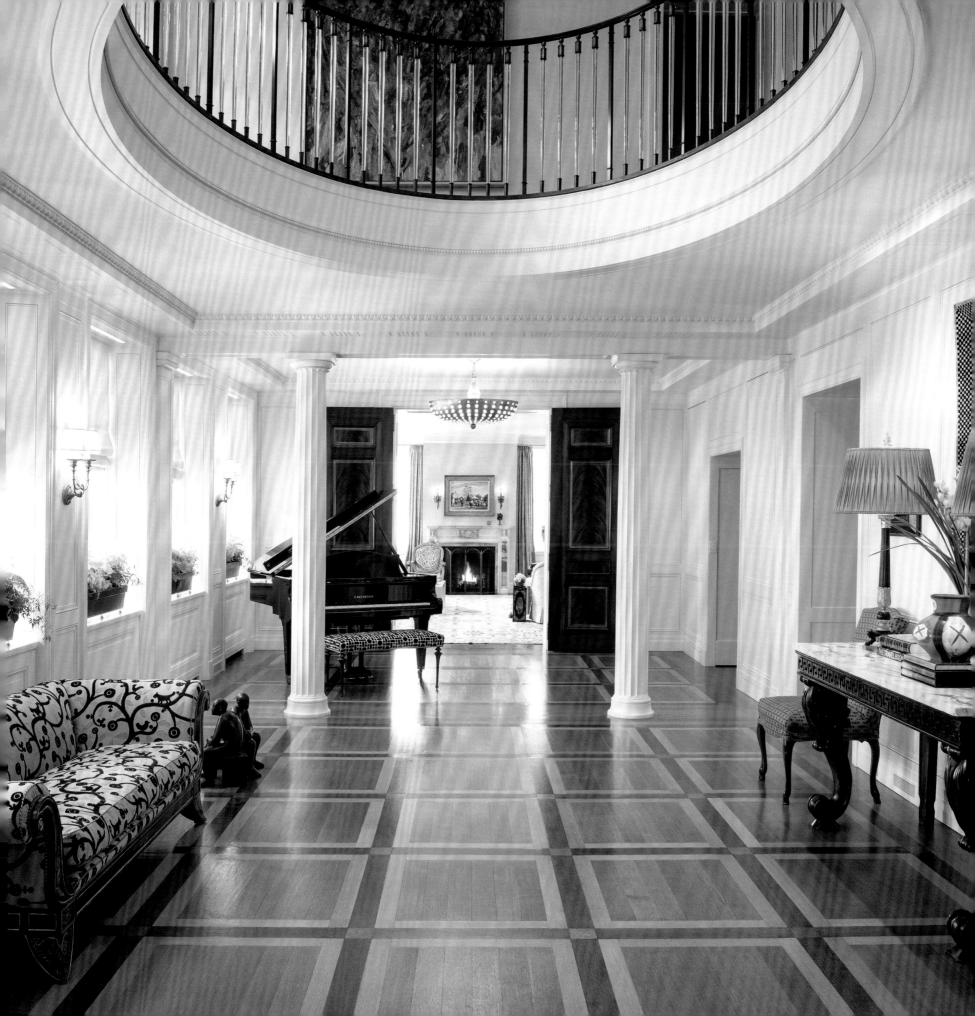

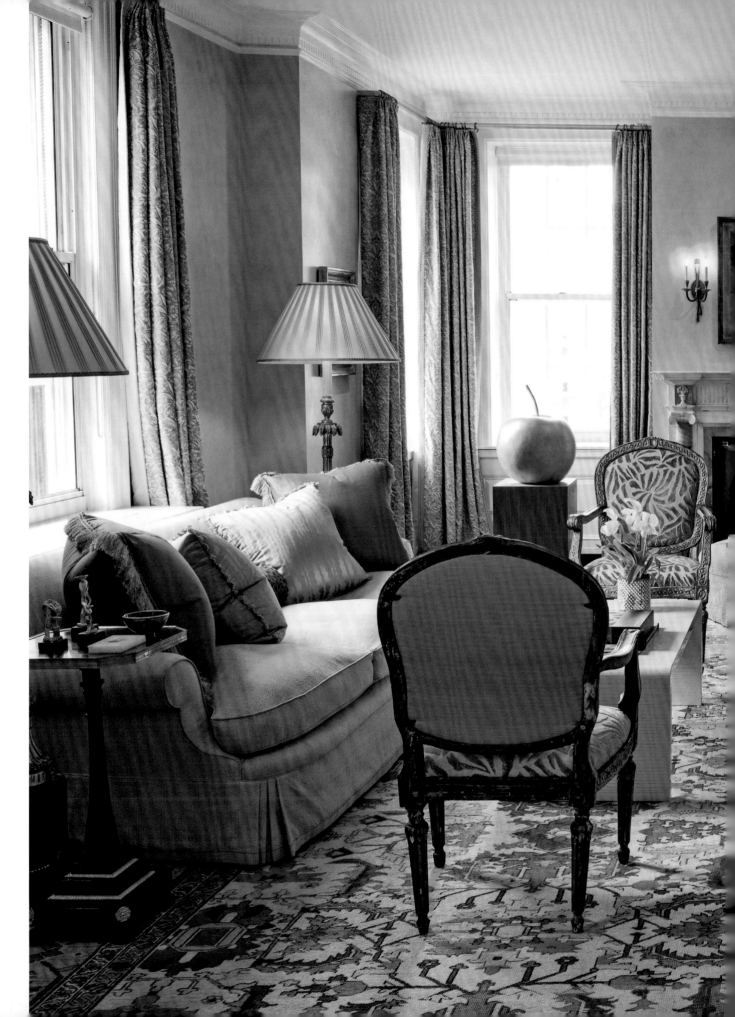

PAGE 207: At least one of the family's four, happy, four-legged friends always welcomes visitors at the front door. PREVIOUS PAGE: An open oculus tops the gracious, newly fashioned entry gallery. Glass spindles in its safety railing allow light to flow through the spaces without obstruction. RIGHT: For entertaining large groups in the reconfigured living room, we designed an extra-long sofa and incorporated a number of easy-to-move, pull-up chairs. A spectacular nineteenth-century Persian carpet covers the floor.

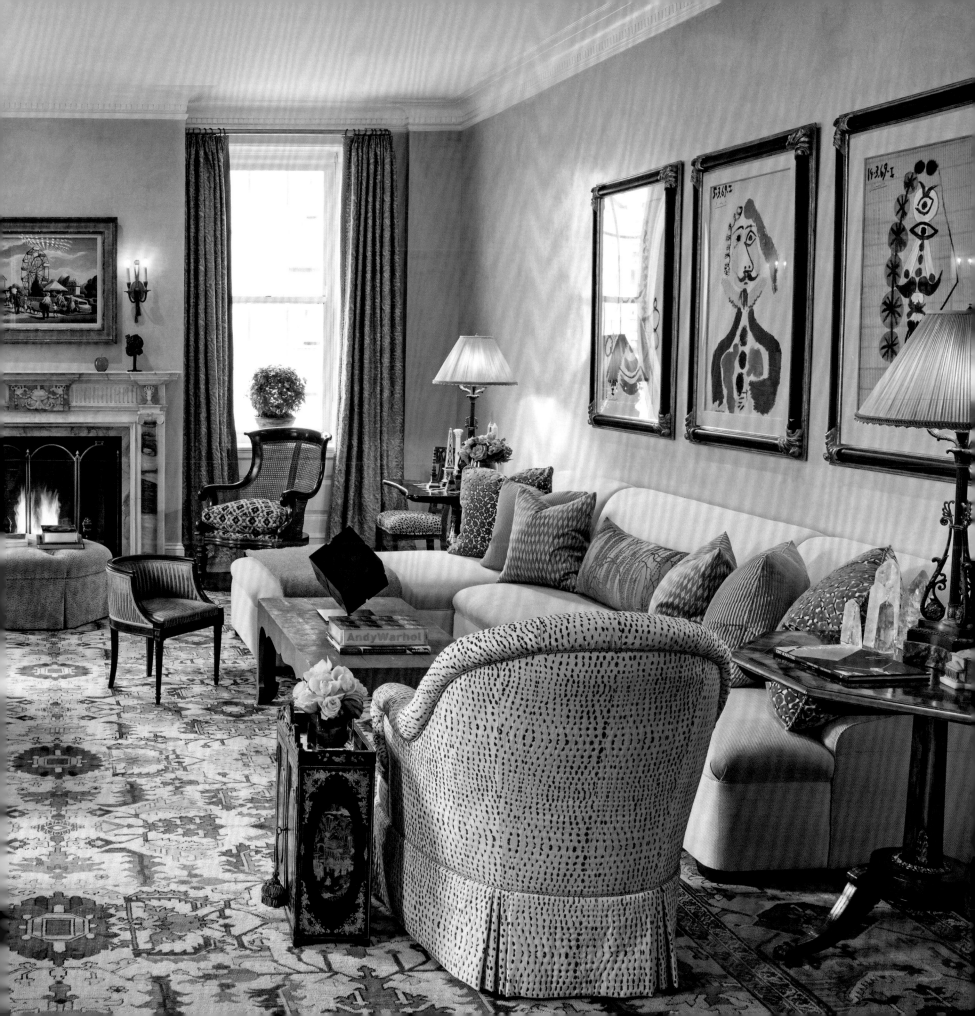

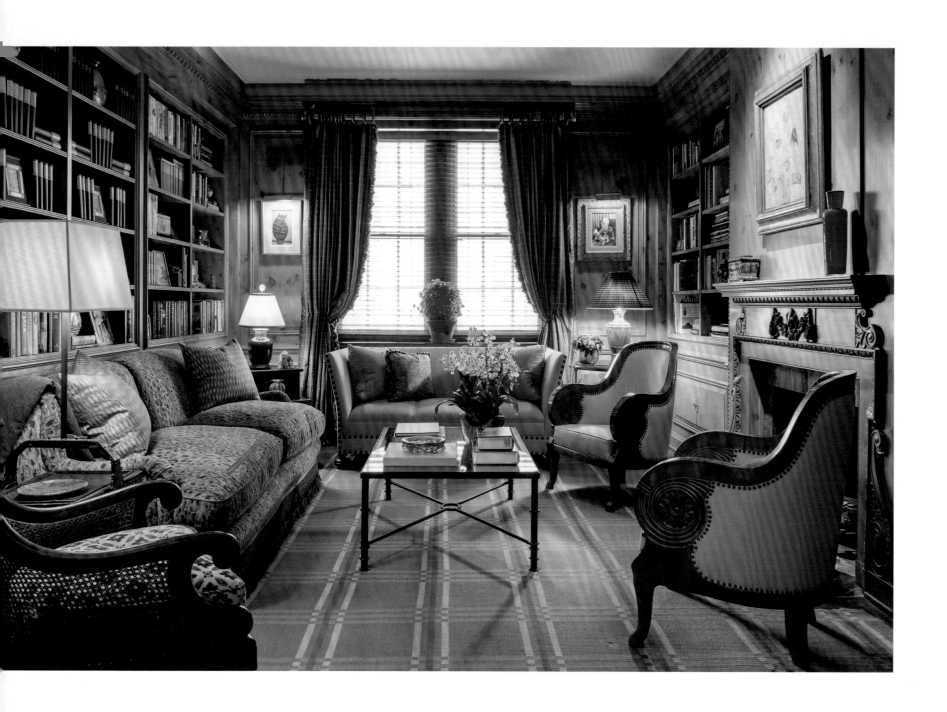

ABOVE: We refreshed the warm, pine-paneled walls of the original library. A handwoven cotton-and-linen carpet provides a comfortable foundation of pattern underfoot. OPPOSITE: Shirred-silk–paneled walls encase the original dining room in a warm, elegant fabric cocoon. Comfortable, slipcovered chairs invite guests to stay at the table.
For an additional touch of fabulousness, I hung a Murano glass chandelier over the conventional English dining table.

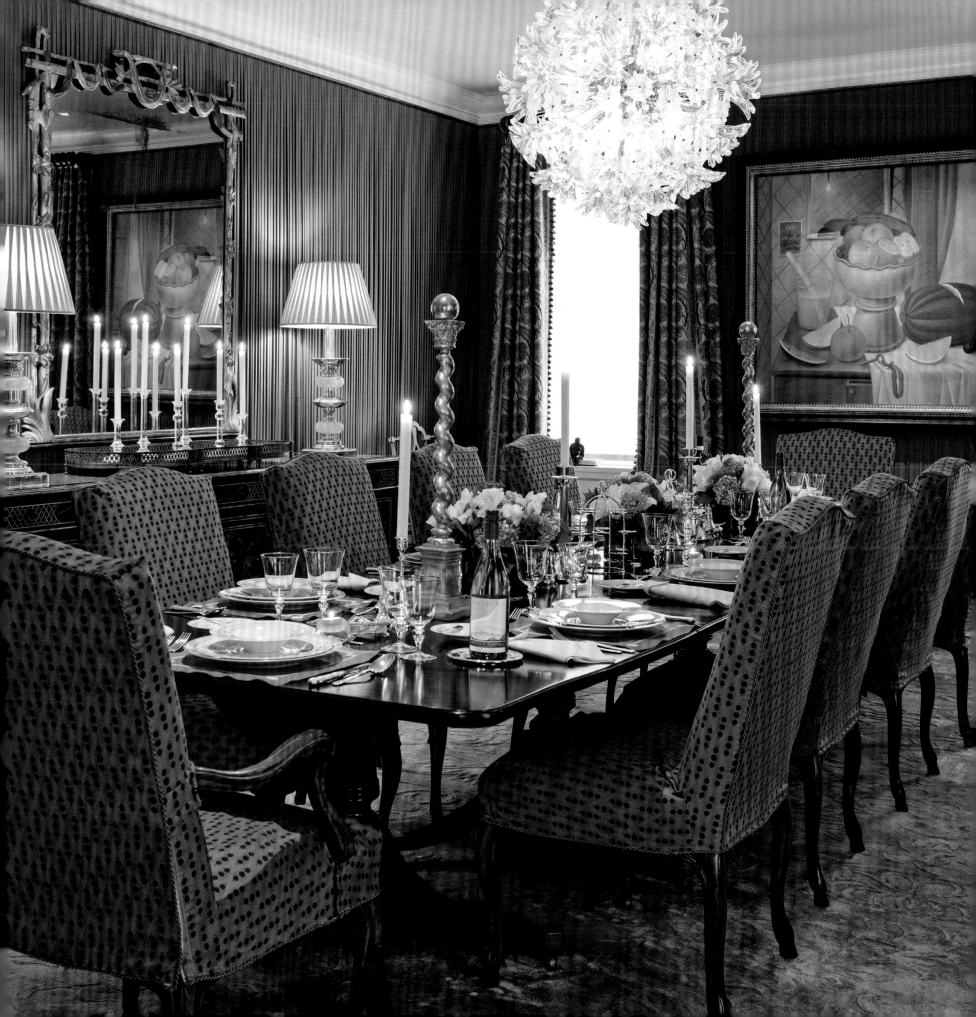

When planning color combinations for a room, it's important to consider everything it will contain. I tend to prefer simple palettes because art inevitably introduces color—and I feel that the art should always stand out.

This new, generously proportioned living/party room contains a collection of extraordinary mid-century designs. A bold, graphic rug ties together the art and all the different pieces.

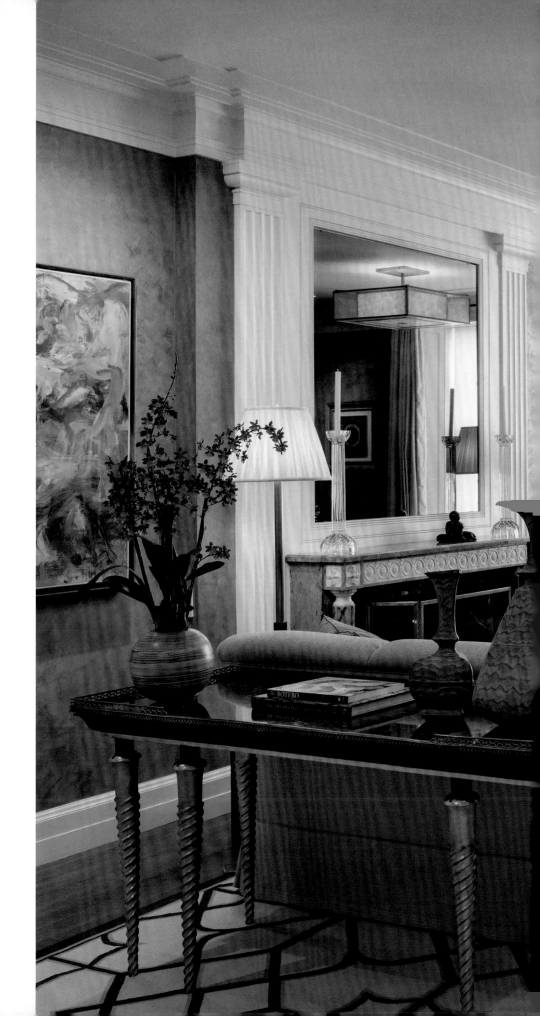

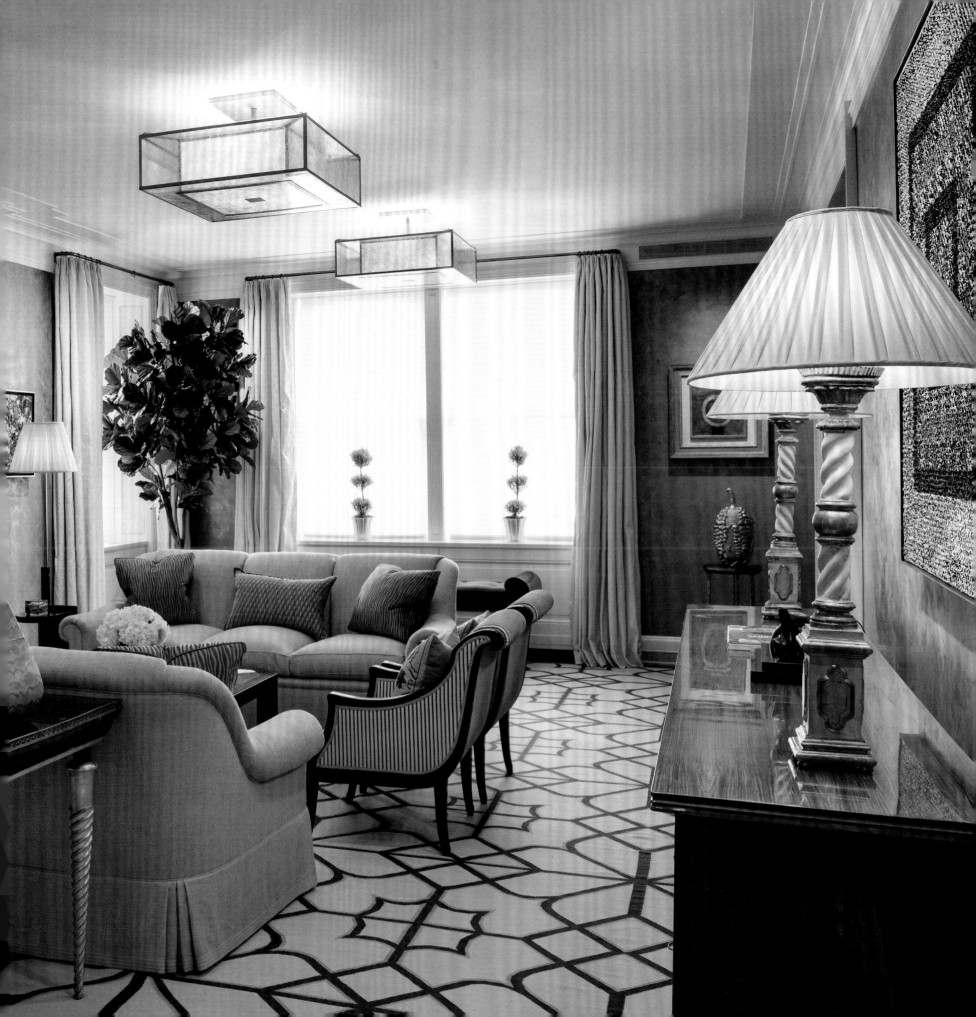

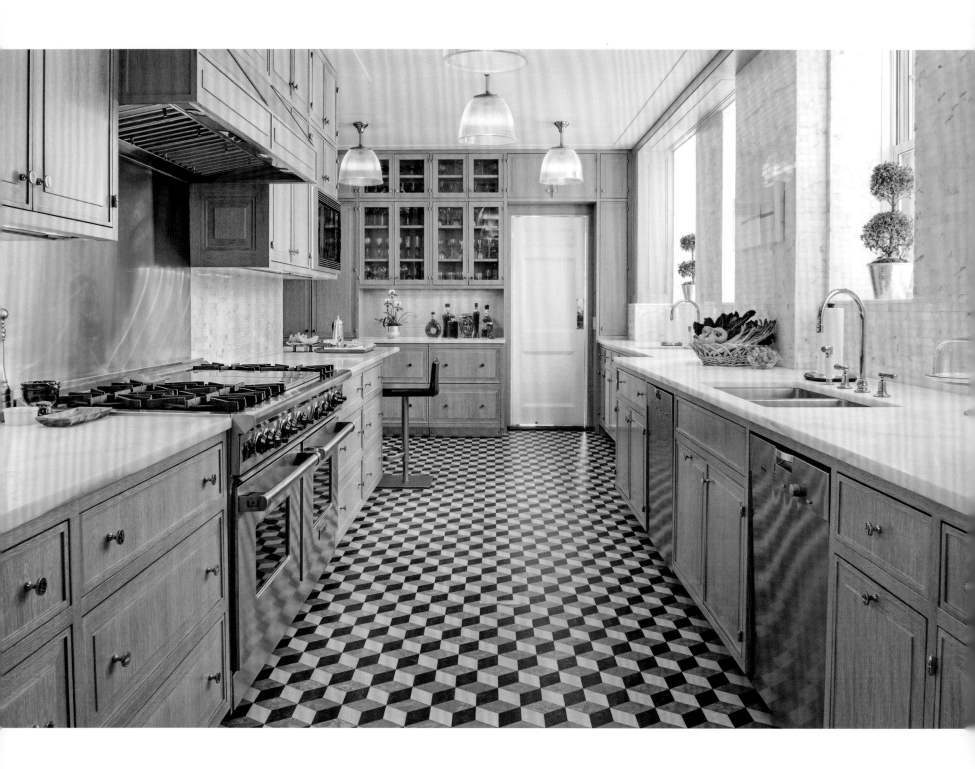

ABOVE: Cerused-oak cabinetry, stainless-steel appliances, and marble countertops give the main kitchen a timeless elegance. The vinyl floor is quiet, comfortable to stand on, and easy to maintain. OPPOSITE: Adjacent to the TV room, this kitchen has become a source of great snacks (everything from popcorn to freshly baked cookies). It was inspired by an image I had seen in an Italian magazine, and I was thrilled to have clients who found the idea of red lacquer as wonderful as I did.

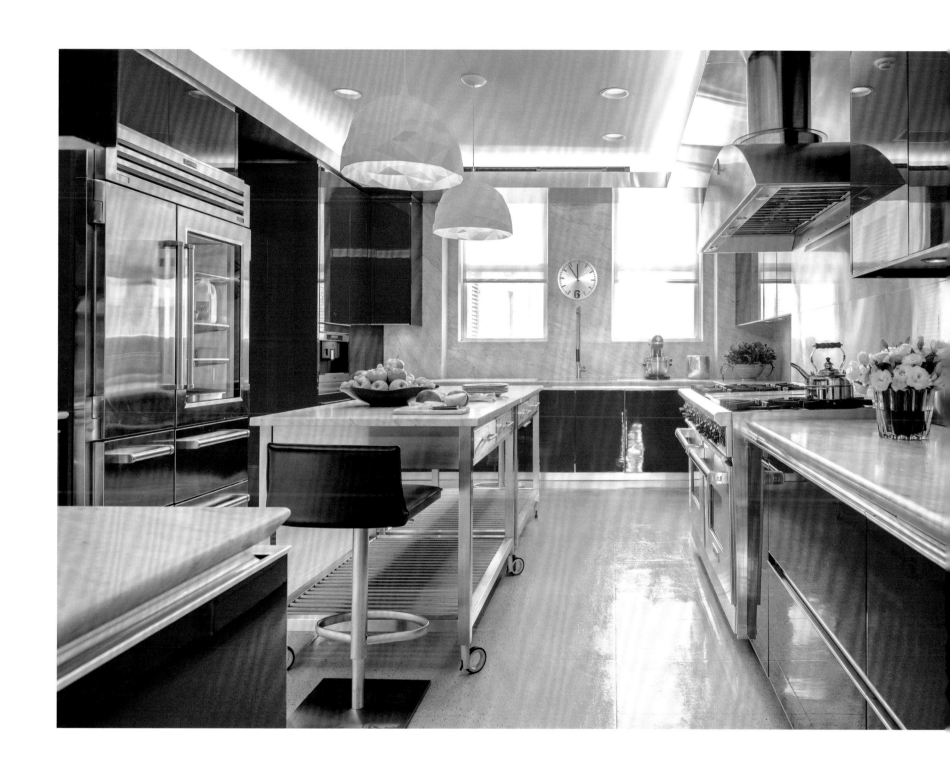

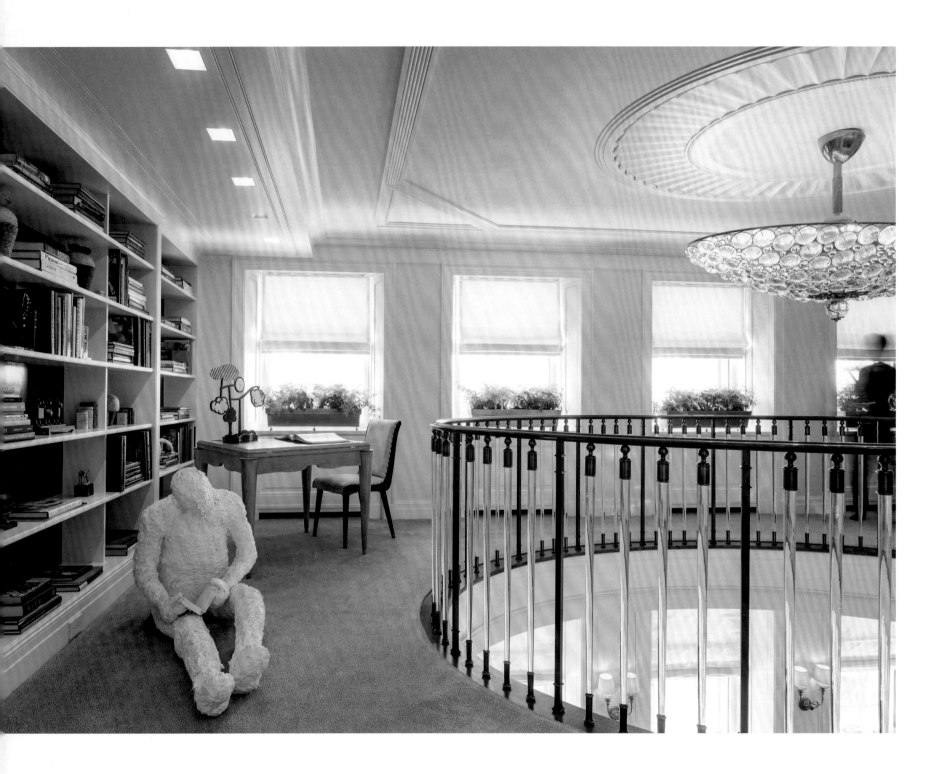

ABOVE: In combining the two apartments, Mark Ferguson and his team created the second-floor gallery. The oculus ties the penthouse and lower floor together visually. A table in one corner is a go-to spot for all sorts of board and card games—and is just right for jigsaw puzzles, too. OPPOSITE: In the office, applied nailhead trim gives texture and definition to walls finished in bleached oak with leather panels.

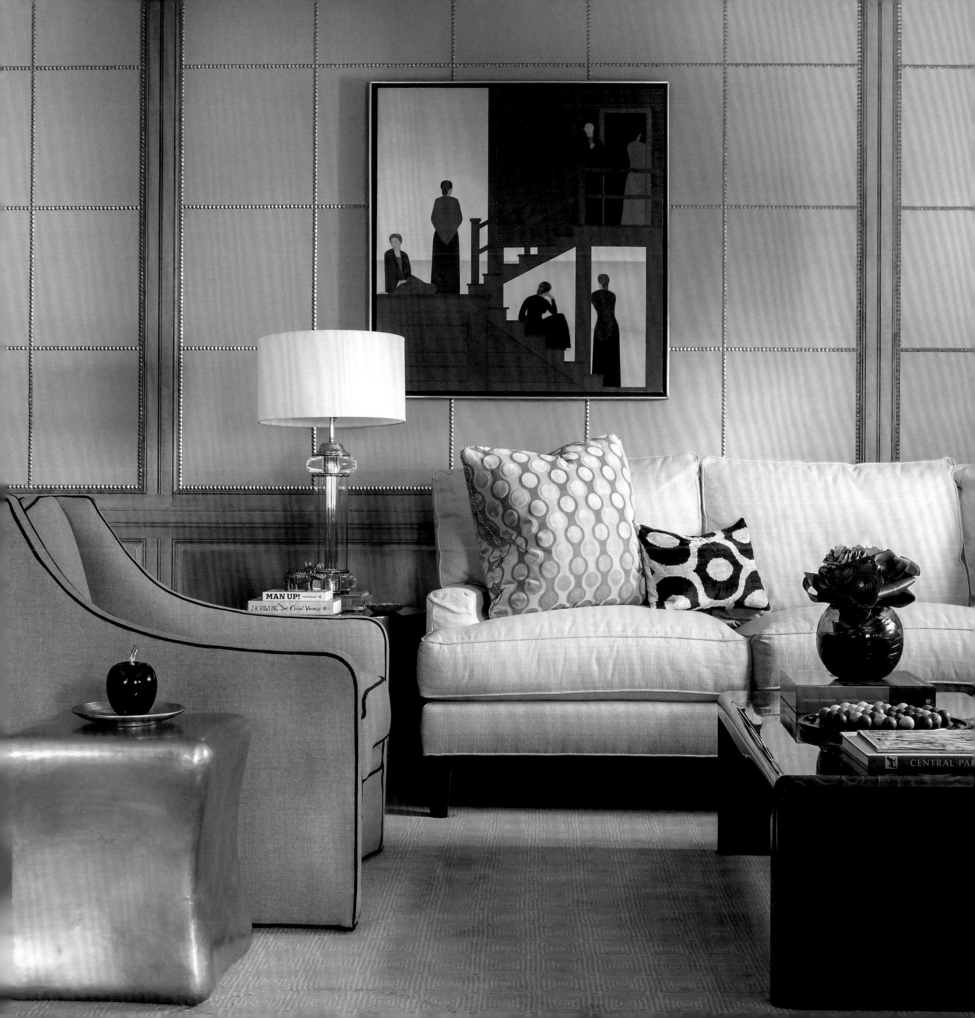

RAISED COTTAGE

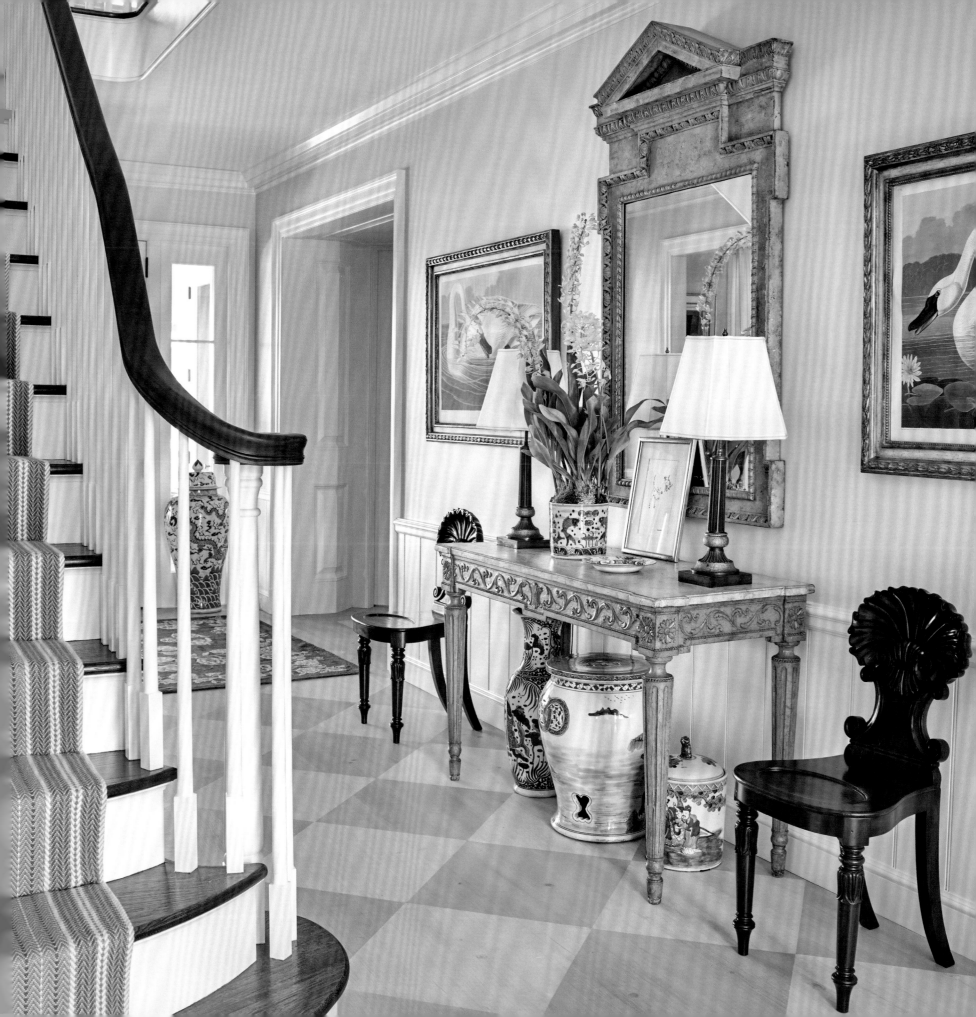

Sometimes tragedy can open the door to an exciting adventure. When former clients and dear friends called to report that Hurricane Sandy had completely flooded their house, we immediately rushed out to retrieve as much of the contents as possible. Furniture headed to restorers; rugs, to cleaners. Once documented, the remaining salvaged contents went to storage.

The house itself was another story. When later we talked with contractors, we realized it was impossible to save. The silver lining appeared with architect David Hottenroth of Hottenroth+Joseph, who was able to design a new house on the existing footprint with the same spirit and a much better plan. (With additions over the years, the original floor plan had become somewhat awkward.)

We made every effort to make this house feel like the original. The newly created front hall has wonderful views front-to-back and floors painted with washed, water-based paints to give an immediate feel of patina to the new construction. The living room remains the same proportions. So does the octagonal dining room, where we re-created Robert Jackson's original painted lattice decoration, which washed away in the storm. Paneled with beautiful cypress boards, the library is a new creation. So is the master suite. The open kitchen greatly improves on its awkward predecessor with space for a working island and a lovely adjacent breakfast room with water views. Large, sunny bedrooms, filled with pieces saved from the storm, now occupy the second floor.

The new building codes mandated that we raise the entire house up from its original foundation, which resulted in much better views and allowed us to construct wraparound porches overlooking the bay. Graced with rocking chairs, these porches have become the most popular gathering points of all. We also enlarged, strengthened, and winterized the screened porch, always the clients' favorite room. Because the storm pummeled a small guesthouse, we developed a new guest bedroom and sitting room where the owners' sons can stay on summer weekends.

Working with clients over a long time is deeply fulfilling, especially because of the memories you share about each and every piece you collect for their homes. Years ago, for her first apartment in New York City, I discovered a fabulous Indian Dhurrie carpet, which we installed in the dining room. This rug became one of her favorite possessions. When she later moved to another apartment, the rug did not fit and went into storage. Now this special piece has found its place again. Just like this couple, it has come home to this house.

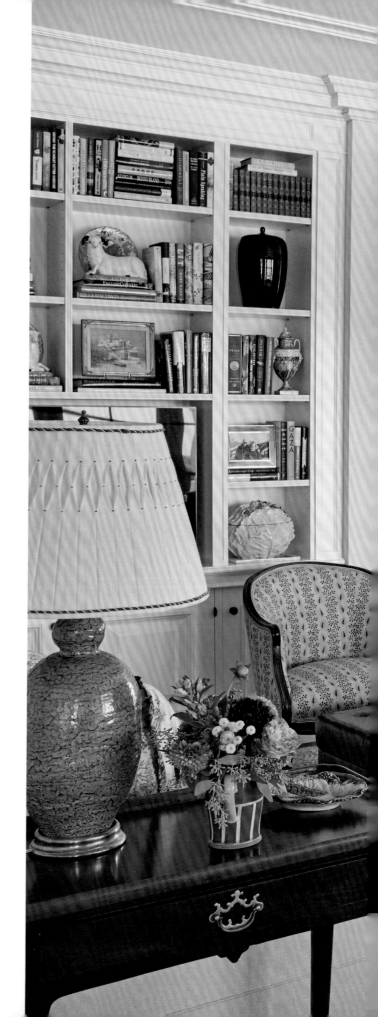

For a room to really be usable, it has to contain all the furnishings and other elements that make it functional daily.

PAGE 221: Washed, water-based paints on the entrance hall floor capture the essence of the views surrounding the house. A handwoven, striped carpet directs the way up the stairs. PREVIOUS PAGE: An antique, gilded Italian table in the entry hall frames a display of the client's collection of blue-and-white porcelain. RIGHT: A TV tucked into a bookcase is visible from all the chairs grouped around the living room fireplace as well as the room's many other vantage points. Cottons and summery floral prints feel appropriate and at home on the couple's English, French, and Italian furnishings. FOLLOWING PAGES, LEFT: Bouquets of summer blooms in a mochaware mug bring the room's floral patterns to life. FOLLOWING PAGES, RIGHT: A painting by artist John Funt hangs over an inviting living room sofa laden with antique textiles.

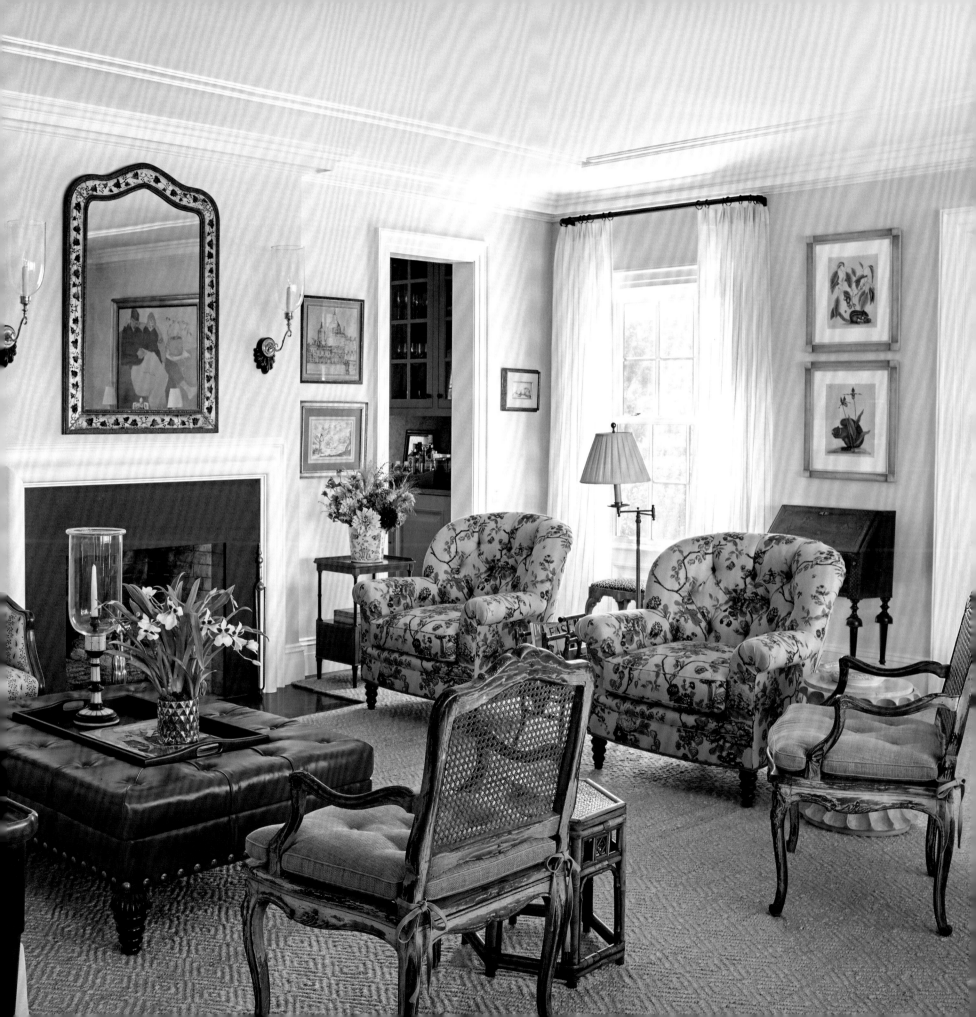

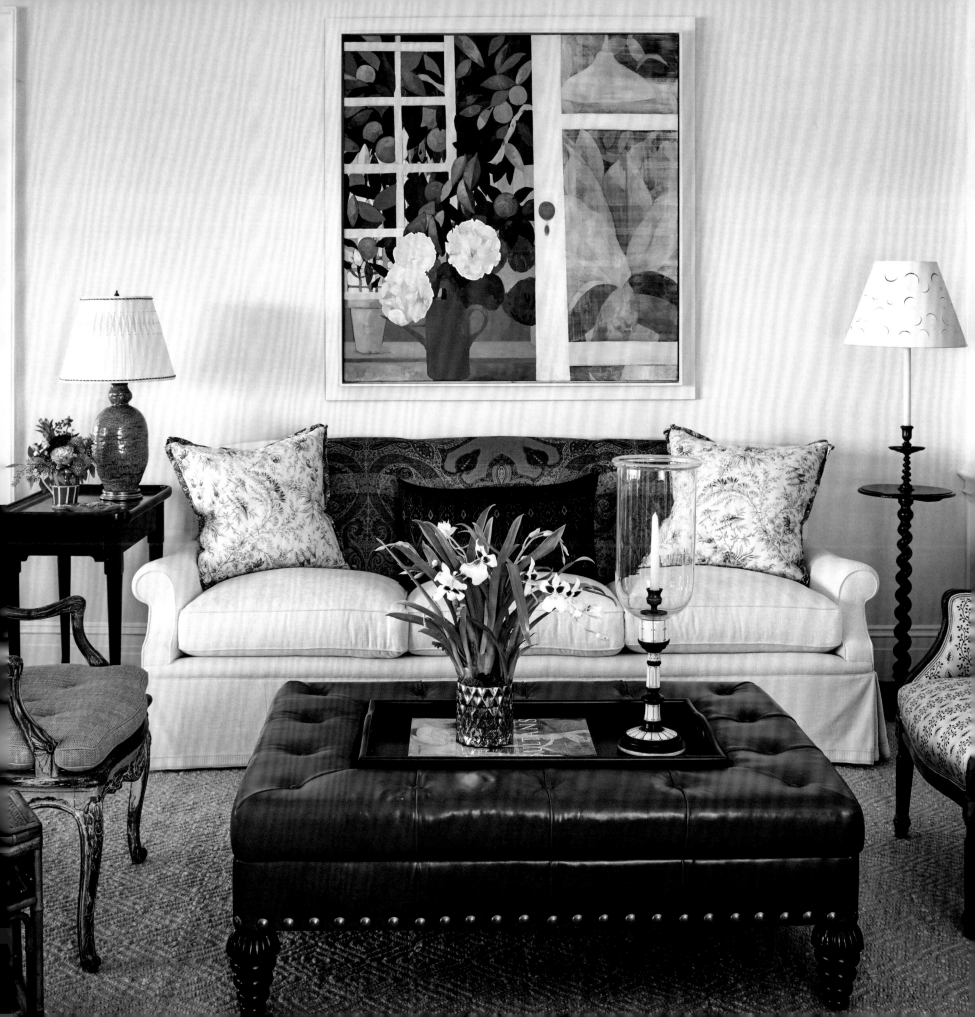

Mixing textiles and prints of different patterns with ethnic embroidered cushions helps to create an impression that a room has evolved over time.

The comfy sofa in the bay window offers the ideal spot for taking an afternoon nap. Under the coffee table, a hooked zebra rug on top of the sisal carpet gives the seating group a solid grounding.

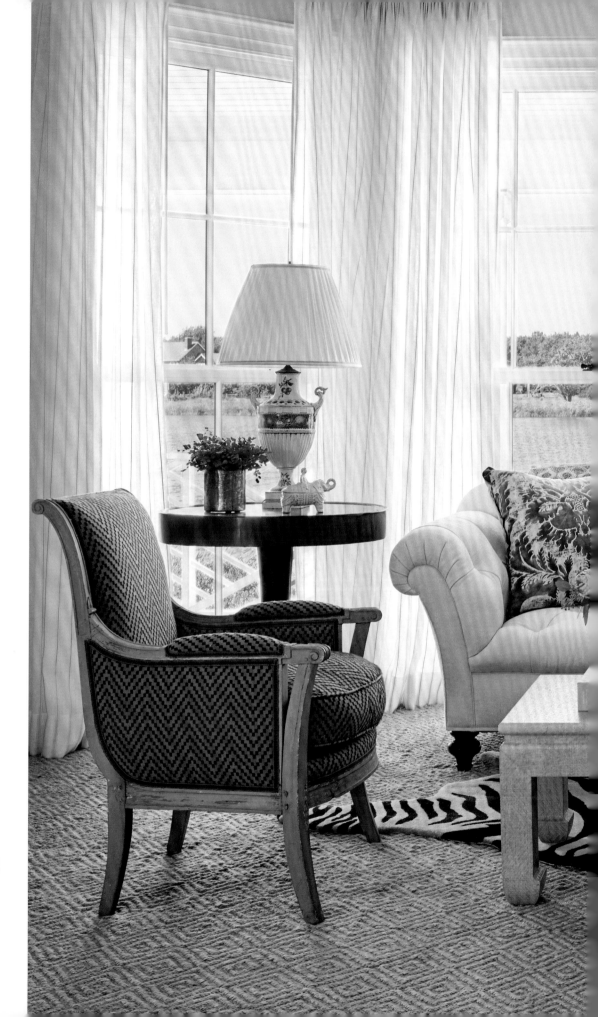

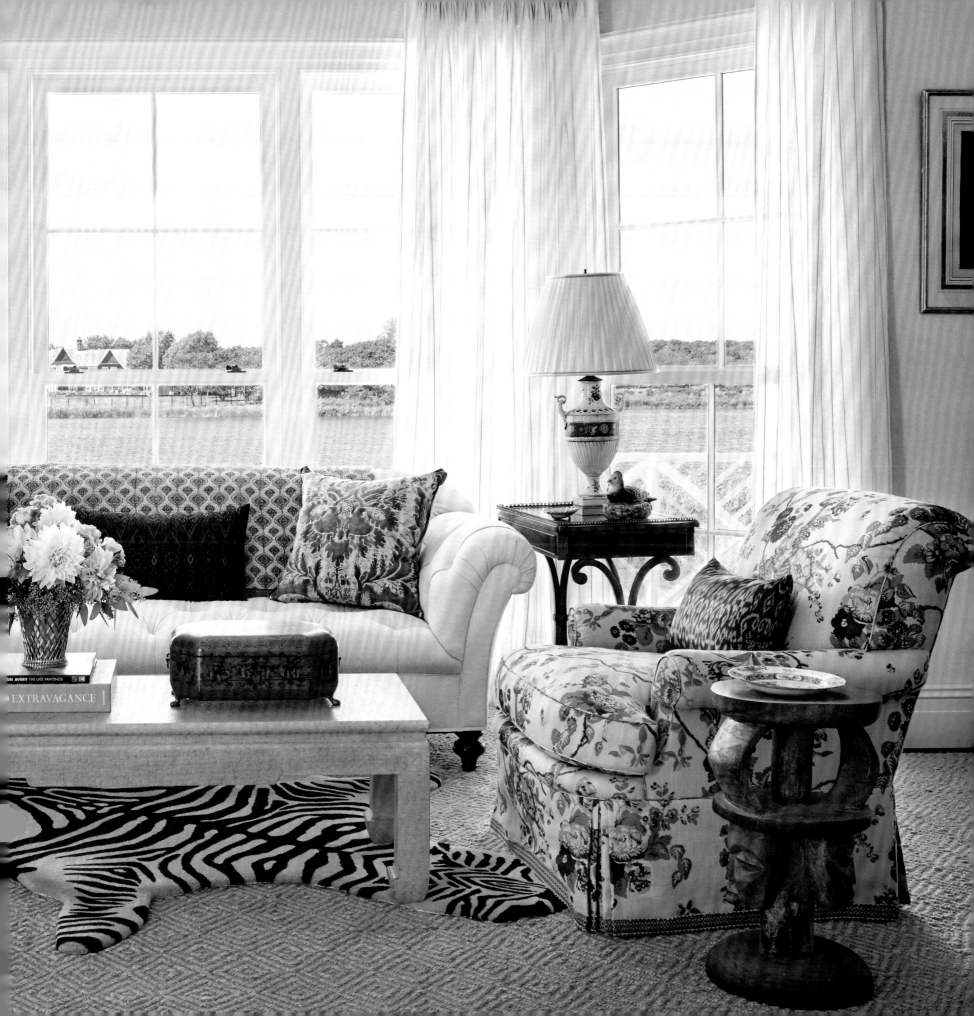

Always buy the pieces you love. They will move with you from place to place and room to room.

RIGHT: Walls with a lattice motif and painted English bamboo chairs help to suggest that this sunny dining room is part of the garden. FOLLOWING PAGES: The character of a house emerges from the small details. The shell back of an English chair, a diminutive Ethiopian drinks table, duck terrines on a dining table, a frog umbrella stand—each is wonderful on its own. Together, they establish personality.

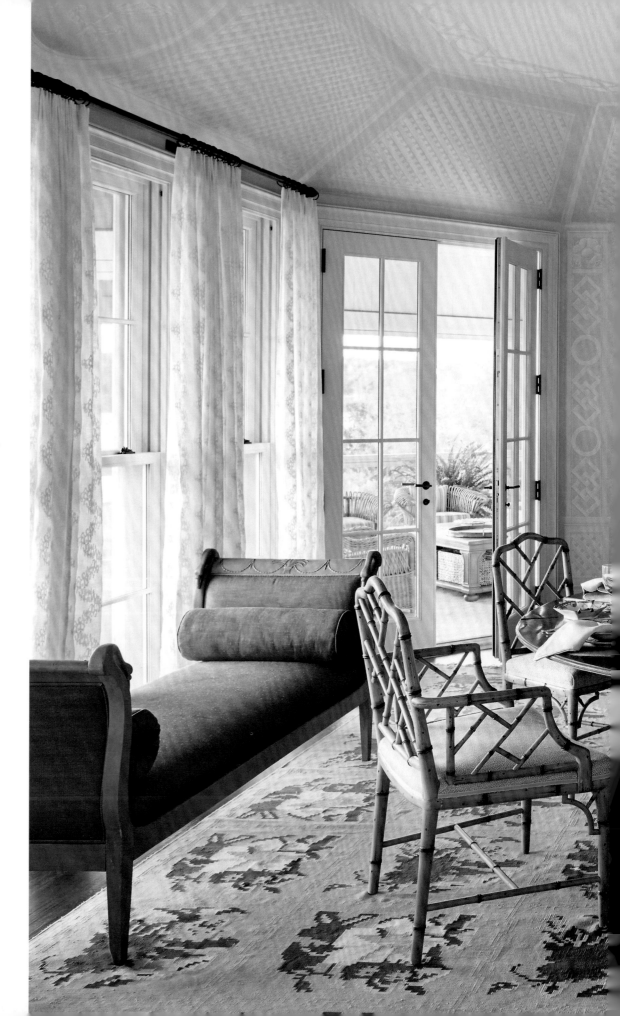

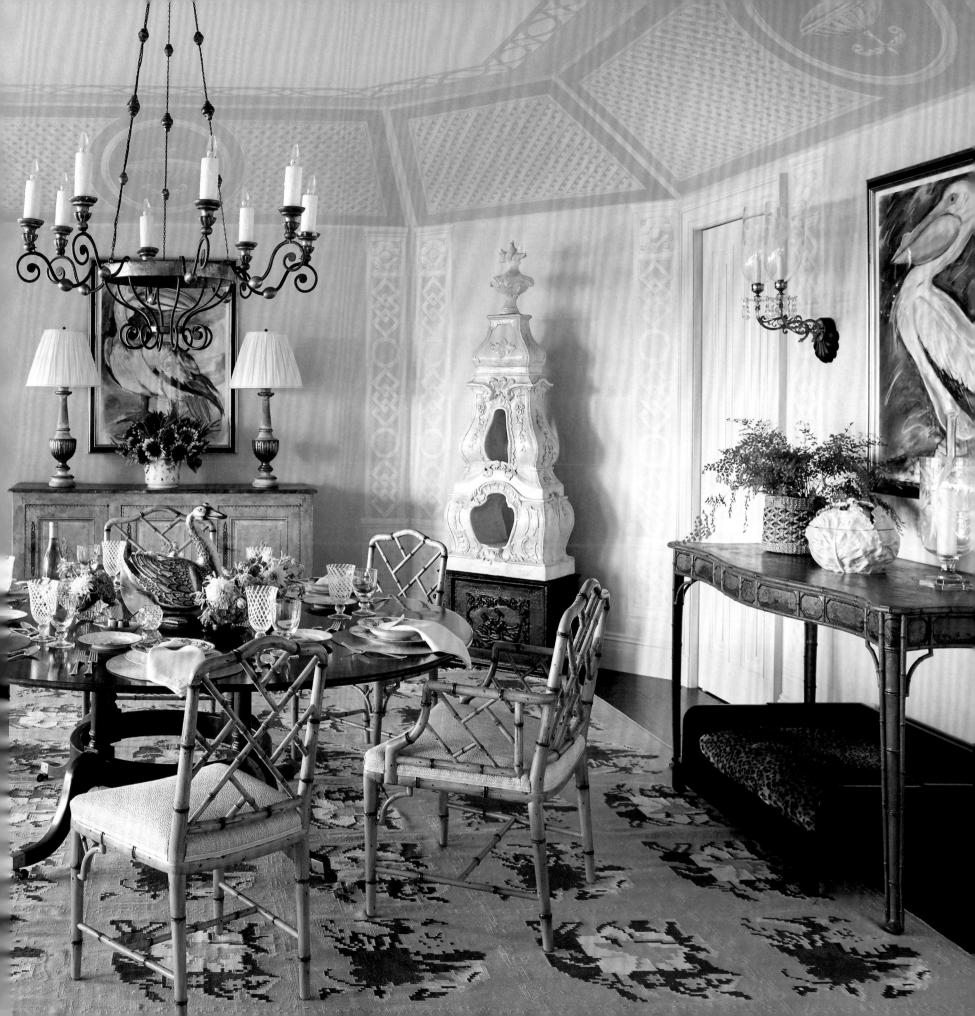

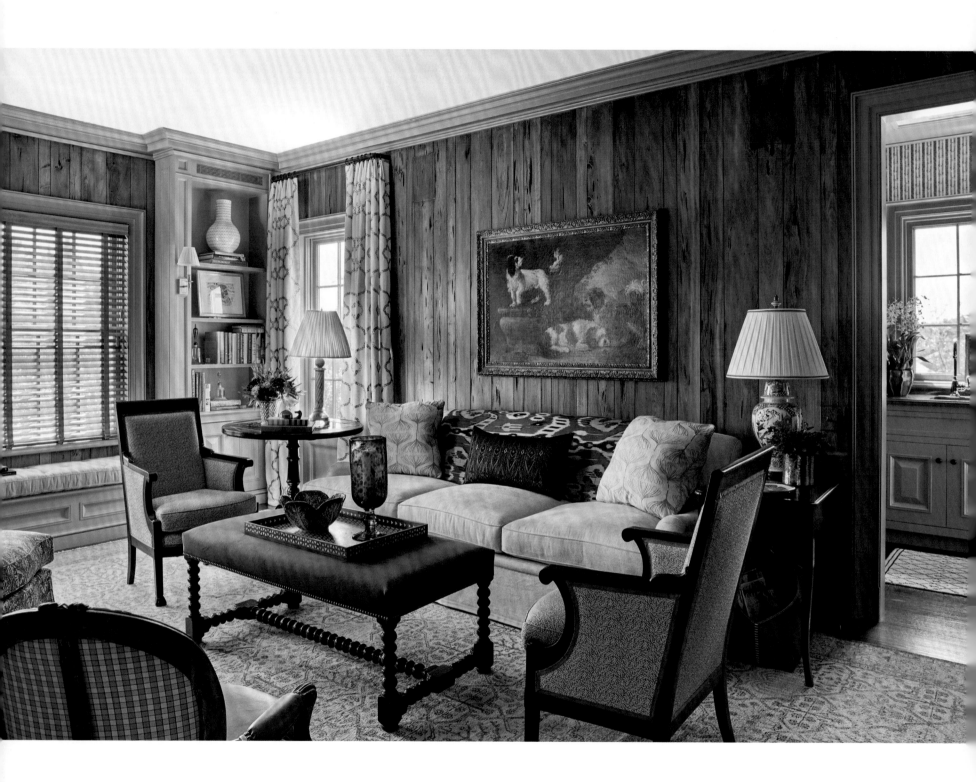

ABOVE: Specialty painter John LaPolla beautifully blended and finished the cypress boards that panel the library. Painted a soft blue, the trim complements the paneling. OPPOSITE: In its redesigned state, the kitchen accommodates a substantial central working island and opens into a delightful breakfast room with views of the water.

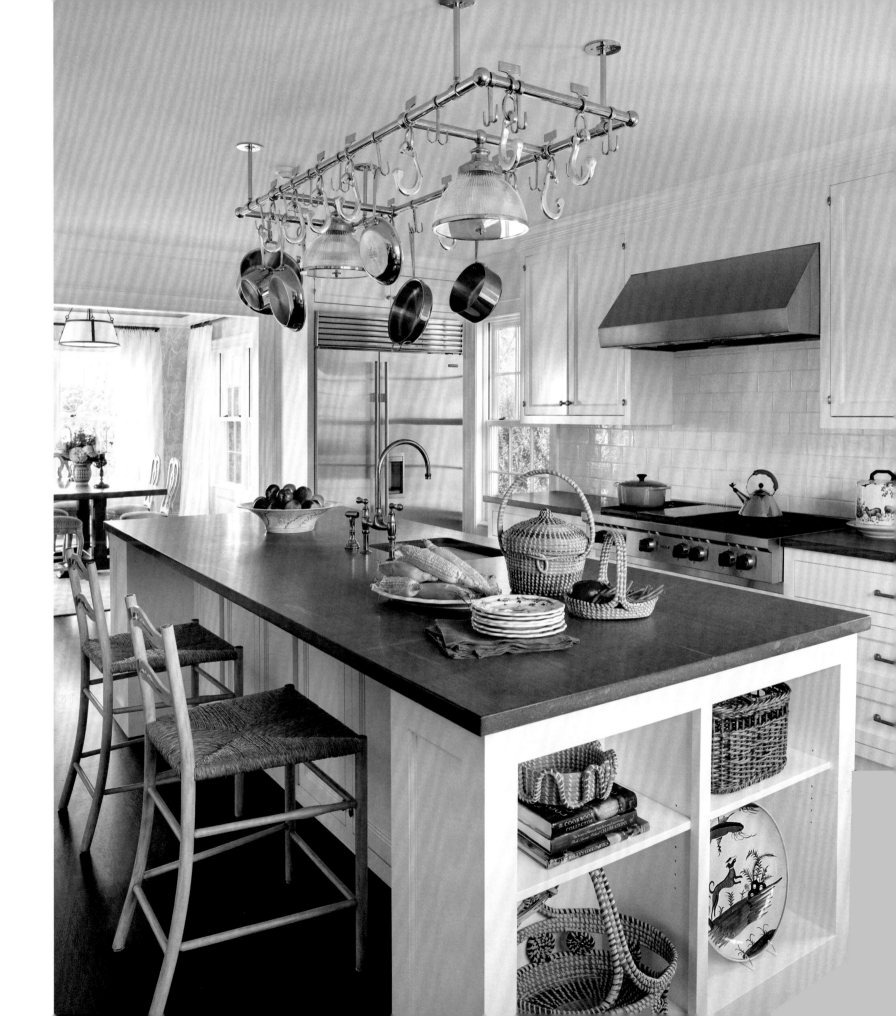

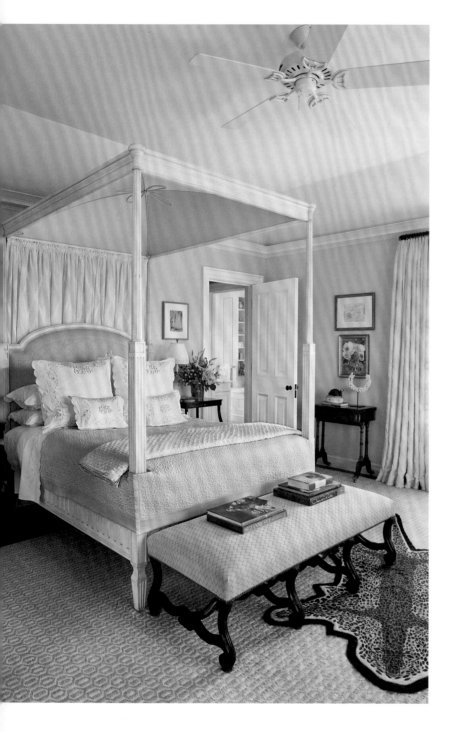

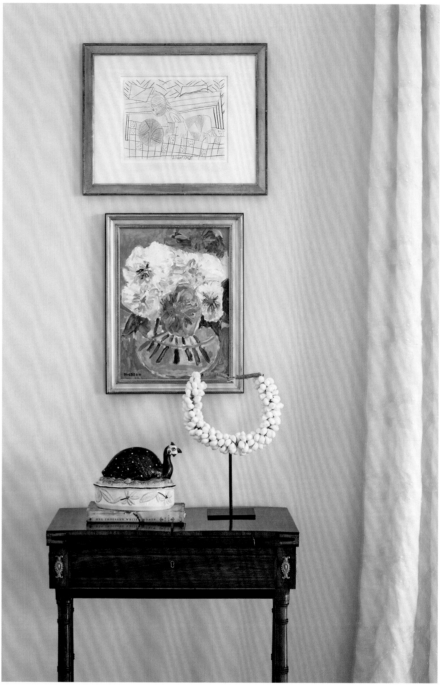

ABOVE, LEFT: In the master bedroom, the color palette complements the view of the water. An embroidered headboard adds a flourish to the white-painted, four-poster bed. ABOVE, RIGHT: Walls painted a soft French blue give the room a watery feeling. OPPOSITE, LEFT: Monogrammed sheets by Léron add to the room's quiet. OPPOSITE, RIGHT: The blue-and-white motif washes up in the master bath's painted cement floor. Beautifully detailed millwork provides storage for towels and bath linens.

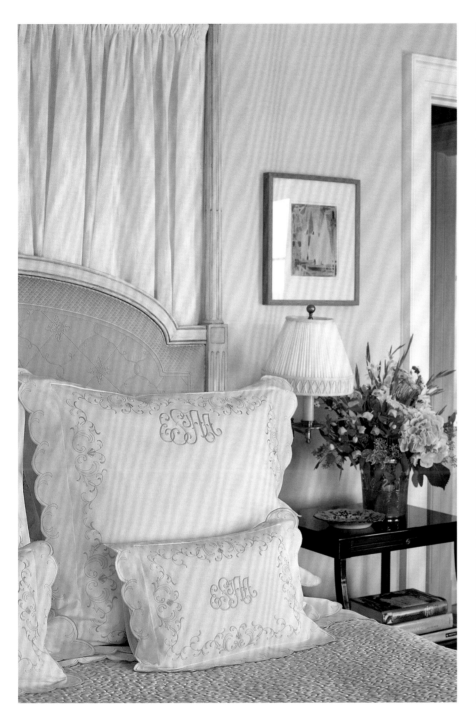

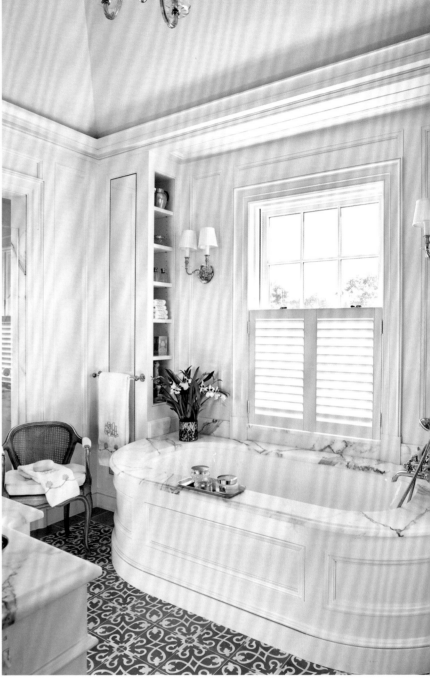

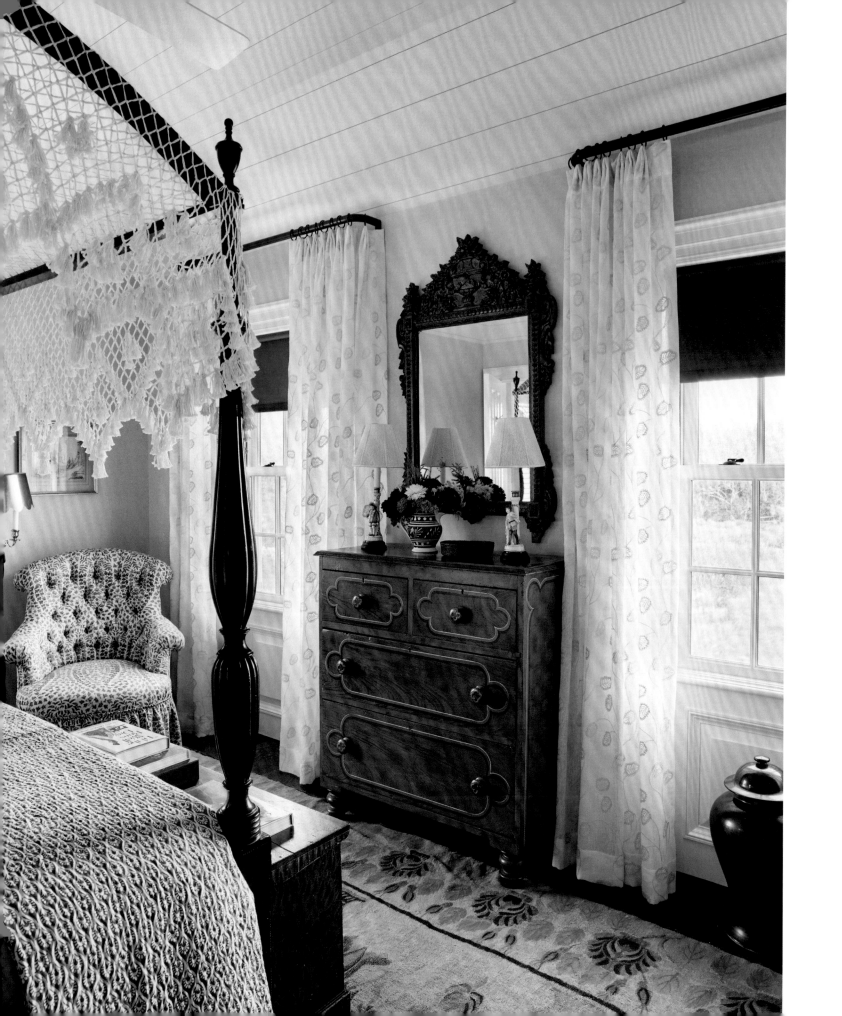

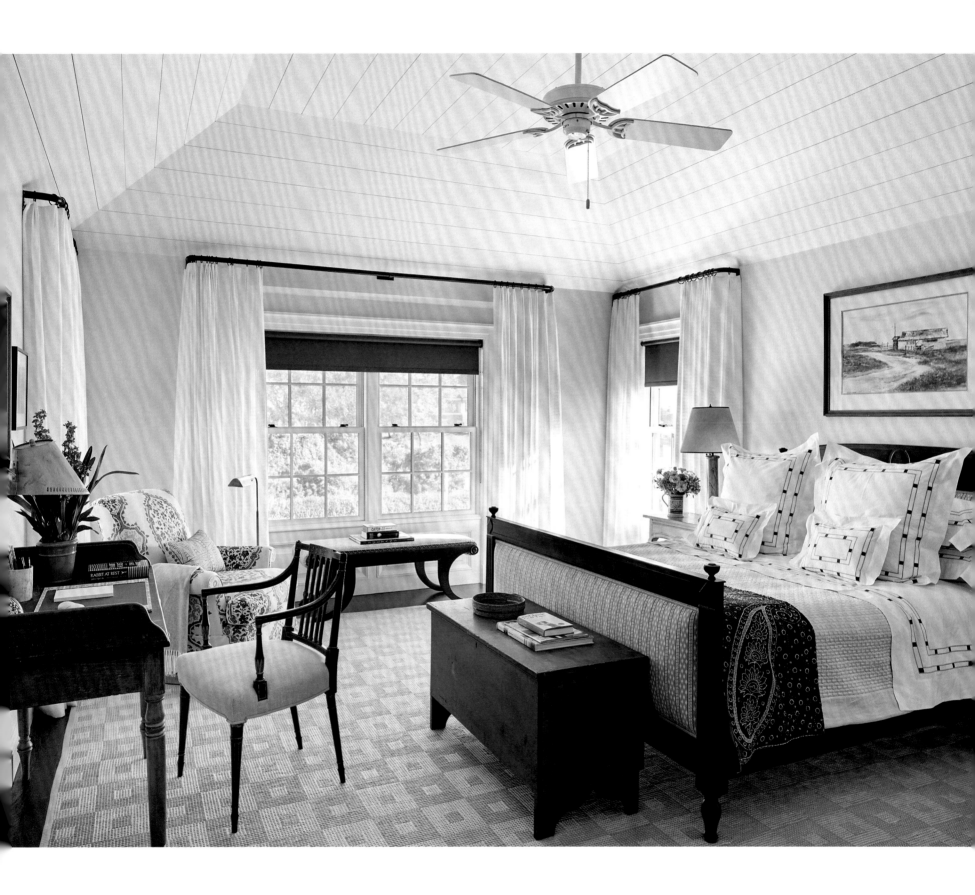

When I'm decorating an indoor/outdoor space, I always try to respect the view and bring it in with the fabrics and color palette.

PREVIOUS PAGES, LEFT: Sheer curtains with old-fashioned, dark-green blackout shades cover the windows in the guest bedrooms. PREVIOUS PAGES, RIGHT: Painted country furniture saved from the original house fills the guest bedrooms. RIGHT: In the renovation, the screened porch was enlarged and winterized. Rattan furniture with soft cushions fills the space. A porcelain-topped table sits in the corner, a perfect place for lunches.

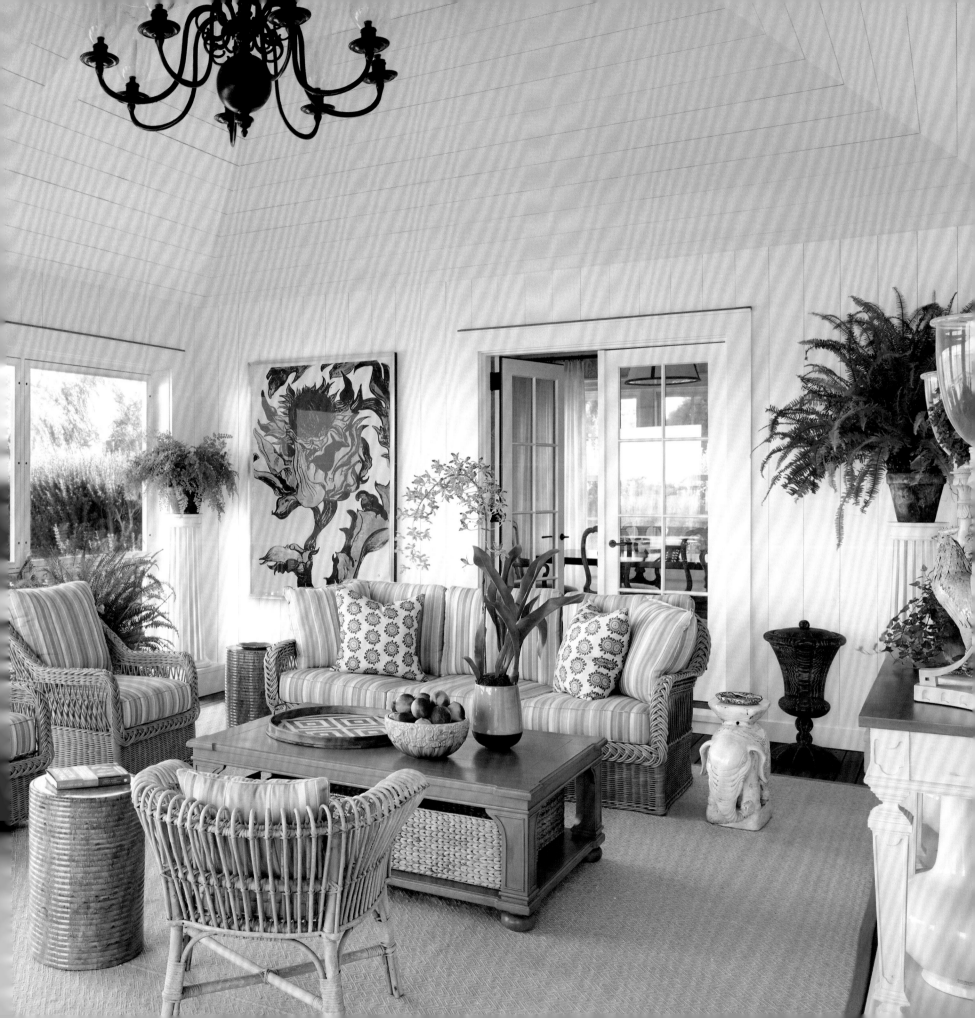

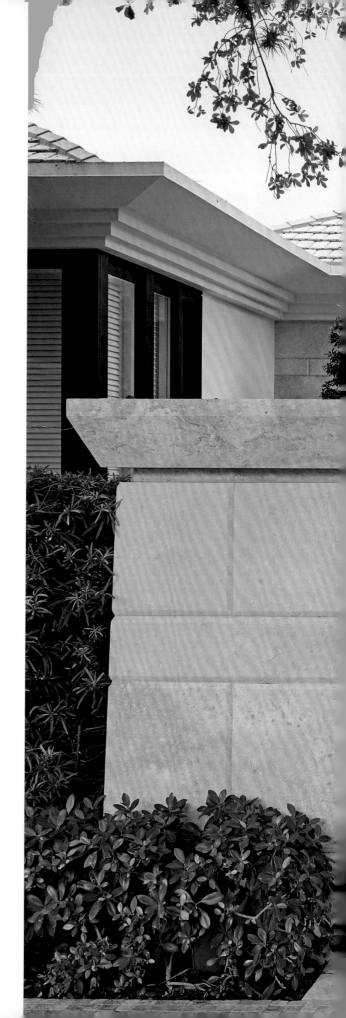

FLORIDA STYLE

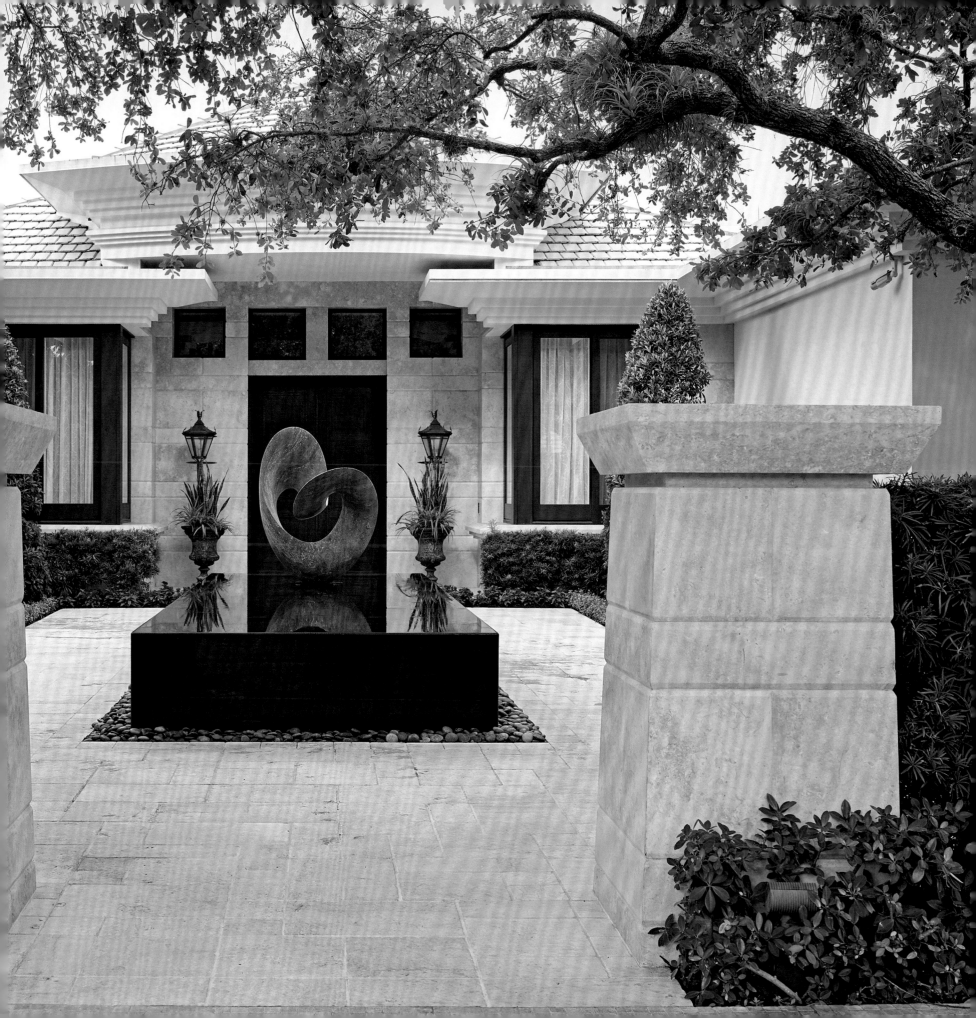

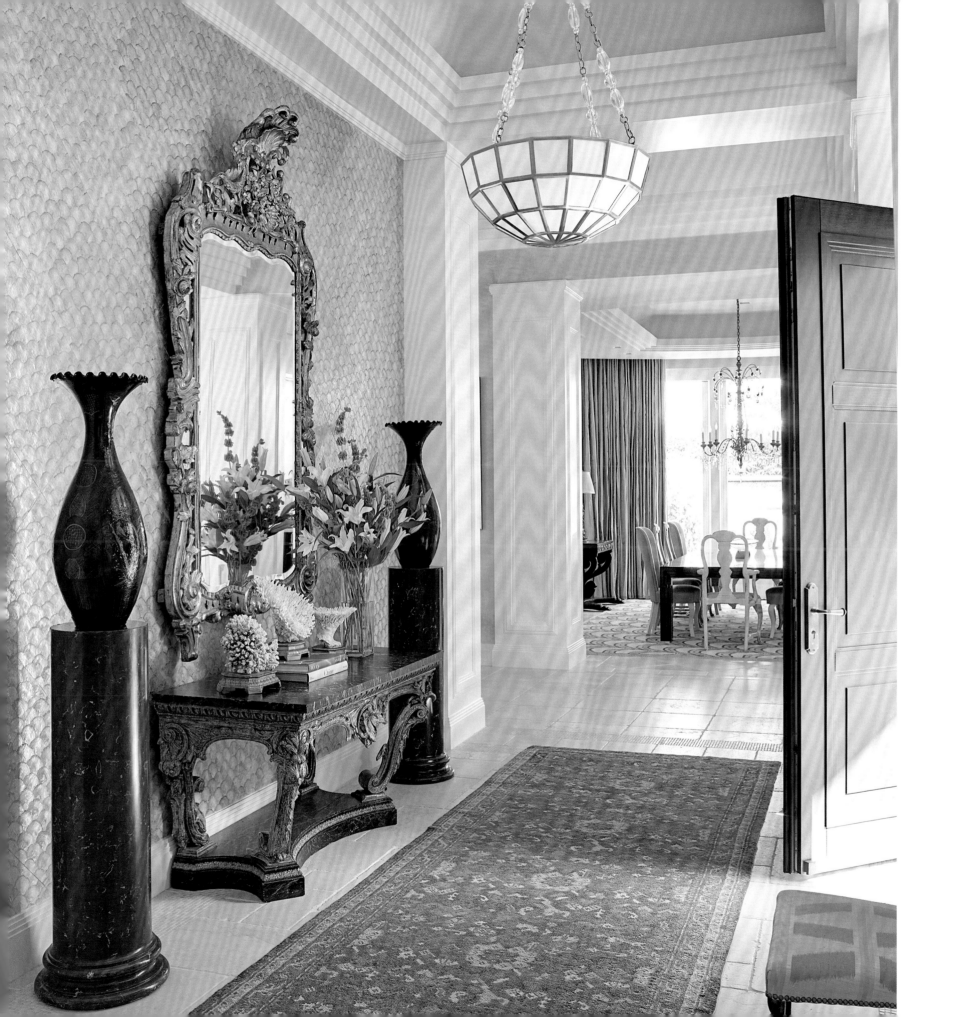

In the midst of working with this wonderful couple on what I thought was going to be their newly built house in Florida, they called and said, "Stop. We've found a house we really love, and we've bought it." They asked me to come immediately to take a look. When I opened the front door, I could see right into the living room—something I've always hated.

Although I was rather intimidated to be decorating for one of America's most famous CEOs, I had to tell him what I thought. So I said, "There are two columns. You've got to put up a wall." And he said, "Absolutely not. I love seeing the water when I open the door." I tried to explain the function of entrance halls: that they give you a place to come in, take off your coat, greet and be greeted. That they allow the house to unfold. He was not having any of it. (I sometimes fail to understand why clients don't listen to their designer's initial instincts.)

We proceeded with the rest of the planning and design. She is an extraordinary cook, so they wanted a large, family kitchen and a breakfast room, a place where he could watch football games while she was making dinner. The master bedroom also needed new closets and bathrooms.

With renovations done, decorating complete, and furnishings in place, the couple moved in. About four months later, he called and said, "Come down and put up that damned wall." I have to say, I felt very vindicated in this. And when they left Florida for the season, we easily created the entrance hall the house always should have had. We are still working together. We love each other very much. And now he tells me, "I'll do anything you say."

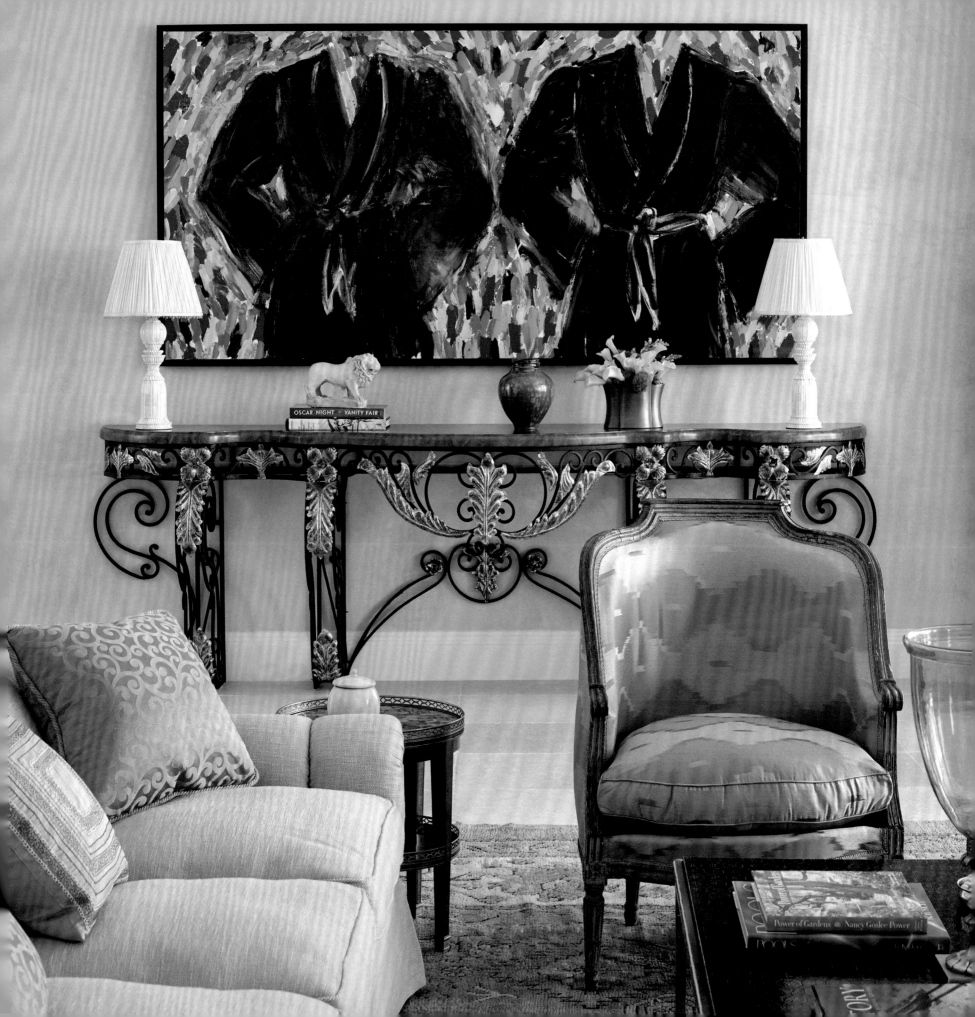

The clients may
not always agree,
but it's important
to say what you
feel, to be honest
and give your very
best advice.

PAGES 242-243: The owners commissioned a
sculpture to give the entrance courtyard a serene
sense of arrival. PAGES 244-245: When I was
finally able to put up the wall, we purchased
an extraordinary eighteenth-century French
console table for the entrance. An abalone
shell wallpaper by Maya Romanoff combines
beautifully with pieces of coral on gilded bases.
PREVIOUS PAGE: When we found the
nineteenth-century Oushak carpet, the living
room's color palette began to emerge. The wall
above a large French iron console table was
perfect for a modern painting. RIGHT: A large
seating group floats in the middle of the room
around an overscale Italian brass coffee table.

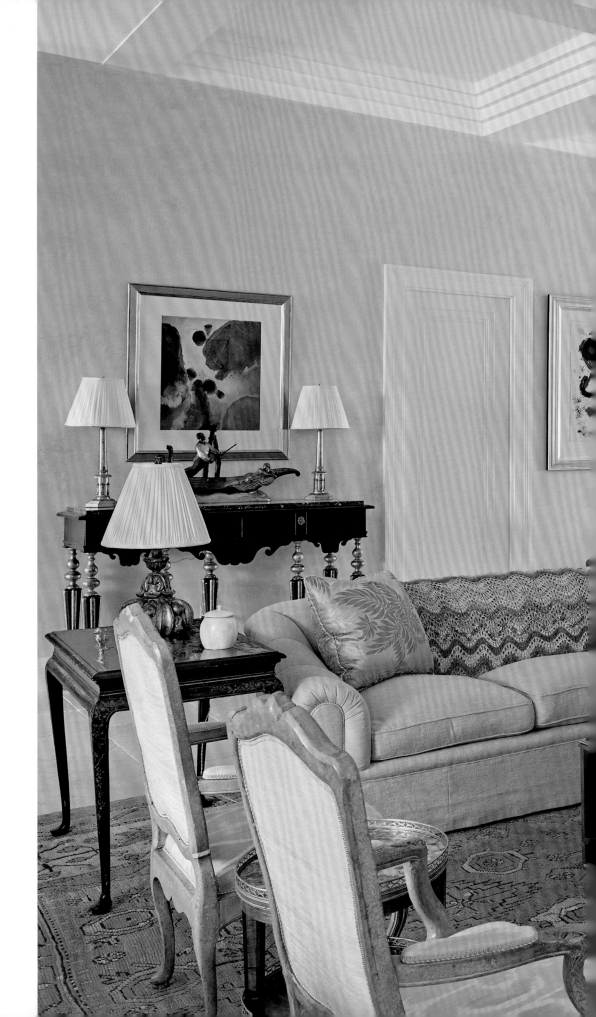

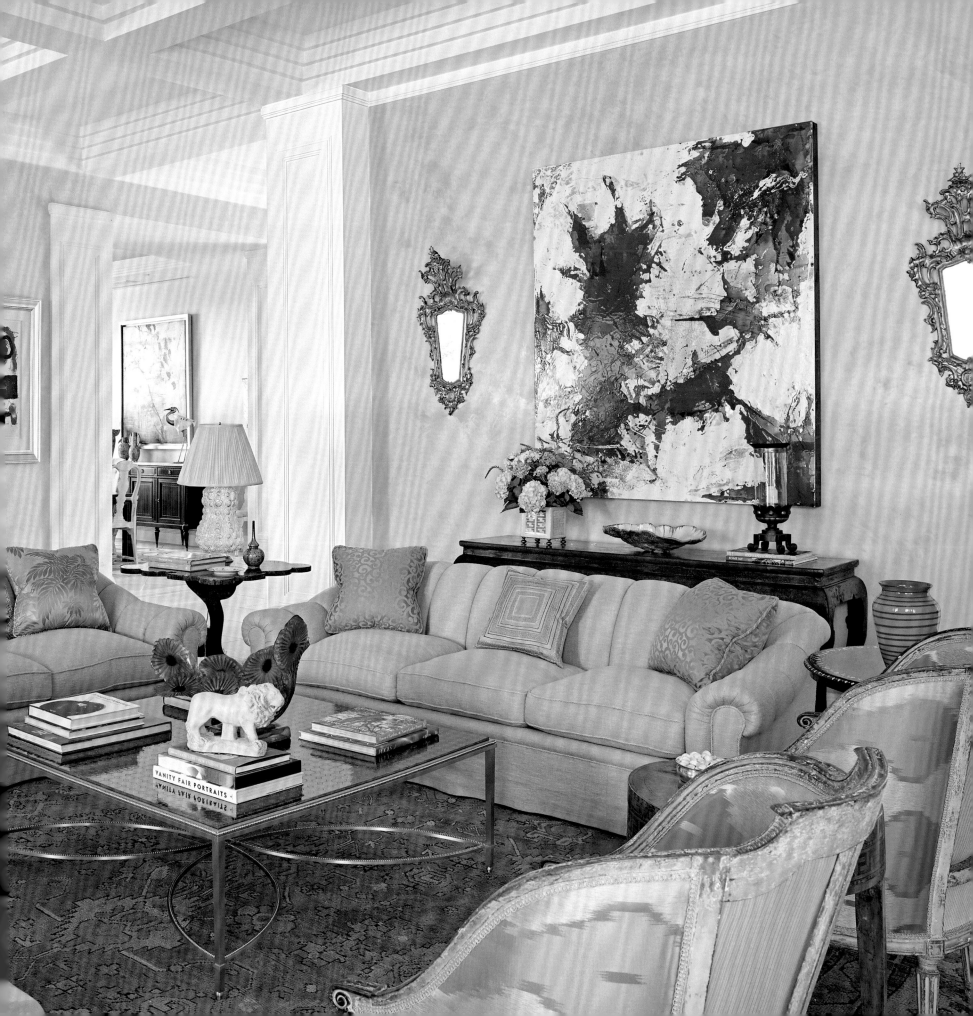

RIGHT: For the dining room, we found a lacquered Parsons table that has an extension. I surrounded it with a mixed collection of upholstered and painted Swedish chairs. The contemporary rug gives the illusion of waves underfoot.

FOLLOWING PAGES, LEFT: An upstairs sitting room in the guesthouse is a perfect getaway place for visiting family and friends.

FOLLOWING PAGES, RIGHT: A corner of the newly designed kitchen with wood-paneled walls and cabinets includes a small seating area, where a Moroccan carpet warms up the stone floor.

250

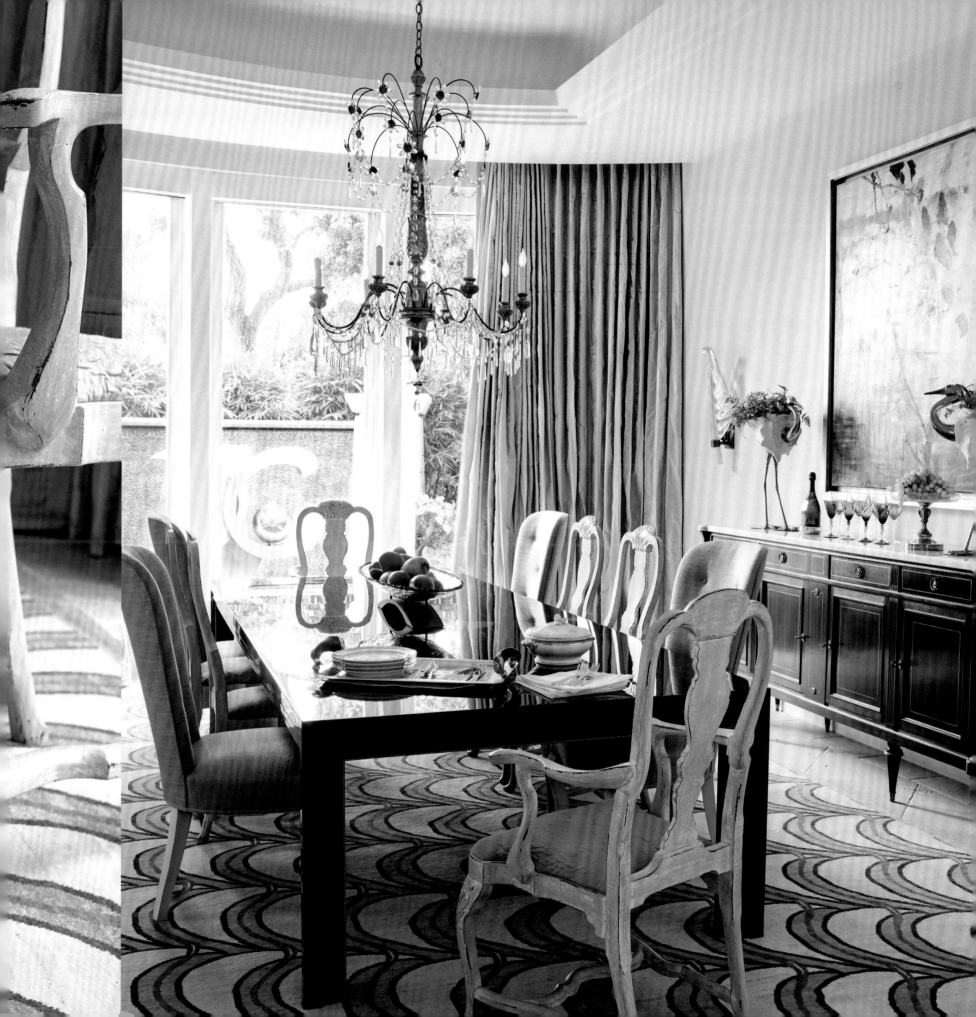

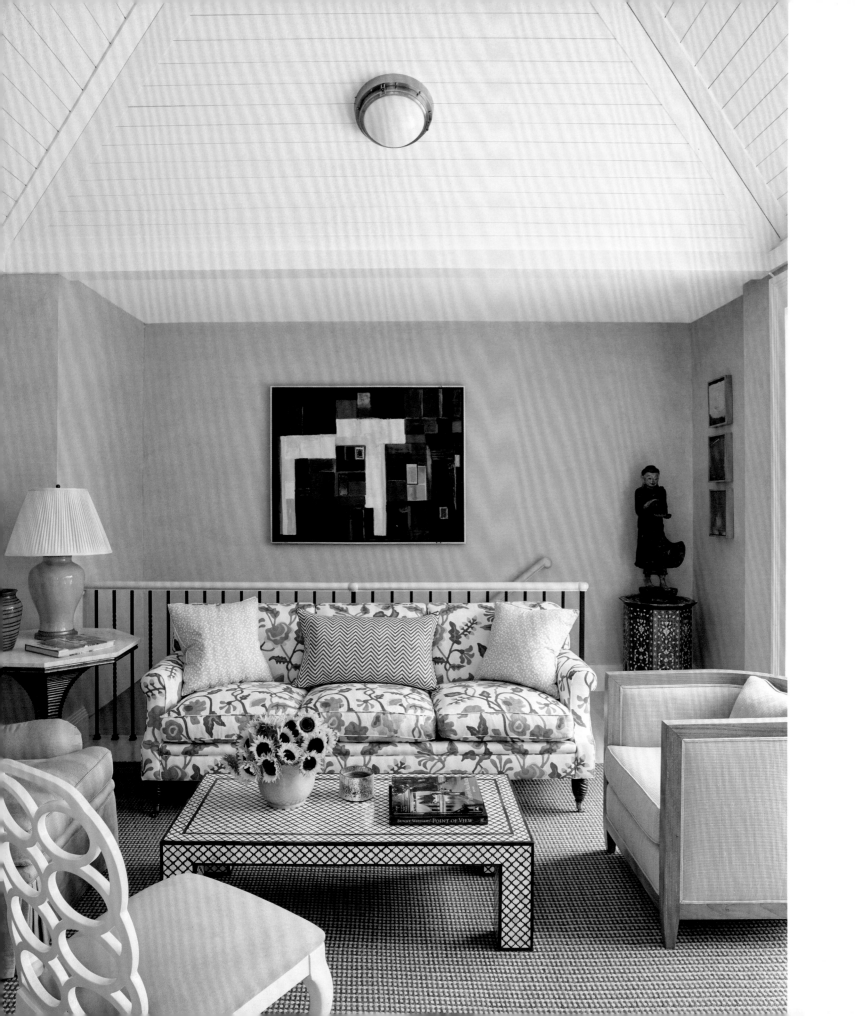

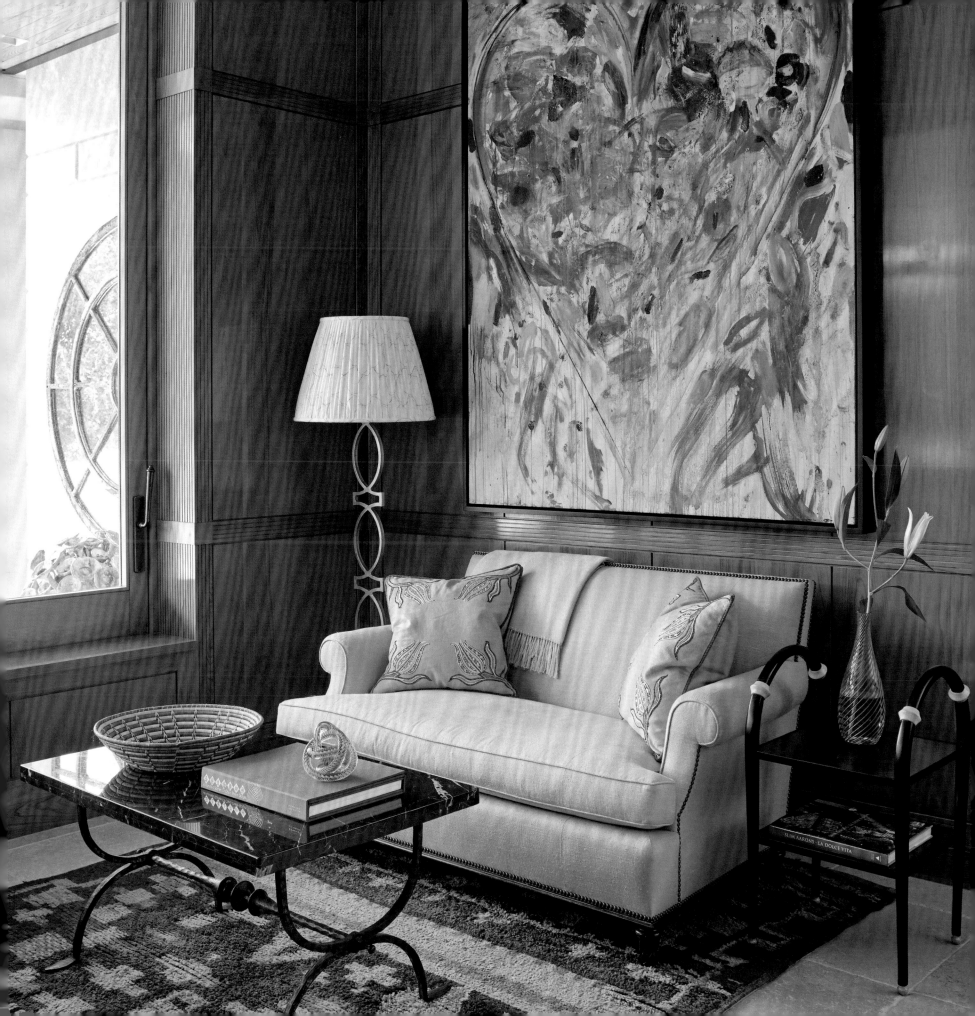

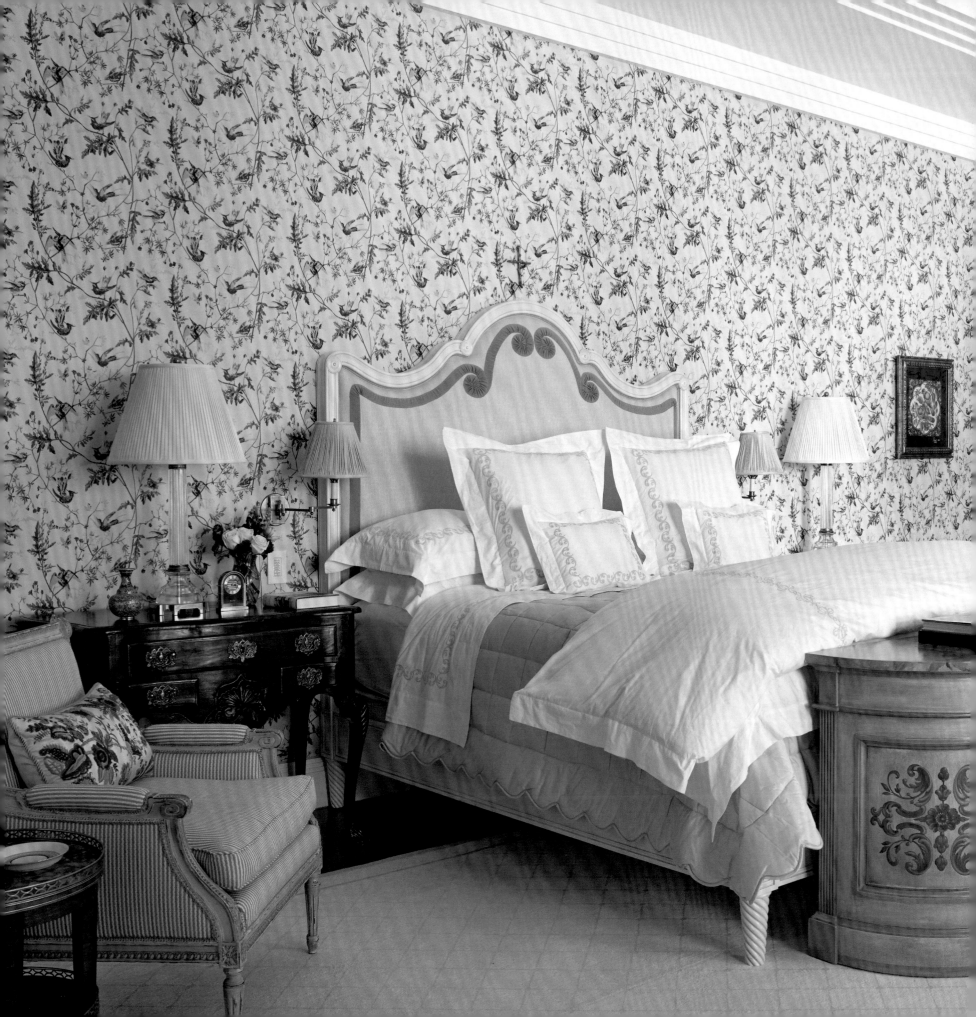

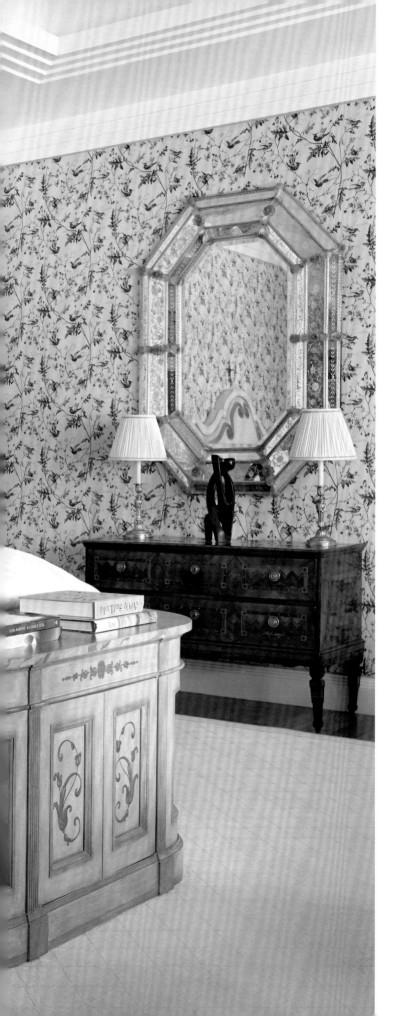

A subtle pattern on wallcoverings and curtains often gives a very large room warmth and intimacy.

In a nod to the local avian population, a soft, floral chintz with birds wraps the walls and windows of the master bedroom. A custom cabinet at the foot of the bed holds a pop-up TV. We based the paintwork on an eighteenth-century Italian commode.

FRENCH
FARMHOUSE

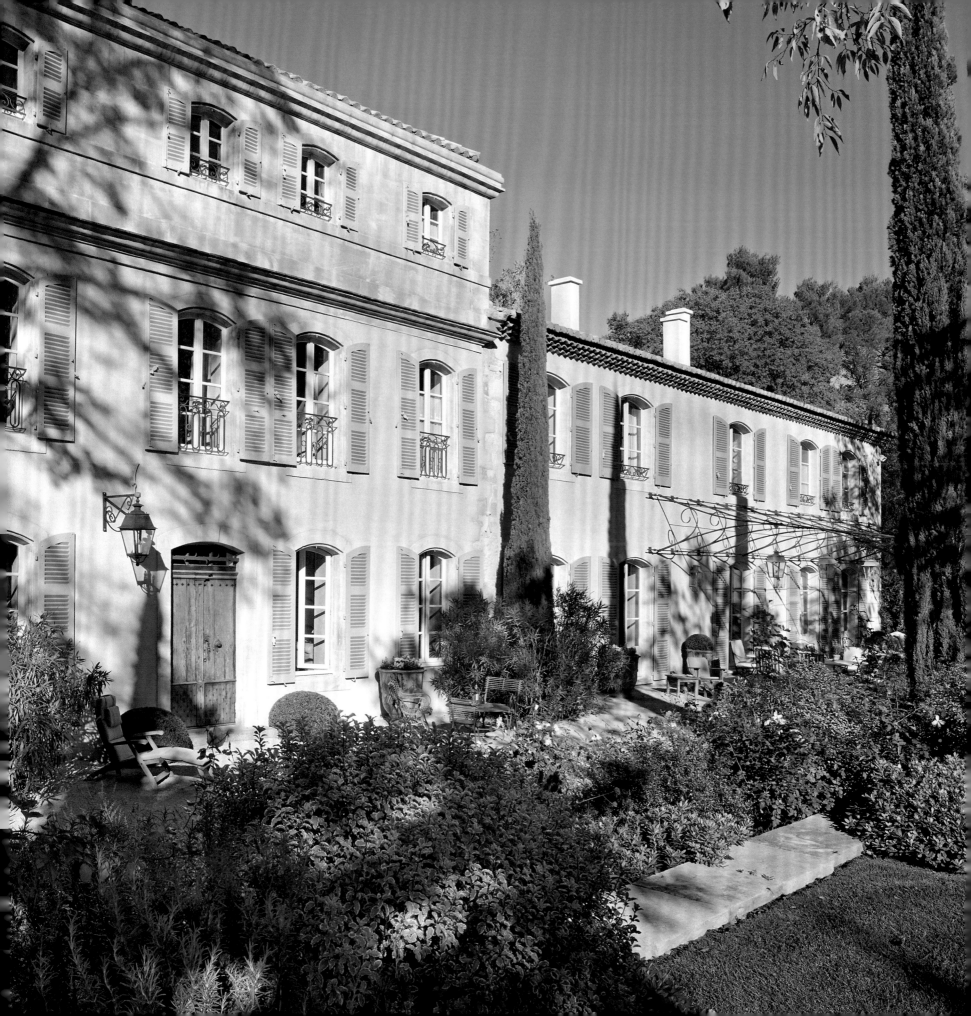

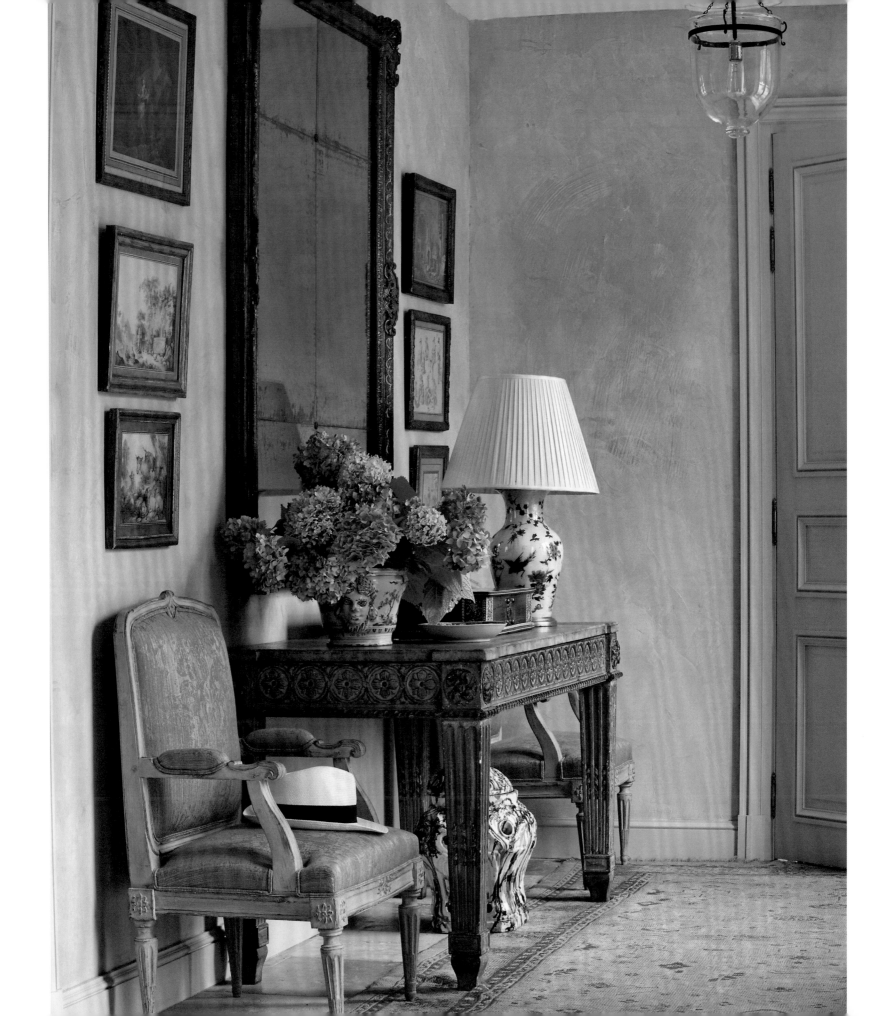

When extraordinary, longtime clients asked us to be part of their new project in Provence—a mas in need of complete remodeling—I was so excited. Like many farmhouses, theirs had evolved over the eighteenth and nineteenth centuries. In a further complication, the house had at some point been broken up into three separate dwellings. Due to strict historic preservation laws, all our changes had to take place within the existing walls and footprint. We wanted to respect the past but bring the house into the present with a coherent floor plan that reunified the interior into a warm, welcoming home for family and many guests.

The couple hired Norman Askins, a wonderful architect and friend, to help create a workable floor plan. They also consulted with Tim Rees to develop new gardens with classic, Provençal elements. (Actually, this client has such knowledge, passion, and an eye for gardens that he could have another career if he so wanted.)

Our objective was to make everything we did appear original to the house. The couple sourced antique floors and mantels. We worked with local craftsmen to mix integrally colored natural plaster for the walls. Most of the fabulous, eighteenth- and nineteenth-century furnishings belonged to the clients, but we selected new upholstery, beds, curtains, and rugs to complete the interiors. Throughout, chairs in their original fabrics and mellow painted furniture combine with warm wood pieces.

In this house of special rooms, the dining room stands unique. This is thanks to a client who adored the idea of doing a room in decoupage—a traditional, French decorative technique that I love and have done myself—especially because our proposal for it involved a garden theme. After finding a volume of seventeenth-century flower engravings and photocopying many of the images, we had an artist cut out each flower and mount them to silver tea paper. After the decoupage work was affixed to panels in New York, we shipped the panels to France. Our artist flew over to install them and add more flowers as necessary to cover the seams. A master carpenter then applied a delicate lattice grid over the entire room. The effect is particularly magical at night, when the silver walls reflect flickering candlelight.

So many other touches help make the house feel timeless, including five antique, painted canvas panels that I found in Paris at Les Puces (the world's largest antiques market). I thought they would be perfect for a corner bedroom. Installed after a thorough cleaning and restoration, they look as if they have always been there.

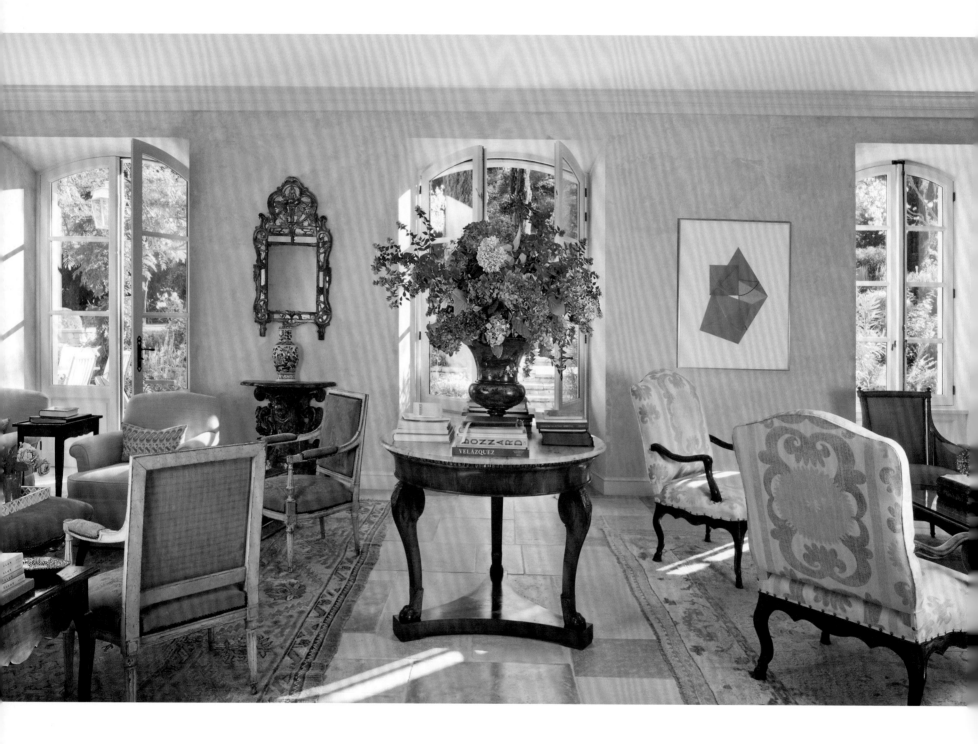

PAGES 256-257: Provence's mistral winds sweep in from the north, so farmhouses generally face south. PREVIOUS PAGE: A beautiful eighteenth-century French table with an antique mirror above greets guests as they enter the house. ABOVE: A substantial marble-topped table divides the long living room neatly in two. Each area has its own distinctive seating group with comfortable upholstered pieces and eighteenth- and nineteenth-century French frame chairs. OPPOSITE: The desire from the beginning was to leave the living room as open to the exterior as possible. The space under a superb French console table offers just the spot for an overscale French basket.

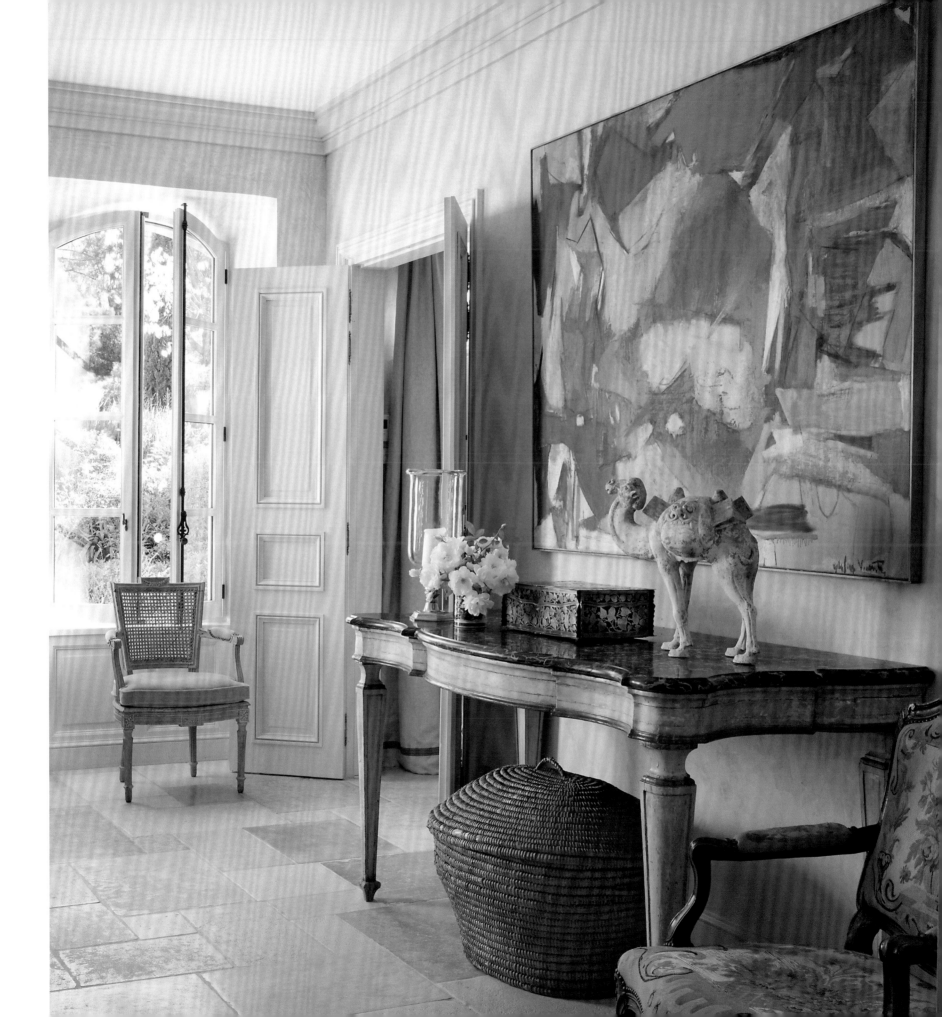

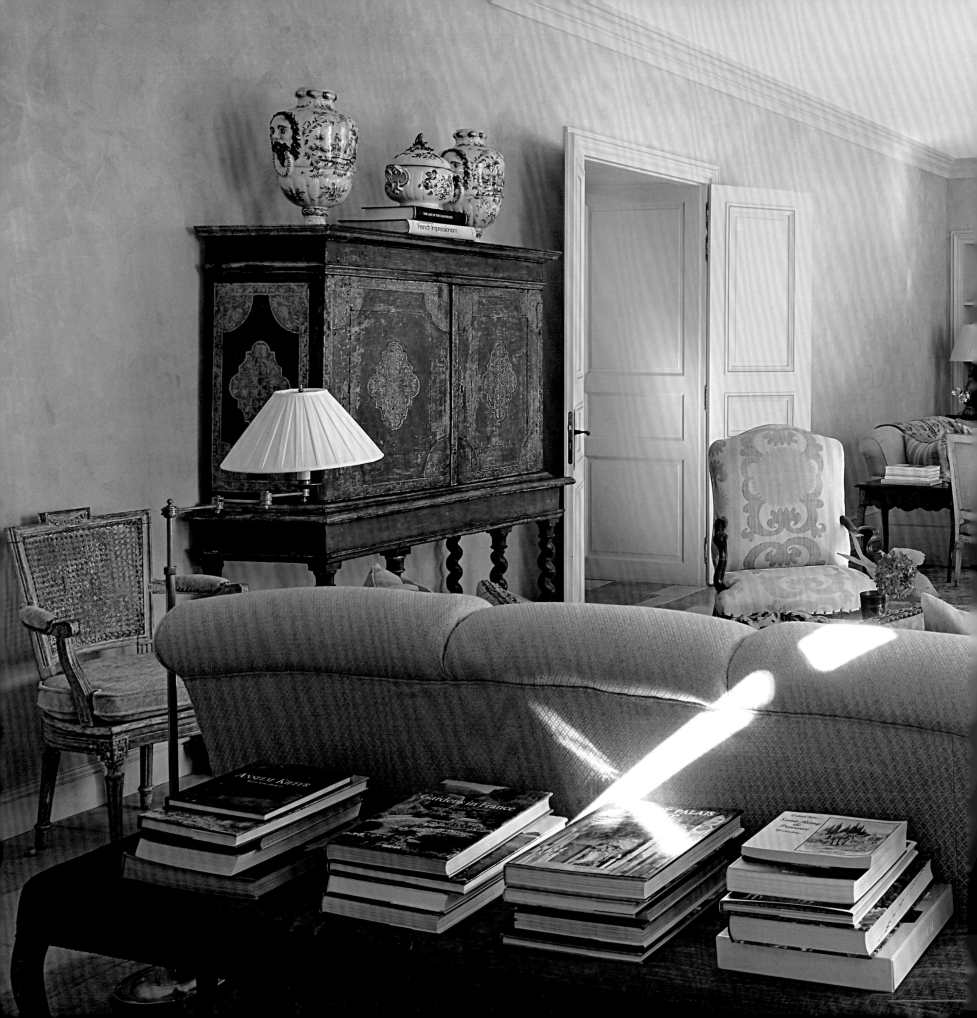

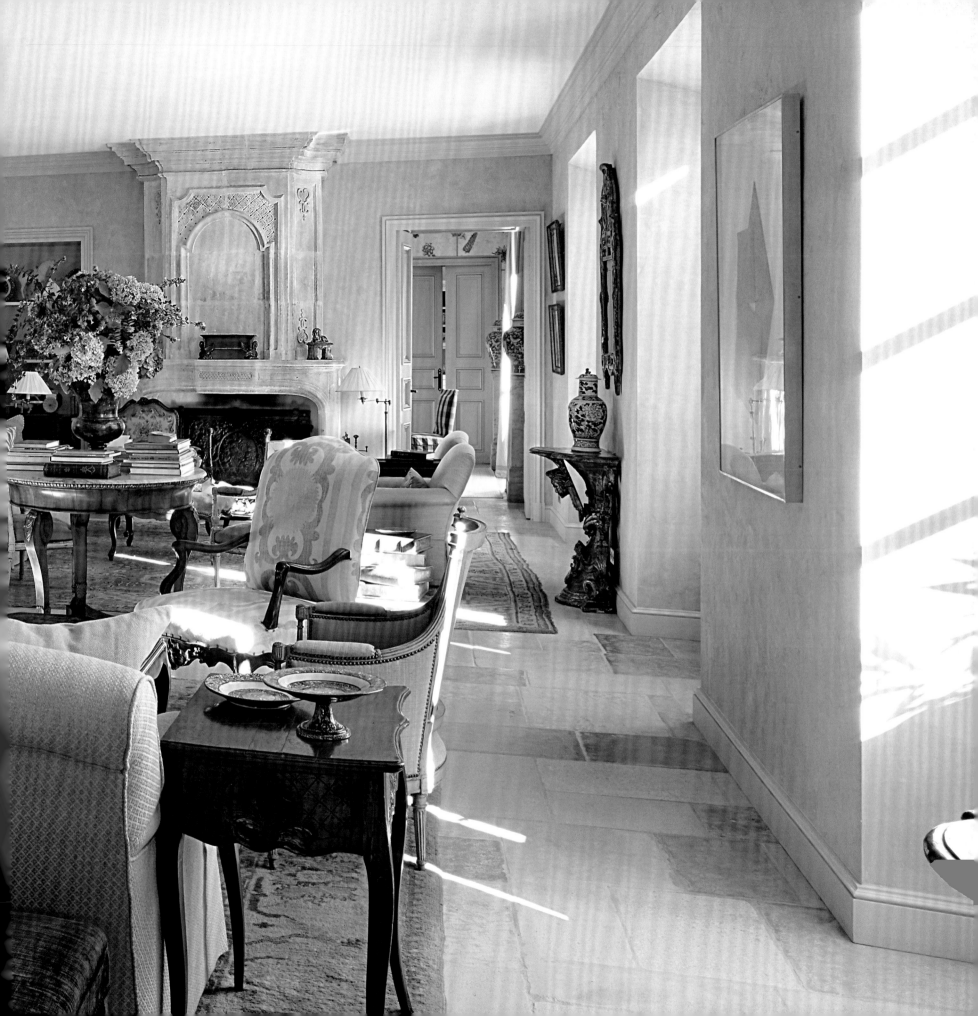

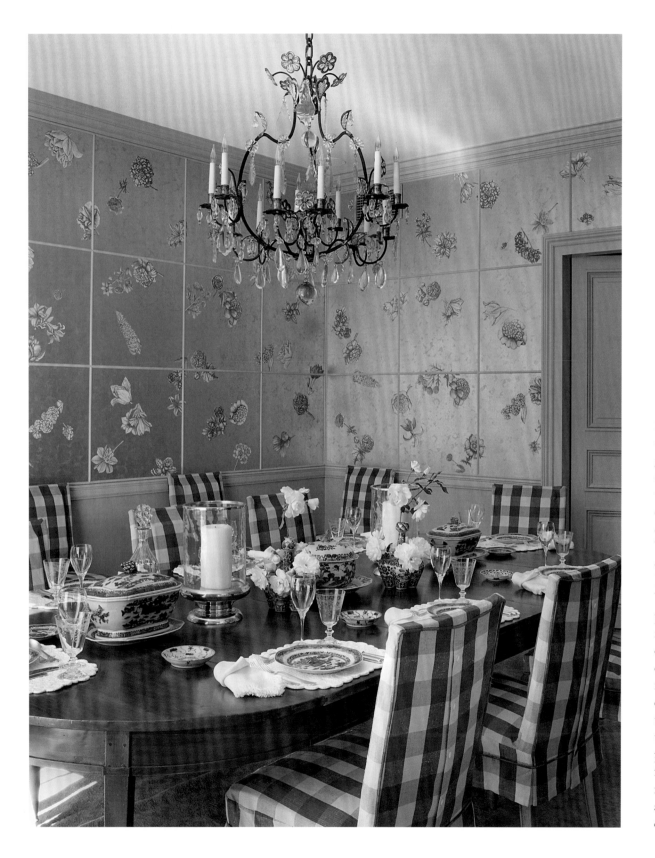

PREVIOUS SPREAD: A fabulous, early Régence chimneypiece gives a dramatic scale to one end of the living room. Because the house was originally built of stone, it has wonderful, deep window reveals. LEFT: This couple loved the idea of a decoupage room, which I had always wanted to do. We decided to use silver tea paper for the ground because it shimmers magically in candlelight; the antique flower engravings bring the garden indoors. OPPOSITE: The checked slipcovers pick up the classic blue and white of the couple's Chinese export porcelain collection, which found a great home in the neutral dining room. The antique mantel, mirror, and chandelier are all French.

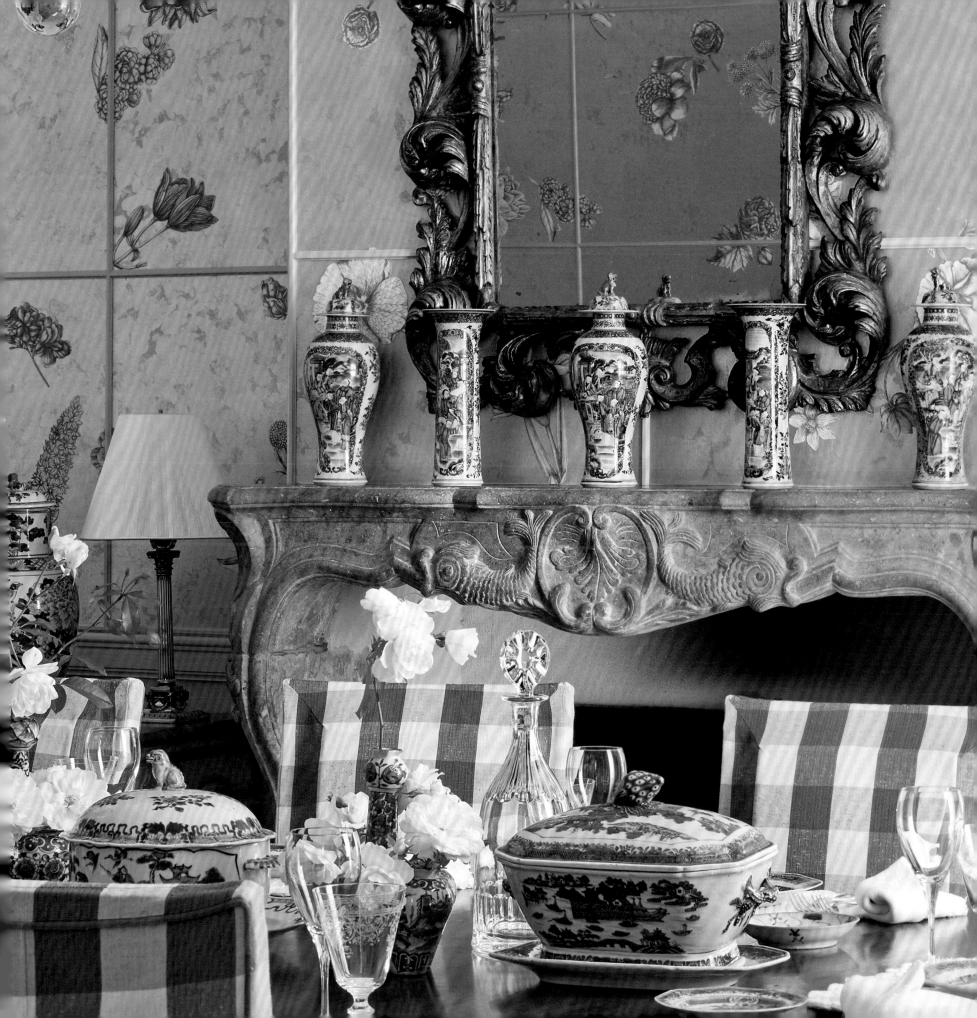

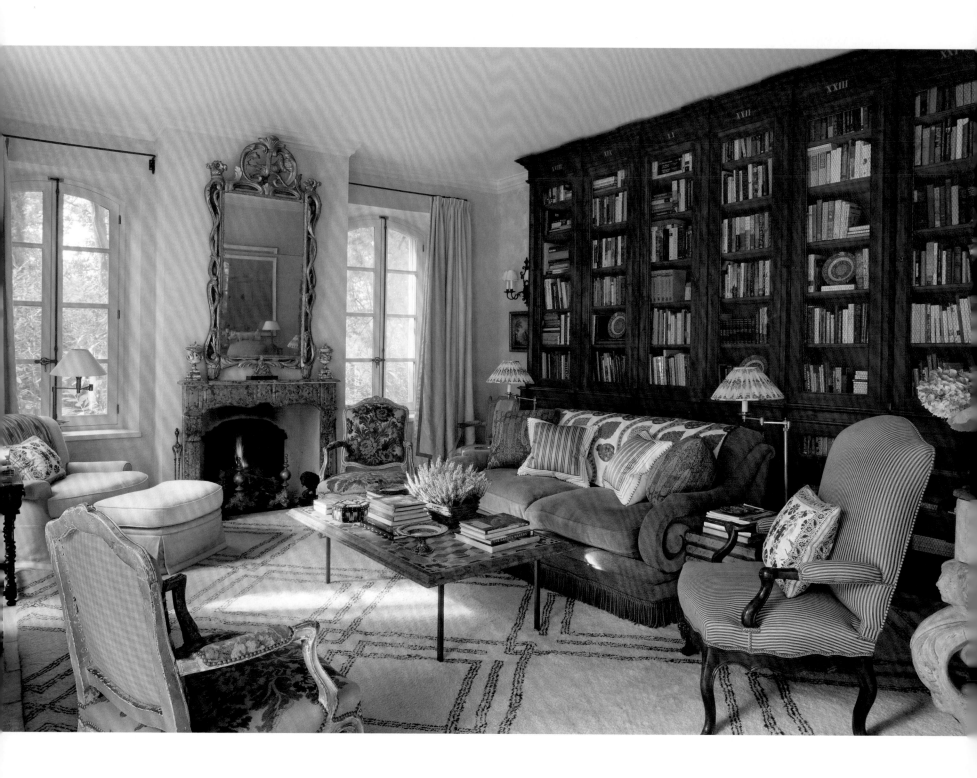

ABOVE: The Moroccan rug warms the library's stone floors and helps make the room intimate and cozy in the winter months. An antique bookcase that once graced another library fills the entire wall. RIGHT: Against one wall, a combination of modern art and early eighteenth-century furniture creates an exciting still life. We had the chair's original needlework fabric restored.

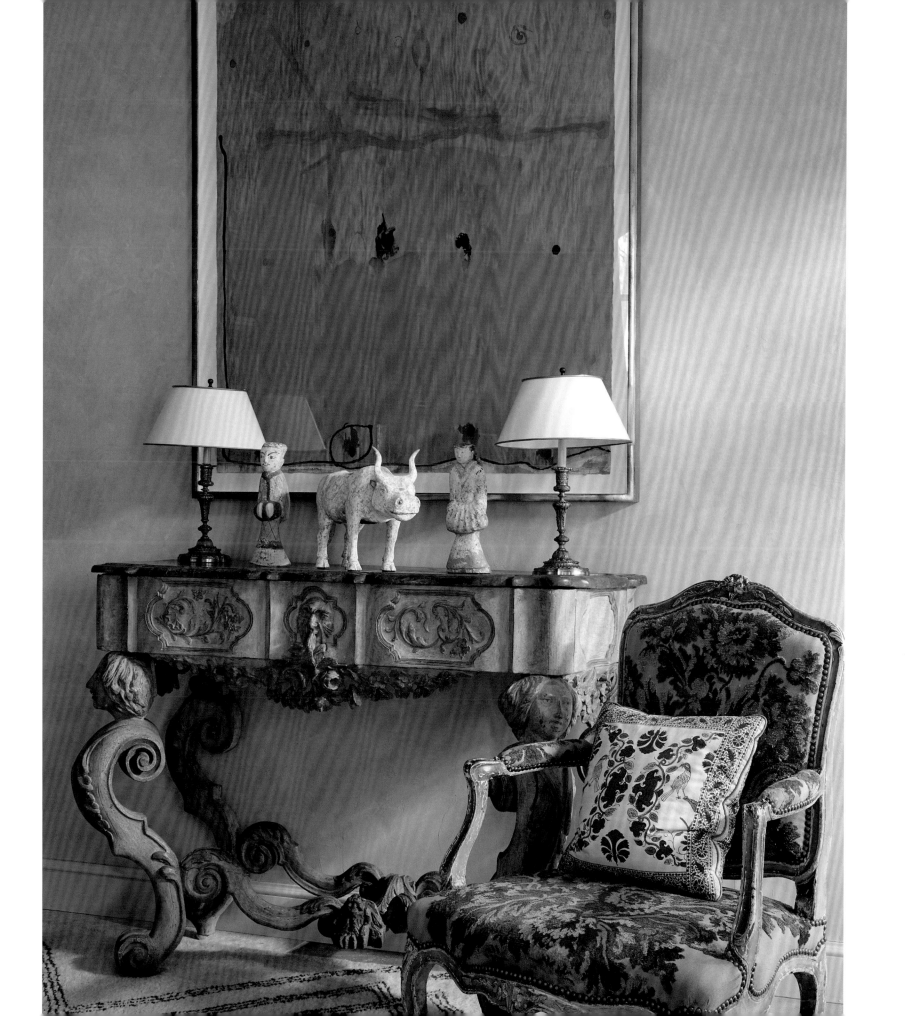

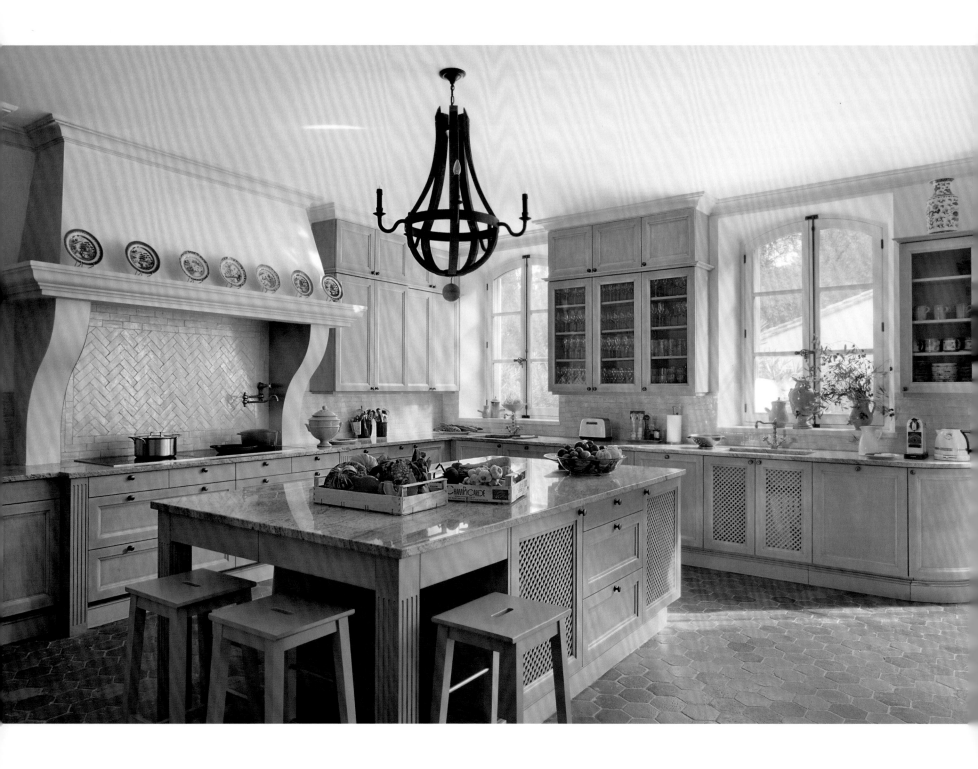

ABOVE: Handmade pearlescent tiles behind the stove cast light around the newly designed kitchen. The soft shade of gray-white that finishes the cabinetry is a color commonly used in French painted furniture. RIGHT: For the chimneybreast of the breakfast room fireplace, we used modern sponged Portuguese tiles to surround an antique Portuguese tile panel. Country ladder-back chairs pull up to an expanding French table. On the wall, French faience pieces pick up the colors from the fireplace tiles.

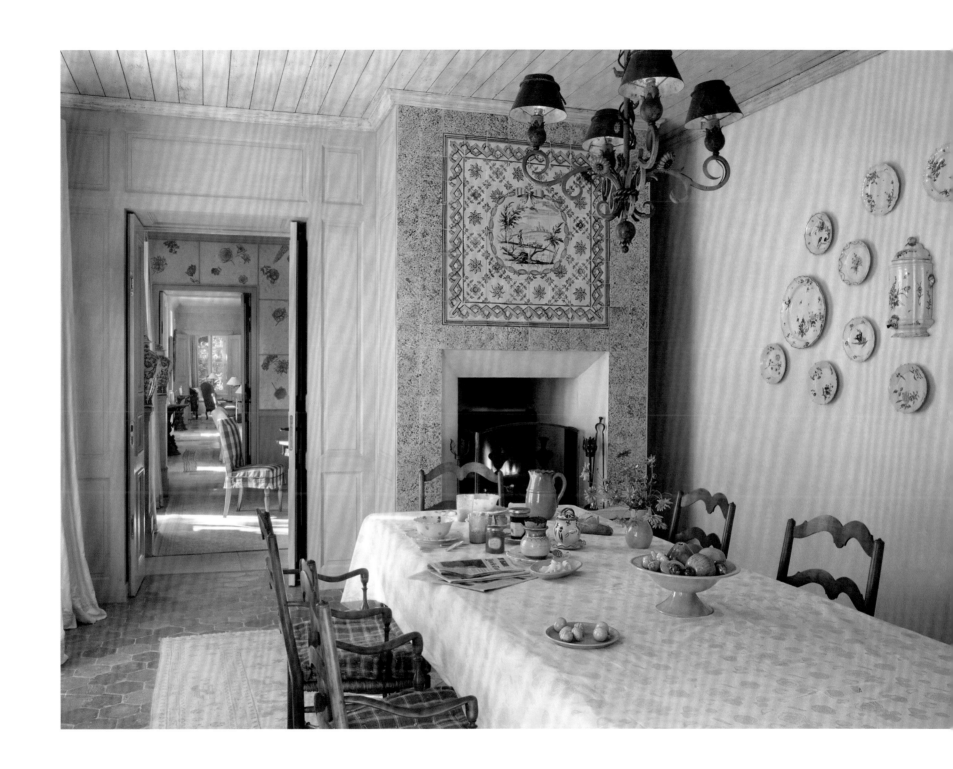

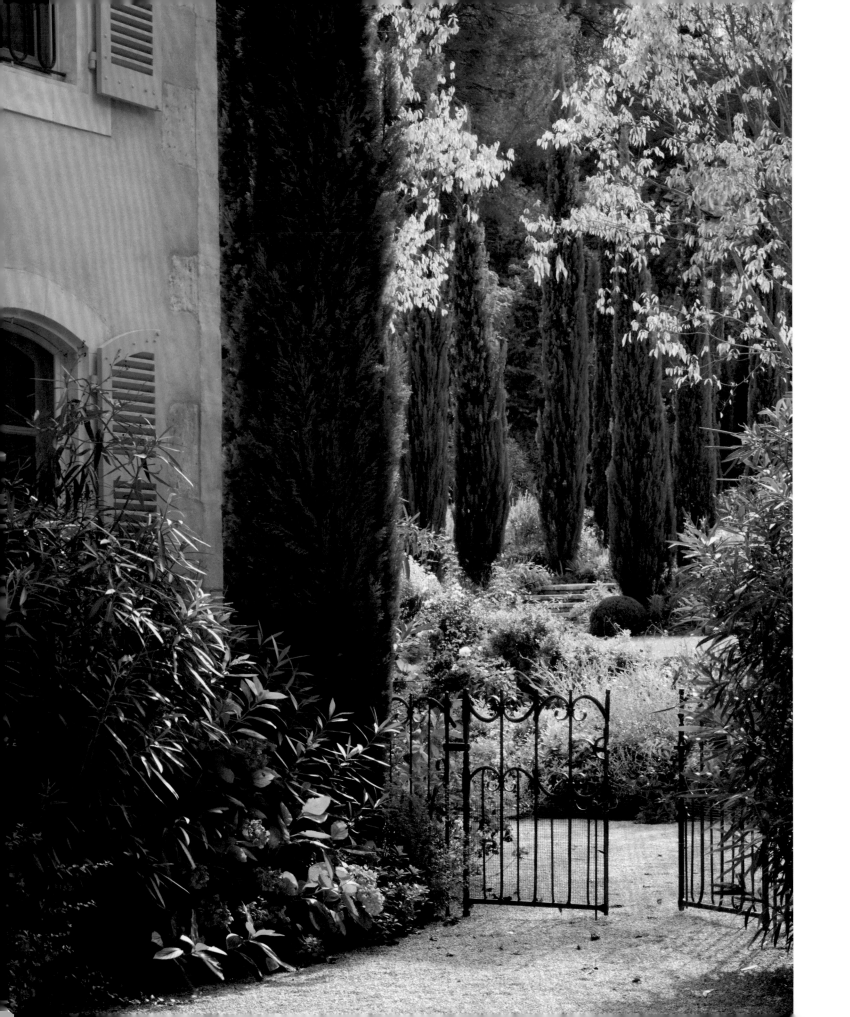

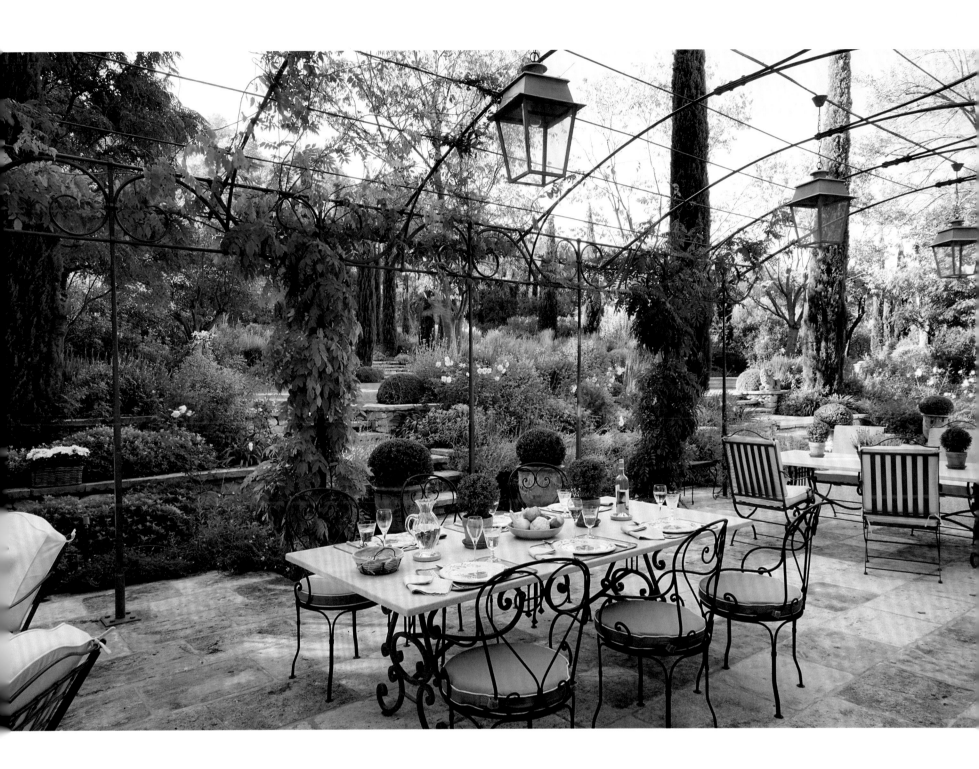

OPPOSITE: All the doors and windows open onto surrounding gardens designed by Tim Rees. ABOVE: The large terrace is an ideal spot for outdoor dining and lounging on Provence's endless, perfect summer days. FOLLOWING PAGES, LEFT: With uncanny symmetry, a window in the stair hall frames a view of the garden stairs leading out into the farther landscape. FOLLOWING PAGES, RIGHT: On the second floor, terra-cotta floors and natural plaster-finished walls make the house feel as if it hasn't been touched in centuries.

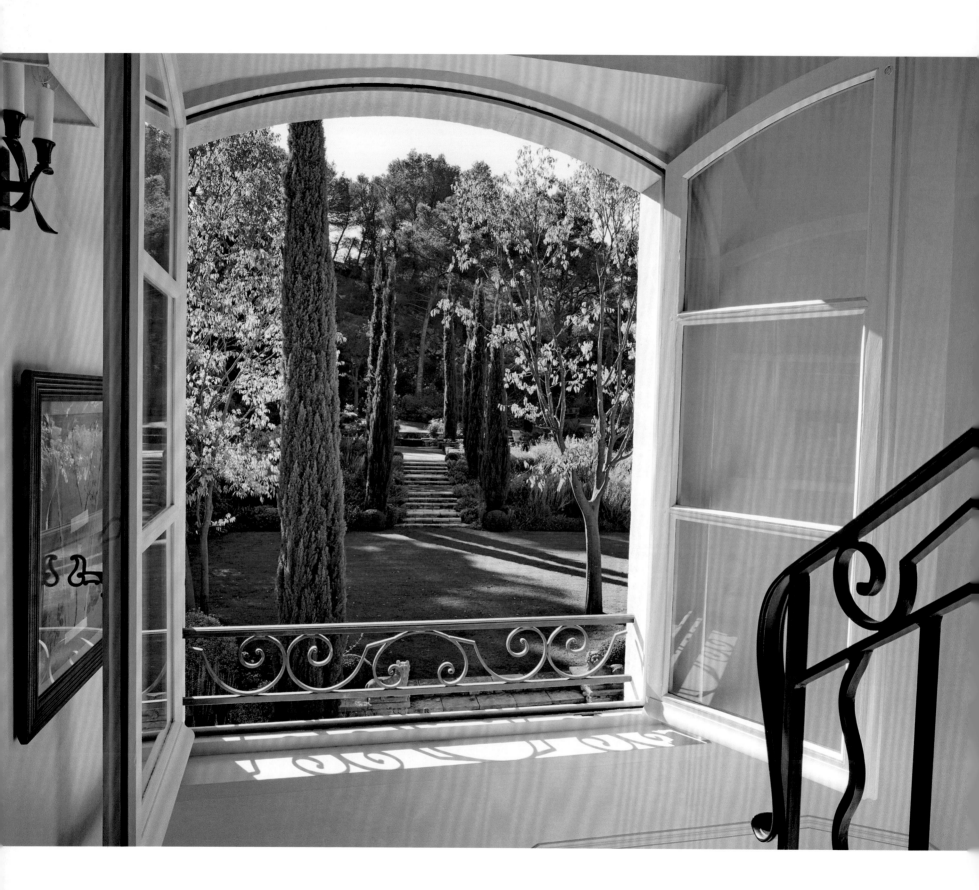

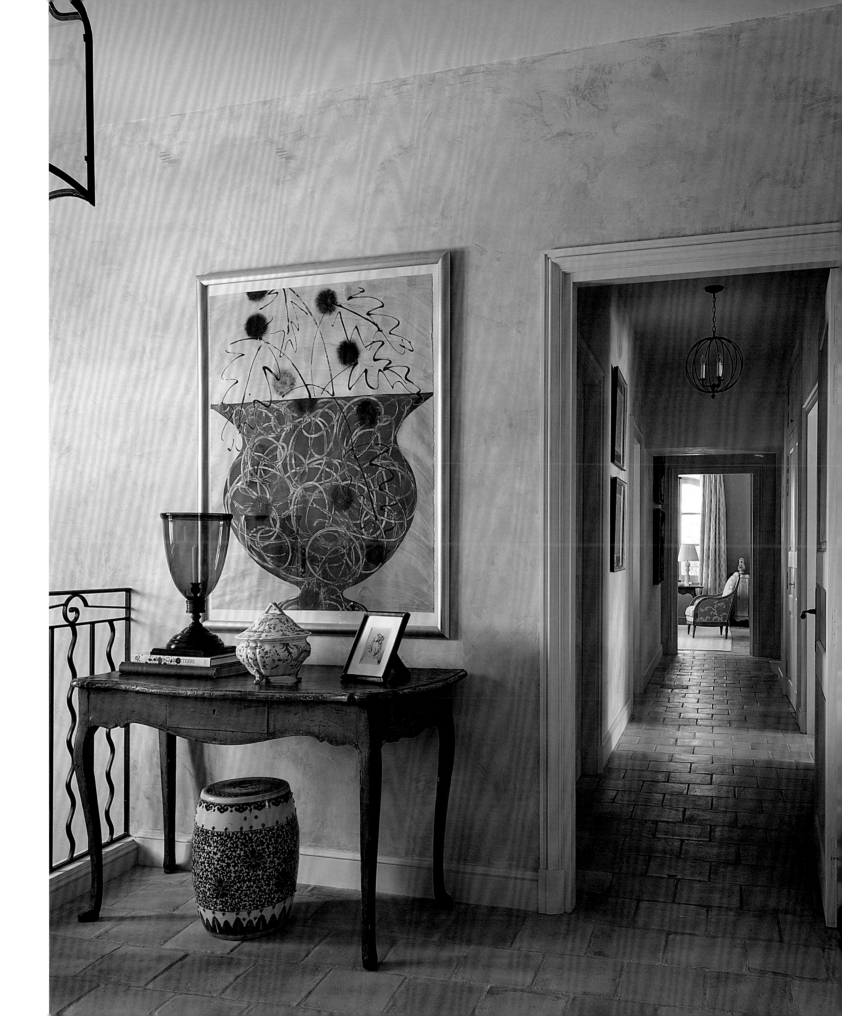

A gently terraced stairway with low, stone steps beckons all comers to move from space to space through the garden.

Paying homage to the sense of place, the garden abounds in boxwood globes, lavender, and towering cypress columns.

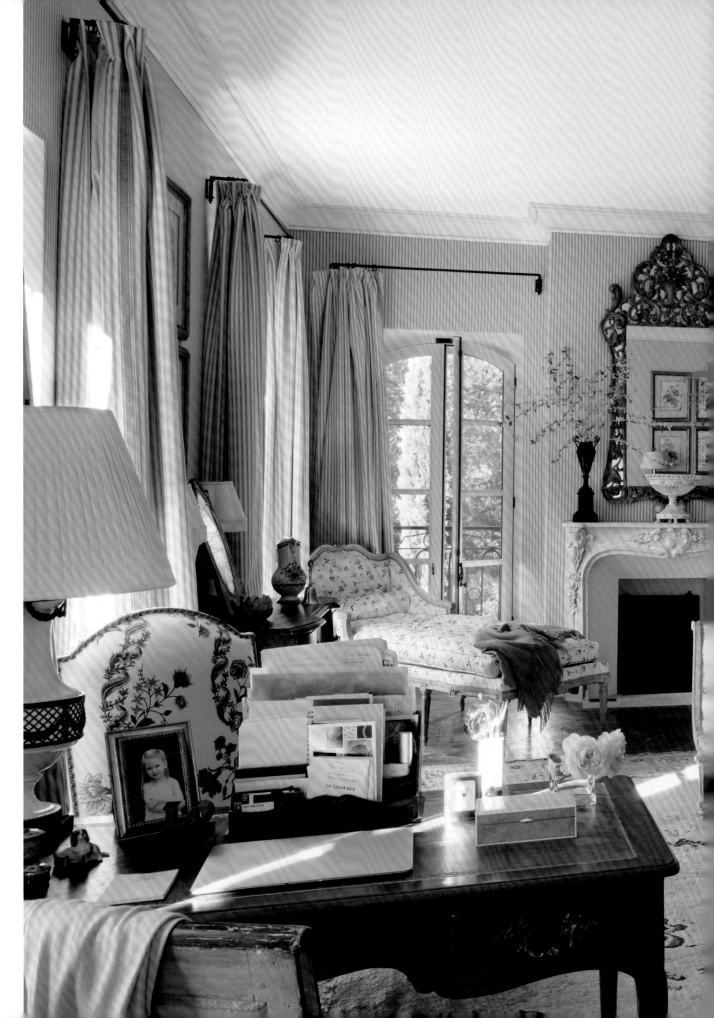

In the master bedroom, walls and curtains in a typical French ticking create a timely, timeless, and appropriate background for a carved Italian bed. The classic French print that drapes the baldachin and repeats on various upholstered pieces layers a foundation of pattern through the space.

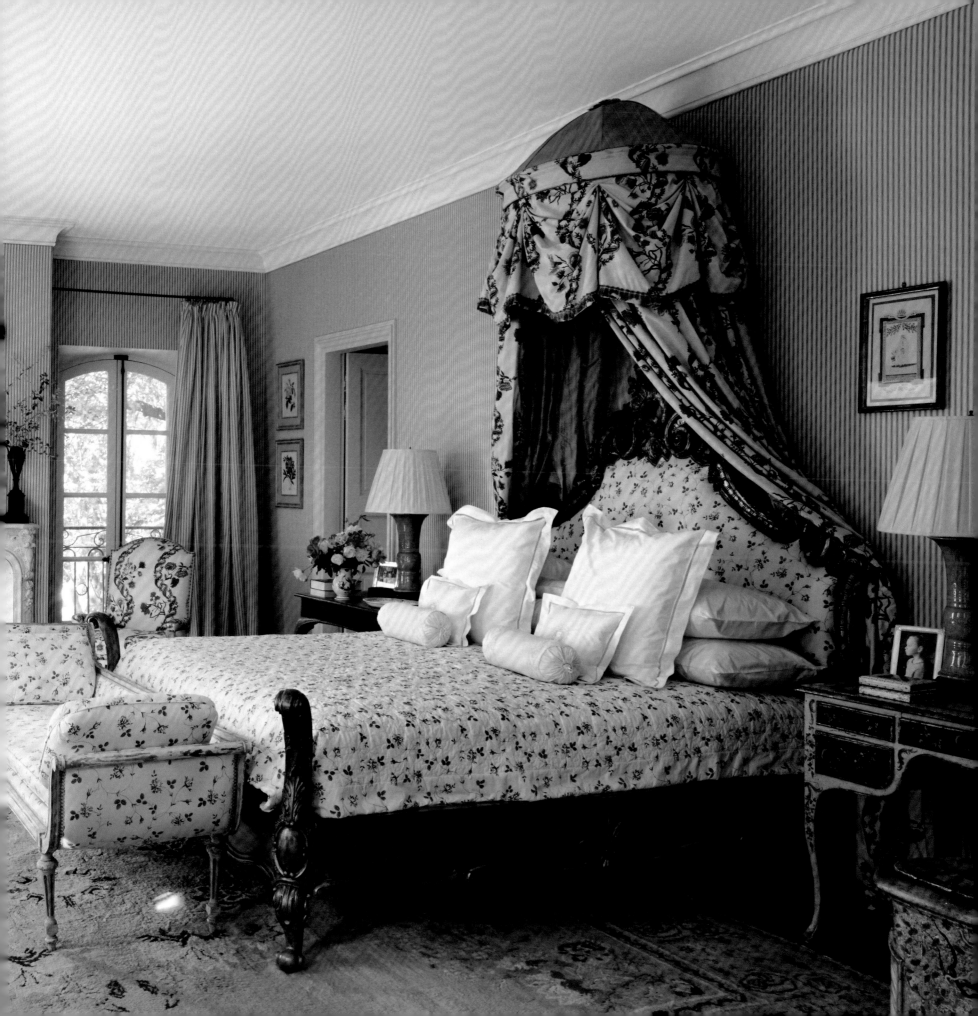

To make guests feel truly at home, every guest bedroom should be as well thought-out as a master suite.

Nineteenth-century panels found in the Paris flea market feel at home in this guest bedroom. Walls painted in a soft, French gray-blue to complement the panels' color palette further enhance the air of authenticity and history.

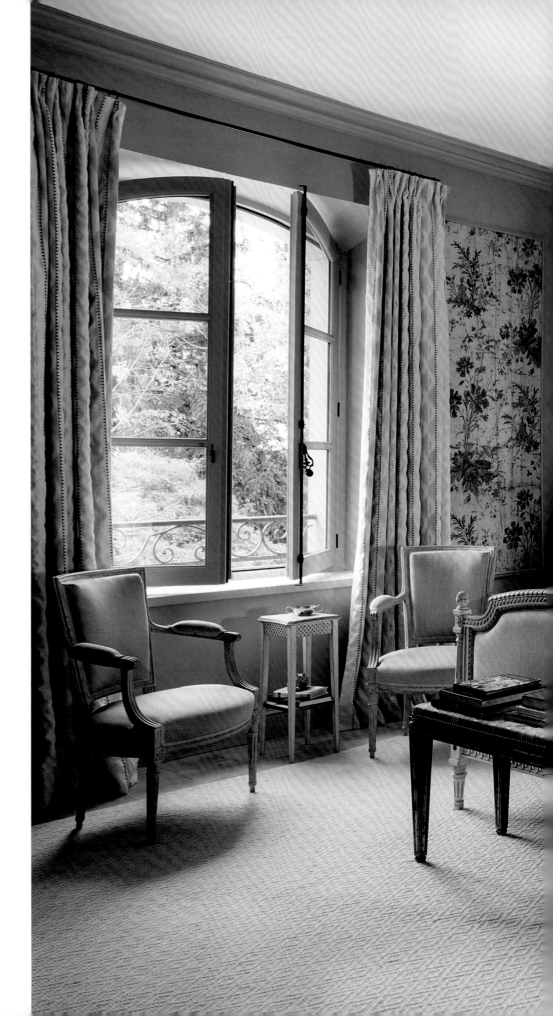

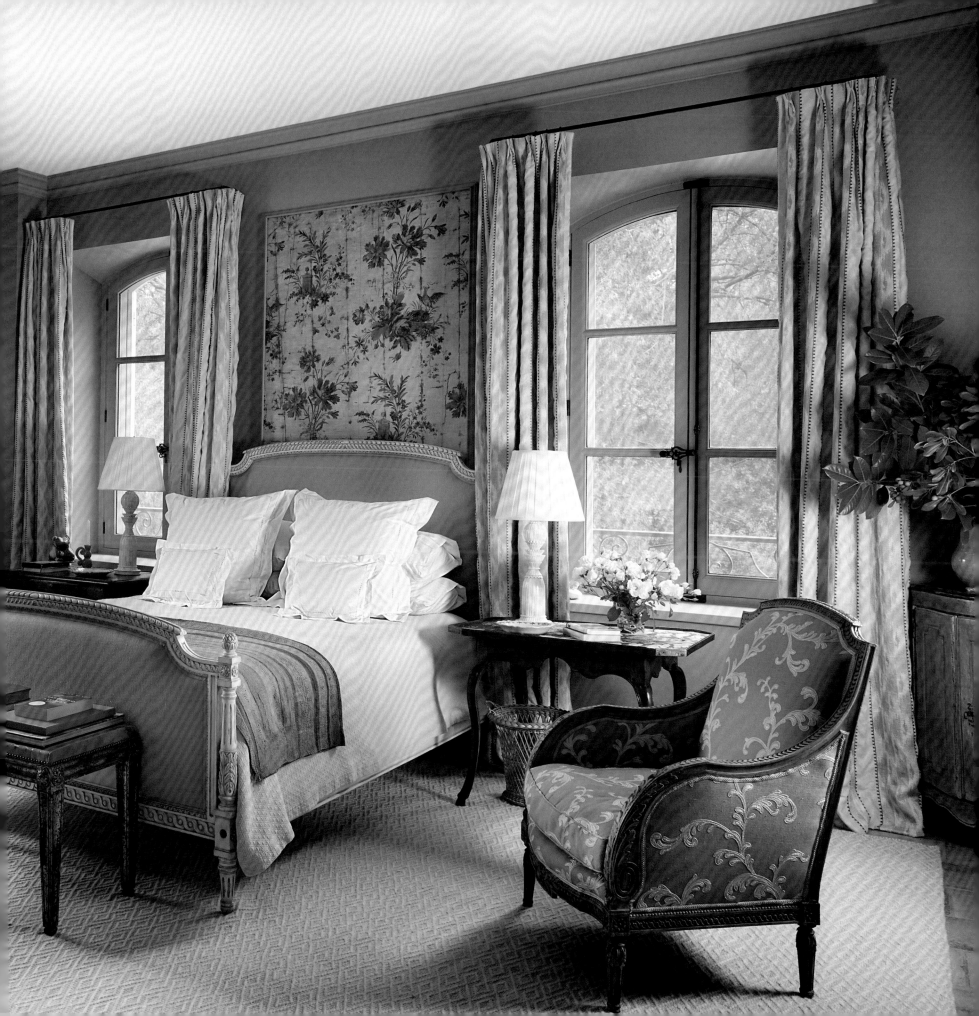

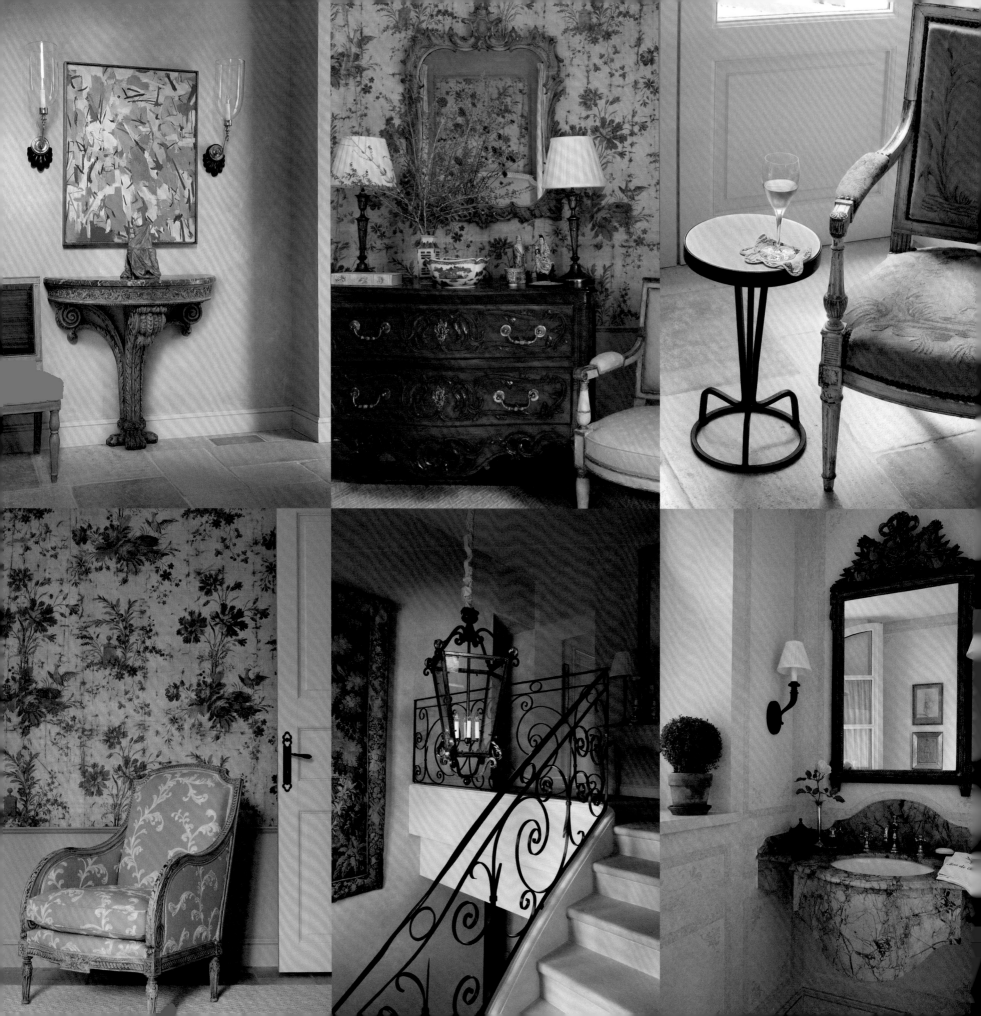

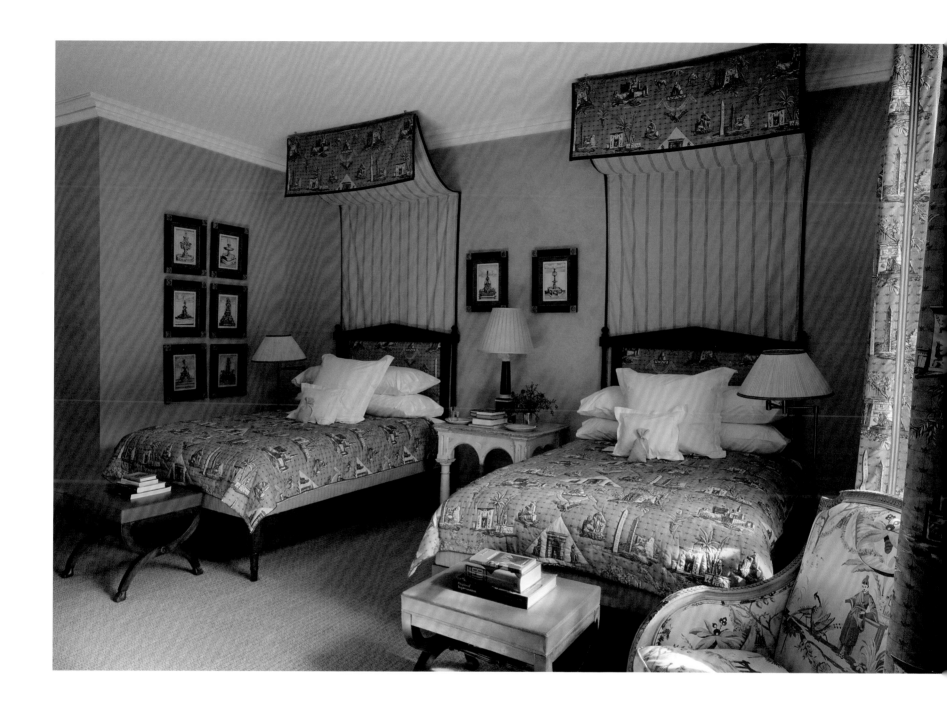

OPPOSITE: Antiques used throughout the house infuse each room with distinctive character, a timeless sensibility, and function above all. ABOVE: A typical French toile for the bed hangings and curtains lends extra, local color to another guest bedroom. For maximum comfort, we designed this pair of reproduction Empire-style beds in a generous, forty-eight-inch width.

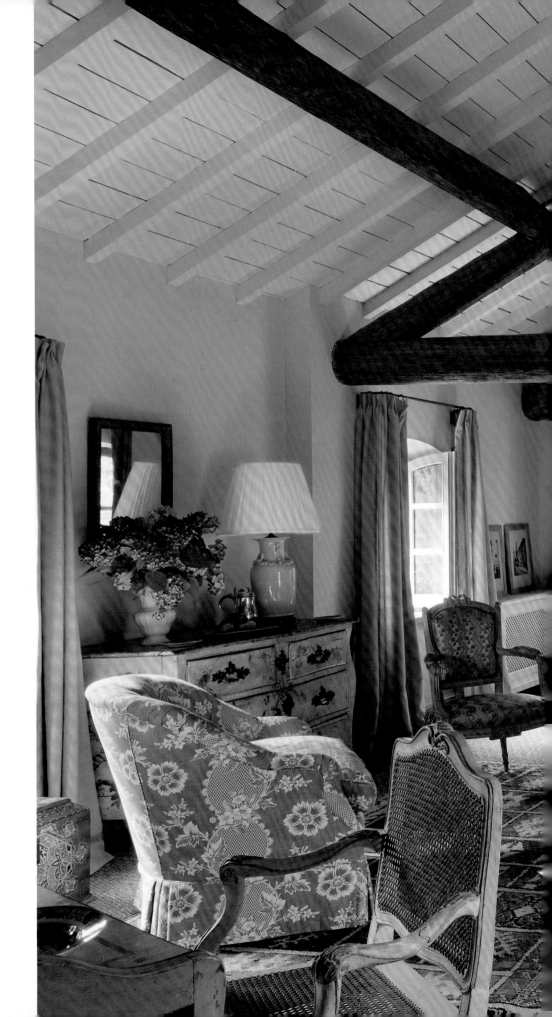

I love garret rooms in French houses. To create that feeling here, we paneled the ceiling in rough, painted boards and preserved the original timber beams.

With a regular bed, a daybed, many comfortable spots for curling up and chatting, and lots of extra pull-up seating to arrange at will, this room is a favorite, special space for the couple's granddaughters when they visit. For extra warmth, we threw a Moroccan rug over the wall-to-wall sisal.

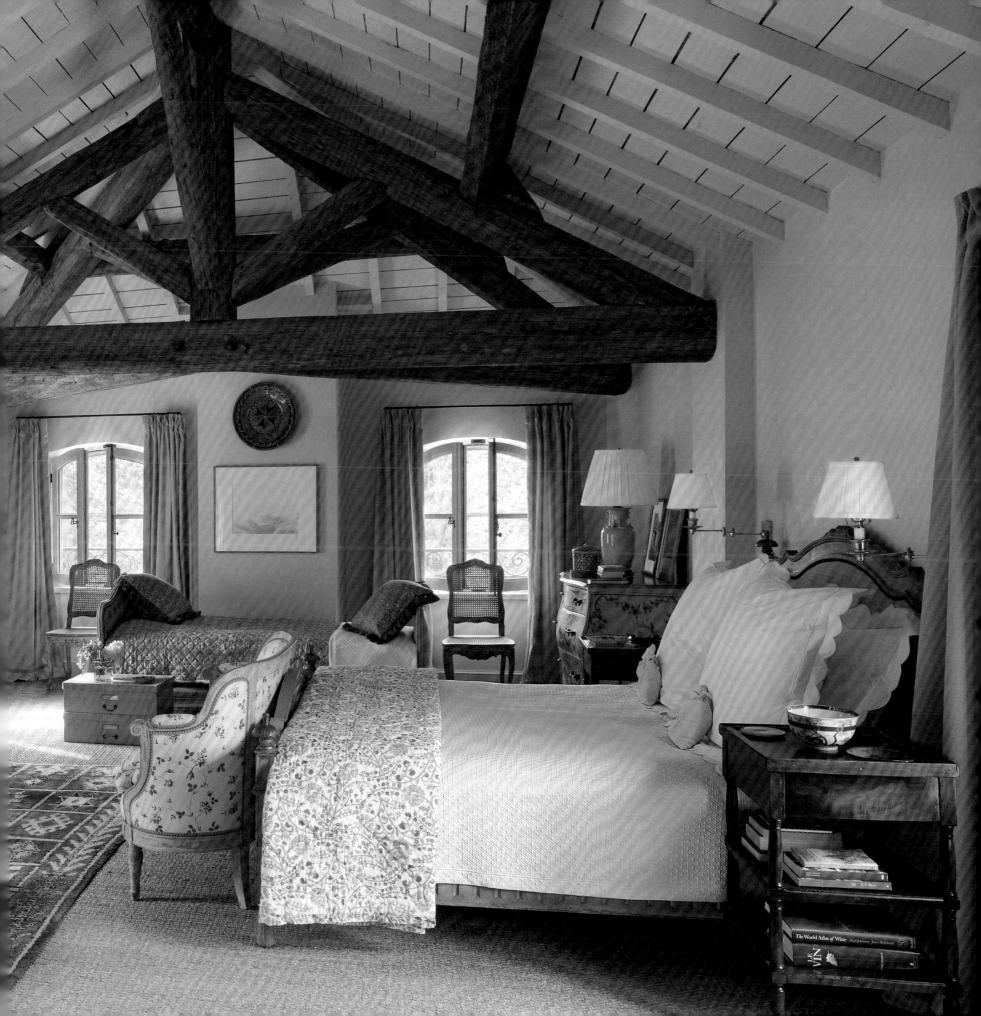

THE STUDIO

LEFT AND OPPOSITE:
Buying this house felt a bit
like kissing an ugly frog.
But I was able to break
the spell and reveal the
handsome prince. As you
can see, the house really
needed a proper entry. For
that, we had to peel off the
awkward front porch.

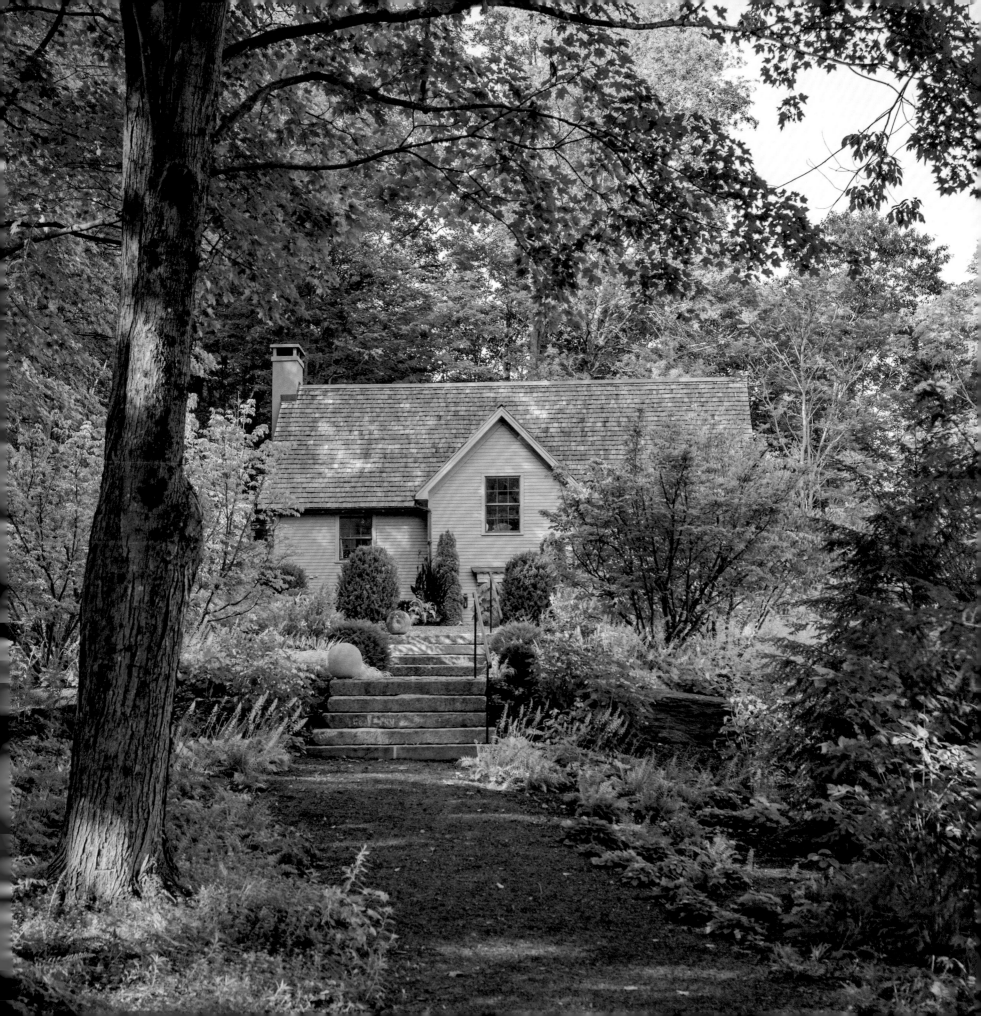

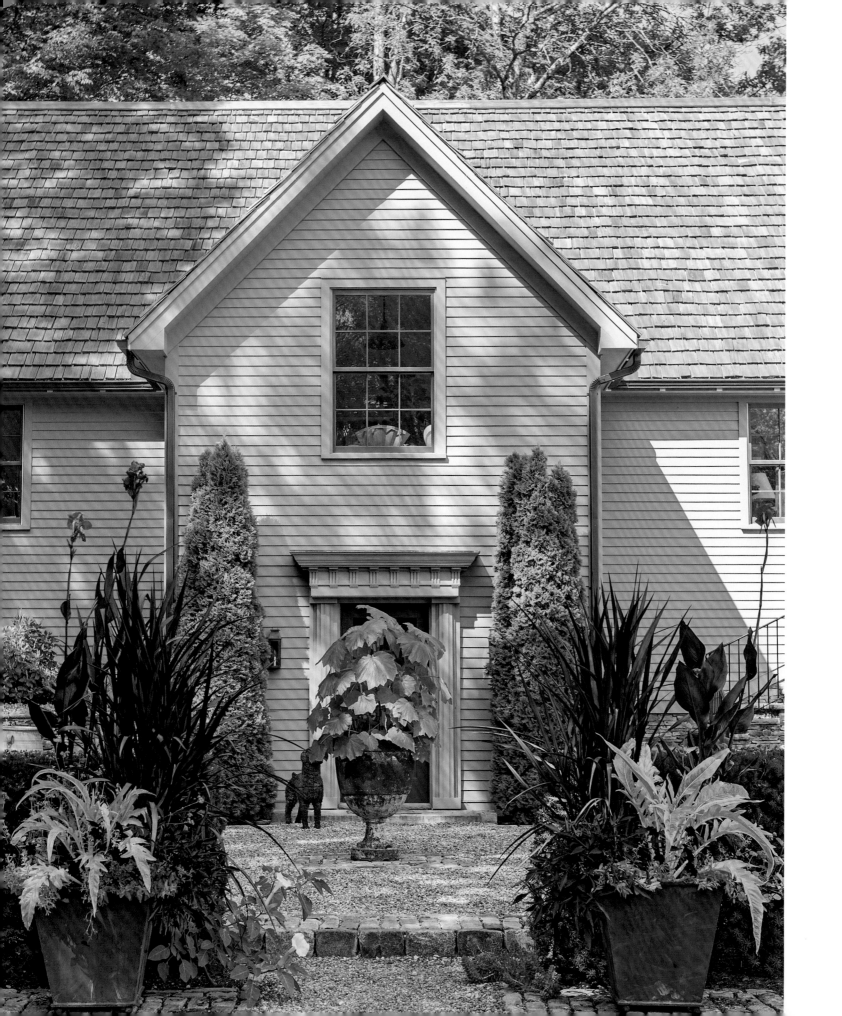

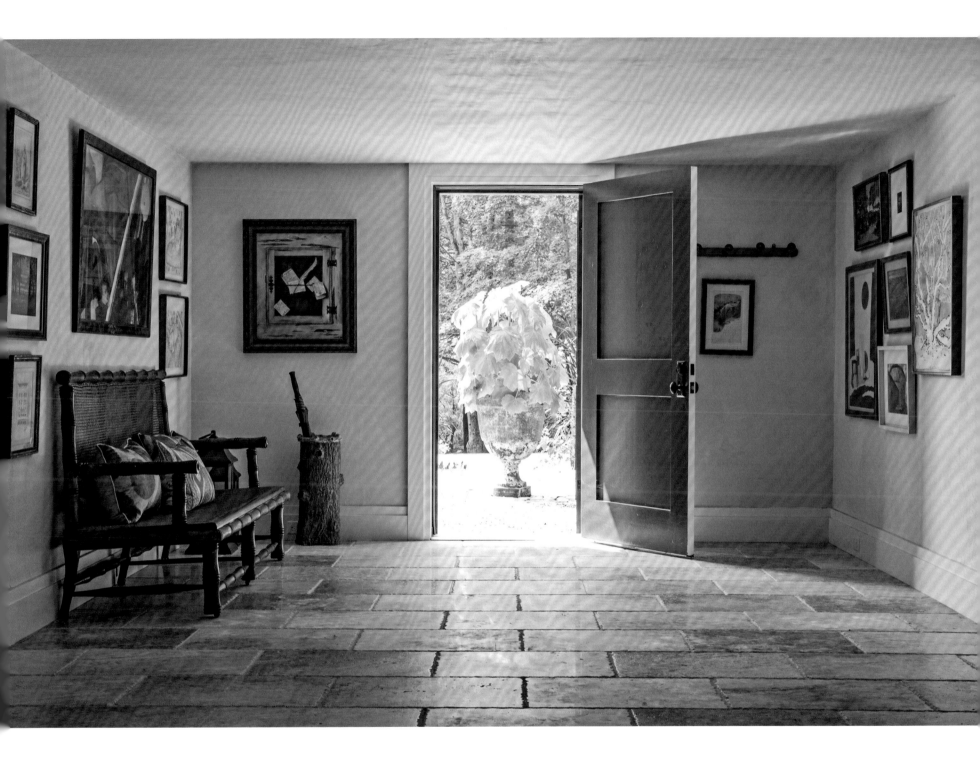

OPPOSITE: Front and center is a copy of a nineteenth-century Federal door, the period of my existing house.
ABOVE: The low-ceilinged basement became the entrance hall. FOLLOWING PAGE: This is a perfect spot for reading, but when I sit here I mostly stare at the clouds and the Litchfield hills. Pages 290–291: I always take delight in cutting a huge branch of something for the glass vase. I use the library table as my desktop and the nearby drafting table for drawing.

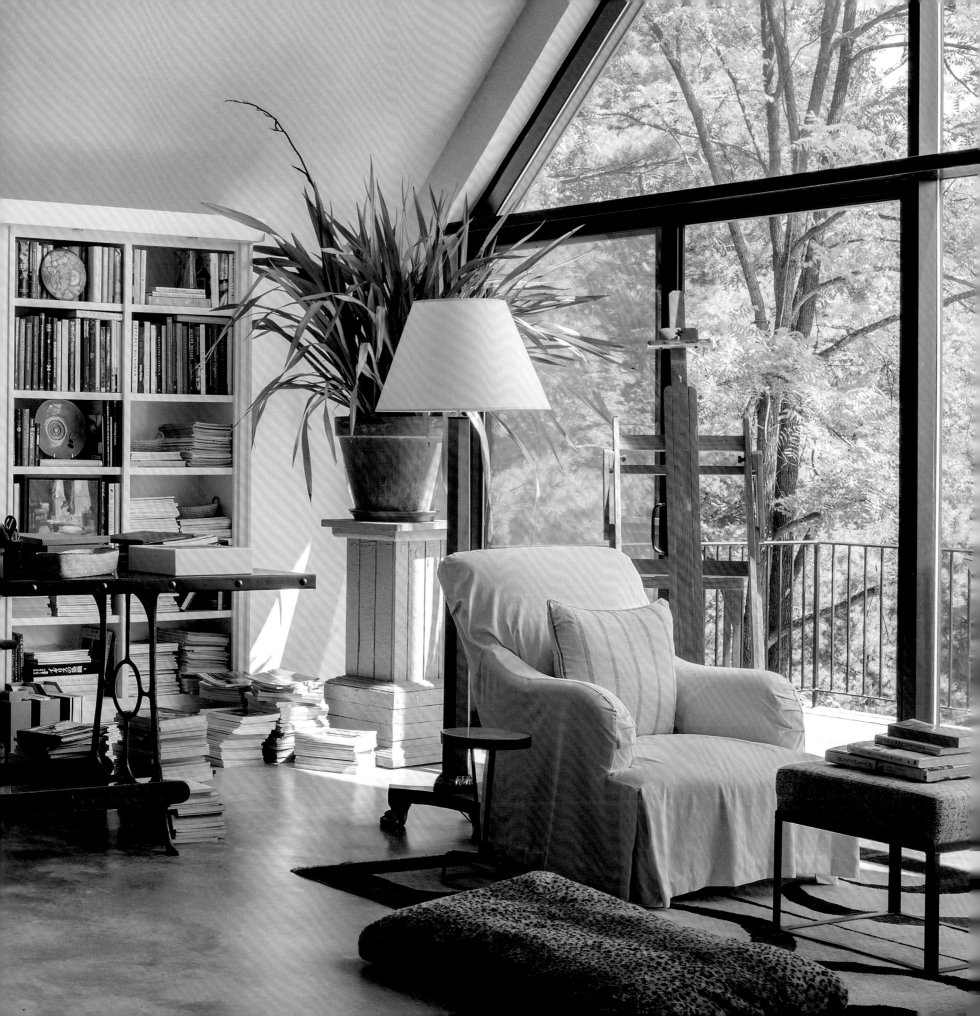

I had always longed for a spacious, bright studio where I could work, paint, study, and be off by myself, completely absorbed in my many projects.

When my neighbors informed me that they were relocating, I climbed up the hill past our pool house to inspect the property. Looking out at the amazing vista of the Litchfield hills, I was smitten. The house itself was rather homely, with three bedrooms, a sleeping loft, and an awkward front deck instead of a proper entrance. I stood back, closed my eyes, and envisioned what I wanted the space to look like. I knew I could convert the house into the studio I imagined, so I guess I can say that what I bought was the view.

I sketched out my plan, removing all the interior walls and creating one large room with a glass wall facing east and a fireplace flanked by glass walls facing west. I preferred to enter on the lower level, which was an unfinished basement with a low ceiling. Executing these changes proved a lot more difficult than I had expected. We had to jackhammer large granite boulders into oblivion to create the entry. But by dismantling the deck and building a new stone foundation, we also made space for a gym.

It was important to me that the entire studio space feel modern and fresh in contrast to my existing traditional house and barn, so I gave it a floor of polished concrete and covered the walls in a natural, hand-troweled finish. In the large room, I built bookcases along the north wall for my collection of design, architecture, art, and gardening books. Stacks of my collections of old magazines have found a place on the shelves.

I had hardly begun construction when I wandered into the shop RT Facts in Kent, Connecticut, and found the eleven-foot-long library table that sits in the middle of the room. There is a seating area by the fireplace where I invite guests occasionally and where John and the dogs can find a cozy place to land. To John's dismay, there is no kitchen, but there is a coffee machine, a refrigerated drawer filled with wine, and a freezer drawer for ice.

Now that the studio is finished, I look forward to every weekend—to walking up through the garden to my special place on top of the hill, turning on an opera, and setting to work on design and creative projects.

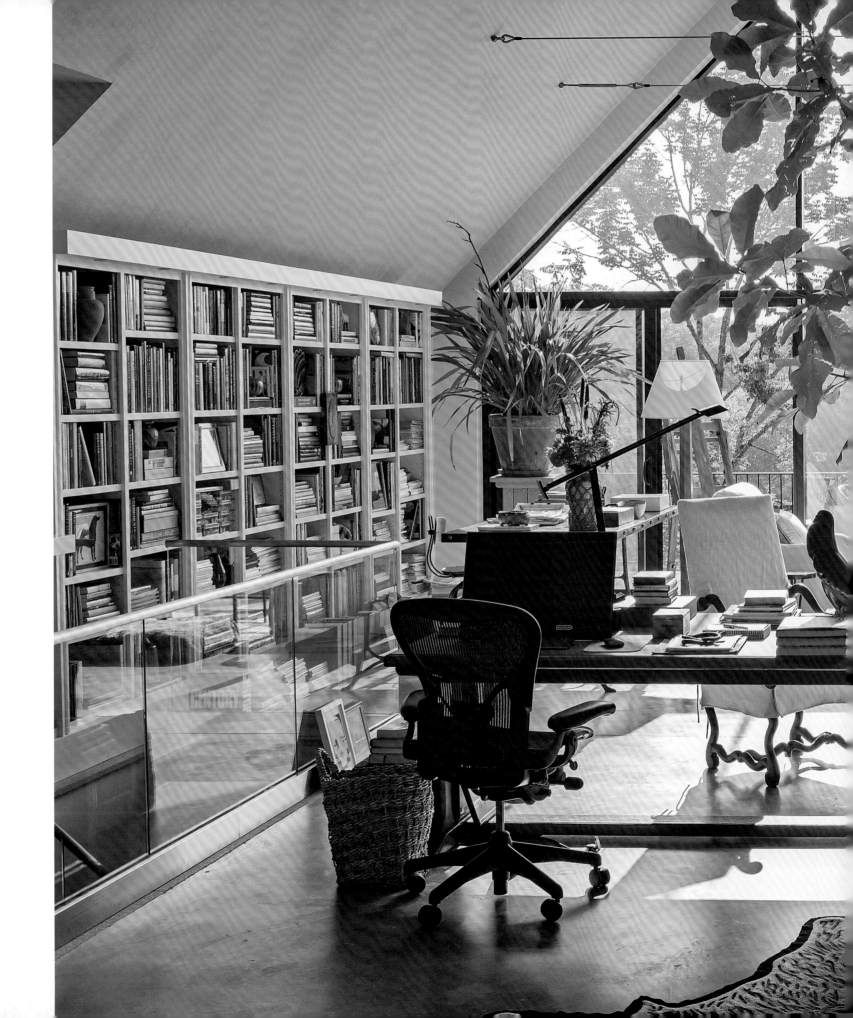

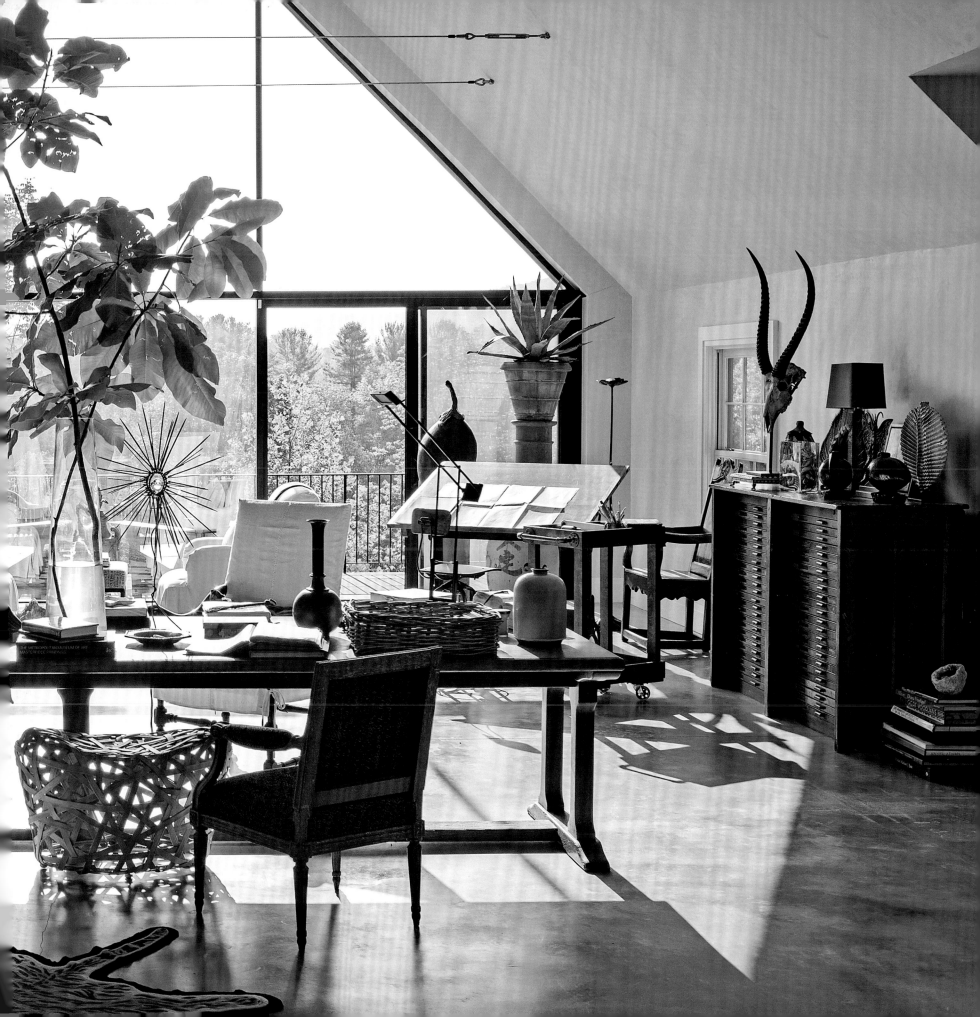

ABOVE, LEFT: The top of a bookcase by the window is just the place for a statue of Pan and a collection of nature's own beautiful artifacts, like coral and petrified wood. ABOVE, RIGHT: I applied magnetic canvas to this wall to create an enormous bulletin board for pinning up images that catch my eye and other things that inspire me. OPPOSITE: The tall, zinc-covered table in front of the bookcase offers a handy place for studying old magazines and books.

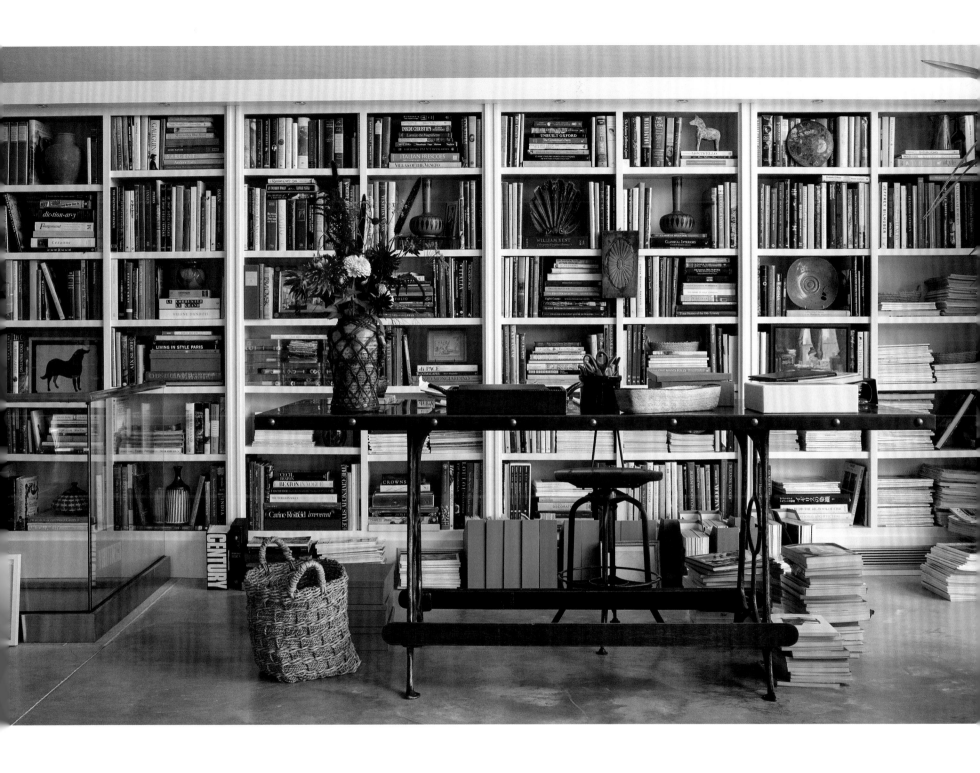

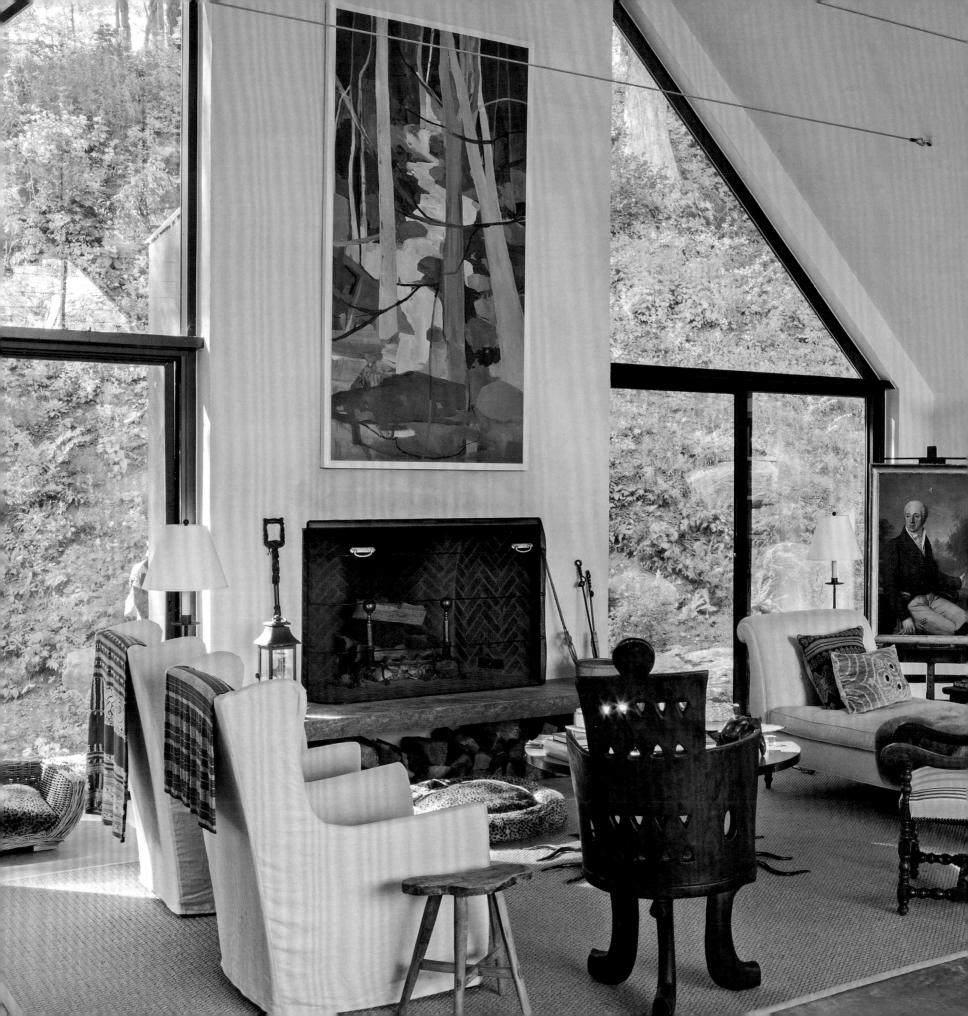

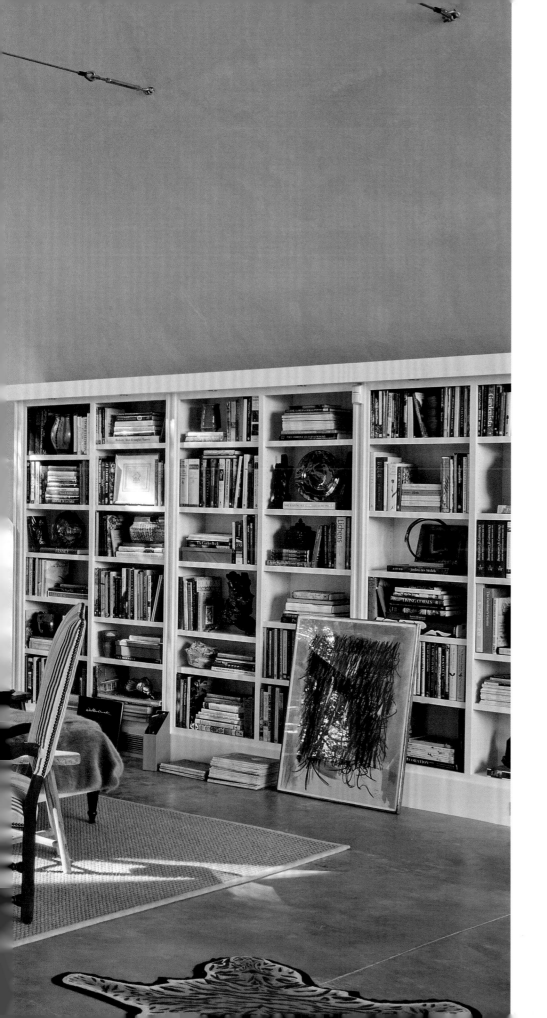

John Funt's eight-foot-high landscape captures our view perfectly. I fell in love with it years ago and am so grateful John still had it when we finished the studio.

The fireplace at this end of the room has a raised stone hearth, which creates space for log storage underneath. The seating area includes a mixture of contemporary and antique pieces, with a French chair and Ethiopian throne complementing comfortable upholstery and a chaise from my furniture collection.

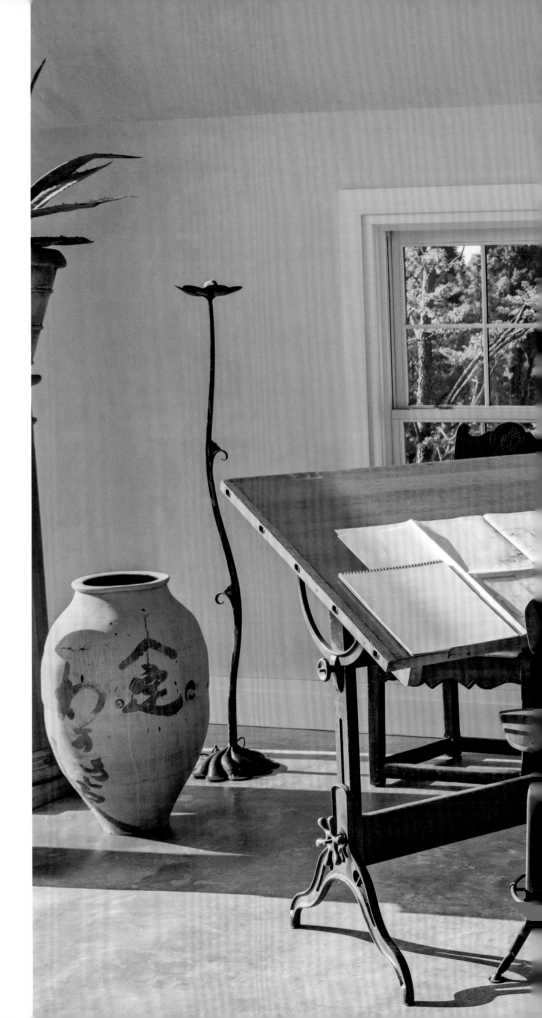

It is so wonderful to have separate places and just the right type of work surface—flat or tilted—to pursue all different types of artwork and creative projects.

RIGHT: A drafting table is convenient when inspiration strikes. The antique flat files hold all sorts of design and art supplies. FOLLOWING PAGES, LEFT: Open vanities work well when they include space for baskets to hold products. FOLLOWING PAGES, RIGHT: I wasn't going to spend any time in the gym unless it was beautiful, so I hung a nineteenth-century French garden tapestry.

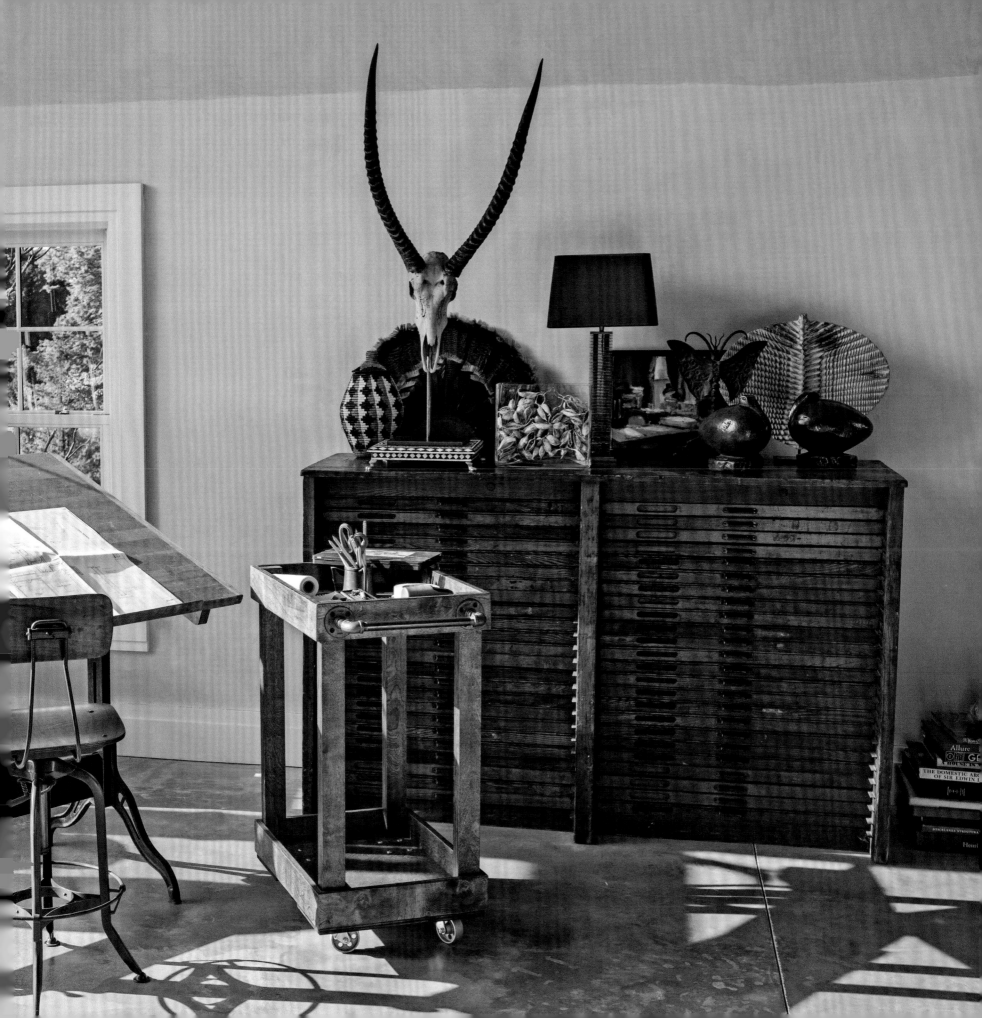

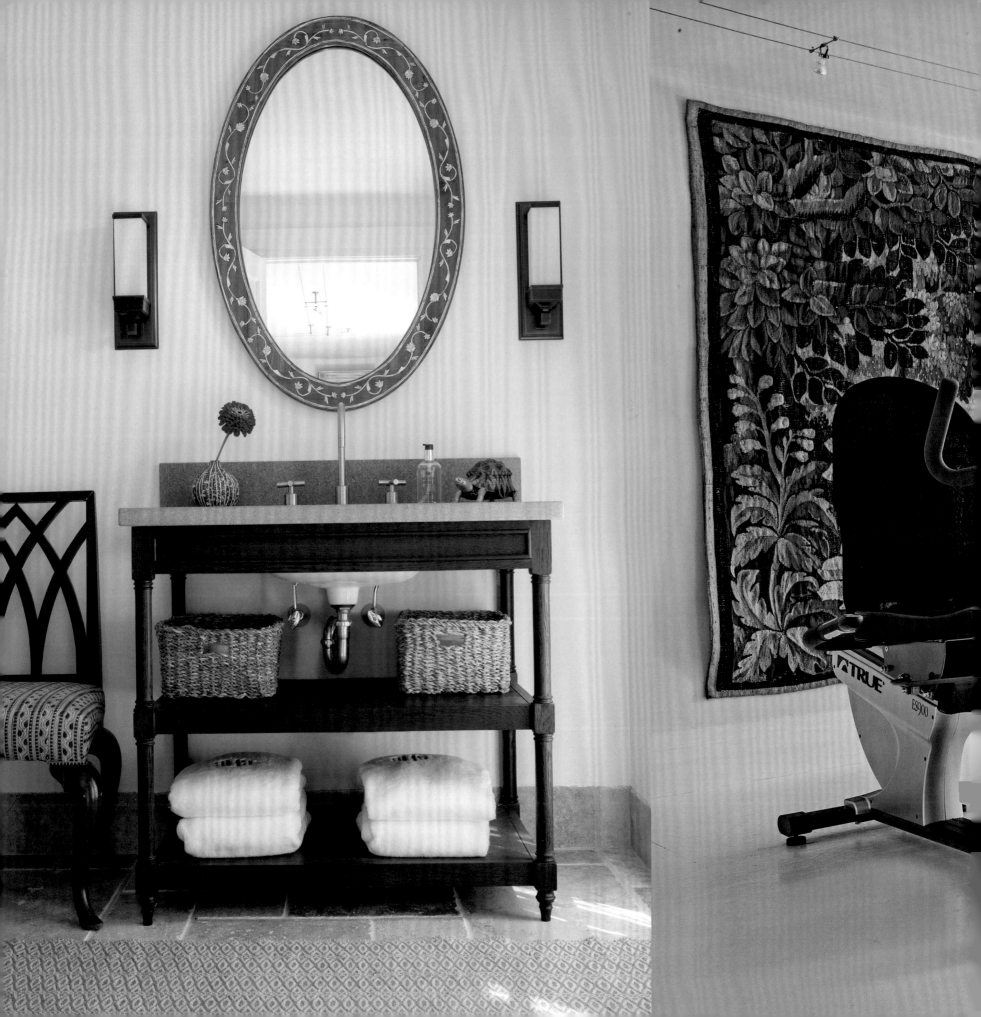

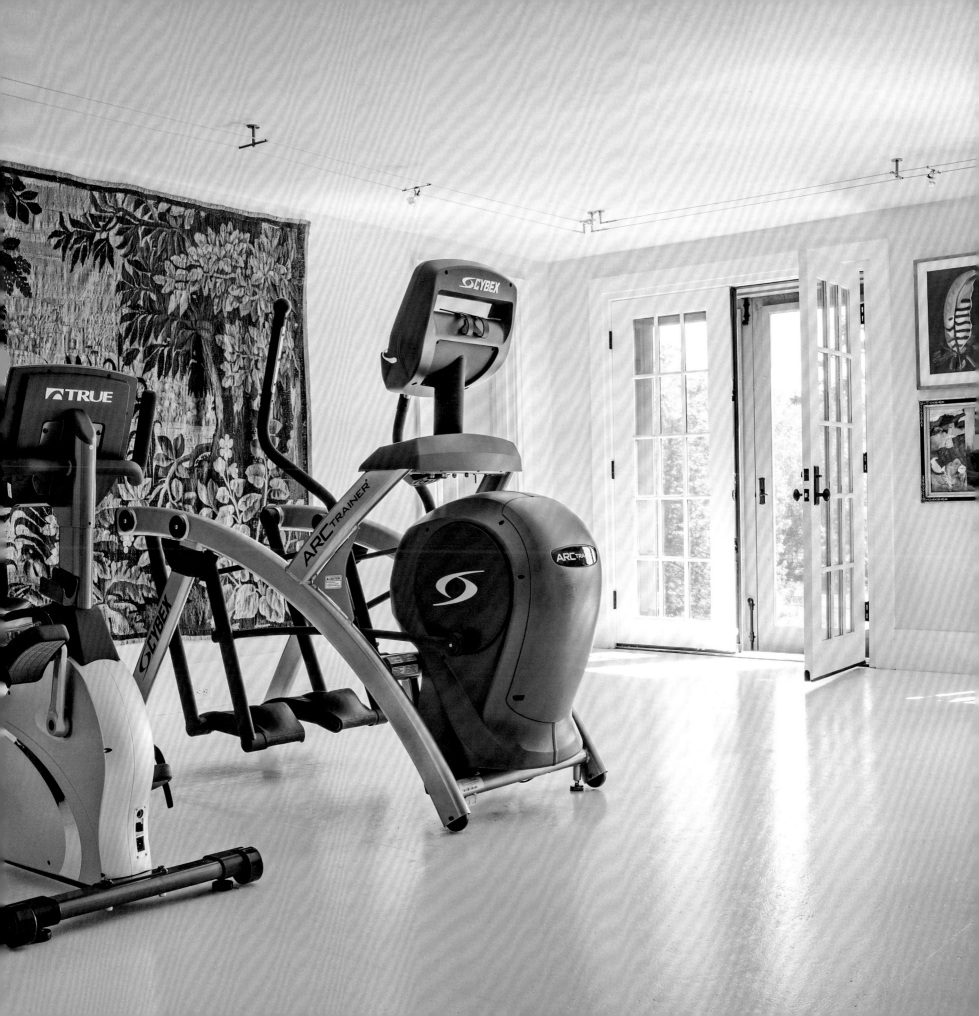

For years I've collected nineteenth-century needlework pictures with floral themes, but I never hung them. Grouped tightly together over this modern sofa, they look completely fresh.

This alcove by the door is another favorite spot, with a comfortable sofa to stretch out with a good book, a chair for John or a friend, and a convenient table to put down a drink.

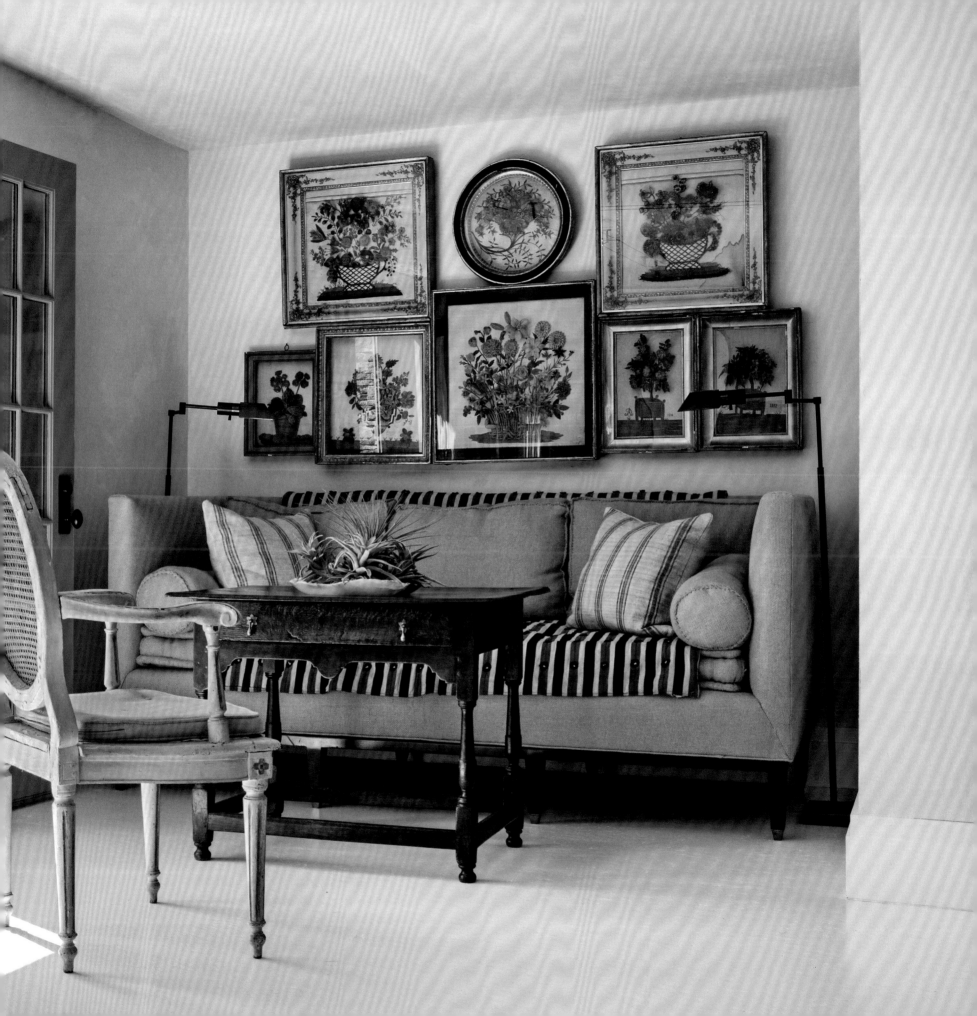

ACKNOWLEDGMENTS

There are so very many people that I wish to thank for helping this book become a reality:

First, I must thank the amazing clients who gave us the opportunity to work on these wonderful projects.

Then, the talented photographers who capture the rooms and spirit so beautifully—Francesco Lagnese, Fritz von der Schulenburg, Paul Costello, Melanie Acevedo, Pieter Estersohn, Carter Berg, Roger Davies.

Then, to Doug Turshen and David Huang, who always bring the visual excitement to my books and hold my hand along the way.

To Shawna Mullen, for her encouragement and patience.

To Judith Nasatir, who helps give my chaotic writing some order.

To Jill Cohen, for all her efforts.

To Chesie Breen, who organizes the most exciting book tours.

To Carolyn Coulter, my assistant without whom I could never accomplish what I do.

To all the craftsmen, artisans, workrooms, architects, builders with whom we collaborate to create each project. We could never do it without all of them!

And especially to Elizabeth Lawrence, my partner who has been involved in so many of these projects.

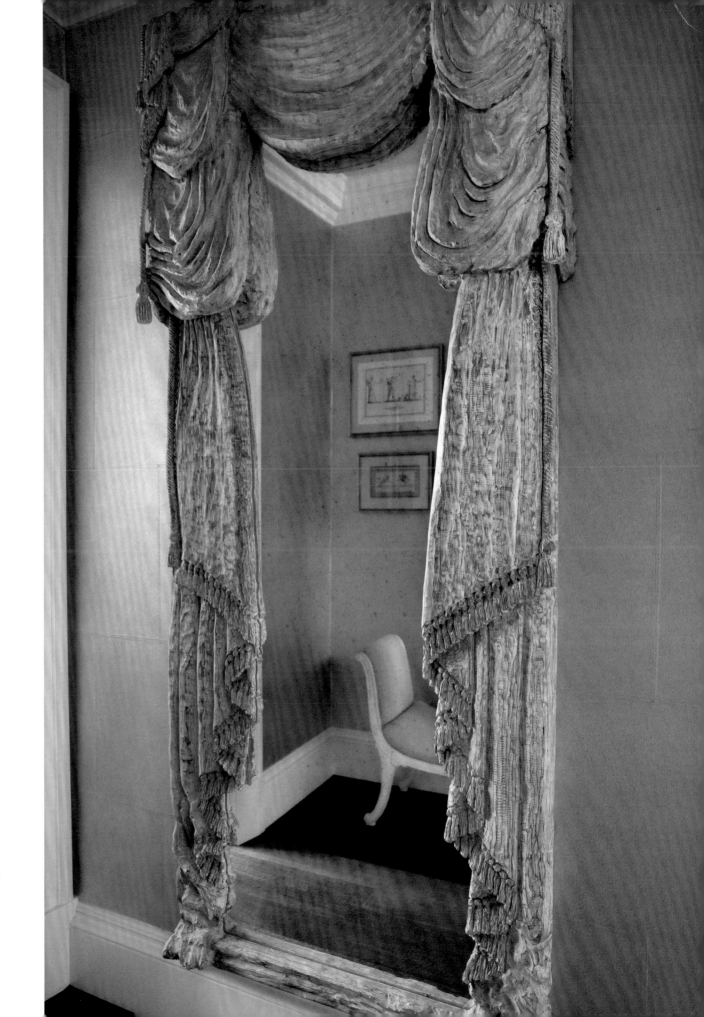

This wood carved drapery was made into a mirror and hung on the wall outside a powder room.

Editor: Shawna Mullen
Designers: Doug Turshen with David Huang
Production Manager: Katie Gaffney

Library of Congress Control Number: 2018936226

ISBN: 978-1-4197-3464-9

Photography by:

Melanie Acevedo, pages 1, 114-115, 117-145, 303

Carter Berg, pages 285-288, 290-301

Paul Costello, pages 102-104, 106-113, 207, 209-219

Roger Davies, pages 74-75, 77-81

Pieter Estersohn, pages 83-85, 87-101

Francesco Lagnese, pages 2-3, 48-52, 54-73, 171, 173-187, 188-189, 191-205, 221-222, 224-240, 242-245, 247-255, 305

Fritz von der Schulenburg, pages 5, 9-12, 14-35, 36-37, 39-47, 147-148, 150-169, 256-258, 260-283

Printed and bound in China
10 9 8 7 6 5 4 3 2 1

Abrams books are available at special discounts when purchased in quantity
for premiums and promotions as well as fundraising or educational use.
Special editions can also be created to specification. For details, contact
specialsales@abramsbooks.com or the address below.

Abrams® is a registered trademark of Harry N. Abrams, Inc.

ABRAMS The Art of Books
195 Broadway, New York, NY 10007
abramsbooks.com

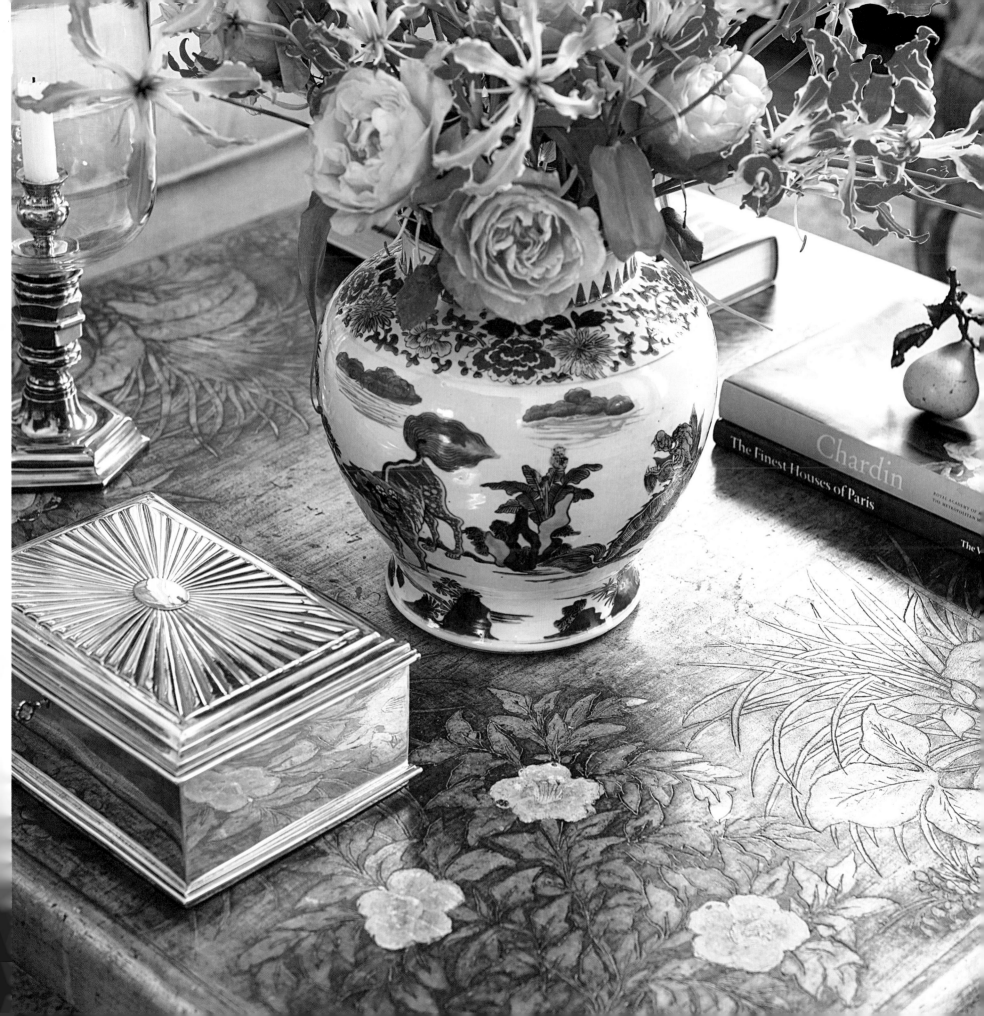